Switzerland

Alpine Country at the Heart of Europe

François Jeanneret Walter Imber Franz Auf der Maur

JOSEPH J. BINNS – Publisher – Washington – New York

Glossary of Names in Different Languages

F = French
G = German
I = Italian
R = Rhaeto-Romance

As a rule, names of places and regions appear on maps in their original language, in the text however in their usual English version, often derived from the French version.

English version	Original name	Other versions
Aar River	Aare (G)	Aar (F)
Aargovia	Aargau (G)	Argovie (F)/Argovia (I)
Basle	Basel (G)	Bâle (F)/Basilea (I)
Bellinzona	Bellinzona (I)	Bellinzone (F)
Berne	Bern (G)	Berne (F)/Berna (I)
Berthoud	Burgdorf (G)	Berthoud (F)
Bienne	Biel (G)/Bienne (F)	Bienna (I)
Bregaglia Valley	Val Bregaglia (I)	Bergell (G)
Coire	Chur (G)	Coire (F)/Coira (I)
Constance, lake of	Bodensee (G)	lac de Constance (F)
Engadine	Engiadina (R)	Engadin (G)/Engadine (F)
Fribourg	Fribourg (F)	Freiburg (G)
Geneva	Genève (F)	Genf (G)/Ginevra (I)
Geneva, lake of	Lac Léman (F)	Genfersee (G) Lago Lemanno, Lago di Ginevra (I)
Grisons	Graubünden (G)	Grisons (F)/Grigioni (I)
Gruyère	Gruyère (F)	Greyerz (G)
Laufon	Laufen (G)	Laufon (F)
Lucerne	Luzern (G)	Lucerne (F)/Lucerna (I)
Lucomagno	Lucomagno (I)	Lukmanier (G)
Maggiore, Lake	Lago Maggiore (I)	Langensee (G)/Lac Majeur (F)
Mesocco	Mesocco (I)	Misox (G)
Morat	Murten (G)	Morat (F)
Neuchâtel	Neuchâtel (F)	Neuenburg (G)
Poschiavo	Poschiavo (I)	Puschlav (G)
Rhine River	Rhein (G)/Rhein (R)	Rhin (F)/Reno (I)
Rhone River	Rhône (F)/Rotten (G)	Rodano (I)
Schaffhouse	Schaffhausen (G)	Schaffhouse (F)
Sierre	Sierre (F)	Siders (G)
Sion	Sion (F)/Sitten (G)	
Soleure	Solothurn (G)	Soleure (F)
Stein-on-Rhine	Stein am Rhein (G)	
St. Gall	St. Gallen (G)	St. Gall (F)/S. Gallo (I)
Ticino	Ticino (I)	Tessin (G)/Tessin (F)
Thoune	Thun (G)	Thoune (F)
Thurgovia	Thurgau (G)	Thurgovie (F)/Thurgovia (I)
Valais	Valais (F)/Wallis (G)	Vallese (I)
Vaud	Vaud (F)	Waadt (G)
Winterthour	Winterthur (G)	Winterthour (F)
Zoug	Zug (G)	Zoug (F)
Zurich	Zürich (G)	Zurich (F) Zurigo (I)

Library of Congress Catalog Card No. 78-53351
ISBN-089674-003-X

Translated from the German by Ewald Osers
English version edited by François Jeanneret

© 1979 Kümmerly+Frey, Geographical Publishers, Berne/Switzerland
Cartography and general production Kümmerly+Frey, Berne/Switzerland
Printed in Switzerland ISBN 3-259-08373-5

Switzerland

Contents

The chapters marked with an asterisk () are by Franz Auf der Maur; the rest are by François Jeanneret.*

From the Introduction
to the Geographical Description
of the Confederation

he Confederation is indisputably the highest and most elevated land in all Europe. A large part thereof consists of long ranges of mountains upon which, in a great many regions, stand other mountains, still higher; indeed not infrequently a third set of mountains is found upon that second set, and upon this follow the unclimbable rocky summits being the uppermost peaks of the mountains. Very often, when travellers believe themselves to have scaled a mountain they only find themselves in a mountain valley and at the foot of a much higher mountain range. But even when the uppermost attainable height has been reached one finds oneself surrounded by bare pyramid-shaped or otherwise fashioned rocks and cliffs whose heights are immeasurable and which deprive the traveller of all views into the valleys. Many of these Swiss mountains stand 9,000 to 10,000 feet above the shore of the Mediterranean Sea. Micheli du Crest even discovered a rocky peak that rises above the head of the Gotthard at 16,500 French shoes above the Mediterranean Sea. The lowest regions of these mountains consist in part of the most excellent forests of fir, larch and beech, and in part of the most luscious meadows yielding tall succulent grass. In these parts of the high mountains the spikes of the herbs sometimes begin to sprout as early as April but commonly in the month of May. At that time the cattle are driven out on to these same grazings. The middle parts of the high mountains are grown with short but excellent fragrant and very powerful herbs which give the cattle the very best nourishment. These middle parts of the mountains are not free from

snow until towards the middle of June. Until that time the cattle find sufficient fodder in the lower parts. At the end of the month of June, however, or at the beginning of the month of July, the cow-herds called Sennen drive up to these higher alps, where they stay with their cattle in the alm huts built for this purpose as long as the weather remains favourable, or as long as they find fodder. Their departure is generally about St. Bartholomew's Day. Often, however, the middle region of the high mountains is also covered with forests, as is seen on Mount Rigi, on the Gotthard itself, and on several other mountains of the second and third magnitude. On some mountains there stand, above these middle alps, even higher ones, but there the herbs for the cattle do not mature until the middle of the month of July; the herdmen's sojourn on these highest alps is therefore only of short duration; rarely does it extend beyond four weeks. Of this nature are the alps of the Urseren Valley, the Bernese Oberland and certain regions of the Grisons. The uppermost parts, however, are infertile throughout the whole year. The rocks have an entirely bare appearance; mostly they are covered with eternal snow and ice. Between the mountains themselves there are frequent mountain valleys and side valleys, which near the fertile mountains are likewise filled with fragrant herbs and yield fodder for the cattle. The valleys between the ice and snow mountains, however, are covered with perpetual ice; they represent flat ice seas, from where at times great pieces of ice descend between fertile mountains into the valleys, with the appearance of pointed towers, and are called glaciers and snowfields. From these and from the ice melted by the sun's rays spring most of the sources of streams and rivers.

As the ice mountains and glaciers make up such an important part of the mountains of Switzerland I will here give further information on them. The whole chain of ice mountains can be divided into ice summits, ice valleys, ice fields and glaciers. Ice peaks are individual eminences of the globe whose substance is of rock but whose surface is covered with perpetual snow. Ice valleys are the depressions which often extend far between the rows of mountains at great altitude and high mountain valleys whose floors are filled with lumps of eternal ice in a solid piece. Icefields are the areas and fields extending often over great distances between the mountains and around their backs and sides; they are covered with almost perpetual snow and ice. The glaciers, however, are the ice births with which the spaces and openings between the ice mountains

are covered and through which the icefields and ice valleys discharge their super-fluity into the low valleys.

These ice mountains are known to foreigners by the name of the High Alps which, however, bear different names according to their position. The Alpes Grajae lie in Valais land over towards Savoy; they extend from Lake Geneva to Great Bernhard. The Alpes Peninnae, which are also called the great Lepontine Alps, begin at the Great Bernhard and reach into the land of Grisons. The Alpes Rhaeticae begin at the border between Italy and Grisons land and extend towards the County of Tyrol. The Alpes Summae comprise all mountains around the great Gotthard in the cantons of Berne, Uri and Grisons. The highest among these are the St. Gotthard, the Furka, the Crispalt and the Lukmanier.

Another proof that Switzerland is highest in Europe is indisputably the number of rivers of first and second magnitude which take their origin from the highest Swiss mountains, and from this elevated country flow into other lower regions. The uppermost area of the Gotthard gives rise to the Reuss, which flows towards the North, and the Tessin which flows towards the South. The Rhodan receives its first water from the Furka, which may be seen as one arm of the high Gotthard mountain. The Rhine, one of the mightiest rivers in Europe, takes its origin partly from the Crispalt, partly from the Lukmanier, which in a certain manner may be seen as branches of the Gotthard. Whether the Inn river, which springs from the Gotthaus-Bund, should not be regarded as the main arm of the great Danube—seeing that it is beyond dispute that the breadth and depth of the Inn, as it unites at Passau with the second arm of the Danube that springs from Swabia, is far mightier than the other—that I will leave to others to decide.

From: Johann Conrad Fäsi, Genaue und vollständige Staats- und Erdbeschreibung der ganzen Helvetischen Eidgenoßschaft, 1765–1768.

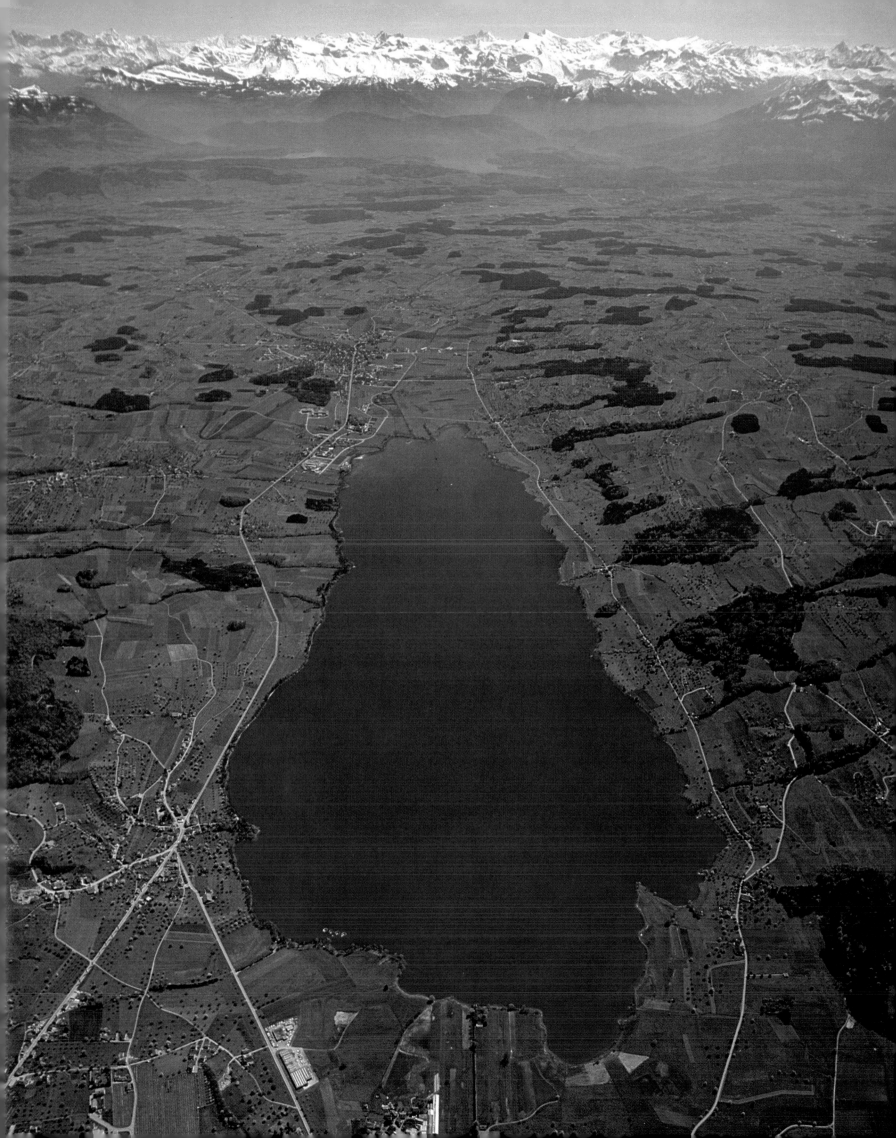

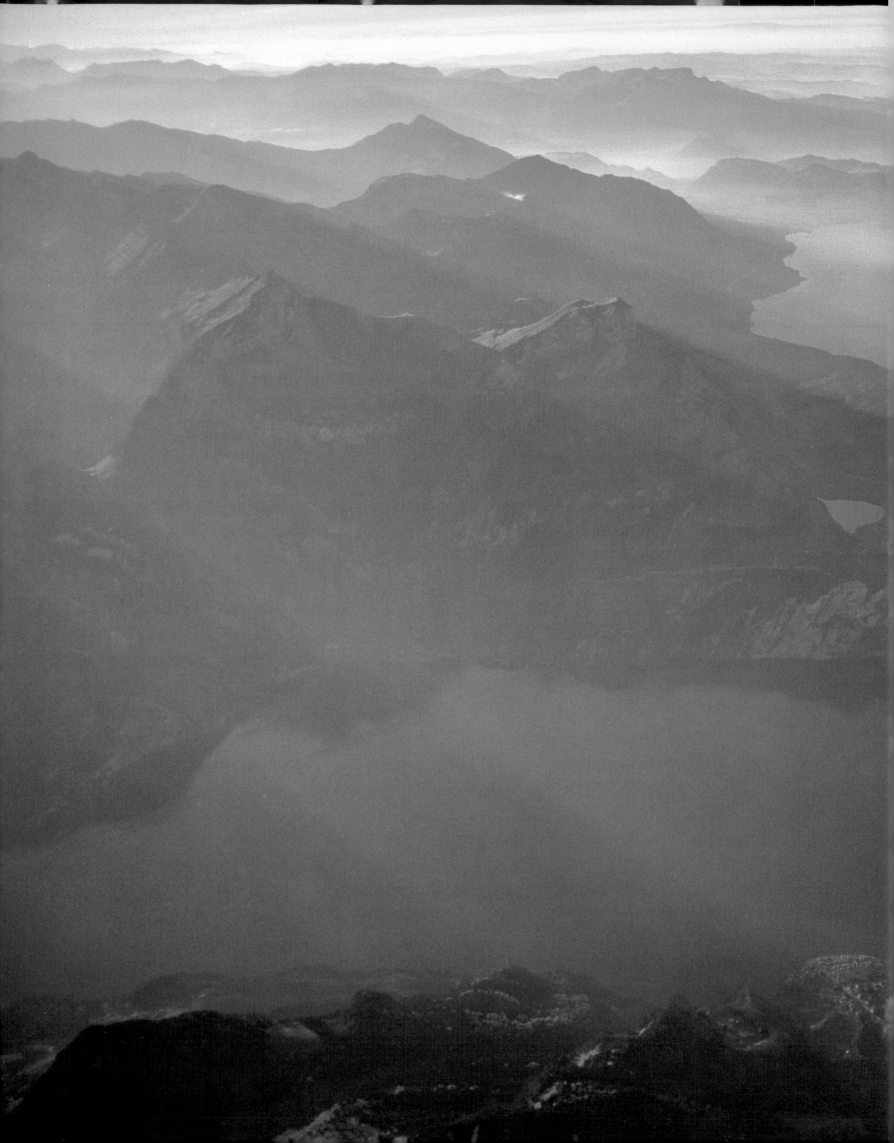

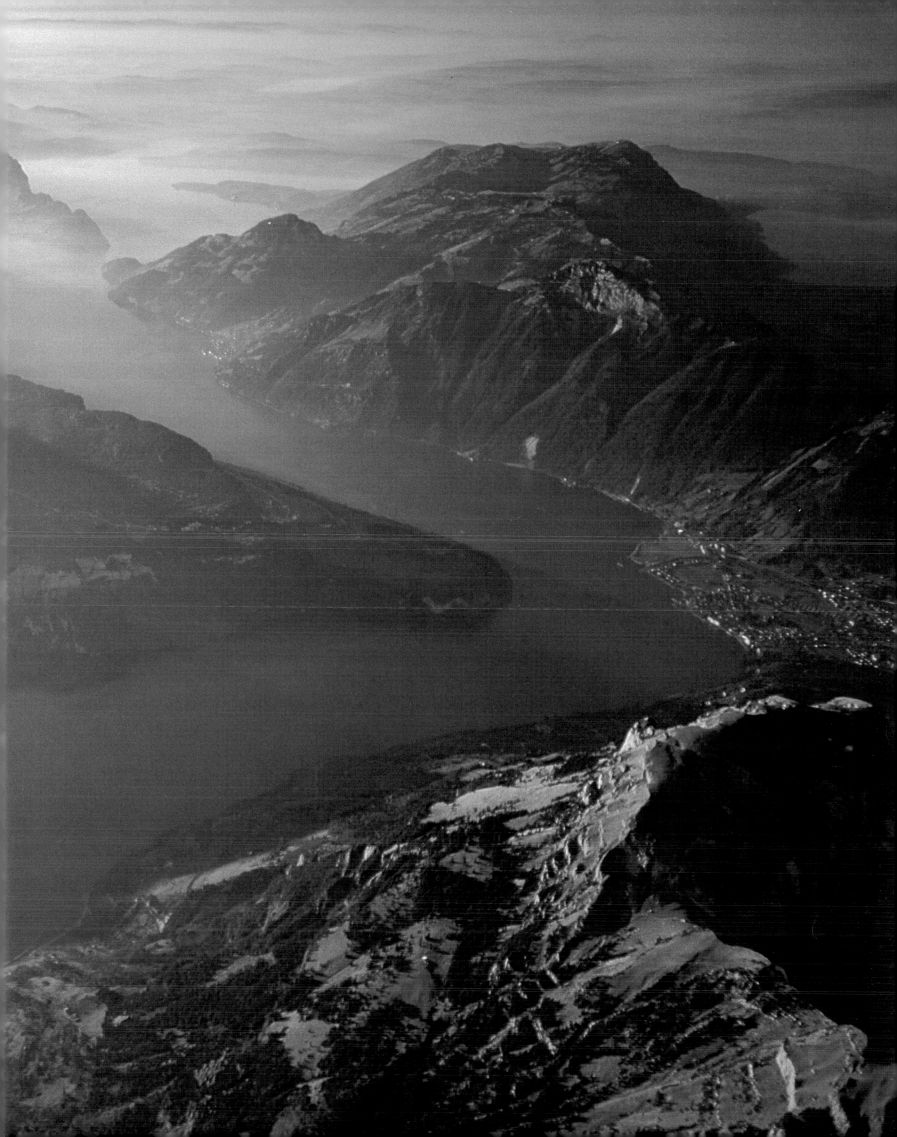

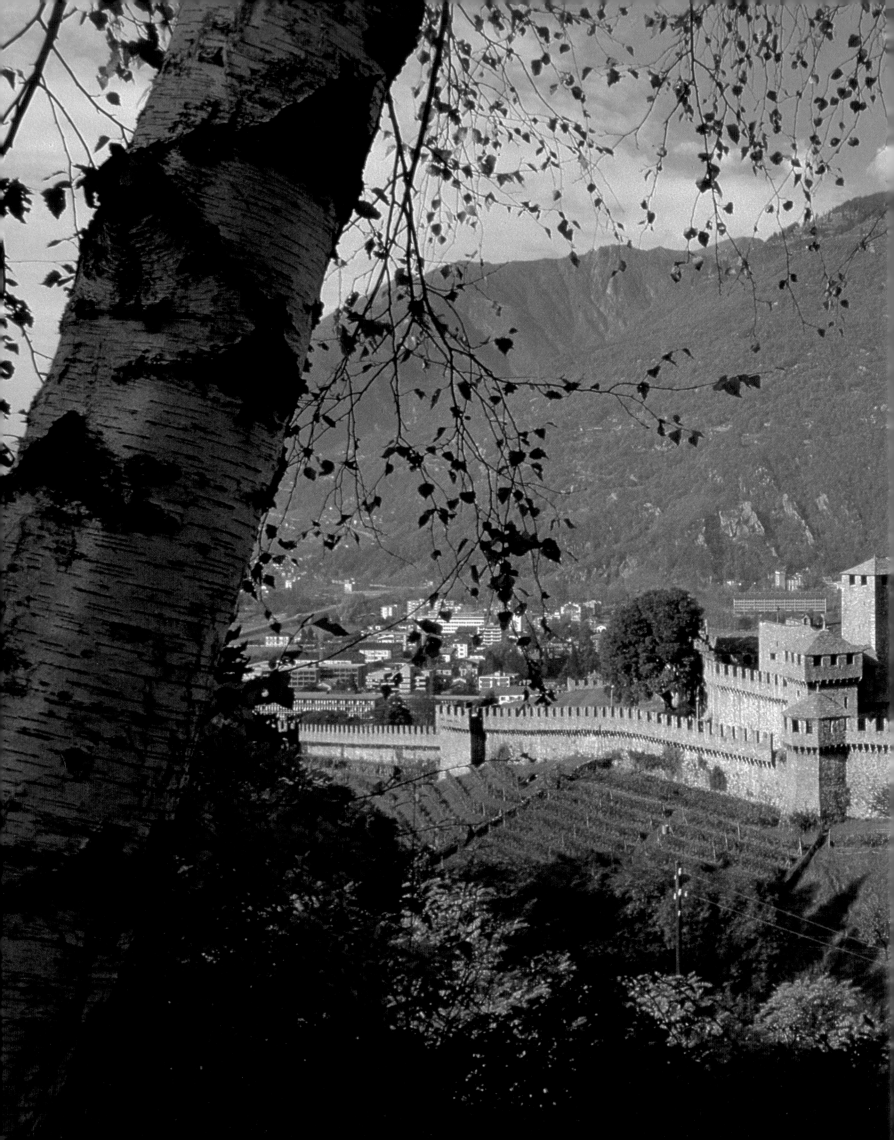

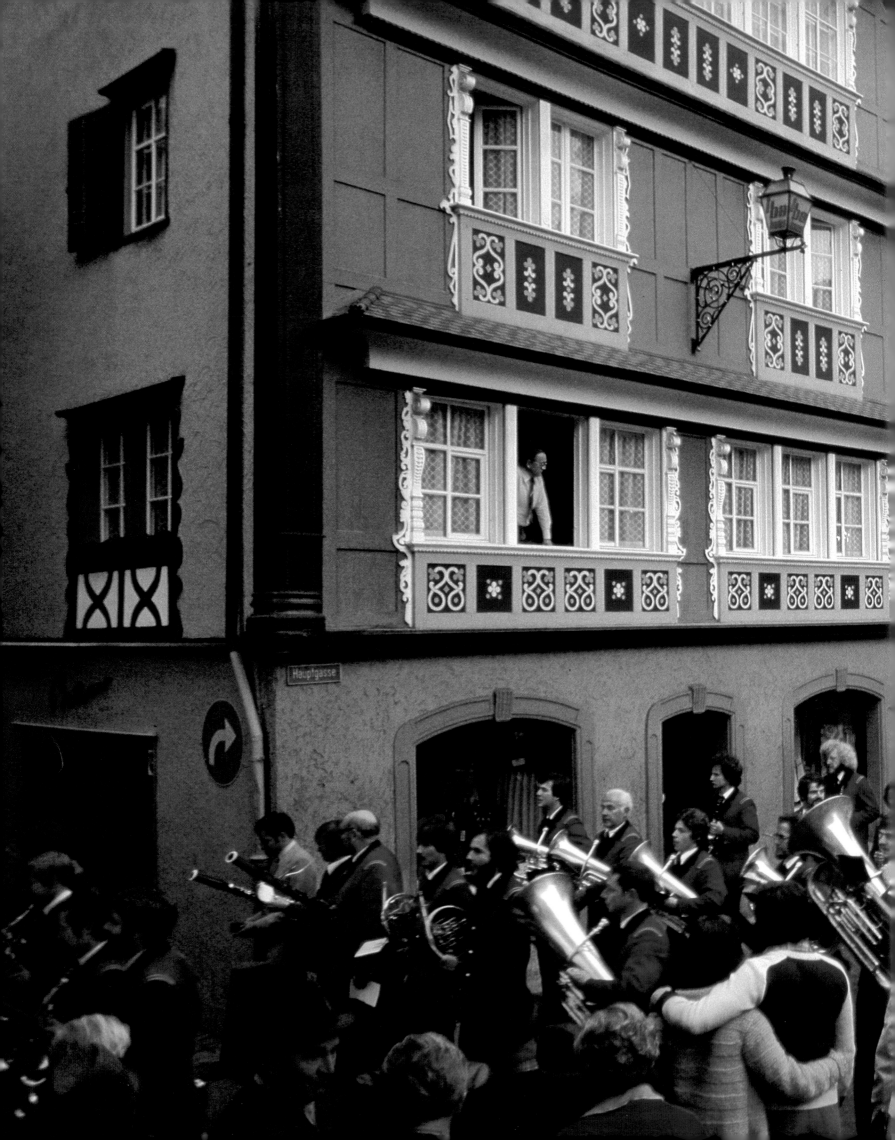

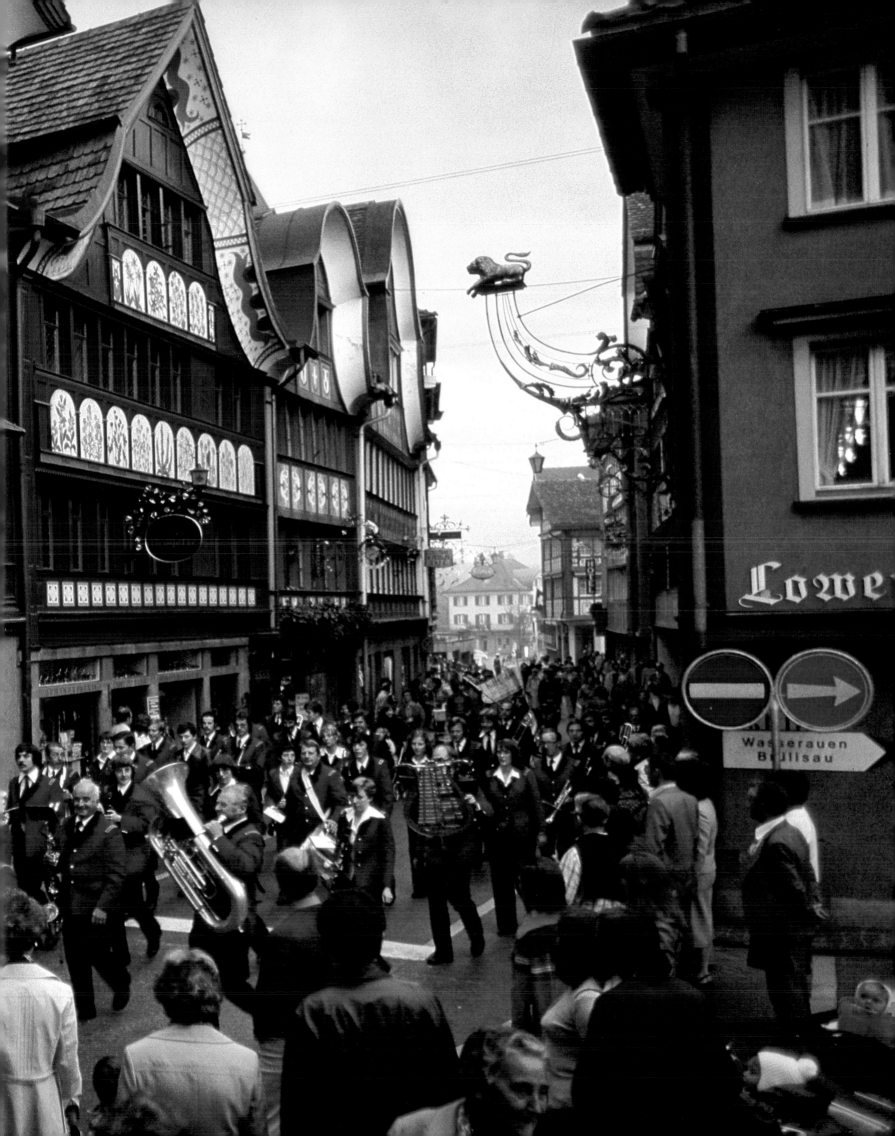

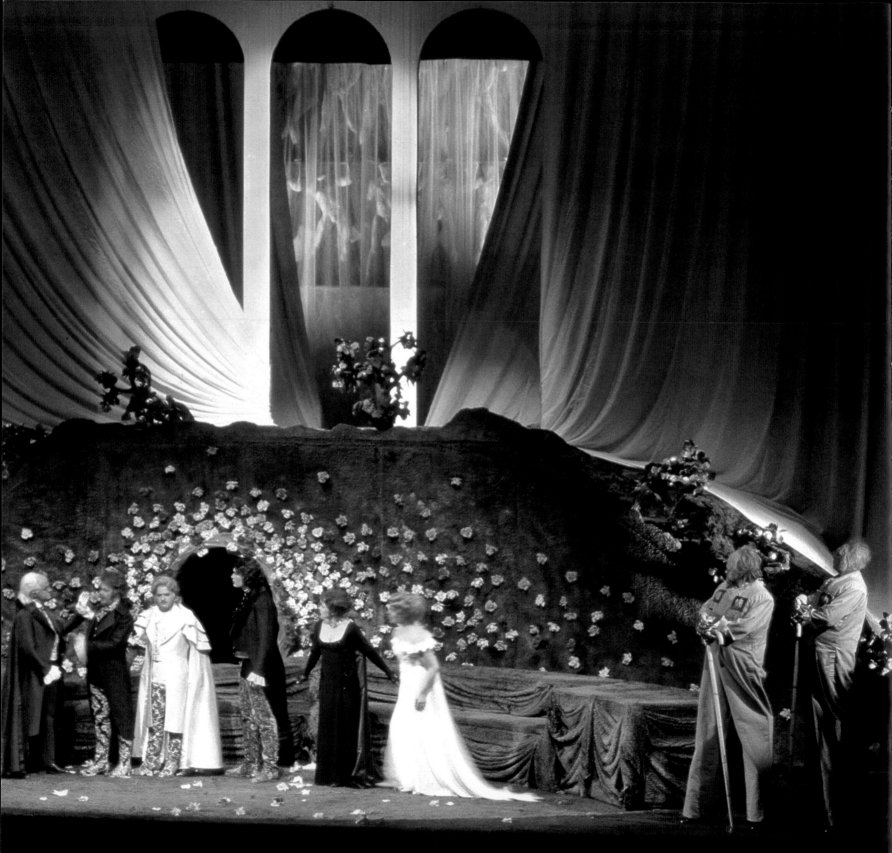

1 Switzerland is an Alpine country: across the fertile hills of the Plateau, reshaped by Ice Age glaciers, the eye travels to the high mountains. A valley in the canton of Lucerne, with lake Baldegg, in the background on the left Mount Rigi and the Glarus Alps, to the right Mount Pilatus and the Inner Swiss Alps.

2 The cradle of the Confederation lies amidst the Alps: Lake Lucerne from the east. Facing the delta of the Muota is the rocky promontory of Seelisberg with the Rütli meadow on the shore of the Uri lake. In the foreground on the right the Fronalpstock, in the background Mount Rigi.

3 Fortified southern Switzerland: wherever the valleys pierce the mountain chains medieval castles control communications. Bellinzona, the cantonal capital of the Ticino, with the fortress of Schwyz (Montebello) in the foreground, behind it Uri Castle (Castello Grande).

4 Living tradition: a brass band marching past historical façades in Appenzell. Many small Swiss towns have succeeded in preserving their charm to the present day.

5 A rich cultural life at the crossroads of European civilizations: a performance of Richard Wagner's opera "Rheingold" at Basle's modern Municipal Theatre (opened 1975).

17

Introduction

Multiplicity in a Constricted Space

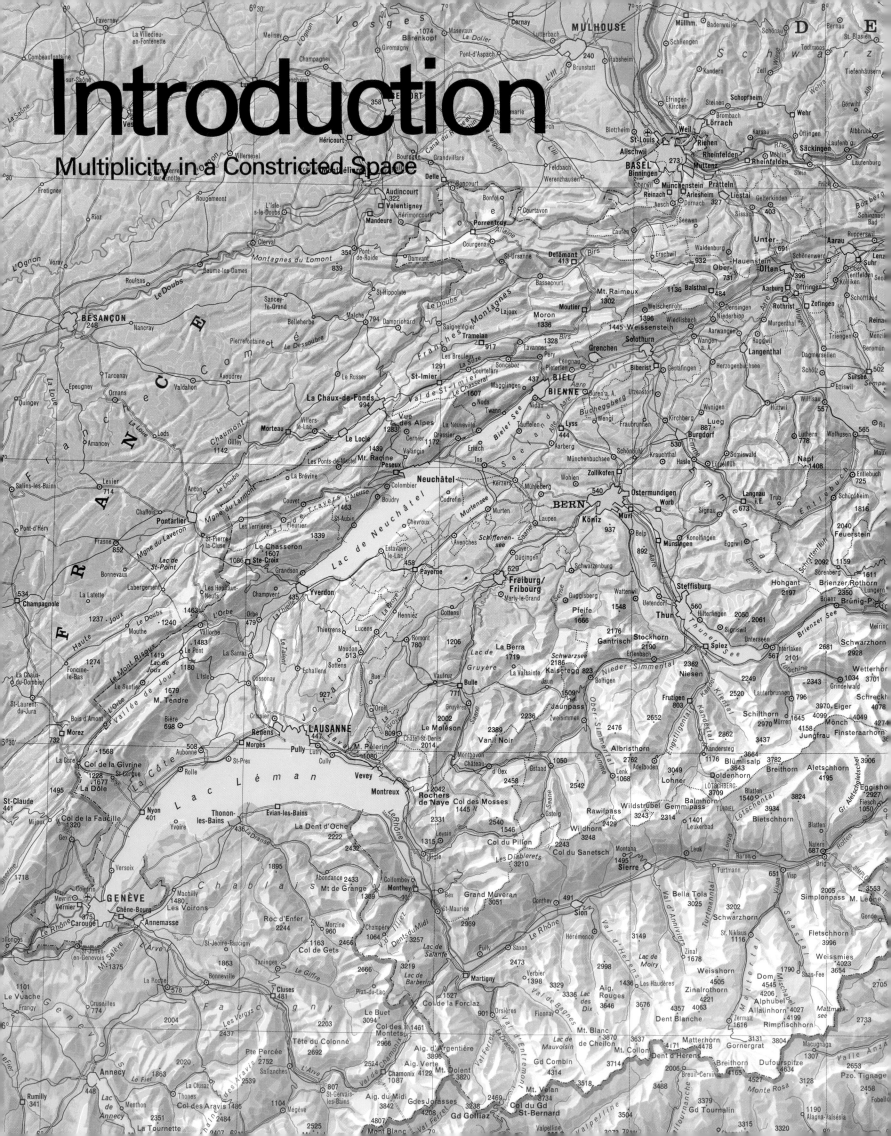

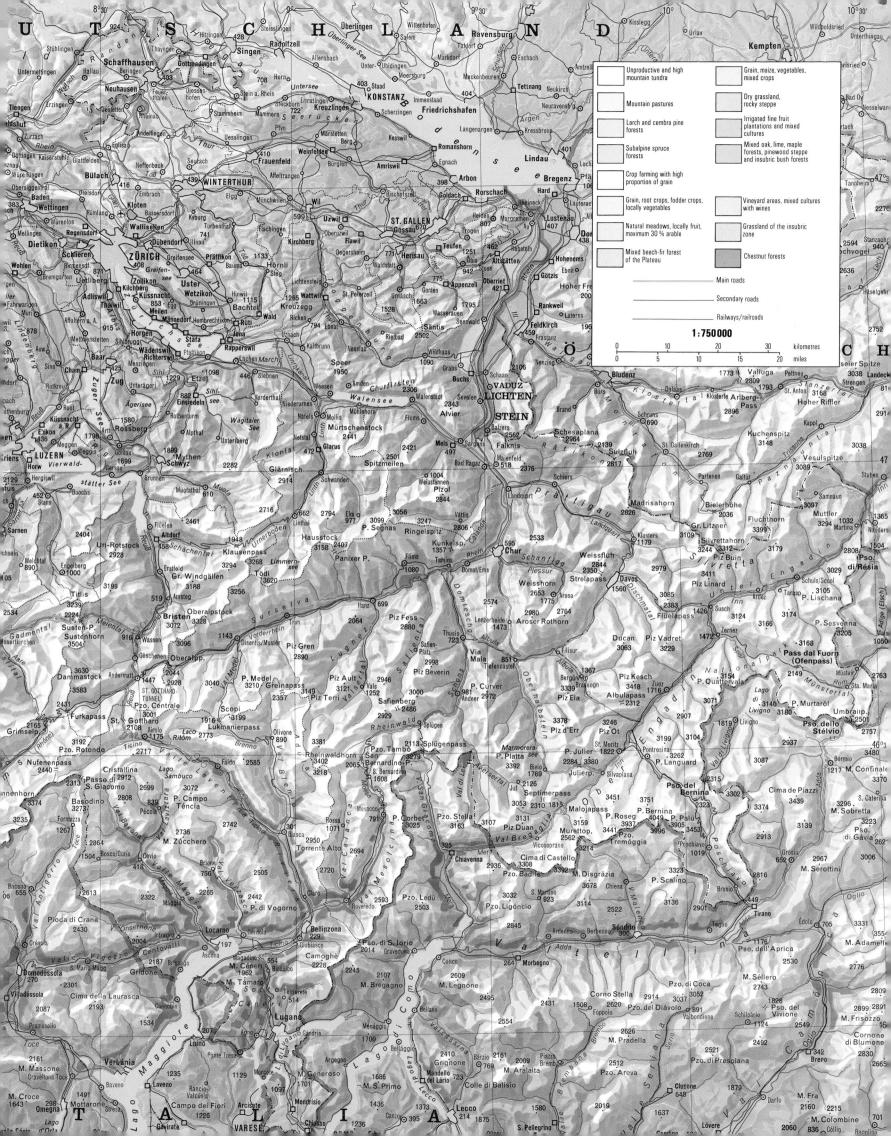

Mountains Mould the Country

Who could doubt that Switzerland is an Alpine country? Certainly not the foreigner for whom the mountains are the very emblem of Switzerland. Matters are somewhat different for the Swiss—since only one out of every four of them still lives in the Alps. The other three live outside the high mountains, predominantly in the Plateau. For them the mountains are a favourite venue—above all in winter—for the odd weekend, and perhaps for a holiday. Sometimes, indeed, the Alps even represent a traffic obstacle to the present-day Swiss when he is lured to the Mediterranean or to even more distant holiday playgrounds in Africa or Asia.

Nevertheless Switzerland is moulded by the Alps. After all, 58 per cent of the State territory lies within the Alpine range, although Switzerland only possesses one-seventh of that range. To the East the mountain system extends 450 km (280 miles) beyond the Swiss frontier, as far as Vienna, and to the South more than 300 km (190 miles) into the neighbourhood of Marseilles. Seven states own a share in the Alps. For France, Italy and Germany the Alps form a fringe, and indeed coincide with the state frontier. Only one south-easterly spur of the Alps extends into Yugoslavia. On the other hand, almost two-thirds of Austria lie within the mountain range. The ancient Danubian Monarchy, however, was oriented towards the countries of the East European plains. Today Vienna, the capital on the fringe of the mountains, plays an important part in that it is the home of one in every four Austrians. The Principality of Liechtenstein, finally, is a genuine Alpine state, though it has to content itself with 0.1 per cent of the Alpine area.

For Switzerland the mountains are not an appendage but the proper substance of the country. The cradle of the Confederation stands among the Central Swiss Alps. To this day the Swiss feel a personal bond with the mountains. Admittedly, many valleys have been infected by the drift from the country and depopulated, and the population now is concentrated in the adjacent plateau region, the *Plateau*. The southernmost part of the Rhine trench, the Basle region, and the Swiss part of the southern Alpine foreland, the Sottoceneri, are other densely settled regions.

Europe's mountainous spine moulds Switzerland as an area and as a nation, even though important parts of its territory lie outside the Alps. The varied landscape units within and outside the Alps are related to each other. Without the folding of the Alps the *Plateau* could not have emerged as a collecting trough for Alpine degradation material. The crustal thrust from the South, which folded the Alps, also led to the emergence of the Jura. Hence even dissimilar landscapes, their colourful history and their culture so powerfully shaped by the environment, can all be reduced to one common denominator.

Switzerland is a mountain country—and it is this aspect that frequently stands to the fore whenever the country is discussed. To

many people the idea of "Switzerland" is tantamount to scenic beauty; indeed throughout the world particularly attractive regions have been given that label. These are believed to number roughly 100. Irmfried Siedentop ("The Geographical Distribution of the Switzerlands", 1977) discovered in every continent localities and regions "equipped with ideal scenic elements". Surprisingly, however, "these 'Switzerlands' display either no or only slight similarity to the variety of landscape features of the 'linguistic mother country'". Admittedly, "Franconian Switzerland" suggests the Jura, though the "Suisse normande" is only gently undulating. There, however, dairy farming plays an important part. In "South Italian Switzerland" (Calabria), on the other hand, tourist traffic is of considerable importance, as it is also in "Spanish Switzerland" (Costa Blanca), "English Switzerland" (the Lake District) and "Luxembourg Switzerland". "The Switzerland of America" in the state of Oregon, the "Argentinian Switzerland" in Rio Negro Province, and finally "the Switzerland of the Pacific" in New Zealand are all examples of mountain landscapes overseas.

But let us return to the Alpine country of Switzerland and to the remarkable variety of landscapes it has to offer. Although nearly any country on the globe can call itself a "land of contrasts" such contrasts are encountered in Switzerland within a particularly small area. Only short distances separate the gleaming glaciers of the High Alps from the luscious vegetation of the Ticino, the bare rocky wastes of the summit regions from the intensively cultivated agricultural areas of the *Plateau,* the solitude of the mountain forests from the cosmopolitan bustle of Geneva or Zurich.

Thus not the whole of Switzerland can be described as Alpine: the Jura is a varied medium-gradient range with wooded ridges, broad valleys, wide basins and undulating plateaus. The *Plateau* extends from alluvial plains in the North to the hill country in the South.

6 ▷ *Switzerland's three main landscapes: the wooded Jura, the inhabited region of the* Plateau *and the pinnacles of the Alps. View of the Bernese/Soleure border region seen from the Leberen range.*

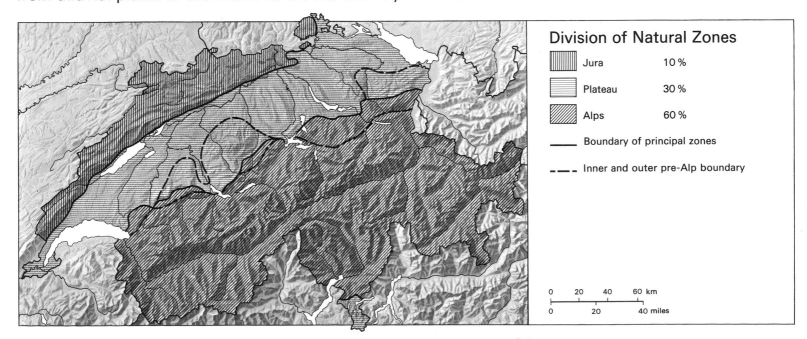

Division of Natural Zones

▥	Jura	10 %
▤	Plateau	30 %
▨	Alps	60 %

——— Boundary of principal zones

‐ ‐ ‐ Inner and outer pre-Alp boundary

0 20 40 60 km

0 20 40 miles

21

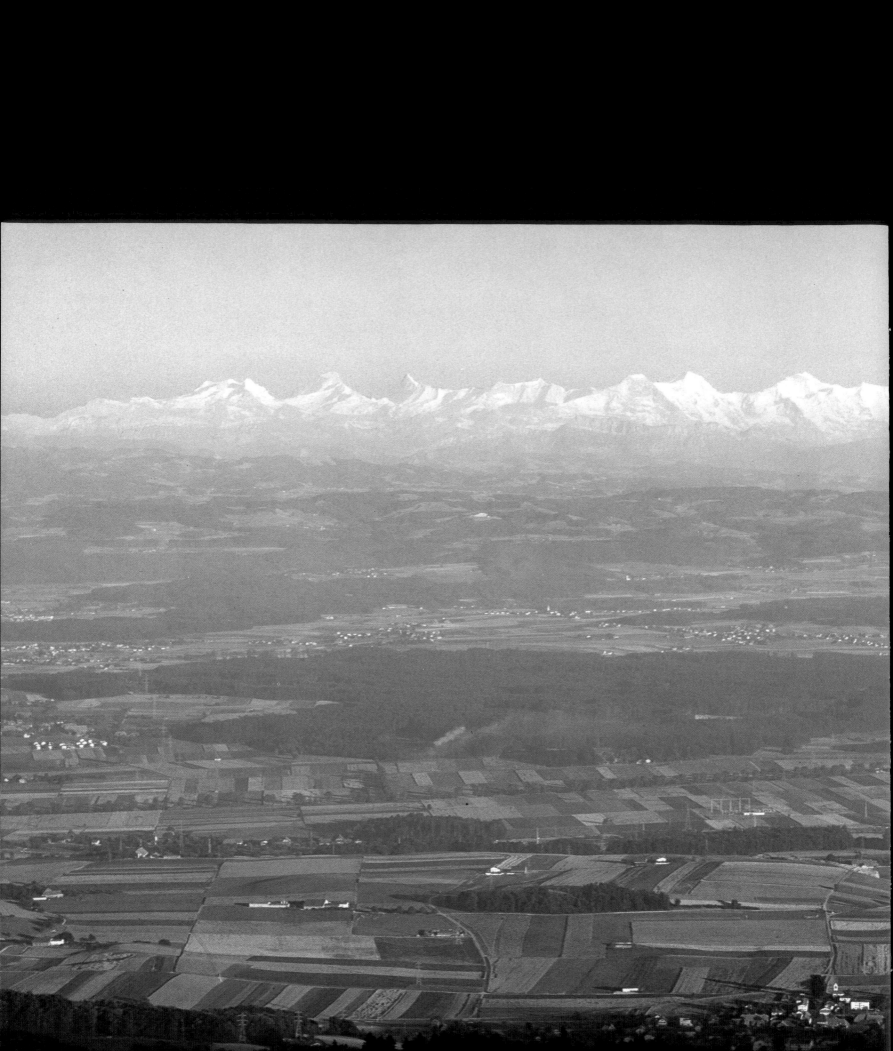

The Alps are the heartland of Switzerland—this is true not only with regard to its scenery and its origin but also to its inhabitants and its historical and political development. Eugène Rambert (1830–1886), an outstanding representative of Western Swiss literature, devoted a six-volume topographical work to Switzerland's high mountains ("Les Alpes Suisses"). In an article "The Alps and Freedom" (1866) he described the effect of mountain landscapes upon their inhabitants:

"The beloved picture of the family blends, in the mind of the mountain dweller, with that of his homeland. They support and strengthen one another. In the plains life is dispersed; in the mountains it is concentrated. If the inhabitant of the plains moves into a neighbouring village he will not find anything strange there in nature, nothing that will remind him painfully of the distance separating him from his parental hearth; he can still see its smoking chimney; he can see it through the trees of the orchards. The mountain dweller, on the other hand, faces a changed sky and horizon after a few steps. Two miles from home he is gripped by nostalgia. (...)

"If, from one of the summits which dominate the Gotthard, one allows one's gaze to roam one may find in the grand outlines of the landscape the essential features of our history, and one may come to believe that they have been written by some Predestination into the book of eternal laws.... It is to the Alps, at least in part, that we owe the democratic constitution of our country and the resistance it develops in struggle against foreign lands. The Alps are not only a symbol but a token, a guarantee of independence. The same obstacles which have prevented the aggrandisement of states have been bulwarks against foreign countries. A land intersected by gorges and crisscrossed by mountains naturally has a great defensive strength, and perhaps there is no other country in Europe that enjoys these advantages to the same degree. (...)

"The mountain world favours the emergence of the spirit of independence. Even in countries of the most fierce despotism the national character in mountainous regions is freer. There may at times be robbers there; but brigandage is a kind of independence or, if you like, revolt. This is not to say that the mountain dweller naturally tends towards brigandage. On the contrary, he is by nature honest, but he is resourceful, strong, bold, sober, persevering; he is of the stuff that good soldiers are made of.... The sense of such superiority is a powerful incentive to independence. The Alpine dweller is hospitable; he is glad to see a stranger sitting by his hearth, but only as a guest, and he turns rough if anyone tries to order him about. He senses that the mountains are his world; he regards them as his property and defends them as such. No one suffers servitude more impatiently."

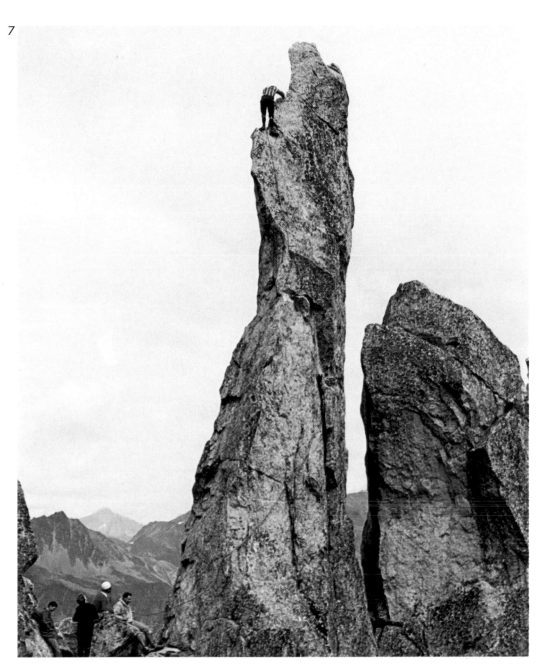

7 Extreme rockwork in the Bregaglia granite massif: the climber fulfils himself in confrontation with the rock.

▽ The geological framework: Alps and Jura belong to a system of young folded mountains running across Europe.

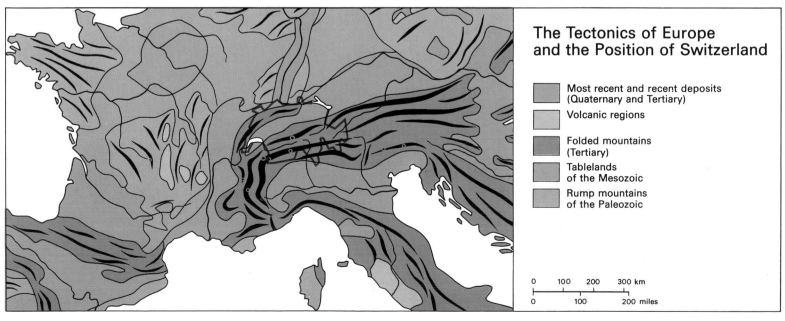

The Tectonics of Europe and the Position of Switzerland

Most recent and recent deposits (Quaternary and Tertiary)

Volcanic regions

Folded mountains (Tertiary)

Tablelands of the Mesozoic

Rump mountains of the Paleozoic

0 100 200 300 km

0 100 200 miles

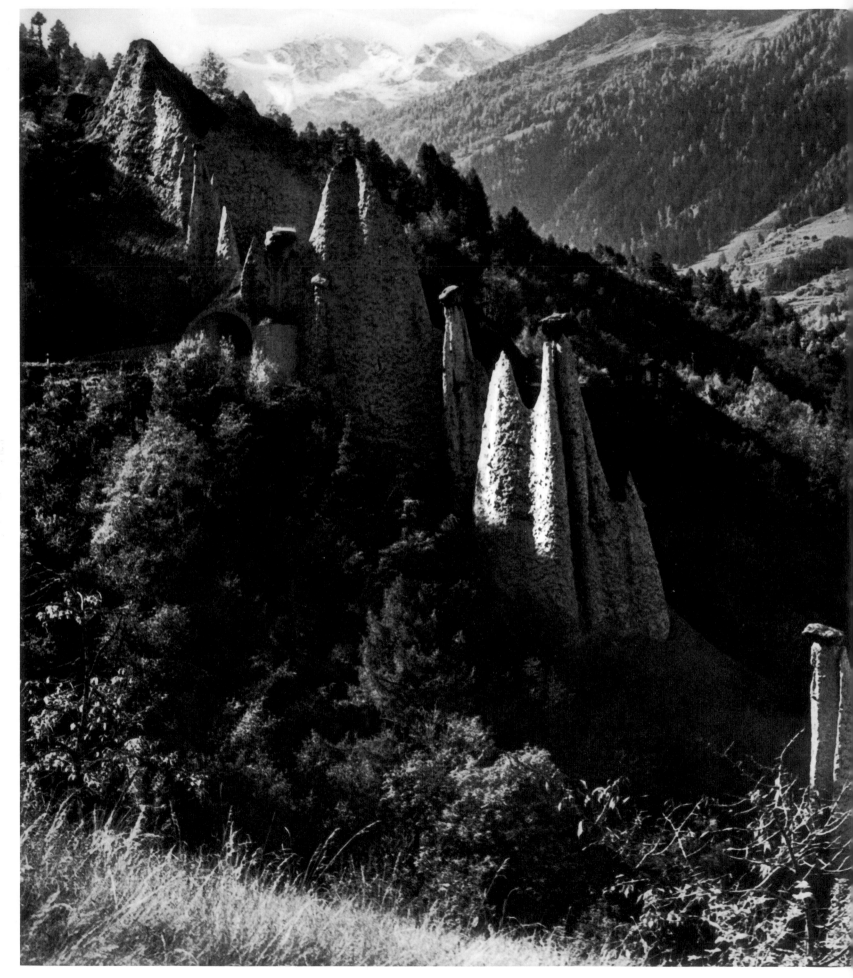

8 Bizarre erosion patterns: the combined effects of nature's moulding forces created the earth pyramids of Euseigne in the Val d'Hérens (Lower Valais). Wherever individual boulders have protected the underlying soft moraine material degradation has not taken place.

Man and Landscape

In the beginning was the hunter. He lived amidst and by nature, and himself was part of it. He was followed by the peasant. He cleared the forest and tilled his land, still in harmony with nature. Later came the scholar. He observed and described what he saw. The poet, too, roamed through the landscape and put in words whatever moved his spirit. Finally came the engineer. He used nature, drained swamps, constructed canals, created reservoirs, built railways, roads and entire cities. The country was transformed in accordance with his plans.

This chapter will discuss man's relationship with landscape, specifically the landscape of Switzerland. The poet's words speak for themselves, and whatever the creative artist has made is clearly visible and requires no special mention. Let us therefore first follow the researcher. Rock and snow fields in the High Alps represented the last serious obstacles to the exploration of the country. About the

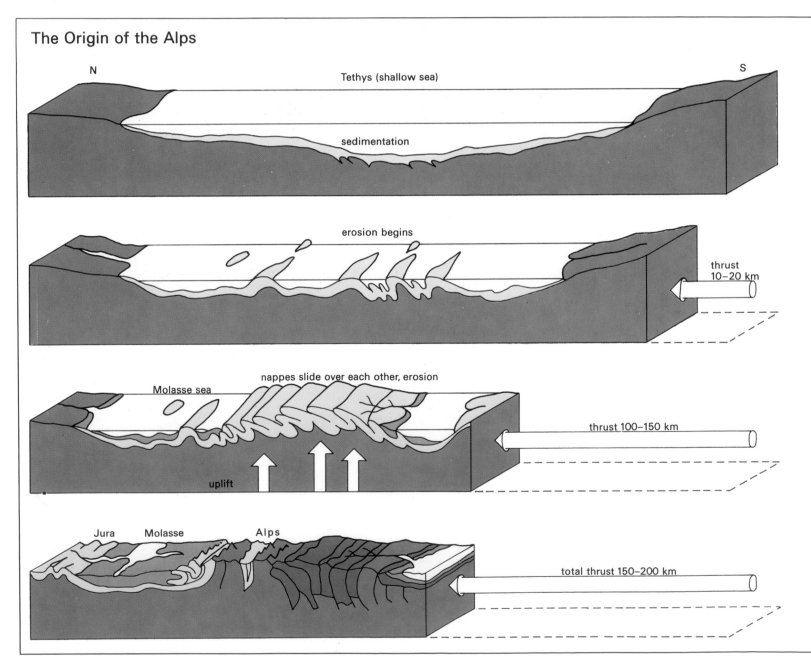

The Origin of the Alps

middle of the past century there were still mountainous areas in Switzerland which had scarcely ever been trodden by human feet. The first to penetrate on their lonely expeditions into remote villages were mountaineers, naturalists and cartographers, who discovered mountain passes, and named peaks which until then had borne no name. The English were the pioneers of alpinism. But they were primarily seeking the excitement of sport. Science received an important stimulus through the foundation of the Swiss Alpine Club (SAC) in 1863. Even though refuges were beginning to be built everywhere throughout the mountains, to provide support points, exploration of the ultimate corners of Switzerland remained a daring venture.

The bearded scholars with their long staves did not confine themselves to their own specialized fields. A geologist would invariably carry with him a vasculum and a biologist would carry a hammer to

▽ *Living geological history: four phases of Alpine folding. Lateral thrust and uplift transformed a marine basin into a high mountain range (left); the geological map and vertical section through the rocks show the present state (right).*

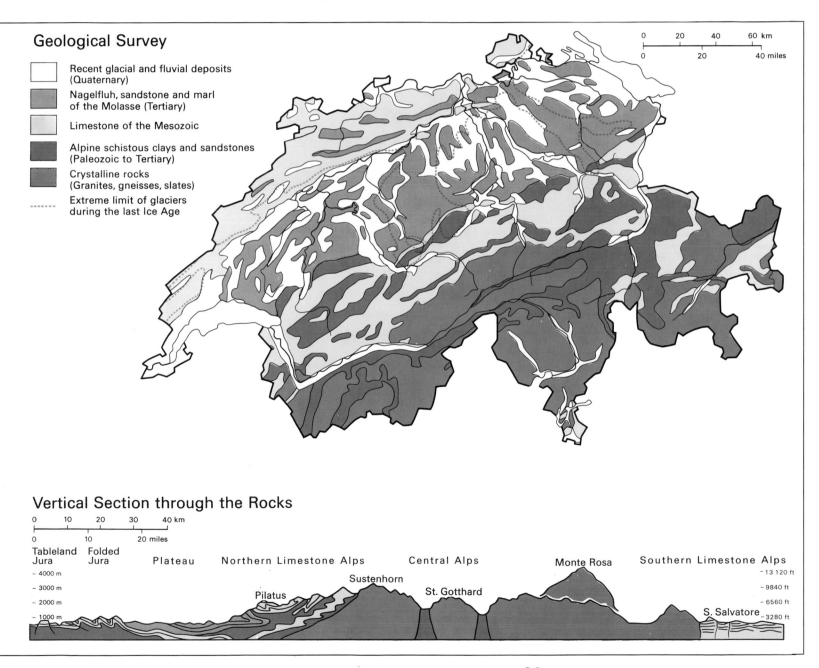

Geological Survey

- Recent glacial and fluvial deposits (Quaternary)
- Nagelfluh, sandstone and marl of the Molasse (Tertiary)
- Limestone of the Mesozoic
- Alpine schistous clays and sandstones (Paleozoic to Tertiary)
- Crystalline rocks (Granites, gneisses, slates)
- Extreme limit of glaciers during the last Ice Age

0 20 40 60 km
0 20 40 miles

Vertical Section through the Rocks

0 10 20 30 40 km
0 10 20 miles

Tableland Jura | Folded Jura | Plateau | Northern Limestone Alps | Central Alps | Monte Rosa | Southern Limestone Alps

- 4000 m — 13 120 ft
- 3000 m — 9840 ft
- 2000 m — 6560 ft
- 1000 m — 3280 ft

Pilatus Sustenhorn St. Gotthard S. Salvatore

chip off rock samples. Both would observe the weather and record atmospheric pressure and temperature. Rest on the summit included sketching the panorama. This hard and often dangerous task was performed by the naturalists of the 19th century in the knowledge that they were at the same time serving science and their country. Anyone who loves his country will wish to know it, and whoever knows it must love it—that was their motto. Nowadays research is more sober. But adventure still exists. The surface of Switzerland, with its area of 41,288 km² (15,937 square miles), is recorded on maps with internationally renowned detail and accuracy, and the line of the frontiers is precisely defined to a finger's breadth even in the high mountains. What has remained largely unknown, on the other hand, is the foundation of the country. In this field there is enough work left for decades to come.

To gather information on the nature of the earth's crust in the area of

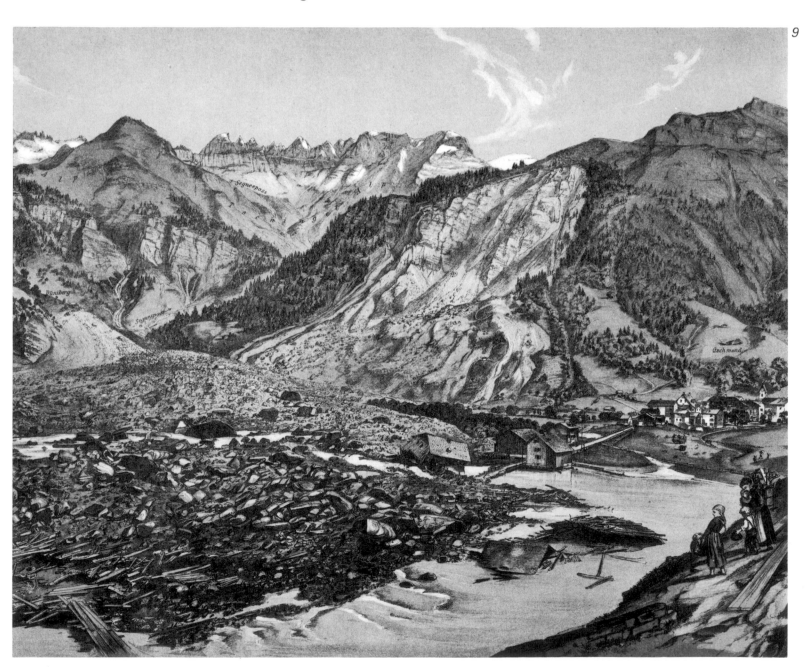

9

the Confederation geologists and geophysicists from all Swiss universities are collecting scientific data along a line 220 km (137 miles) in length. This line, called the "geo-traverse", starts in the Rhine trench near Basle, crosses the Tableland Jura and the folded Jura, the basin of the *Plateau,* the complex-structure zone of the northern rim of the Alps and the Limestone Alps, the Aar massif as well as the Gotthard massif, and finally the Ticino Alps, and terminates on the southern rim of the Alps near Chiasso. Precision measurements along the geo-traverse have shown that the Gotthard massif—and with it the entire Central Alps—rises by rather more than half a millimetre annually. The highest values are not in the pass region itself but about 50 km (30 miles) further south in the Biasca area. If, however, a mountain range rises by even half a millimetre each year, this adds up to a whole kilometre over two million years—and geological history is measured in millions of years. Admittedly, Switzerland is unlikely ever to have any proud 5,000 m (16,500 ft) peaks—if only because weathering counteracts the uplift and through continuous degradation ensures that the mountains do not grow into the sky.

Other long-term research programmes in connection with the geo-traverse project are concerned with an inventory of rocks (Switzerland has the greatest imaginable variety of rocks within a small area) and measurements of radioactivity, seismic activity and rock magnetism. From all these data scientists are trying to establish a picture of the basal structure. This kind of work is not a mere academic game but of great practical use.

When the railway tunnel was built through the Lötschberg between Kandersteg (Bernese Oberland) and Goppenstein (Valais) little was known about conditions inside the mountains—all too little, as was to be demonstrated disastrously. On 24th July 1908 the mining engineers were drilling 160 m (525 ft) below the surface of the Gastern Valley and struck a waterlogged mass of gravel. Instantly a torrent of pebbles and sand burst into the gallery, swamped it over a length of 1,800 m (5,900 ft) and buried 24 workmen. No one had suspected that the overdeepened Gastern Valley was filled with such an enormous layer of loose rock. A similar disaster very nearly occurred during the construction of the Gotthard railway tunnel between Göschenen (Uri) and Airolo (Ticino): only a thin roof of solid rock separates the route of the tunnel from the recent valley fill of the Urseren Valley which at Andermatt consists of a layer of 250 m (820 ft) of groundwater-saturated mountain detritus.

Like the tunnel builders, the Alpine population is at the mercy of the guiles of the mountains. In recorded history between 4,600 and 5,000 people have been buried under landslides in Switzerland, according to an estimate by Professor Albert Heim of Zurich (1849–1937), the grand old man of Swiss geology. In his book "Landslides and Human Life", published in 1932, he wrote:

31

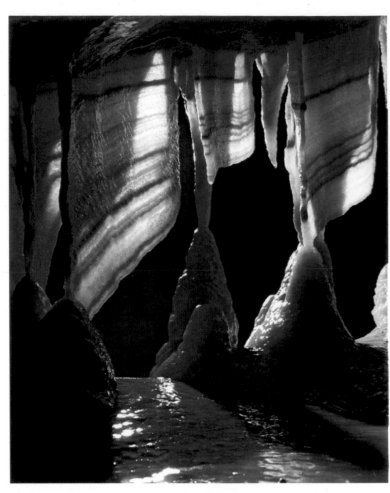

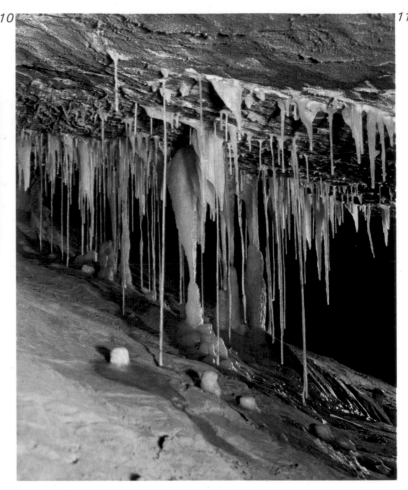

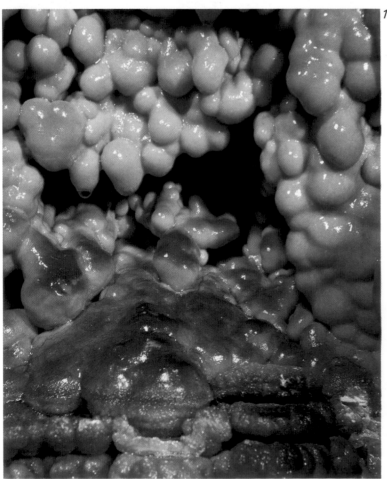

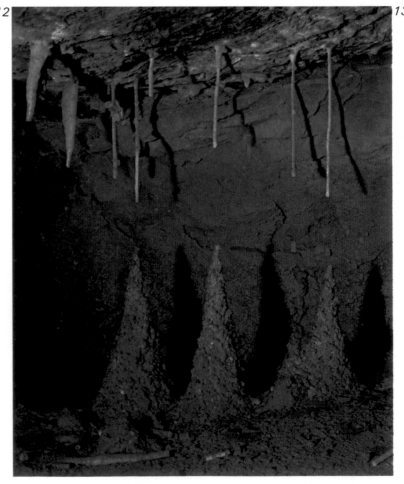

32

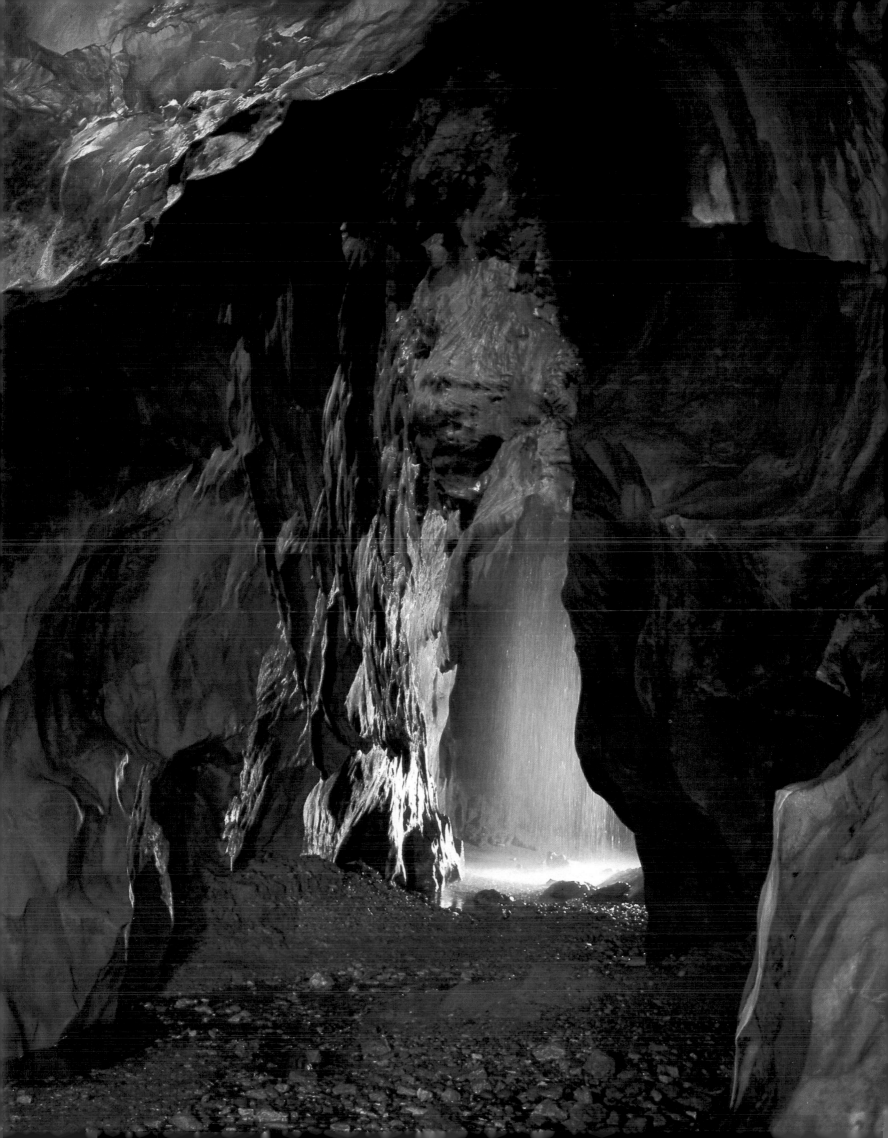

"Our life is short. The memory of mankind as a whole is poor. The few landslides which happened in our lifetime have left us with the impression that landslips are most unusual, exceptional phenomena. But that is not so. Landslips are normal phenomena in the mountains. In the mountains, especially in the high mountains, they are legitimately at home. There they have their part to play in the moulding and in the final polishing of the mountains, working away irresistibly, ruthlessly and ceaselessly in their shaping processes."

The greatest landslide disasters were those of Plurs in the Bergell (September 1618, over 2,000 killed), Goldau in the canton of Schwyz (2nd September 1806, when 457 people were killed by boulders crashing down from the Rossberg) and Elm in the canton of Glarus (11th September 1881, with 115 victims). The Elm disaster had been caused by negligent mining of slate. Fissures and falling rock had given advance warnings of all the above landslips but people refused to heed the warnings. Landslips show impressively that landscape is subject to continuous transformation. That is borne out also by other aspects. A less dramatic one is the disappearance of lakes. They are progressively filled with river-transported detritus. Switzerland's lakes were considerably more extensive a few thousand years ago. The lakes of Brienz and Thoune (Thun) were then joined, and the lakes of Neuchâtel, Morat (Murten) and Bienne (Biel) formed a single vast sheet of water. Altogether the landscape looked very different in the past. The ice age flora, for instance, bore unmistakable Arctic features. With the approach of the glaciers (details of this will be found in the chapters "Glaciers Now—Glaciers in the Past" and "Traces of the Ice Ages") the warmth-loving species perished. A cold steppe emerged, without trees. As in northern Siberia today, or on the Arctic Ocean coast of Alaska and in northernmost Canada, it was chiefly mosses, lichens and a few dwarf shrubs that thrived in the neighbourhood of the glaciers of the Swiss *Plateau*.

The earliest inhabitants of Switzerland have left only scant traces. The most ancient find ever, a hand axe, lay buried in gravels of the late Mindel Ice Age near Pratteln (Basle region) for nearly 400,000 years until a schoolboy discovered it in 1974. More recent and more numerous are the remains of Neanderthal Man who began to roam the country 130,000 years ago, during the warm period between the Riss and Würm glaciations. When the glaciers once more advanced the robust Neanderthal people did not yield. They died out some 30,000 years ago for reasons as yet unknown. Their successors, likewise Ice Age hunters and gatherers, developed into masters of the manufacture of stone tools. These people are the direct ancestors of the present-day Europeans. As the climate became more favourable during the post-glacial period they began to practise agriculture and stockbreeding and to process metal.

34

15

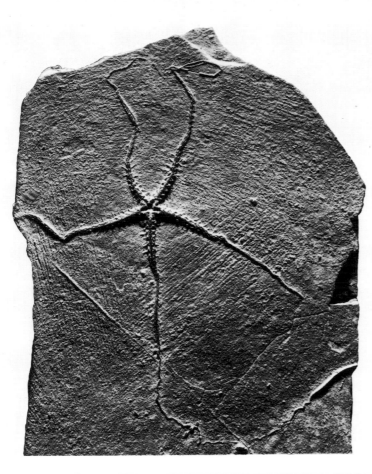

16

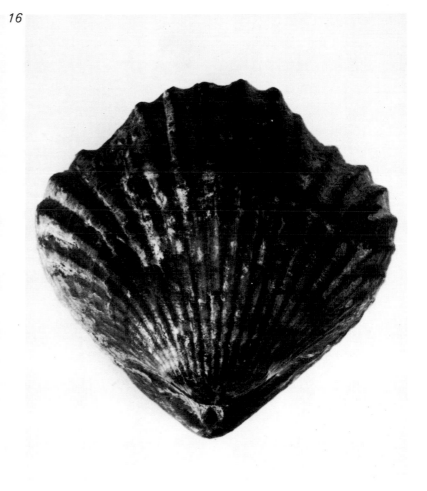

17

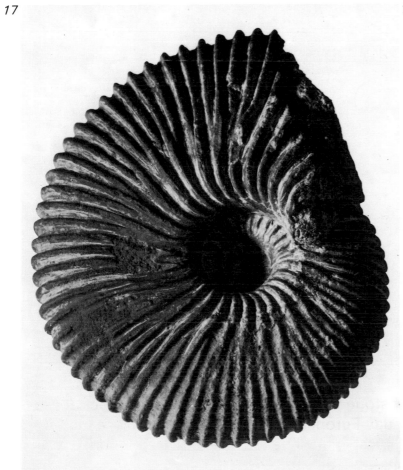

18

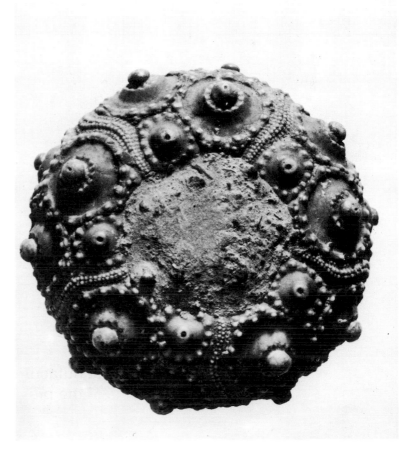

35

19/20 Snapshots from landscape history—two wall paintings in the Lucerne Glacier Garden Museum: Lucerne during the last Ice Age (15,000 to 20,000 years ago) by Ernst Hodel, 1927. Woolly mammoths standing up to the cold. From the Alps moraine-loaded glacier streams descend into the Plateau. In the picture on the right, Mount Pilatus (top). Lucerne during the Miocene (20 million years ago), by Ernst Maass, 1968. A warm climate allows open forests of palms and fig trees to thrive. Amongst them move primeval, now extinct, animals, such as the elephant-like Mastodon (bottom).

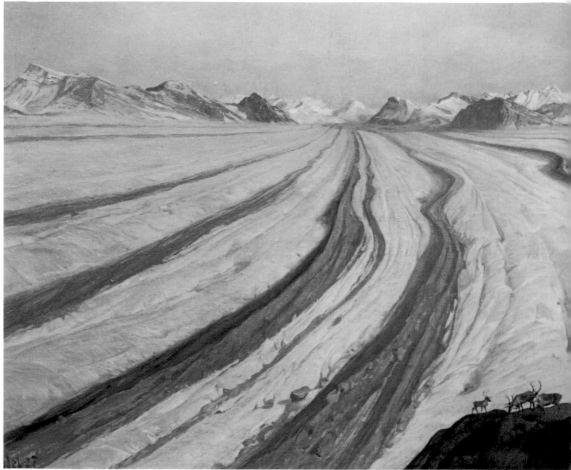

19 20

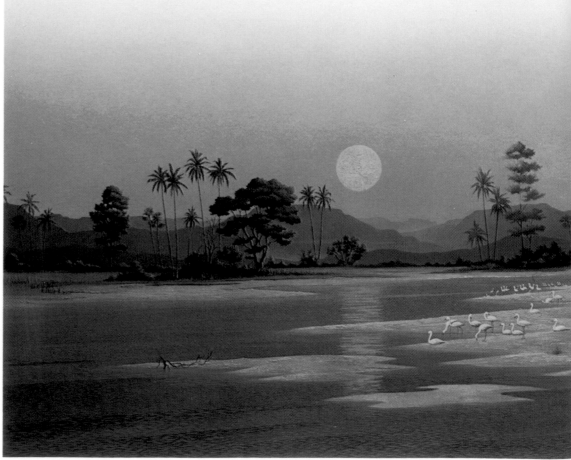

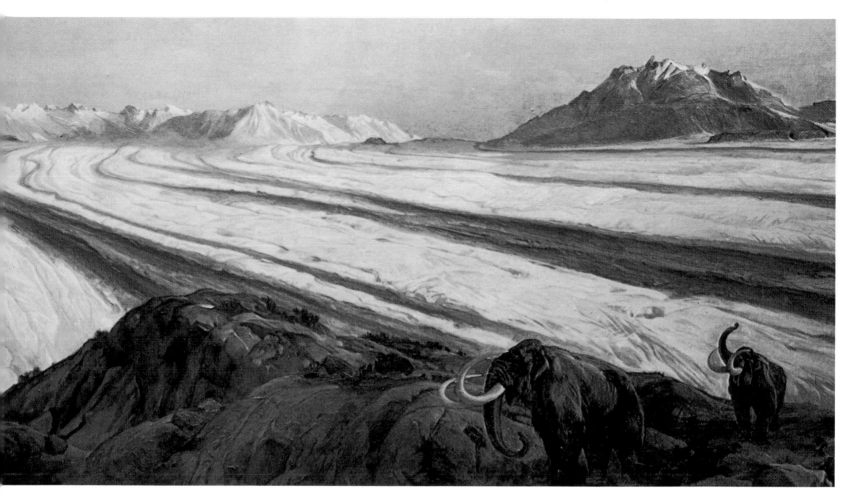

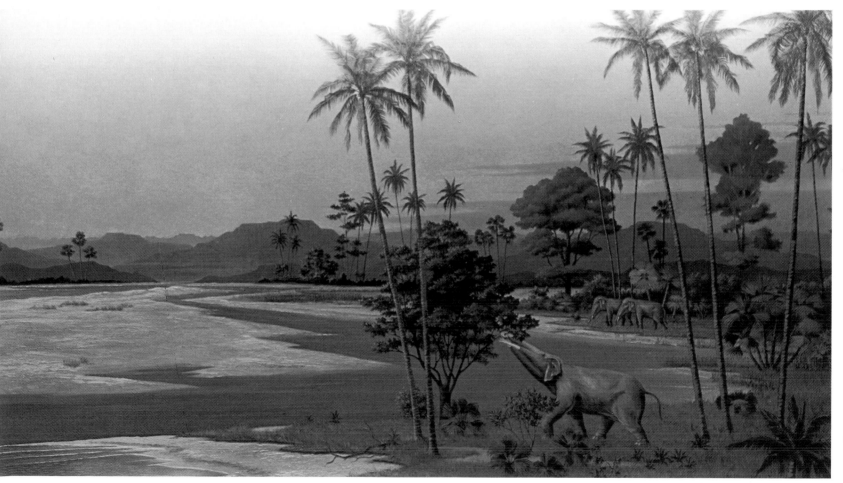

300 Million Years of Swiss History

It was no accident that, on that summer evening in 1291, the first Confederates met amidst the Alps to take their Confederation Oath. The destinies of Switzerland are closely linked with its mountains. A small European state, even if composed of a great many cantons, could not be situated in the plain. The gales of history would have long swept it away. Indeed, without the protection of the summits it would probably not have been born.

If rocks could speak they would have a long story to relate—the geological history of that small patch on the world map which today calls itself the Swiss Confederation. Swiss history did not begin only in 1291. The foundations on which this country rests were laid 300 million years ago. Just as the history of a state or a nation, so the history of the earth has periods of restlessness and revolution which are followed by periods of tranquil development. One such ancient revolution, the Caledonian orogeny in the early Paleozoic more than 400 million years ago, can now be identified only by blurred traces on the territory of Switzerland. Subsequent revolutions have re-shaped all rocks, so that only the experts' measuring instruments can identify those earliest developments. Not until the late Paleozoic does the picture emerge more clearly, in the upper Carboniferous System. Then, approximately 300 million years ago, a further revolution shook those regions from which Central Europe was to emerge very much later—the Herzynian orogeny. It is in that event—no matter how much historians may protest—that we propose to see the beginning of our Swiss history.

During that Herzynian orogeny enormous masses of red-hot molten granite were forced up from the depths to the upper levels of the earth's crust. The liquified rock (the magma) gradually cooled and rigidified into granite. In the Jura, in the *Plateau* and in part of the Alps it is concealed below more recent strata. But it is exposed over considerable distances, i.e. accessible to observation, in the Lower Valais (Aiguilles Rouges massif, Mont Blanc massif), in the Central Swiss Alps (Aar massif, Gotthard massif) and in the Grisons. The granites of the Black Forest and of the Vosges, Switzerland's immediate northerly neighbours, likewise date from that period. Wind and weather gnawed away at those Herzynian mountains and erosion gradually levelled them down. The Paleozoic was followed by the Mesozoic, an era of dominance of the sea. Throughout approximately 160 million years layer upon layer of rock was deposited on the floor of a tropically warm sea. The rock formed was chiefly limestone, the building bricks of the Jura and the Limestone Alps. The sea subdivided into troughs and ridges, and islands rose up above the water. Numerous creatures of the Mesozoic have come down to us as fossils—ammonites and belemnites (crustaceous relations of the squids, now extinct), shells and marine snails, corals, fishes and saurians. Fossils are the signposts of geological history. They indi-

cate the age of rock strata and reveal what the prehistoric landscape must have been like.

In his now famous book "Switzerland's Primeval World" (2nd edition 1879) the Zurich naturalist Professor Oswald Heer (1809–1883) describes the scenery of the Mesozoic. The chapter on the Jurassic Sea—Jurassic refers not only to a mountain range but also labels a period in geological history—takes us back to a period when, 150 million years ago "...an immense sheet of sea extended over a large part of Europe and when only isolated islands and coral reefs showed up from that sea in our own country. We feel as though we were gazing out on a boundless surface, as though we were seeing the blue flood turning into white spume where it is driven over rocky reefs; we feel as though we could hear the distant thunder of its surf when it flings its waves over the rocks against the dry land, or its soft murmur when its foaming water retreats from the beach."

An ocean idyll in the centre of Switzerland. Who would still call it a landlocked country? To return to Professor Heer: "There is no doubt that the same laws which govern the plants and animals of present-day seas also applied to pre-history. We find in our Jura rocks filled with remains of animal life, and others of great massiveness in which all major forms, at any rate, are totally lacking. The former suggests a coastal formation or at least shallow water, while the latter, especially if consisting of a fine-grained formerly muddy mass, suggests great depths."

Towards the end of the Mesozoic, during the Cretaceous Period, the tranquillity was definitely at an end: The Alpine orogeny began. (This is described in detail in the chapter "Biography of a High Mountain Range"). At the beginning of the Cainozoic the Alps rose mightily up and the detritus of the emerging mountain range was deposited in the northern foreland (chapter on "Molasse Country").

▽ *Human life is but a moment: geological time and geological clock (millions of years reduced to minutes).*

Time Scale

Period	Systems	Million years ago	Time on geological clock	Events on what is now Swiss territory
Cainozoic	Quaternary			glacial + interglacial periods
		1,5	23 h 59 min 24 sec	
	Tertiary			origin of Alps + Jura
		65	23 h 34 min	
Mesozoic	Cretaceous			warm + humid
		136	23 h 6 min	
	Jurassic			warm + oceanic
		195	22 h 42 min	
	Triassic			warm + dry
		225	22 h 30 min	
Paleozoic	Permian			desert climate
		280	22 h 8 min	
	Carboniferous			tropical climate
		345	21 h 42 min	
	Devonian			origin
		395	21 h 22 min	
	Silurian			+
		500	20 h 40 min	
	Cambrian			degradation of ancient rocks
		570	20 h 12 min	
Precambrian	Proterozoic			earliest animals
		1750	12 h 20 min	
	Archean			earliest plants

Origin of the Earth about 5 billion years ago

Geological Clock
(The last 3,600 million years equated with 24 hours)

Man since 23.59 hrs. 48 seconds
Flowering plants since 23.30
Mammals since 22.40
Amphibians since 21.35
Fishes since 20.40
Algae since 04.00
Lower animals since 18.00

39

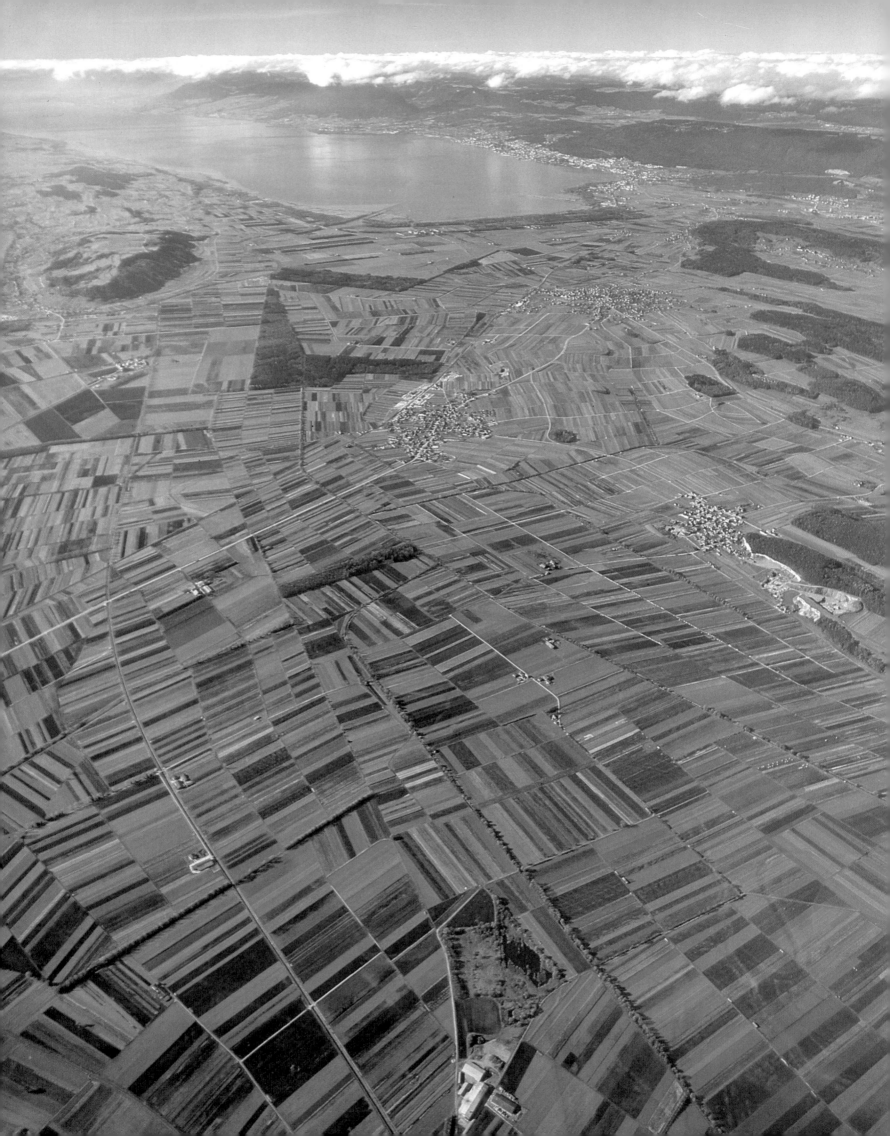

A final phase of powerful overthrust, folding and uplift was followed by the Ice Ages. Glaciers repeatedly advanced into the *Plateau* and moulded the present landscape (see later details). Eventually man appeared on the scene and created his world. What will remain of it when, in a few million years' time, the Alps have been degraded? Naturally enough, short-lived man finds it difficult to think on a geological time scale, to comprehend developments which have occurred in geological history. To him the Matterhorn, the Jungfrau, the Eiger are "eternal mountains". He finds it difficult to visualize that the summit of a 4,000 m peak is built up of limestone that was once formed on the bed of a sea. And the phrase "as hard as stone" makes him forget that, under pressure entire bundles of strata are folded and deformed as though they were made of paper.

Gold, iron, manganese, copper, zinc, lead—all these metals and a few additional ones are found in Switzerland, mainly in the Alps. Nevertheless the country is regarded as downright deficient in raw materials. And with some justification, since under present-day market conditions the deposits are not worth working. Enviously the Swiss gaze eastwards, where their neighbours in Austria are operating a flourishing mining industry. This seemingly unfair share-out of wealth can be explained by the divergent geological pre-history: the Eastern Alps are older, in other words they were folded during an earlier phase of orogeny, and that is why there has been time for erosion to expose the metalliferous lower zones. No doubt extensive ore deposits are lying hidden also in the depths of the more recent Swiss Alps. All we need is a few million years' patience for the unprofitably overburden to be stripped away.

When the last Swiss mine, the iron mine at Gonzen near Sargans, was forced by economic pressures to close its gates in the summer of 1966, an ancient mining tradition—the mine had been operated there since 1396—came to an end. The high costs of extraction and freight had rendered any further ore mining unprofitable. A short while earlier the iron mine at Herznach in the Frick Valley in Aargovia had also suspended operations. The Swiss mining industry flourished in the nineteenth century and during the two world wars. Further iron ore deposits worth mentioning are at Mont Chemin in the Lower Valais, where high-grade magnetite ore is found at the eastern end of the Mont Blanc massif; several deposits in the Grisons which often also contain manganese in addition to iron; the area of Erzegg—Planplatte above Innertkirchen in the Bernese Oberland, which used to supply cannon balls for the Sonderbund War of 1847; and finally the Jura "bean ore", accumulations of nut-sized down to pea-sized grains which used to be worked especially in the Delémont basin.

Swiss deposits of non-ferrous metals are mainly confined to the Central Alpine region. There they are exceedingly numerous and

21 An irreplaceable basis of livelihood: the lakeland with its fertile bog and ground moraine soils is one of Switzerland's most profitable agricultural regions. Beneath recent field crop structures the courses of filled-in rivers can still be traced. In the background the lake of Neuchâtel.

Mineral Wealth

22

22 *Great expectations: drilling for oil at Romanens (canton of Fribourg), like many other attempts before it, proved unsuccessful.*

23–25 *Switzerland as a mining country: extraction of metal ores (iron mine of Herznach in the Aargau Jura, 23; lead and zinc mine of Goppenstein in the Lötschen Valley, Valais, 24) had to be discontinued on economic grounds. The Rhine valley saltpans, on the other hand, near Basle and at Bex (canton of Vaud, 25), have survived and supply the whole country with salt.*

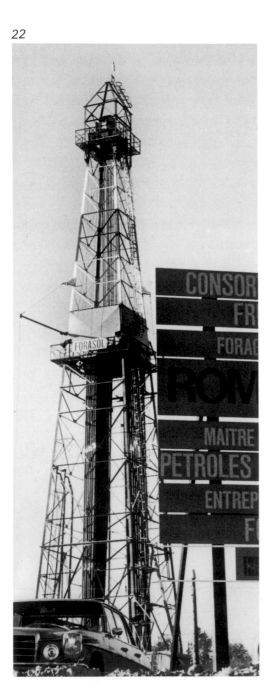

varied but present difficult problems to extraction because the run of the seams is as a rule unpredictable and lacks any regularity. Many a company had to go into liquidation because a promising vein suddenly came to an end. Lead and zinc, which as a rule occur together and whose ores also contain a little silver, have been extracted in several southern lateral valleys of the Lower Valais, also near Goppenstein in the Lötschen Valley and near Trachsellauenen in the Bernese Oberland. In the Grisons there are well-known mines on the Silberberg near Davos and on the Bleiberg above Schmitten, as well as in the Scarl Valley in the Lower Engadine. Copper was mined chiefly in the Val d'Anniviers (Lower Valais), on the Bristenstock in the Reuss Valley (Uri) and on the Mürtschenalp in the canton of Glarus. Nickel and cobalt also frequently occur together. Ancient galleries are found chiefly in the Val d'Anniviers and in the nearby Turtmann Valley. Molybdenum ores, used for high-grade steel, are found in the Baltschieder Valley northwest of Brig. A few years ago a French firm intended to start extraction there but had to abandon the project because of the transport difficulties arising from the unfavourable location at an altitude of over 2,700 m (over 8,800 ft).

There is also gold in Switzerland. In the nineteenth century it was extracted at the "Goldene Sonne" mine on the Calanda near Coire (Chur) (nuggets of up to 125 g) and in the Gondo area on the southern flank of the Simplon Pass. Several of the famous "Vreneli" coins were minted from Gondo gold. The rivers and streams of the Napf area along the boundary between the cantons of Berne and Lucerne carry auriferous sand. However, extraction was never profitable. Nowadays adventurous weekend gold seekers swish their prospecting pans about in the hope of finding a tiny flake of the precious metal.

Ore mining will probably never be of great economic importance in Switzerland, even though some deposit or other may occasionally be worked profitably. For most of the deposits, however, the words of Professor Albert Heim still apply, when in 1900 he had to dash the hopes of the Grisons administration: "No technical improvements in extraction, transport or smelting can outweigh the one overriding fact: the good ores are unfavourably distributed in the rock and are present in quantities far too exiguous for economic working ever to be profitable."

Among ores uranium occupies a special place. It is extracted not for the manufacture of metal but serves as a fuel in nuclear power stations. In Switzerland uranium ore has been found in several places, such as the Valais (Emosson, Isérables, Nendaz, Mattertal, Naters), in the Grisons (Anterior Rhine Valley near Trun) and in the canton of Glarus (Mürtschenalp). The threshold value of uranium content ensuring profitable working fluctuates with supply and demand in the world market; generally speaking, deposits are considered economical only at a concentration of 1 kg of uranium to 1 t of rock, and at a

usable quantity of at least 2,000 t of uranium. Although several of the known deposits in the Alps exceed that minimum concentration by a multiple, the quantities are not too encouraging. The Swiss will probably have to bury their dream of early self-sufficiency with regard to nuclear fuels; their high-grade uranium deposits of, unfortunately, insufficient extent are of interest only to the scientists. Experts are now pinning their bold hopes for the future on the masses of granite in the Aar massif and in the Mont Blanc massif; these contain finely distributed uranium over considerable areas at a content of 10 to 30 g of uranium per ton of rock. A technology more advanced than that available today might well make these downright inexhaustible reserves of raw material useful one day.

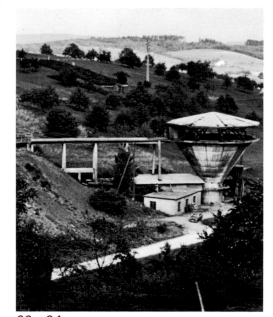

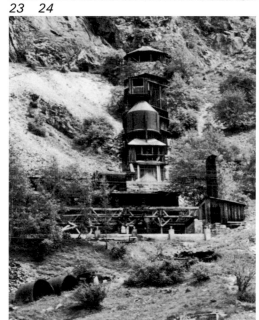

23 24

Coal, until the emergence of oil the main source of energy, occurs in various areas of Switzerland. Because the deposits—the remains of sub-tropical and tropical vegetation—as a rule are of slight extent and rarely above average quality, extraction can only be economical at times of acute crisis. Thus part of the domestic demand during the two world wars was met by Swiss coal. Extraction in the 18th and 19th centuries had mainly satisfied local demands. In the Alps the economically useful coal deposits are confined to two regions—ash-rich anthracite in the Valais and sulphur-rich hard coal in the Bernese Oberland. To the regret of mining experts the seams have been crushed, broken and torn apart by the forces which built the mountains. The most important workings in the Valais were the mine at Ferden in the Lötschen Valley, the settlements of Grône, Bramois, Nendaz and Isérables on the slopes south of the Rhone Valley between Sierre and Martigny, also Dorénaz and Collonges in the Lower Rhone Valley; in the Bernese Oberland several deposits in the Simmen Valley and the Kander Valley have proved reasonably productive.

25

In the *Plateau* layers of marl of the Molasse formation are occasionally accompanied by coal seams and coal nests. In the course of millions of years laurels, cypresses, palms and cinnamon trees turned to shiny black jet-type lignite of a relatively high caloric value. Unfortunately a substantial admixture of sulphur impairs the quality; moreover, a lot of soot is produced during combustion. Coal deposits in the *Plateau* are more regular than in the Alps, as will be seen from the following list. This contains, arranged by cantons, only mines of some importance—in addition there used to be many low-yield mining locations. Vaud: numerous mines in the Palézieux—Oron region; Fribourg: Semsales on the edge of the Alps; Berne: Blappach south of Langnau in the Emmental; Lucerne: Sonnenberg near Littau; Aargau: Spreitenbach; Zug: galleries along the ridges of the Hohe Rone; Zurich: Käpfnach near Horgen, Elgg east of Winterthur, Riedhof in the Reppisch Valley; Thurgovia: Herdern near Frauenfeld; St. Gallen: Rufi near Schänis in the Linth plain. Shaly lignites, embedded in Ice Age morraines and gravel, are geo-

26

27

logically recent formations. They are situated close to the surface and can therefore as a rule be worked open-cast. Because of their high water content they have to be dried before marketing. Switzerland's entire shaly lignite production has surpassed one million tons; its extraction in consequence was greater than that of anthracite, hard coal and Molasse jet-type lignite. The most important deposits are at Uznach and Wetzikon (Canton of Zurich), Mörschwil (St. Gallen) and Gondiswil-Zell (on the Berne/Lucerne border).

When drilling for oil came to be suspended at Romanens near Bulle in the Canton of Fribourg at a depth of 4,022 m (13,200 ft) at the beginning of December 1977 Switzerland's oil prospectors had lost yet another illusion. They had placed a great many hopes on this particular borehole near the edge of the Alps. However, discovery of hydrocarbons—the term used by experts to cover oil and natural gas—is often a matter of luck. On an international average only about one in every twenty boreholes strikes oil. And since more than twenty attempts have so far been made in Switzerland the hoped-for success should not be too long in coming. So far the drilling has been mainly in the *Plateau,* where the presence of hydrocarbons is suspected in the porous sandstone of the Molasse formation. That this mineral wealth is in fact present at great depth is proved by repeated finds of traces of oil and also of certain quantities of natural gas, though not enough to make economic extraction a serious possibility. Productive fields do exist east of the Swiss *Plateau*—to be precise, in the German pre-Alp region and in the north-eastern part of Austria.

All natural oil was formed millions of years ago from the remains of marine life. Dead protozoa and plants (plankton) were transformed by bacteria into hydrocarbons. Sand and mud covered these oily decomposition products. As they hardened new rock, was formed whose pores were filled with crude oil. Mountain pressure subsequently forced the oil out of the mother rock, it was displaced and eventually gathered along faults and in the crests of anticlines of rock strata. It is the task of geologists to spot such oil traps. The search for them continues indefatigably. Further drillings are planned in the *Plateau* as well as in the Jura, and also in the southern Ticino.

Land-locked Switzerland owes its supply of salt—a supply sufficient for many centuries to come—to the legacy of an ancient ocean. Some 200 million years ago—during the Triassic System of the early Mesozoic—when shallow seas and lagoons dried out, considerable layers of rock salt were left behind. These deposits were later covered by layers of limestone and clay and thereby protected against being leached out. Swiss rock salt (chemically: sodium chloride) is used as table salt and as industrial salt and is nowadays produced in two regions—the Rhine Valley between Zurzach and Basle, and near Bex in the Lower Rhone Valley (canton Vaud). Water forced under-

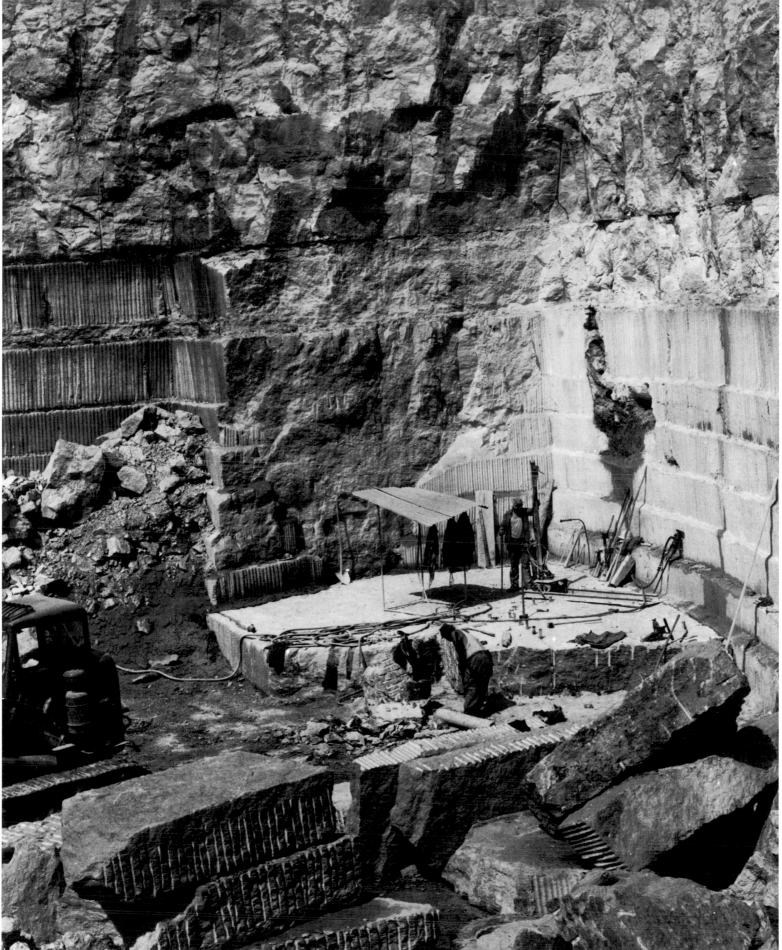

ground through drill-holes is saturated with the readily soluble raw material; the salty fluid, known as brine, is then pumped to the surface and put through an evaporation process until the mineral crystallizes out again. This method gives rise to underground cavities which occasionally cause subsidence. Potassium salt, important as an agricultural fertilizer, though plentiful in neighbouring Alsace, has nowhere been found in Switzerland.

Gypsum and anhydrite were deposited during the same period in geological history as rock salt. Gypsum is calcium sulphate containing water and serves as an indispensable cement in the building industry. The two most important deposits are Leissigen on the lake of Thoune (Thun), where the soft stone is predominantly quarried by the open-cast method, and the deep mine of Felsenau in Aargovia with its extensive system of galleries. Anhydrite, the anhydrous calcium sulphate, has only been utilized for a short time. In the opinion of experts anhydrite deposits would make suitable dumps for radioactive residue. In Switzerland five deposits are known, where, if necessary, the waste of nuclear power stations might be stored underground: At Bex, in the Airolo area of the northern Ticino, in the western part of the canton of Obwalden, near Lenk in the Bernese Oberland, and in the Aargovia plateau Jura. It is, of course, true that even the first preliminary geological surveys in these areas have aroused anger among the population.

That the schoolbook phrase of Switzerland being deficient in raw materials applies only with qualification is proved by the numerous quarries, gravel pits and clay pits. Rock suitable for above or below ground construction or road-making, as well as the raw materials of the cement and brick industries, are all plentiful. In the Val de Travers in the Neuchâtel Jura, moreover, Europe's biggest asphalt mine has been in operation for over a hundred years.

The concept of mineral wealth also includes all mineral springs. Since time immemorial places have been known throughout Switzerland where curative waters have welled from the ground, containing mineral substances in solution. Switzerland's geological variety is reflected here, too, in nature's assortment: thus the character of different springs is marked by calcium, sulphate, sulphur, iron or radium. Water from great depths issues as a hot thermal spring and is used, as a rule, for balneological treatment. Cold mineral springs are used for baths or drinking. Spas are of great medical and tourist importance, and the sale of mineral water as a table beverage is an important branch of the foodstuffs industry.

The beneficial effects of mineral substances dissolved from rock and soil were known long before balneology became a medical science. From the 16th to the late 19th century countless local spas flourished throughout Switzerland, where visitors found easement of their troubles as well as entertainment. Thus we read in a document of 1785, about the Rothbad in the Valley of Diemtigen (Bernese

Oberland), that its spring had "since time immemorial been used as an excellent bath for the limbs and for many ailments of the human body, and found of exceedingly curative effect". And in 1862 the physician Friedrich Wilhelm Gohl had this to say about Rothbad: "Beneficent naiads often dispense their gifts in secret; thus it is in this institution on the north-western slopes of the Niesen range, 11 hours from Berne. The near and more distant surroundings are entirely Alpine, consisting of many connected mountain peaks from which the perfume of the most fragrant herbs rises to the sky every morning. The mineral source wells about 45 paces from the building in a sloping meadow whose masses of gravel, covered with a little earth, rest on limestone. The water has a significant iron content and is readily digested even by a weak stomach. In both modes of application (baths and drinking cures) it has a revitalizing and invigorating effect, stimulating skin and kidney activity, activating the circulation, improving the composition of the blood, increasing muscle power, augmenting heat development, and becoming a medicament for pathological functions of the intestinal canal, disturbances of menstruation, anaemia, infertility and tendency towards miscarriage, in states of marked debility and exhaustion, softening of the bones, etc."

▽ *Mineral raw materials: annual production and principal uses of important raw materials.*

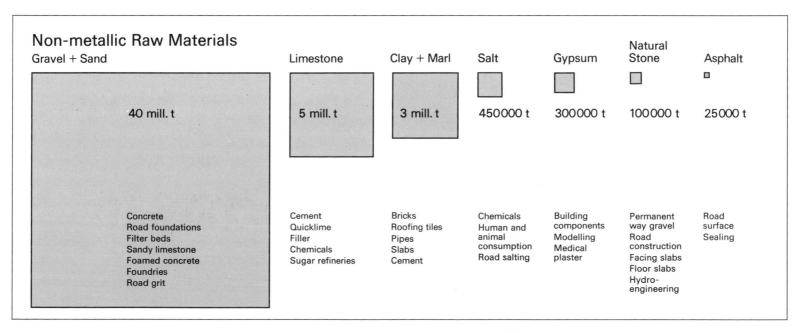

Non-metallic Raw Materials

Gravel + Sand	Limestone	Clay + Marl	Salt	Gypsum	Natural Stone	Asphalt
40 mill. t	5 mill. t	3 mill. t	450000 t	300000 t	100000 t	25000 t
Concrete Road foundations Filter beds Sandy limestone Foamed concrete Foundries Road grit	Cement Quicklime Filler Chemicals Sugar refineries	Bricks Roofing tiles Pipes Slabs Cement	Chemicals Human and animal consumption Road salting	Building components Modelling Medical plaster	Permanent way gravel Road construction Facing slabs Floor slabs Hydro-engineering	Road surface Sealing

Climate and Vegetation

"Real headache weather," an inhabitant of the valley on the northern slope of the Alps might complain on a warm, brilliantly bright spring day! "You should be pleased to have such fine weather taking over at last from cold grey weeks and months," a neighbour might object. "What's more, the wind will bring floods and fire in the mountain villages," the first speaker might add.

He would be right: The warm descending wind from the South is treacherous. A storm could spring up on the lake, such as the poet Hermann Hesse (1877–1962) has so brilliantly described in his novel "Peter Camenzind": "When the Föhn is approaching, men and women, mountains, wild animals and cattle all feel it several hours beforehand. Its coming, almost invariably preceded by cool winds from the opposite direction, is heralded by a warm deep rushing sound. The bluish-green lake turns ink-black within a few moments and suddenly puts on hasty white ridges of spume. And presently, though soundless and peaceful a few minutes before, it pounds the shore with a furious force like the sea. At the same time the whole landscape huddles anxiously together. On mountain tops, which normally float in the remote distance, one can now count the rocks, and in villages normally seen as distant brown patches one can now discern roofs, gables and windows. Everything moves closer together—mountains, meadows and houses—like a fearful herd. And then begins the angry rushing, the tremor in the ground. Whipped-up waves on the lake are driven like smoke through the air and all the time, especially at night, you can hear the desperate struggle of the gale with the mountains."

If, however, one compares Switzerland with countries in other climatic zones it has little to worry about weather and climate. Admittedly, the six-weeks' drought of the summer of 1976 confronted a great many farmers with tricky problems—but there is no question of a proper drought disaster. Floods, too, are fortunately rather rare; however, the summer of 1977 in the canton of Uri, in the Bernese Plateau and in the Ticino will remain a grim memory. As a rule, however, Switzerland has a fairly evenly distributed rainfall, and to many foreign visitors the eternally green meadows and pastures are an unfamiliar but exceedingly pleasant sight. The temperate climate ensures a reasonably balanced precipitation and heat budget throughout the year and prevents extreme or disastrous weather changes. Of course, weather confronts the farmers with ever new challenges. No other occupation is at the mercy of nature to the same extent. But then tourism also depends on good weather, and transport, in spite of countless technical facilities, is by no means independent of the weather. Thus the weather remains a popular and inexhaustible topic of conversation also in Switzerland.

There is no Swiss climate that would be typical of the country as a whole. Although Switzerland is small it is strongly articulated and sub-divided. That explains the variety of climate which in turn gives

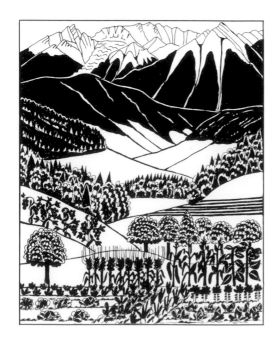

rise to such diverse agricultural, economic and cultural zones. Elsewhere such a variety would be spread over a far greater territory. The arch of the Alps greatly influences the climate and weather of central Europe. On the one hand the mountain system channels the air masses in a west-easterly direction; on the other the Alps represent a climatic divide since they render difficult the exchange of air masses from north to south and vice versa.

For man precipitation plays a vital part. Agriculture requires plenty of rain and moisture to ensure plant growth; winter sports depends on great masses of snow. Important work phases in the farming year—such as hoeing or harvesting—require the most persistent possible good weather, while the catering industry also hopes for plenty of sunshine at weekends and during holiday time.

Precipitation depends largely on elevation above sea-level since any drop in temperature means, in that moist atmosphere, an in-

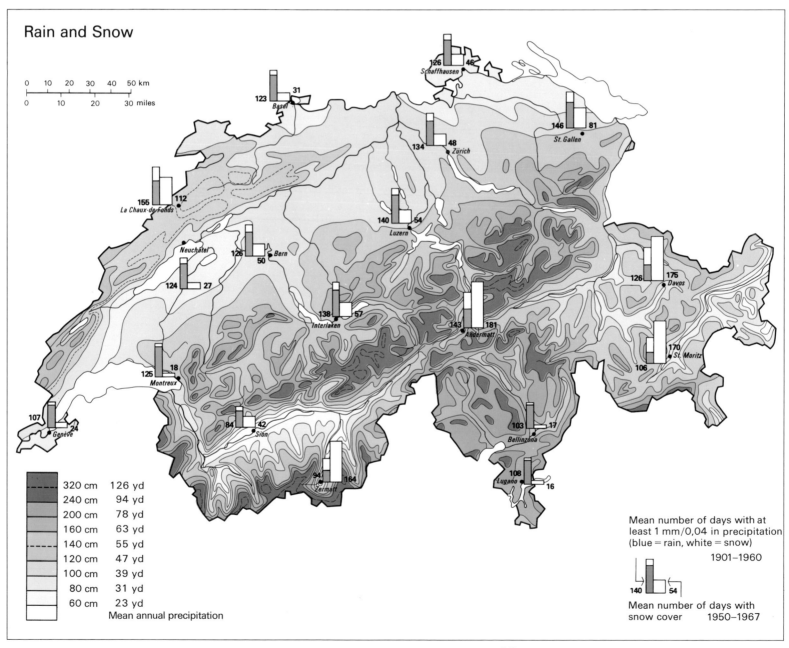

Rain and Snow

320 cm	126 yd
240 cm	94 yd
200 cm	78 yd
160 cm	63 yd
140 cm	55 yd
120 cm	47 yd
100 cm	39 yd
80 cm	31 yd
60 cm	23 yd

Mean annual precipitation

Mean number of days with at least 1 mm/0,04 in precipitation (blue = rain, white = snow)
1901–1960

Mean number of days with snow cover 1950–1967

creased condensation of water. There is more rain in the mountains than in the plains. On an annual average precipitation in the lower *Plateau* reaches 800 to 1,000 mm or 800 to 1,000 litres per square metre; in the Alpine summit region, on the other hand, precipitation reaches 4,000 mm and more. All mountains act as rain traps, and that is why a precipitation map essentially reflects landscape features. Jura, *Plateau* and Alps can be clearly distinguished on a chart of mean annual precipitation. Within the Alps, however, major longitudinal troughs are clearly discernible. The Grisons, the Rhine Valley, the broad valley floor of the Engadine and, above all, the Valaisian Rhone Valley are among Switzerland's regions with the lowest precipitation. These dry islands are surrounded on all sides by a circle of peaks which intercept the precipitation.

Whenever the temperature drops to near freezing point snow falls. In the *Plateau* this happens only in winter, though at elevations

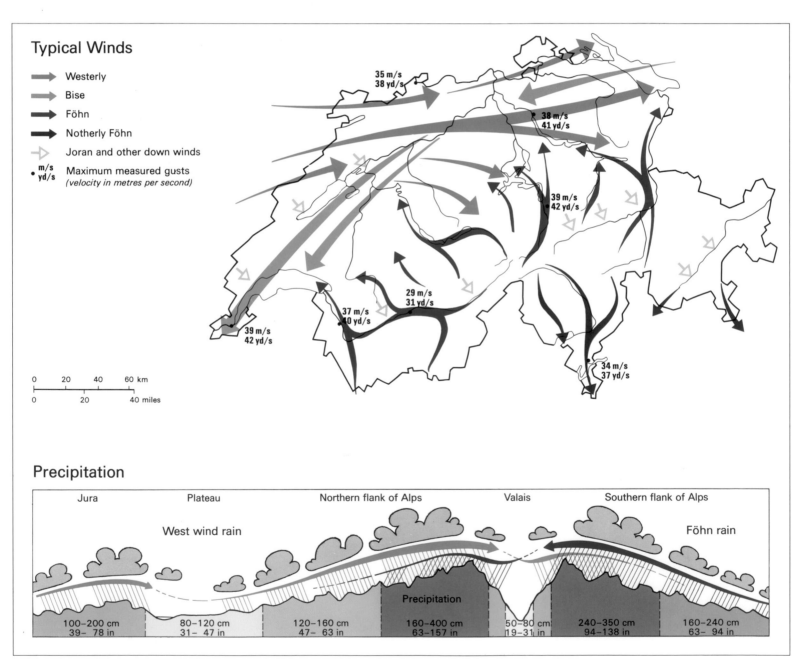

Typical Winds

→ Westerly
→ Bise
→ Föhn
→ Notherly Föhn
⇨ Joran and other down winds
•m/s
 yd/s Maximum measured gusts
(velocity in metres per second)

35 m/s
38 yd/s

38 m/s
41 yd/s

39 m/s
42 yd/s

29 m/s
31 yd/s

37 m/s
40 yd/s

39 m/s
42 yd/s

34 m/s
37 yd/s

0 20 40 60 km
0 20 40 miles

Precipitation

Jura	Plateau	Northern flank of Alps	Valais	Southern flank of Alps		
West wind rain				Föhn rain		
			Precipitation			
100–200 cm	80–120 cm	120–160 cm	160–400 cm	50–80 cm	240–350 cm	160–240 cm
39– 78 in	31– 47 in	47– 63 in	63–157 in	19–31 in	94–138 in	63– 94 in

50

above 3,500 m (11,500 ft) this occurs throughout the whole year. At winter sports centres about 30 to 50 per cent of all precipitation is in the form of snow. The duration of the snow cover is of importance to winter tourism, as well as road and rail traffic. It clearly increases from west to east: skiing areas in the Grisons have more reliable snow than resorts at the same elevation in western Switzerland. The climate, however, is characterized not only by the amount of precipitation but also by the frequency of rain and snow. On the northern side of the Alps one may count on an average of 120 to 160 days per year when precipitation falls, whereas in the Ticino valleys far greater amounts of precipitation are concentrated within 100 to 120 days. This means that the precipitation pattern on the southern flank of the Alps is far more violent. Thunderstorms and downpours are impressive experiences in the Ticino.

Mountain ranges influence the direction of flow of the air masses,

29 *A billowing sea of mist: cloud cover separating valleys and lowlands from sunny heights. The Gadmen Valley in the Bernese Oberland.*

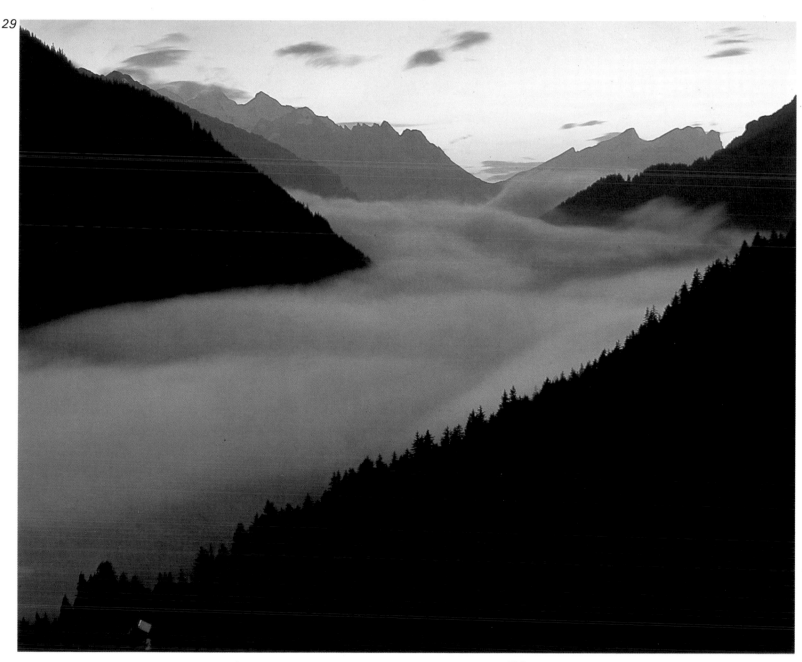

29

30 Morning after a cool March
night: hoarfrost—frozen dew—outlines a
cold air pool. Enclosed valley basin in the
pre-Alp area.

i. e. of the wind. The *Bise,* a cold dry wind, comes from the vast land masses of eastern Europe and is channelled through the Jura and the Alps. The west wind, on the other hand, carries warm moist sea air from the Atlantic to central Europe. It is well known as a bad weather and rain-carrying wind. Air currents can cross also high mountains. The *Föhn* cools down while rising along the southern flank of the Alps and in doing so loses its humidity. On the northern side of the Alps it appears as a warm, dry and violent down-wind in the transversal Alpine valleys—the *Föhn* lanes—and there produces astonishing rises in temperature. These valleys have come to know the *Föhn* as a great danger: many a village has been the victim of *Föhn* fires. Great differences of altitude within a small space result in appreciable temperature gradients. Only a few miles separate the shores of Lago Maggiore, with their luscious Mediterranean vegetation, from the Arctic scene presented by the glaciers of the High Alps. The inhabitants of the Alps and of the *Plateau* are also well acquainted with temperature inversions: while normally temperature drops with increasing altitude it sometimes happens that cold, heavy air accumulates in the valleys and basins. White frost formation and fog are often a feature of cold-air pools. They disappear as soon as the rising sun produces enough heat for the normal temperature distribution to re-establish itself. The number of hours of sunshine very clearly reflects the importance of temperature inversion;

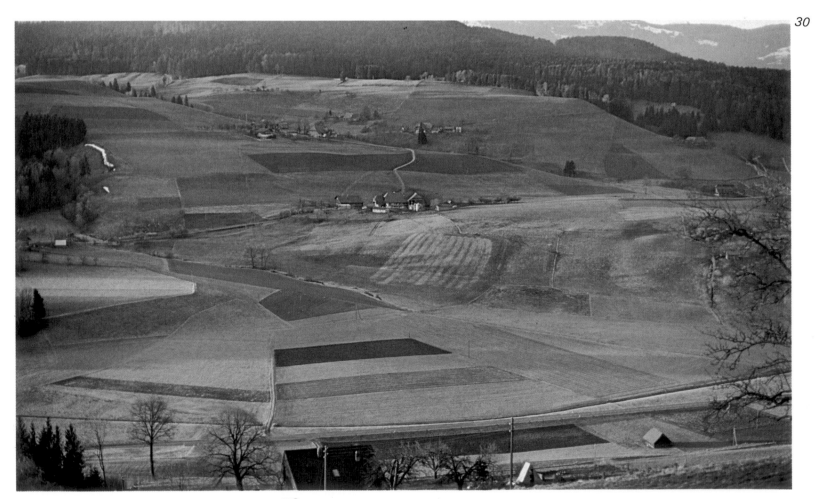

January Temperatures and Hours of Sunshine

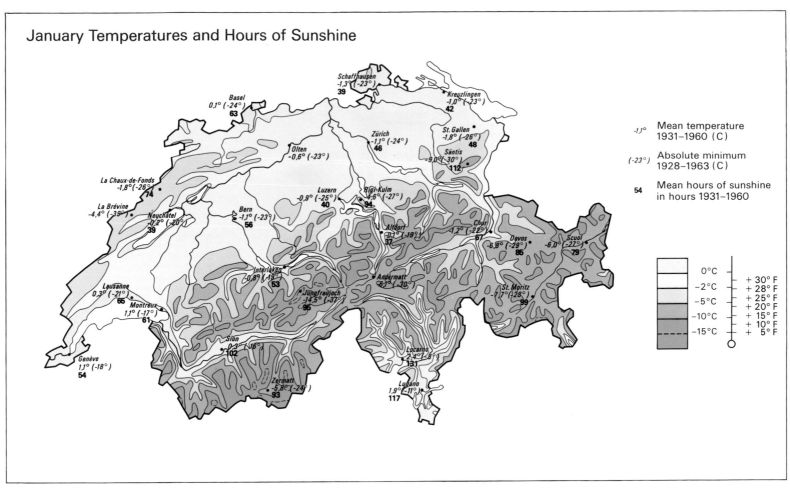

Schaffhausen
-1,3° (-23°)
39

Basel
0,1° (-24°)
63

Kreuzlingen
-1,0° (-23°)
42

Zürich
-1,1° (-24°)
46

St. Gallen
-1,8° (-26°)
48

Olten
-0,6° (-23°)

Säntis
-9,0° (-30°)
112

La Chaux-de-Fonds
-1,8° (-26°)
74

Luzern
-0,9° (-25°)
40

Rigi-Kulm
-4,6° (-27°)
94

La Brévine
-4,4° (-39°)

Neuchâtel
-0,2° (-20°)
39

Bern
-1,1° (-23°)
56

Chur
-1,2° (-22°)
67

Davos
-6,9° (-29°)
85

Scuol
-6,0° (-27°)
79

Altdorf
-0,1° (-19°)
57

Interlaken
-0,8° (-19°)
53

Andermatt
-6,1° (-30°)

Lausanne
0,3° (-21°)
65

Jungfraujoch
-14,5° (-37°)
95

St. Moritz
-7,7° (-28°)
99

Montreux
1,1° (-17°)
61

Genève
1,1° (-18°)
54

Sion
-0,3° (-16°)
102

Zermatt
-5,8° (-24°)
93

Locarno
2,4° (-8°)
131

Lugano
1,9° (-11°)
117

-1,1° Mean temperature
 1931–1960 (C)

(-23°) Absolute minimum
 1928–1963 (C)

54 Mean hours of sunshine
 in hours 1931–1960

	0°C + 30° F
	-2°C + 28° F
	-5°C + 25° F
	-10°C + 20° F
	+ 15° F
	+ 10° F
	-15°C + 5° F

July Temperatures and Hours of Sunshine

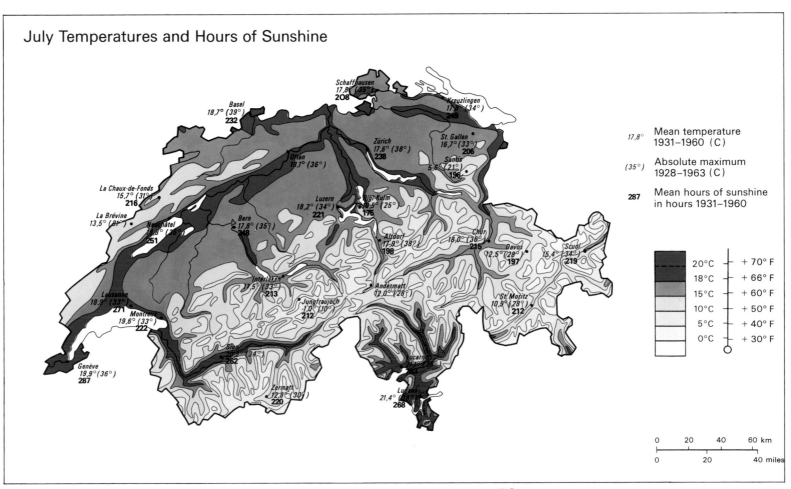

Schaffhausen
17,9° (35°)
208

Basel
18,7° (39°)
232

Kreuzlingen
17,8° (34°)
249

Zürich
17,6° (38°)
238

St. Gallen
16,7° (33°)
206

Olten
18,1° (36°)

Säntis
5,6° (21°)
196

La Chaux-de-Fonds
15,7° (31°)
216

Luzern
18,2° (34°)
221

Rigi-Kulm
10,5° (25°)
175

La Brévine
13,5° (31°)

Neuchâtel
18,8° (36°)
251

Bern
17,8° (35°)
248

Chur
18,0° (36°)
215

Altdorf
17,9° (38°)
198

Davos
12,5° (28°)
197

Scuol
15,4° (34°)
219

Interlaken
17,5° (33°)
213

Andermatt
12,0° (28°)

St. Moritz
10,9° (28°)
212

Lausanne
18,9° (33°)
271

Jungfraujoch
-1,0° (10°)
212

Montreux
19,6° (33°)
222

Genève
19,9° (36°)
287

Sion
34°
282

Locarno
36°
Zermatt
12,8° (30°)
220

Lugano
21,4° (34°)
268

17,8° Mean temperature
 1931–1960 (C)

(35°) Absolute maximum
 1928–1963 (C)

287 Mean hours of sunshine
 in hours 1931–1960

	20°C + 70° F
	18°C + 66° F
	15°C + 60° F
	10°C + 50° F
	5°C + 40° F
	0°C + 30° F

0 20 40 60 km

0 20 40 miles

53

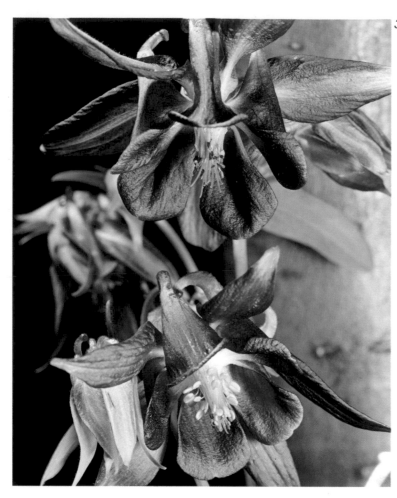

31

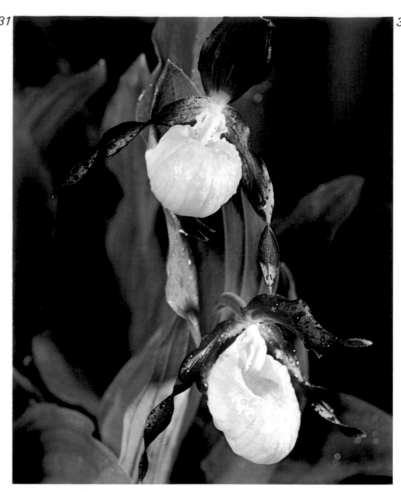

32

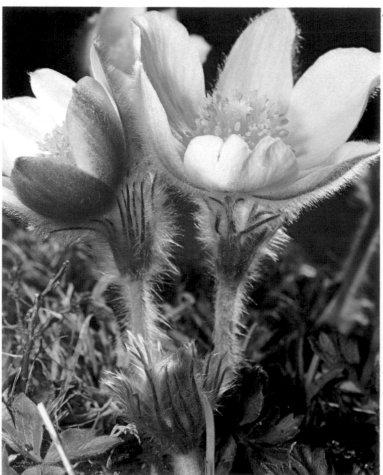

33

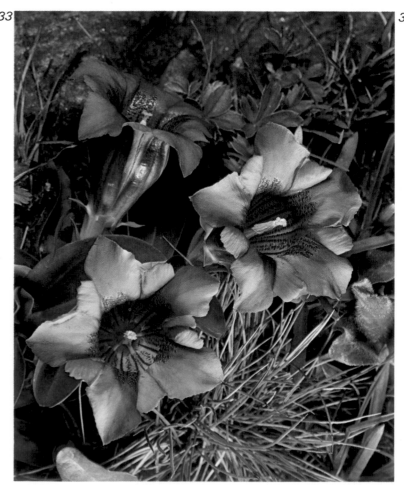

34

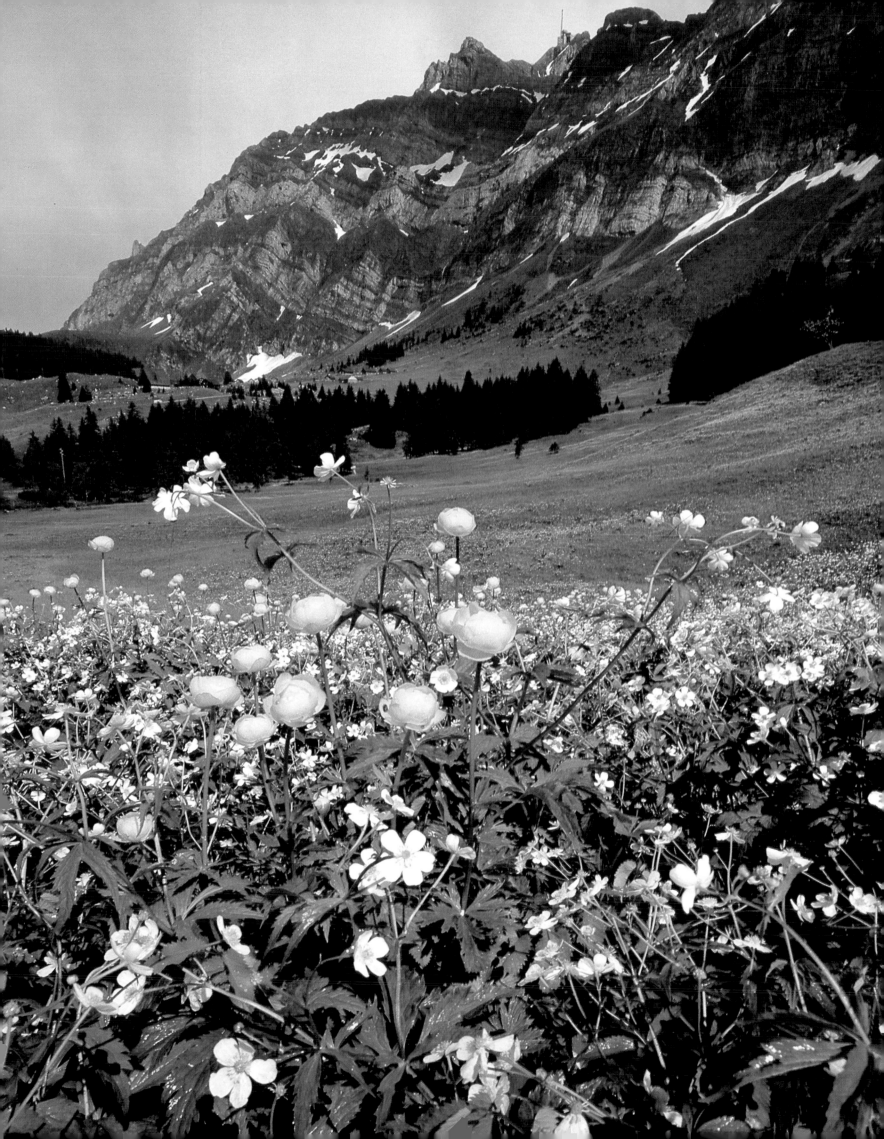

Levels

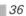

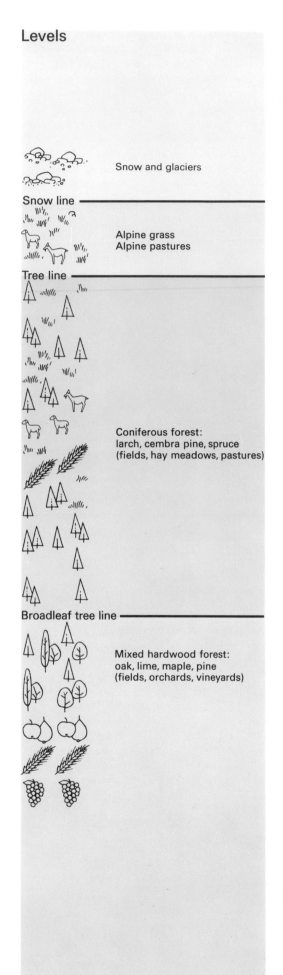

Snow and glaciers

Snow line ——————

Alpine grass
Alpine pastures

Tree line ——————

Coniferous forest:
larch, cembra pine, spruce
(fields, hay meadows, pastures)

Broadleaf tree line ——————

Mixed hardwood forest:
oak, lime, maple, pine
(fields, orchards, vineyards)

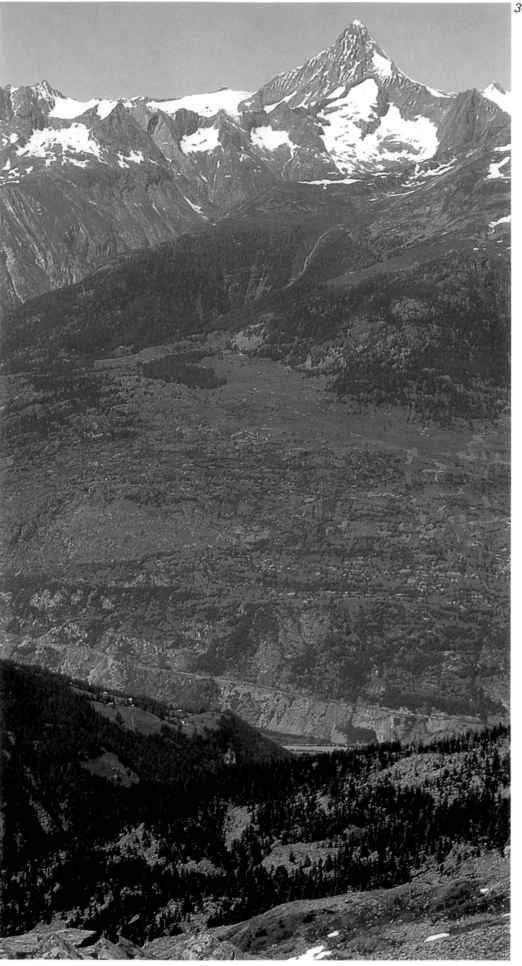

after all, high altitude stations can record over 100 hours of sunshine in January while in the *Plateau* only half that number may be expected. In summer, on the other hand, the clouds are caught by the peaks so that the hours of sunshine recorded in the Jura and in the Alps in July rarely exceed 200 hours. During the same month the *Plateau* has about 250 hours of sunshine, and the lake Geneva area and the southern Ticino 280 hours or more.

The flora of Switzerland reflects the variety of Europe. True enough, the present-day vegetation is the result of a thousand years of history. It may be justly claimed that virtually every square foot of vegetation in Switzerland has been transformed or influenced by man. This may have been by far-reaching measures such as building or forest clearance, or by agricultural use associated with a change of species association through mowing, grazing, manuring, ploughing and other forms of intervention such as the picking of wild flowers, the laying out of ski runs, or the extermination of certain animal species. Not even the Swiss National Park comprises true primeval forests.

A mountain ramble provides a cross-section through the vegetation belts which are governed by the diverse climatic conditions within the different altitude levels. Switzerland offers within a narrow confine the kind of variety that would be encountered on a journey from the Mediterranean area to the Arctic. The mountain rambler will start his walk at the cultivated or hill level. This lowest belt extends to the vine line and embraces the most fertile and most densely populated areas of the country, i.e. the areas most intensively transformed by man. The natural broad-leaf and mixed forests of this belt consist predominantly of beech, but also of yew, white fir and pine, and at lower altitudes also oak. In the southern Alpine valleys the tall chestnut forests belong to the same level of altitude. In the Ticino this belt ends at about 1,500 m (4,900 ft) with the broadleaf forest line, and on the northern flank of the Alps at 1,000 m (3,300 ft) after which the rambler enters the pure coniferous forest. There spruce or red pine predominate, with pine and deciduous larch taking a share. At an elevation of 1,800 to 2,200 m (5,900 to 6,600 ft) the rambler finally emerges from the close forests, as he passes the treeline, and now, in the zone of alms or meadows, enjoys an unobstructed panorama. The uppermost combat zone of the treeline is inhabited by gnarled cembra pines, which are succeeded by stunted pines and shrubs. The mountain flora adapted to extreme climatic conditions is reminiscent of the Tundra. At even greater altitudes the vegetation cover gradually dissolves and yields to congelifracts. Between 2,500 and 3,000 m (8,200 and 9,800 ft) the rambler eventually reaches the snowline.

31–34 Splendour of Alpine flowers: The Alpine columbine, Aquilegia alpina (31), the ladies's lipper, Cypropedium calceolus (32), the spring anemone, Pulsatilla vernalis (33), the trumpet gentian, Gentiana kochiana (34).

35 Mountain meadow with spring flowers: Alpine flowers have especially brilliant colours. Yellow globe-flower, Trollius europaeus, and the white buttercup, Ranunculus aconitifolius, at the foot of Mount Säntis.

36 Vegetation levels in the mountains: with increasing altitude the climate becomes more hostile to life, as reflected by the plant cover. Southern flank of the Lötschberg in the Valais with Bietschhorn (3,934 m = 12,911 ft above sea level).

37 Struggle against the forces of nature: stunted and twisted growth on the treeline.

37

Genesis of an Alpine State

The area which the Swiss inhabit is characterized largely by inhospitality, rough climate and, at least in the mountains, a hostility to all life. How could such an environment fail to leave deep marks on its people, how could it fail to impress on them character features reflecting those of the landscape?

True, Switzerland today is an industrialized nation. The peculiarities of the people are becoming blurred in the anonymity of an increasingly urbanized society. Three out of every five Swiss now live in towns—admittedly a lower percentage than in France (70 per cent), the United States (75 per cent) or New Zealand (81 per cent). Yet even amidst this drift from the country into the cities the peculiar characteristics of a population, moulded in its struggle for survival in an inhospitable and dangerous environment, still persist.

The seclusion of remote homesteads in Alpine valleys and in the higher parts of the *Plateau* have moulded the character of their in-

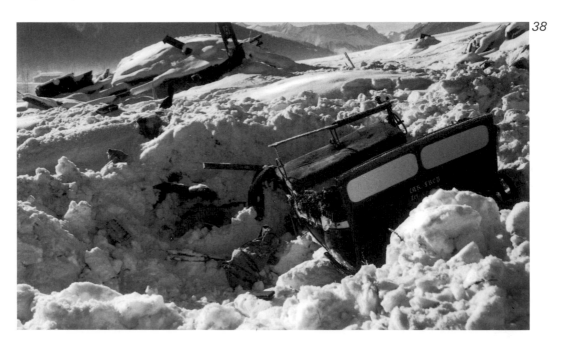

38

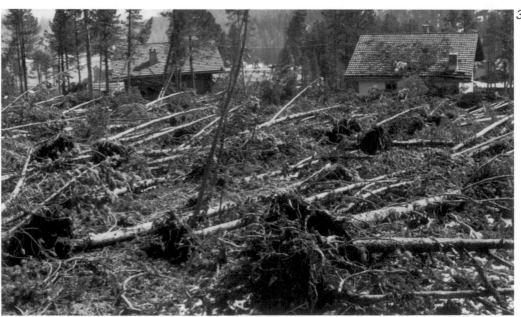

39

habitants. The poet Jakob Bosshart (1862–1924) in his writings portrays the ''homestead spirit'' of his native land, the Zurich Oberland (quoted from M. Konzelmann's biography of Bosshard published in 1929): ''Their lives unrolled in the tranquillity of farmsteads and the narrow confines of their families; they were totally dependent upon themselves and jealous of their freedom. That is why, on those remote farmsteads, where you would expect people to cling to one another of necessity, contacts between individual households do not go much beyond 'Good morning', 'Good afternoon' and 'Good night'. They would rather starve than live by charity... Upbringing on the farmsteads sees to it that emotions do not spill over; though the heart may be breaking, the working clothes will hide it and there will not even be a tremor because their clenched teeth are trusty guardians of the gate.''

In the Alpine valleys the even harsher conditions of life have

38–40　*Unleashed elements: snow masses bring death and disaster (38). A torrent has burst its banks and uprooted dozens of trees (39). Nothing can withstand the destructive power of a huge powder avalanche (40).*

40
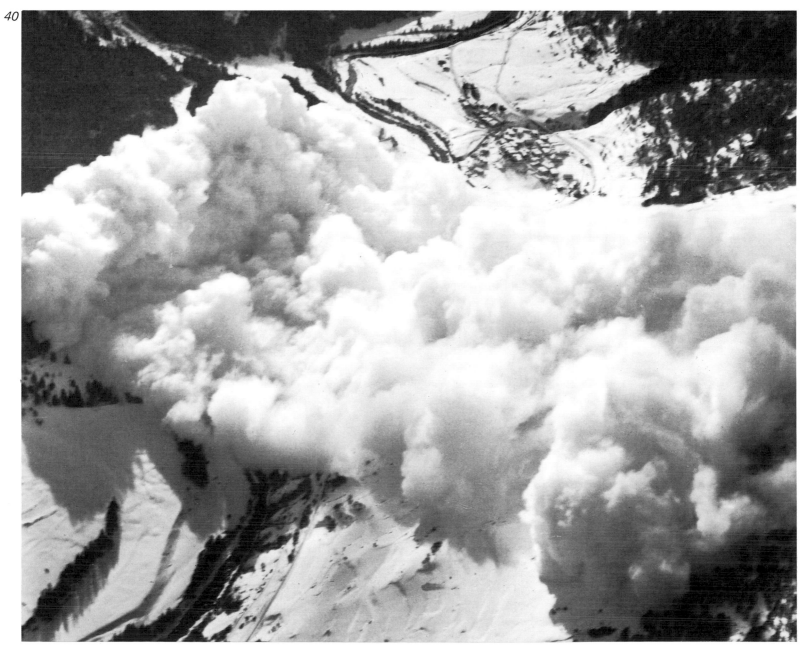

moulded the character of their people. The mountain dweller as a rule is a silent, rather reserved person, tough and hard-working, modest and undemanding. The exceedingly difficult road conditions have also caused cultural exchanges between the different valleys to be restricted to a modest scale. This is witnessed by dialects, customs, traditions, costume and other characteristics which vary from one valley to another.

Perhaps the Forest Cantons did not have quite that importance in the young Confederation that later historians have ascribed to it.

Quite certainly, however, the rigours of life and livelihood among the mountains have always compelled the mountain dwellers to stick together. What could a mountain peasant in the Middle Ages achieve on his own against a hostile environment? Thus the idea of valley communities must have come into being, the idea of a voluntary association of the inhabitants of one valley. In this way, presumably, the institution of the "common" came into existence, a common grazing for a valley community. Construction and maintenance of roads and paths similarly called for joint efforts. Passes over the mountains played an increasingly important part in the economic life of the valleys concerned as international travel and trade intensified in the Middle Ages. The communal effort in tackling such tasks gradually resulted in political alliances.

The Confederate Charter of 1291 is by no means the only but probably the most important testimony of that kind. "Faced with evil times the men of the valley of Uri, the land community of the valley of Schwyz, and the community of the lower valley of Unterwalden, in order better to protect themselves and their chattels and to keep them more safely in decent conditions, have pledged themselves in good faith to assist one another with help, all kinds of counsel and every favour, with life and possessions.... Thereon they have sworn

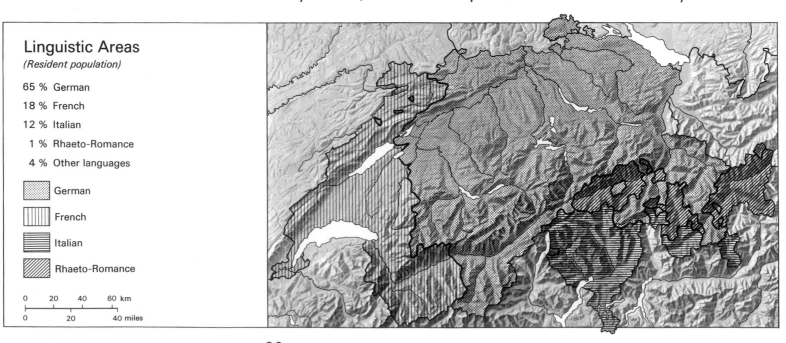

Linguistic Areas
(Resident population)

65 % German

18 % French

12 % Italian

1 % Rhaeto-Romance

4 % Other languages

German

French

Italian

Rhaeto-Romance

| 0 | 20 | 40 | 60 km |

| 0 | 20 | | 40 miles |

a bodily oath to keep that promise regardless of all danger, and have thus renewed the ancient sworn form of the Confederation by this present Charter.... Likewise by common counsel we have unanimously and single-mindedly promised, resolved and decreed that in the above named valleys we shall not accept or otherwise acknowledge any judge who might have acquired such office for a price or perhaps for money, and who is not our fellow countryman or fellow inhabitant." (Translation from the Confederate Charter, the original being in Latin.)

This means that the forest settlements were striving for juridical and hence also for political independence. At the same time such alliances testify to the democratic spirit that arose from those challenging conditions; they also reflect a determination to work together closely in the utilization of landscapes of such limited potential and in the struggle against a harsh natural environment.

Swiss Cultural Life

What is culture anyway? Nowadays the term is understood to cover not only artistic effort and creations but everything that serves the material and spiritual mastery of existence. There is culture in Switzerland—but is there a Swiss culture?

Culture and nation are concepts which are often used together. Yet the question arises whether this bracketing is also justified in Switzerland. Culture largely depends on linguistic expression. And Switzerland is quadrilingual; each linguistic region, therefore, in cultural terms leans upon the foreign country of its language.

Switzerland, in consequence, does not comprise a single nation with a single language and culture. Hermann Weilenmann (1893–1970) remarks: "Present-day Switzerland has chosen not the road of compulsion but that of mutual aid: because it cannot exist without freedom it has renounced uniformity of its people and contents itself with its unity.

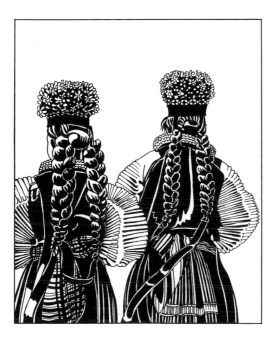 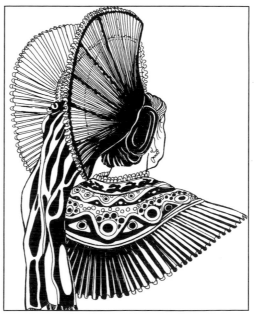 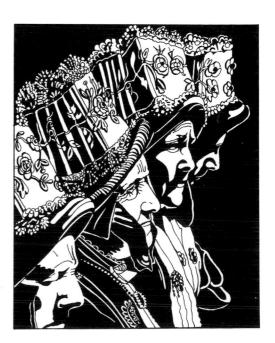

It is not therefore necessary that its citizens should share the same physical or otherwise conspicuous characteristics that would identify them as a portion of humanity distinct from all other nations; nor does Switzerland's territory require any nature-determined frontiers that would fatefully divide it from other countries. We content ourselves with an allegiance to that common asset to which all Swiss can have the same relationship—our own state. The only national characteristic which every Swiss must have is the determination to be and to remain Swiss."

To return to the languages. In Roman days the language spoken in Helvetia, as in the rest of Gaul, was the Celto-Romance language developed from vulgar Latin and Celtic, which subsequently also became the language of the Burgundians; these, in consequence, participated in its development towards French. After the Age of Migrations the Swiss-German dialects developed in the settlement

41

area of the Alemanni. The Rhaeto-Romance people—inhabiting the southern Alps—were gradually pushed back, and the Rhaeto-Romance language with them. The Ticino and Veltlin, as common lordships, fell into Confederate hands. Subsequently, German, French and Italian became the main languages—a state of affairs which was later enshrined in the Confederate Constitution of 1848. In 1938 Parliament declared Rhaeto-Romance the fourth national language. Each linguistic region nowadays has its own problems. The Swiss-German dialects differ so much from one another that a man from the Upper Valais might think a man from Basel to be a German. To learn literary German is a difficult matter for Swiss-German children.

The Czech philologist Olga Neversilova has compared it to the task of learning to play the piano simultaneously with learning to drive a car. Whereas to an adult dialect and standard German are two totally

41 Harmonious and functional: the Corbusier house in Zurich, a late work of the famous architect (1964), used for exhibitions and conferences.

42 The artist at work: the sculptor and painter Alberto Giacometti (1901 to 1966) in his studio.

42

43 *Man accepts the challenge: in his painting «The Woodcutter» (1910) Ferdinand Hodler (1853–1918) has set a monument to primordial strength.*

44–47 *Livelihood from Swiss soil: tractors have largely replaced horses (44). Mechanized potato harvest; all the family lends a hand (45). Stockbreeding and dairy farming are typical of Swiss agriculture (46). Grain crops, promoted by the state, lessen the country's depencene on foreign supplies (47).*

separate concepts, to the school-age child they initially run into each other.

French Switzerland—like France itself also had its dialects, its *patois,* but these have been displaced by the uniform "language of the Bible". For a long time the schools tried to exterminate the dialects. Nowadays efforts are made to preserve what few *patois* have survived in the canton of Vaud, in the Jura, in the canton of Fribourg and in the Valais. In Italian Switzerland, on the other hand, there is still a coexistence of standard language and dialects, similar to German Switzerland. Standard Italian, however, comes more easily to the Ticino speaker than standard German comes to a German Swiss; to him it is the language of the intellect while the dialect is that of the heart.

This linguistic multiplicity naturally leads to an influx into Switzerland of a multiplicity of cultural elements from different cultural spheres. The multilingual character of the country, however, also harbours the danger of cultural isolation of the different linguistic regions: the German Swiss only rarely takes note of the literary products of other linguistic regions, just as the work of modern German Swiss authors is scarcely known in non-German areas. Simultaneously artistic life in the foreign country of one's own language is closely observed.

Many Swiss artists feel that the rough nature of an Alpine country provides an infertile soil for cultural development. Perhaps the horizon limited by high mountains so affects the local inhabitants that a Swiss only rarely is a prophet in his own country. Be that as it may—over the centuries Switzerland produced numerous respected thinkers and artists. The country, moreover, was spared warlike involvement in Europe, and this has resulted in a valuable artistic and cultural continuity. Besides, domestic creativity has at all times been enriched by immigrants.

Not until after the peak of the Middle Ages can there be any talk of "Swiss" literature proper. A list of German-Swiss writers of more than regional importance might perhaps begin with Salomon Gessner (1730–1788) and Albrecht von Haller (1708–1777) and reach into the 20th century with Max Frisch (born 1911), Friedrich Dürrenmatt (born 1921), Kurt Marti (born 1921), Peter Bichsel (born 1935) and many others. In the *Suisse romande* an analogous list might lead from Jean-Jacques Rousseau (1712–1778) to Maurice Chappaz (born 1916) and Jacques Chessex (born 1934). Artists from southern Switzerland frequently work in Italy; this is as true of the humanist Francesco Cicereio (1521–1596) as it is of the poet Francesco Chiesa (1871–1973). The slight scope of Rhaeto-Romance literature is due to the modest dimensions of its linguistic region. Important writers of Rhaeto-Romance Switzerland were, for example, Peider Lansel (1863–1943) in the Engadine and Giachen Caspar Mouth (1844–1906) in the Surselva Valley.

47

44 45

46

The visual arts are not to the same extent contained by the linguistic regions. In painting, sculpture, architecture, and also in music some present-day Swiss have gained international reputations. Nature has not lavishly endowed Switzerland with mineral wealth. All the greater the significance attaching to the products of the spirit—whether cultural, economic or technological. This was voiced by Charles Edouard Jeanneret (1887–1965), better known as an architect, town planner and painter under his pseudonym Le Corbusier. In his book "Sense and Nonsense of Cities" (1970) this artist, born in the Neuchâtel Jura and active predominantly in Paris, discusses this problem from a technical and intellectual point of view:

"Technology, to start with, is the sum total of spontaneous and non-commital inventions springing from chance or from the laboratory; next, it is the road that leads things to unexpected and sometimes revolutionary results. There are no small or great inventions; there are only small or great consequences. Gunpowder or the printing press were enough to turn a new page in human history....

Inventions are the prerequisite and basic conditions of life. The question therefore arises: Should one or should one not make use of inventions? This question is posed nowadays even by those who oppose our efforts in order to reject inventions....

Technological processes have not destroyed the areas of fantasy or poetry. Through the precision of their measuring instruments they have fantastically enlarged the expanse lying before us, and hence also the dream—the universe and the vertiginous depths of life upon our earth."

Ferdinand Hodler (1853–1918) is another national modern artist of Switzerland who should be quoted here. To him landscapes and in particular the high mountains are of great importance. He developed into a symbolist and, for instance, represented mountains as an idea, internalized and yet powerful. This is what he wrote about his views on parallelism (from C. A. Loosli: "Ferdinand Hodler. Life, Work and Bequest", published 1921–1924):

"By parallelism I mean any kind of repetition. Whenever in nature I most intensely experience the charm of things I am always struck by a sense of unity.

If my path leads me through a fir forest, where tree after tree rises towards the sky, then I see before me, beside me and behind me trunks rising like countless columns. (...)

Or consider an area thickly covered with boulders, the remains of a landslide, as for instance at the foot of the Salève, and you will immediately have an impression of melancholy grandeur conditioned by the repetition of similar forms and colours.

We are subject to similar though much stronger impressions when we find ourselves on a mountain peak amidst the Alps. All the countless peaks around us trigger off admiration of that stimulus that stems from the repetition of the homogeneous."

48 To the limits of what is humanly possible: the Emmental farmer wrests his crops even from the steepest hillsides.

49 Encircled by concrete: can this farmstead, now reduced to an island, withstand the advance of the big city?

50 A mountain farmer: the tough struggle for a livelihood has made him prudent and silent.

73

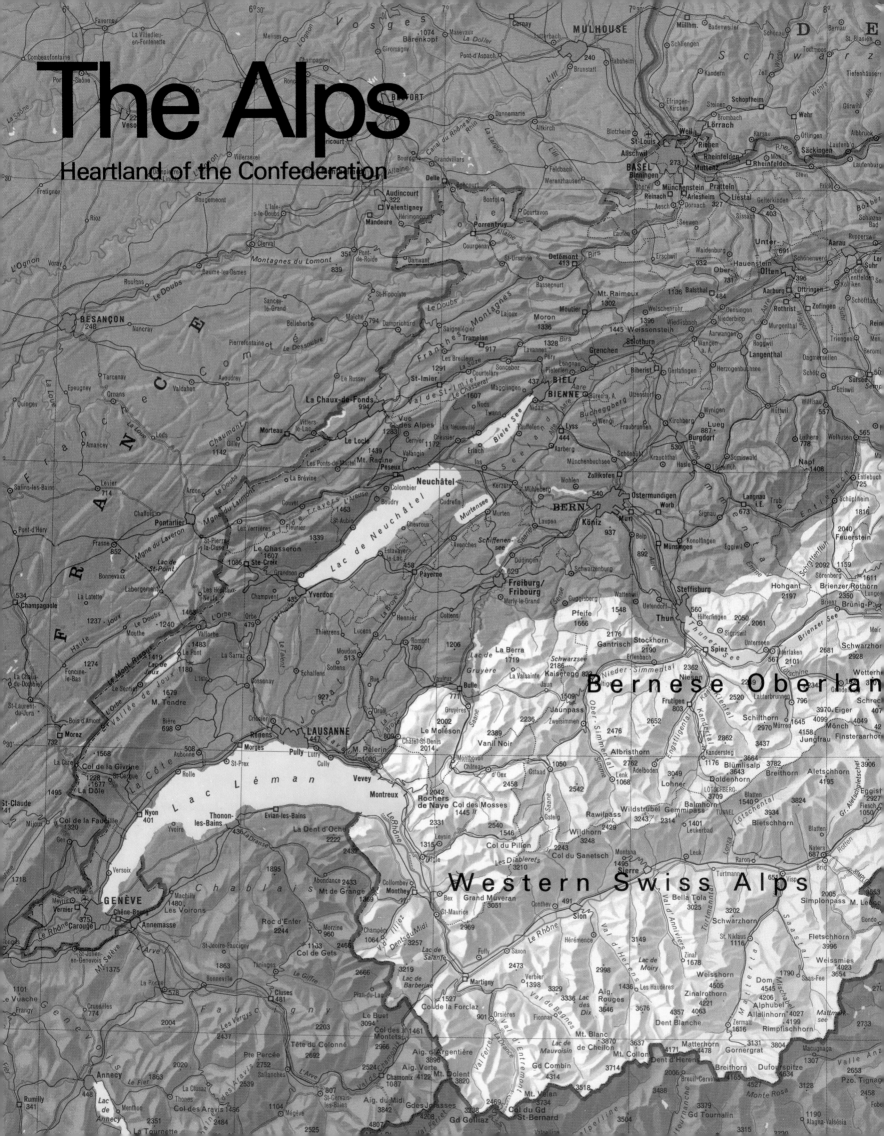

The Alps

Heartland of the Confederation

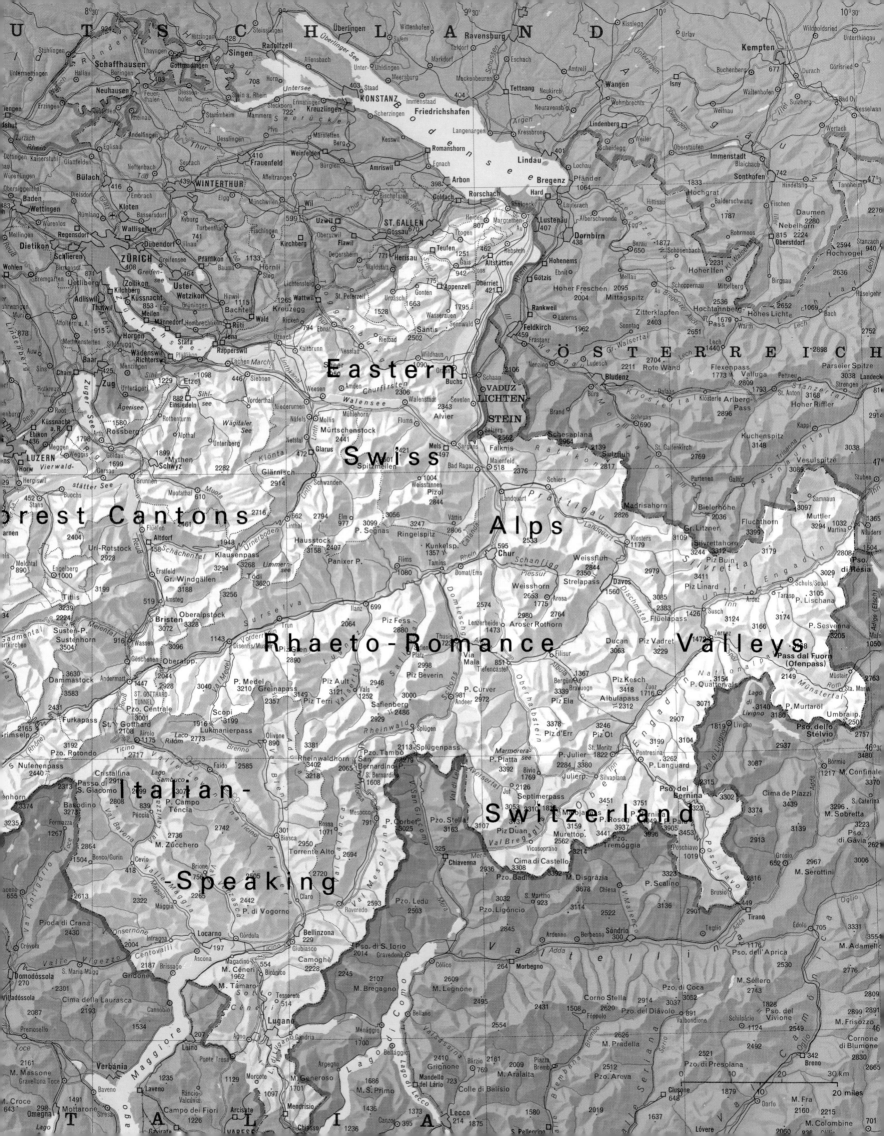

Opening up of the Alps

Why has such a wild and inhospitable high mountain range as the Alps been continually travelled and indeed settled since prehistoric times? Even during the Ice Ages cave-dwelling bear hunters inhabited the still glaciated valleys—under living conditions scarcely imaginable nowadays.

The arc of the Alps has always divided the civilized people of the Mediterranean region from the inhabitants of the central European plains. The 1,000 km (600 miles) long traffic obstacle was scarcely avoidable, and various tribes have crossed the Alps since the Neolithic period and indeed settled them. At that time—approximately 7,000 to 5,000 years ago—certain passes were traversed, and the "First Swiss" (to use the title of Christin Osterwalder's book) highly esteemed the hunting ground of the Alps. Bears and marmots were the principal quarry. Since the beginning of the Iron Age an important part was also played by the ore finds in the Alps; the fact that the deposits were mostly rather modest did not worry the people of that time.

The development of considerable parts of the Alpine region was due to the search for ores. Production of the coveted metal, above all copper and iron, as well as its processing and the trade in mineral products, provided the basis of a livelihood for the inhabitants of Alpine valleys.

Near Meiringen in the Hasli Valley a silver drachma of Alexander the Great was found, and other coins have been discovered not far away, at Innertkirchen. It is hard to visualize the difficulties involved in crossing the rough passes of the Bernese Oberland with pack mules. Since the fourth millenium B.C. the Alpine inhabitants cultivated crops and bred animals. In the valleys preference was given to areas not threatened by inundation, and above the natural treeline they were spared the trouble of forest clearance.

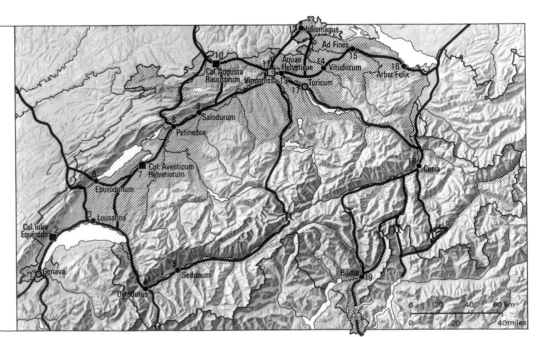

Switzerland in Roman Times

Settled areas
(Celtic tribes, Rhaetians and Lepontines)

□　Legion camp

■　City

○　Toll post

●　Village, farmstead (vicus)

———　Important Roman long-distance military road

1	Geneva	10 Augst
2	Nyon	11 Windisch
3	Lausanne	12 Schleitheim
4	Martigny	13 Baden
5	Sion	14 Winterthur
6	Yverdon	15 Pfyn
7	Avenches	16 Arbon
8	Jensberg	17 Zurich
9	Soleure	18 Coire (Chur)
	(Solothurn)	19 Bellinzona

The Romans were compelled by their expansionist policy to conquer the principal transport routes through the Alps to Romanize their vicinity. After Hannibal's spectacular crossing of the Alps, if not before, they realized that there were a great many roads open to their enemies. That Carthaginian general had crossed a pass in the western Alps in 218 B.C., with 50,000 men, 9,000 horsemen and 37 war elephants and had thus been able to mount a surprise attack. Yet in spite of their intensive concern with the Alps and their transport problems the Romans were not impressed by the charms of the high mountain scenery or by the beauty of nature along their way. "The hideous Alps ... with their abysses reaching down to the underworld"—as the Roman historian Livy put it—remained alien and closed to man until the Middle Ages. However, military and economic interests demanded the crossing of the mountains. The Romans established an extensive road network whose intersection points were made secure by roadside stations and military posts. That transport system opened up numerous passes such as the Great St. Bernhard, the Splügen and the Maloja.

As so often in the history of mankind, military operations gave rise to great achievements also in the Alps. In Napoleon's day the Alps were an important theatre of war. On 19th September 1799, Field Marshal Alexander Suvorov set out from the Ticino with 21,000 Russians, 4,500 Imperials (Austrian troops) and 5,000 horses, as well as 25 cannons loaded on mules. He forced a crossing over the Gotthard and on 26th September reached Altdorf. He advanced towards Muotathal over the Kinzig Pass but—continually involved in skirmishes with the French—was forced to retreat over the Pragel Pass into the canton of Glarus and even over the Panixer Pass, already covered in snow, into the Grisons.

The peaks of the Alps were avoided well into the late Middle Ages because they were credited with mystic powers. The phenomena of the high mountains were not yet understood and were therefore veiled in legend. In 1387 six clergymen climbed the summit of Mount Pilatus; their pioneering feat, which infringed a prohibition, was rewarded with imprisonment. Humanists and artists of the Renaissance were the first to venture a description of the Alps. Albrecht von Haller (1709–1777) and Jean-Jacques Rousseau (1712–1778) began to sing the praises of the mountains and of nature, and this paean has not so far died down. The journeys of enthusiastic naturalists eventually led to the alpinistic exploration of the mountains. Alongside the local inhabitants it was the English who in the 19th century played a decisive part in the opening up and exploration of the Alps.

In the course of the Middle Ages and more recent times the Alps were also settled. No doubt the population pressure throughout Europe was one of the factors which gradually filled the mountains with settlements, some of them at altitudes above 2,000 m

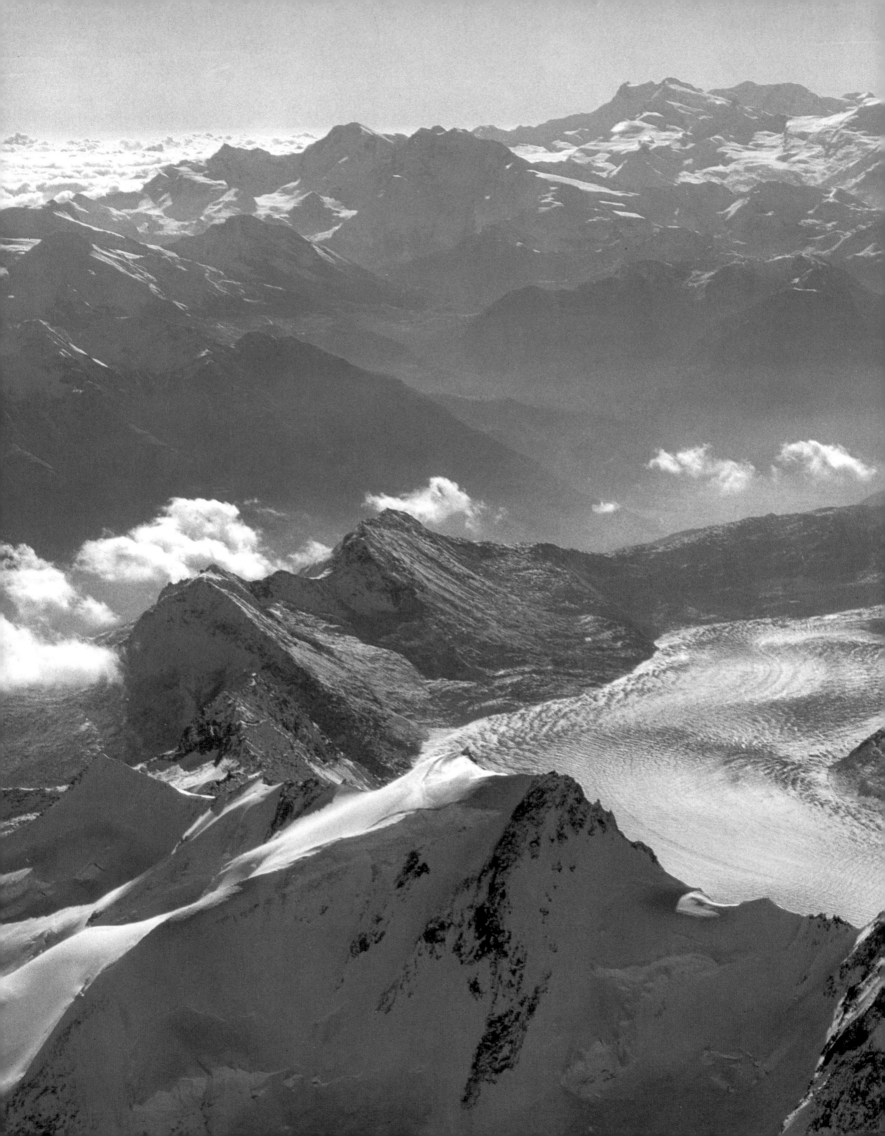

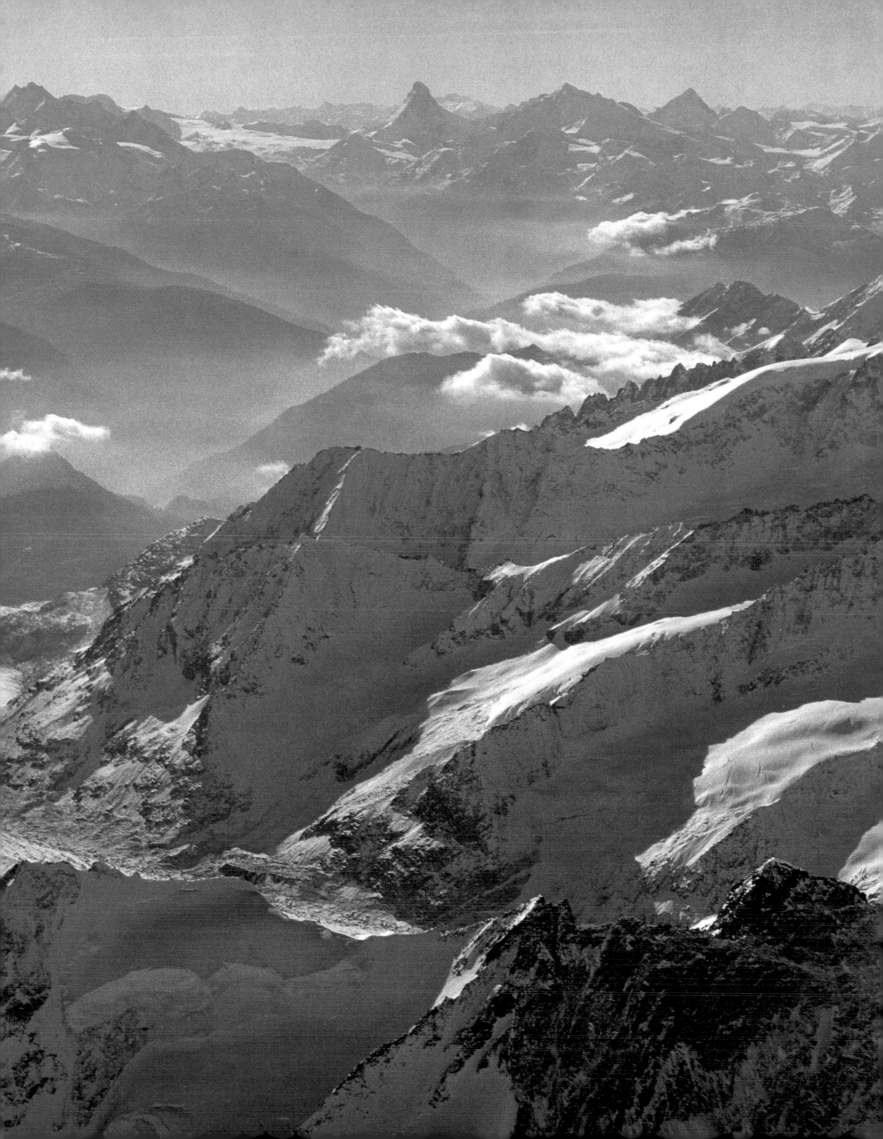

51◁ *Europe's longest ice flow: the Great Aletsch Glacier runs down to the Rhone Valley from the border ridge between the cantons of Berne and the Valais. In the background Switzerland's highest peak, the Monte Rosa Massif with Dufour-Spitze (4,634 m = 15,289 ft), Mischabel Group with Dom (4,545 m = 14,917 ft, left) and Weisshorn (4,506 m = 14,789 ft, right). The characteristic pyramid of the Matterhorn (4,478 m = 14,697 ft) pierces the skyline in the right-hand half of the picture.*

52 *Memorial to a dramatic crossing of the Alps: the Suvorov Monument in the Schöllenen Gorge on the Gotthard Pass road. In the autumn of 1799 the Russian general with 25,000 men struck at the rear of the French troops.*

53 *A rare scene nowadays: house repair in the Verzasca Valley. The Ticino valleys—like many other mountain valleys—are being depopulated. On the southern slopes of the Alps, especially, entire villages are being abandoned and allowed to fall to rack and ruin.*

(6,500 ft). The pattern of life which emerged was one of self-sufficiency since the exceedingly difficult communications compelled the mountain dwellers to produce everything they needed themselves. The basis of self-sufficiency was agriculture, supplemented by crafts focused on the people's own requirements. Production of slate, timber and metals as well as the processing of wool, hemp and linen were practised mainly during the long winter months.

The 19th century also revolutionized life in the mountains. The Alps were losing their economic and social equilibrium. Railways linked mountain valleys with the plain and further increased the gap between the disadvantaged High Alps and the favoured valley floors. Where standard gauge railways were too expensive, narrow gauge railways were built; rack railways overcame great gradients and climbed passes and summits. Roads followed, making valleys and villages accessible.

As coal is rare in the Alps and difficult to extract numerous traditional crafts disappeared. The textile industry, based on water power, could no longer compete with the cheap products of the lowlands. Even mountain agriculture felt the pressure of increased competition. This trend has, since the 19th century, led to an irresistible depopulation of the Alps. The drift reached a peak during 1871–1890—but it persists in all valleys which are unable to stablize their population either through the electric industry or through tourism.

The most recent and also the most far-reaching phase in the development began with the advent of the motor car at the start of the 20th century. The first petrol-driven carriage reached the St. Gotthard Hospice in 1902. The roads built during the horse-and-carriage age had to be progressively adjusted to the demands of the motorcar and to an enormous increase in traffic. Soon it appeared that villages without railway or road were scarcely viable any longer. Since the sixties road tunnels and motorways have been built through the Swiss Alps, ensuring all-year-round communications between north and south: the Great St. Bernhard, the San Bernardino, the St. Gotthard.

Air traffic is also gaining in importance. Holiday-makers from all over Europe are flown direct into the Alpine valleys and trans-Atlantic flights have brought Switzerland within reach of overseas tourists, especially Americans and Japanese. In the high mountains helicopters and light aircraft fitted with skis take skiers to the top of magnifent runs—especially in the summer when the snow withdraws to higher altitudes. Alpine aviation, however, also serves the mountain population—difficult cargoes are easily handled nowadays—and mountain rescue: many a mountaineer who suffered an accident owes his life to such a silver bird.

52

53

Representation of the Alps

As man's interest grows in a particular landscape, the more urgently does he need a scale representation, a map. The territory of Switzerland first appears on Roman maps. Although the really detailed maps were probably then engraved on bronze tablets—which were destroyed in the Middle Ages—certain road maps, the Peutinger Chart, from the 4th century A.D. have come down to us. The Alps are marked merely as a stylized barrier: the Romans had little interest in mountain scenery as such.

The first maps of Switzerland date back to the Renaissance. Many cartographic representations were paintings which combined the results of observation and measurement with artistic impressions. The representation of the mountains, naturally enough, reflected man's attitude to them. One cartographer might draw a rather confused jumble of elevations and peaks while another artist might express his respect of the Alps by choosing terrifying shapes. Characteristically the early map-makers were neither cartographers nor geodetists but followed a variety of professions: doctors, naturalists, historians, artists and others.

In a mountainous country the problem of the representation of the third dimension provides a particular stimulus. It was a long road from the lateral aspects ("cavalier perspective") of the early maps to the modern relief picture ("hill shading"), a road leading via the shading by short lines ("hachure"). The pride of Swiss cartographers is to this day the realistic representation of rocks, in a way that can reflect even their geological structure. When comparing maps of different periods, however, one should consider not only technological progress but also allow for the expression of a subjective feeling for a landscape. This aspect more than any other faithfully reflects the spirit of an age.

▷　Maps from fifteen centuries: to the Romans the Alps were primarily a traffic obstacle (left page: detail from the Peutinger tablets, about AD 350, from a copper engraving by C. F. von Schweyb, 1753). Johannes Stumpf differentiates mountain ranges from valleys (top left: the Valais from the geographical plates of 1538–1547), while Hans Conrad Gyger was the first to represent landscape with a threedimensional effect (top right: detail from his map of Switzerland of 1657). The "Atlas Suisse" (1796–1802) by Johann Rudolf Meyer, Johann Heinrich Weiss and Joachim Eugen Müller, a collection of 16 accurately surveyed hachured maps was the forerunner of official state cartography (from the sheet covering Lake Lucerne).

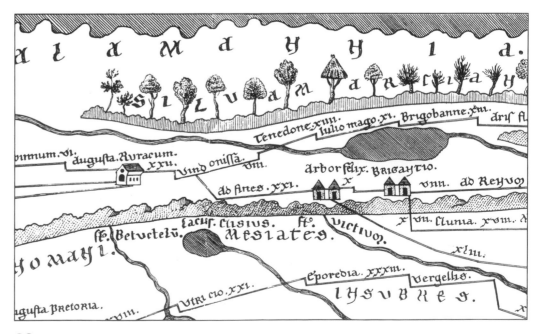

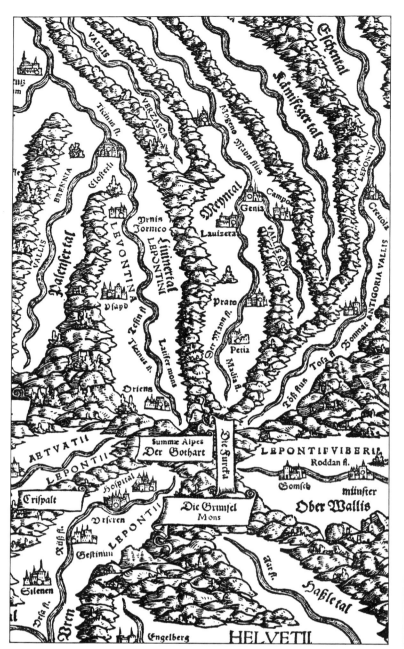

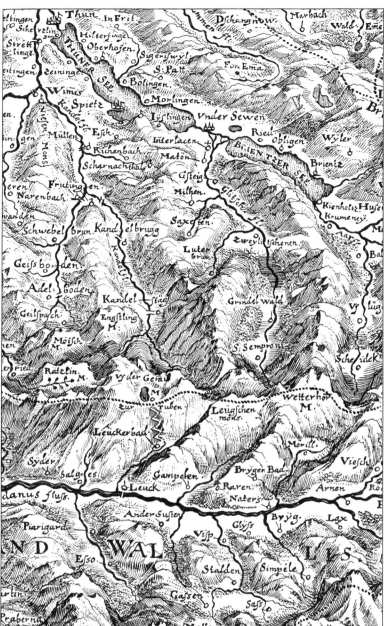

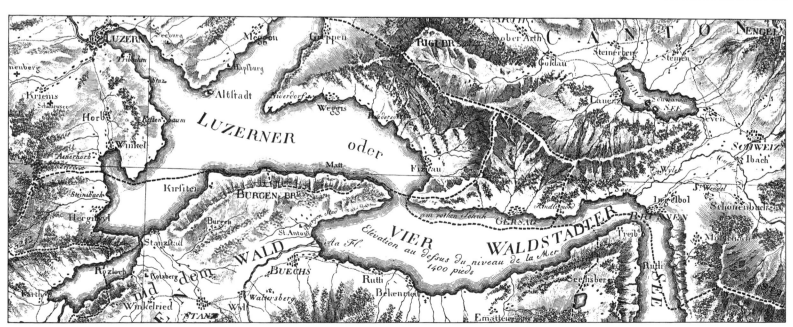

83

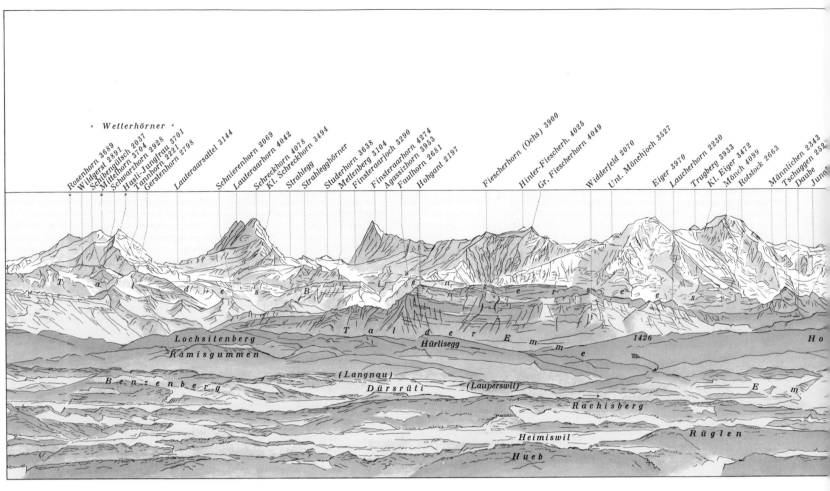

Wetterhörner

Rosenhorn 3689
Wildgerst 2891
Schibengütsch 2037
Mittelhorn 3704
Schwarzhorn 2928
Hasli-Jungfrau 3701
Tannhorn 2221
Gerstenhorn 2798
Lauteraarsattel 3144
Schnierenhorn 2069
Lauteraarhorn 4042
Schreckhorn 4078
Kl. Schreckhorn 3494
Strahlegg
Strahlegghörner
Studerhorn 3638
Mettenberg 3104
Finsteraarjoch 3290
Finsteraarhorn 4274
Agassizhorn 3953
Faulhorn 2681
Hohgant 2197
Fiescherhorn (Ochs) 3900
Hinter-Fiescherh. 4025
Gr. Fiescherhorn 4049
Widderfeld 2070
Unt. Mönchjoch 3527
Eiger 3970
Laucherhorn 2230
Trugberg 3933
Kl. Eiger 3472
Mönch 4099
Rotstock 2663
Männlichen 2343
Tschuggen 252
Daube
Jung

T a l d e s B r i e n z e r s e e s

Lochsitenberg

Rämisgummen

T a l d e r E m m e

Hürlisegg

1426

Ho

Benzenberg

(Langnau)

Dürsrüti

(Lauperswil)

E m

Rachisberg

Heimiswil

Rüglen

Hueb

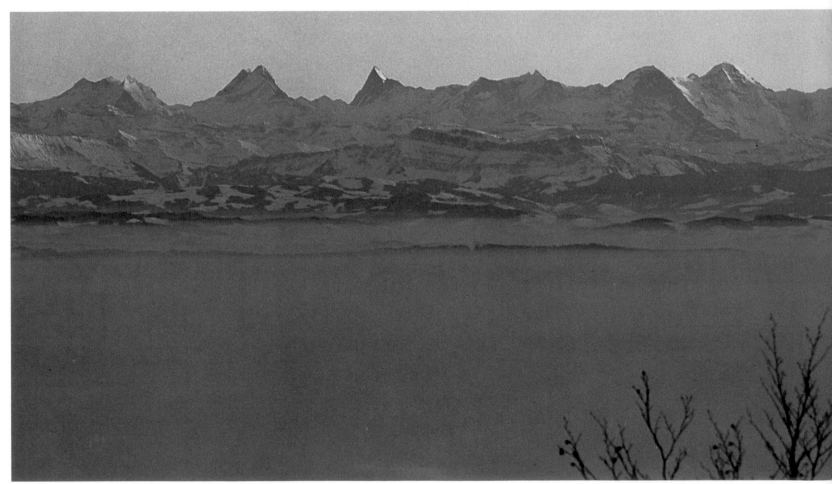

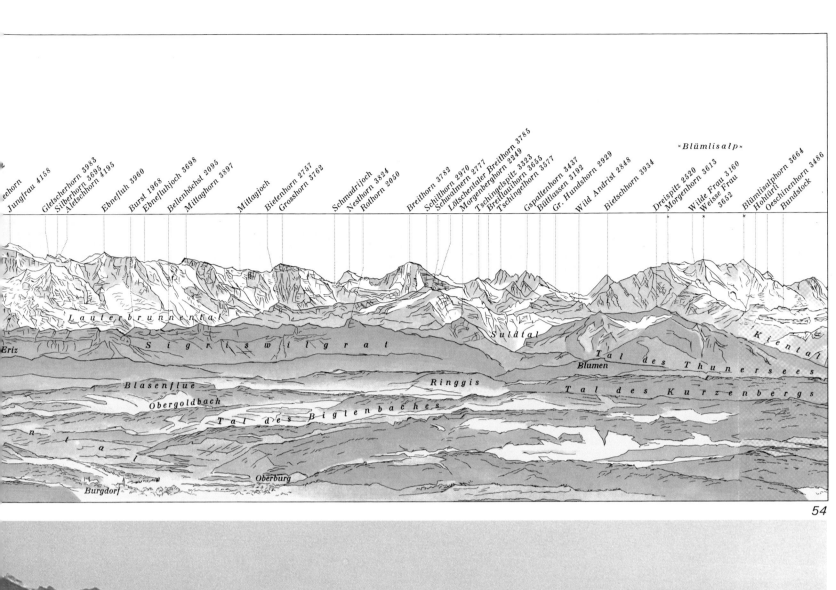

eehorn
Jungfrau 4158 Gletscherhorn 3983 Silberhorn 3695 Aletschhorn 4195 Ebnefluh 3960 Burst 1968 Ebneflühjoch 3698 Bellenhöchst 2095 Mittaghorn 3897 Mittagjoch Bietenhorn 2757 Grosshorn 3762 Schmadrijoch Nesthorn 3824 Rothorn 2050 Breithorn 3782 Schilthorn 2970 Schwalmern 2777 Lötschentaler Breithorn 3785 Morgenberghorn 2249 Tschingelspitz 3323 Breitlauihorn 3655 Tschingelhorn 3577 Gspaltenhorn 3437 Büttlassen 3192 Gr. Hundshorn 2929 Wild Andrist 2848 Bietschhorn 3934 «Blümlisalp» Dreispitz 2520 Morgenhorn 3613 Wilde Frau 3260 Weisse Frau 3652 Blümlisalphorn 3664 Hohtürli Oeschinenhorn 3486 Bundstock

Lauterbrunnental
Eriz Sigriswilgrat Suldtal Kiental
Blasenflue Ringgis Blumen Tal des Thunersees
Obergoldbach Tal des Kurzenbergs
Tal des Biglenbaches
n
t
a
l
Oberburg
Burgdorf

54

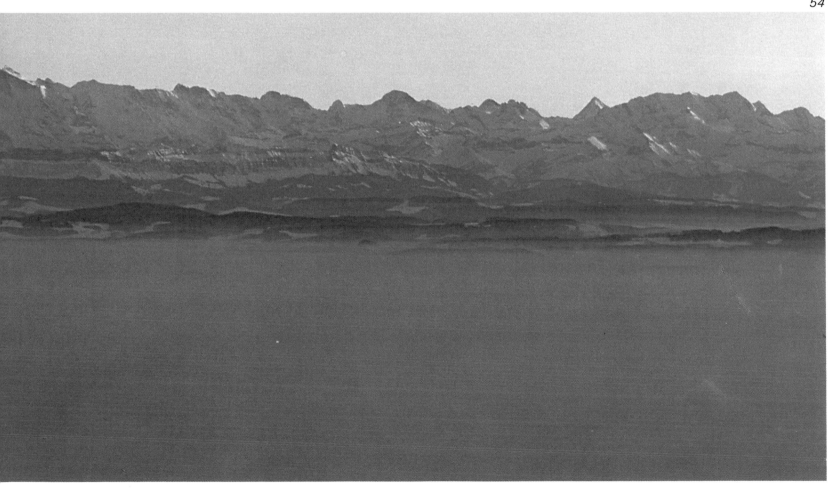

85

Biography of a High Mountain Range

Who piled up the Alps? The suggestion of volcanic forces offers itself. Vulcanism, however, only played a subsidiary role in the magnificent spectacle of orogeny and indeed was its consequence rather than its cause. It was the collision of two continents that, millions of years ago, slid parts of the earth's crust over one another and produced a fold system which sweeps in a wide arc from the south of France to Vienna.

When in 1915 the German polar researcher, meteorologist and geophysicist Alfred Wegener published his continental drift theory he provided the key to the understanding of the genesis of the Alps—the idea that enormous slabs of rock float on a viscous base, are swallowed up by the depths and dissolve, and that simultaneously a new ocean floor is formed, characterized modern geology under the concept of slab tectonics.

Tethys is the name given to the long-vanished ocean in which accumulated the rock material of which the Alps are made. In the Mesozoic, during the Jurassic and Cretaceous Periods, that sea formed an elongated basin (a geosyncline) which was subdivided by thresholds into several troughs. In the troughs fissures opened and streams of red-hot lava spilt over the seafloor. Such submarine eruptions produced volcanic rocks which now, metamorphized by mountain pressure, are found mainly in the Valais and in the Grisons (serpentines and other green rocks under the collective label of ophiolites.)

The sediment which formed in the flatter areas of the Tethys were mainly limestones and, in the lower zones, slate. The slate deposited during the Jurassic and Cretaceous Periods over large parts of the geosyncline are generally labelled Grisons slate, even though their occurrence is not limited to the territory of the canton of Grisons.

About 100 million years ago, around the middle of the Cretaceous Period, the scene came to life. The African continent drifted northward at a speed of 5 cm (2 inches) a year, compressing the seabed of the Tethys and piling entire rock packages on top of each other—the Alpine orogeny had begun.

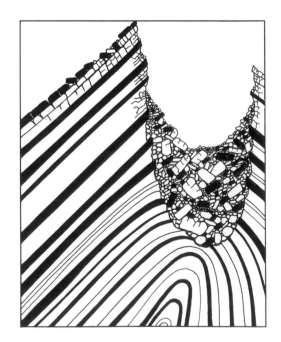

The extent of the compression is considerable. If it were possible to "unfold" the Alps, Basle and Lugano, at present 200 km (125 miles) apart, would be at least 500 km (310 miles) apart. Folding took place in several phases: displaced by the thrust from the south to the north, one rock layer piled upon another. In the process there was some fusing of parts of the earth's crust and the formation of a string of volcanoes. These fire mountains have totally disappeared and only their degradation products survive. In the area of the Bergell the granite melt penetrated the overlying structure. But it was a single last uplift phase about three million years ago which made the Alps a high mountain range. The accidents of geological history have endowed every single patch of the mountain country with its own specific biography, a biography recorded in stone.

Let us pick one example: the Rütli on the lake of Lucerne, the cradle of the Confederation.

One hundred million years ago: during the Cretaceous Period those limestones which today form the constituents of the mountains overlooking the lake of Uri, the south-easterly lobe of the lake of Lucerne, were deposited in the late Mesozoic sea.

Ten million years ago: The Alpine orogeny pushed the Cretaceous strata together, piled one on top of another, raised and transported them some 40 km (25 miles) northward. Traces of that journey can still be observed—the rock strata on both the left and right lake shore exhibit a variety of loops and folds. This can be observed very clearly along the Axen road between Brunnen and Flüelen.

One million years ago: the orogeny was approaching its end. Through pressure and superimposition the limestones in the neighbourhood of the Rütli had been heated to about 200 °C. Degradation began. Along deep fractures, weak zones in the rock, rivers were cutting their beds. Presently the glaciations set in. The glaciers followed the river valleys.

One hundred thousand years ago: this was the great inter-glacial period, with a warm climate. In several advances the glaciers had carved out U-shaped valleys with tall steep walls and then had temporarily withdrawn into the mountains. Once more they were to advance towards the *Plateau* and in doing so grind out the small terrace of the Rütli from the rock.

Ten thousand years ago: the latest Ice Age was coming to an end. A lake now filled the basin of the melting glacier. Gradually the bare landscape was changing. The fierce torrent of the Reuss began, from the south, to fill in the lake basin with detritus from the High Alps. From the north-east the Muota emptied into the lake of Uri and accumulated the valley floor of Ingenbohl/Brunnen. On the Seelisberg plateau, 300 m (1,000 ft) above the Rütli, the glacier had

54 *The bulwark of the Bernese Alps, seen from the Weissenstein (Soleure Jura): Xaver Imfeld (1853–1909) with his crayon produced a work of art which in expressiveness yields nothing to a photograph.*

55 *Erosion patterns in limestone: running water has carved deep grooves into the rock. Karst landscape near Melchsee-Frutt, canton of Obwalden.*

▽ *Architecture of the Alpine edge: Mt. Säntis in eastern Switzerland displays the three main features of orogeny—folds, faults and overthrusts.*

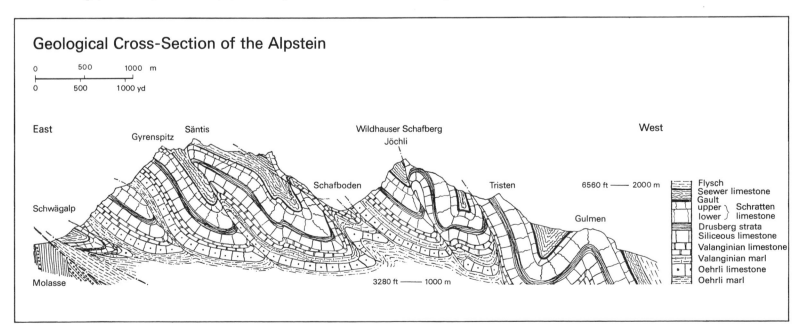

Geological Cross-Section of the Alpstein

Flysch
Seewer limestone
Gault
upper ⎫ Schratten
lower ⎭ limestone
Drusberg strata
Siliceous limestone
Valanginian limestone
Valanginian marl
Oehrli limestone
Oehrli marl

left a small trough behind. Now a small lake was glistening there. It possessed no above-ground outlet. Instead its water seeped through the ravines in the limestone rock and, not far from the Rütli, emptied into the lake of Uri as a shore spring.

One thousand years ago: Immigrant lumberjacks from Sweden—so the legend has it—worked on a projecting rock which now at last had a name—Rütli means a small area of cleared land.

Minerals and Crystals

Crystals are mountains in miniature. Their bold shapes are suggestive of steep rock faces and gleaming crystal surfaces of smooth glacier ice. At one time the word crystal was used only of rock crystal—perfectly crystallized quartz. Nowadays the term is used in a wider sense and describes any body bounded by naturally grown flat surfaces (scientists include laboratory-made crystalline solids among the crystals; minerals, on the other hand, belong exclusively to the realm of inanimate nature).

The principal sources of mineral finds in Switzerland are in the Alps. But they are not uniformly distributed. There are zones with a marked wealth of crystals, such as the Grimsel, the Reuss Valley in the canton of Uri with the Maderaner Valley, the Tavetsch in the western Grisons, the regions around the Gotthard and Lukmanier Passes, and the Binn Valley in the Upper Valais. Alongside these there are extensive mountain regions where even the trained eye of the crystal-seeker scarcely spots anything other than "ordinary" stones. What is the cause of this conspicuous concentration of mineral wealth? Partly it is due to geological causes. But in many cases even the expert has no answer.

The question of how the crystals came into being is better understood. About 16 to 10 million years ago, in a late phase of the Alpine orogeny, stress fissures and ravines developed in the rock, and these filled with hot aqueous solutions. These leached out the adjacent rock and withdrew from it various substances. Upon cooling the dissolved substances crystallized out again and grew into the cavities. To this day many crystals contain minute occlusions of the mother liquor from which they grew.

Much as the Alpine minerals may differ in shape, size, colour, hardness and chemical composition—they all delight the collector's heart. There are smoked quartz clusters weighing several hundredweights just as there are rare sulfo-salts the size of a pinhead; there are metallically gleaming foliated hematite crystals, step-shaped adularia coated with green chlorite dust, and matted clusters of amianthus. The scientifically most interesting finds by far have been made in Switzerland at the village of Lengenbach in the Binn Valley. There, in a white sugar-grained dolomite rock nearly 20 types of previously unknown minerals have been found.

Crystal collecting has become a veritable national sport over the past few years. Motivated by a taste for adventure and by the collec-

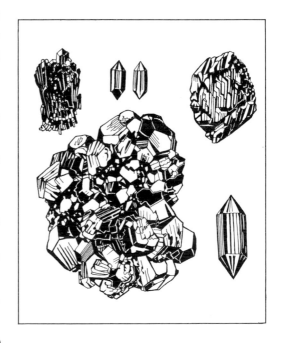

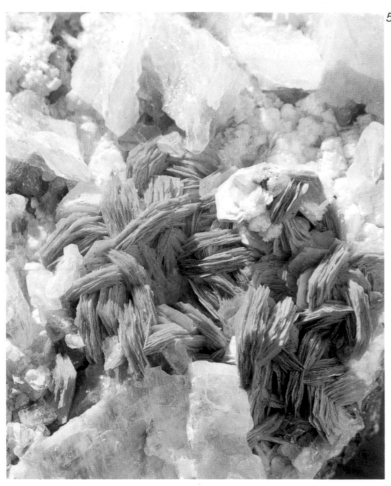

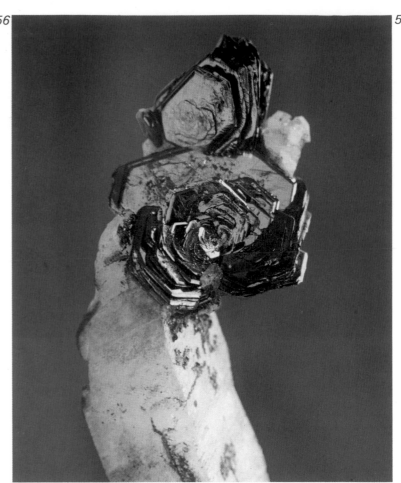

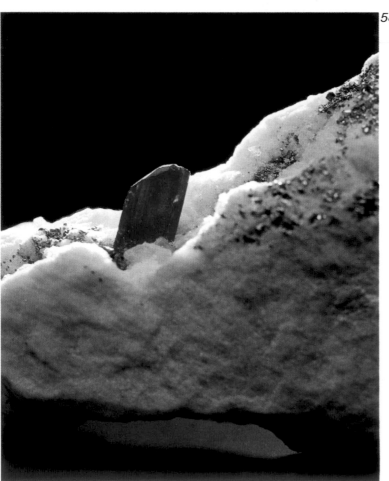

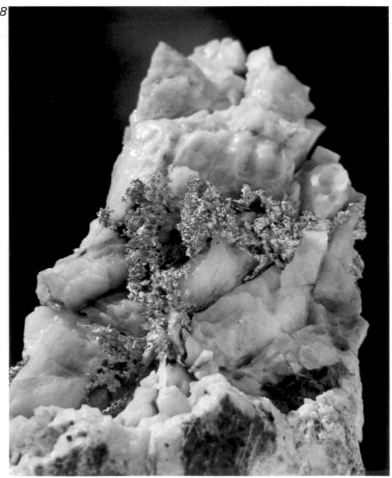

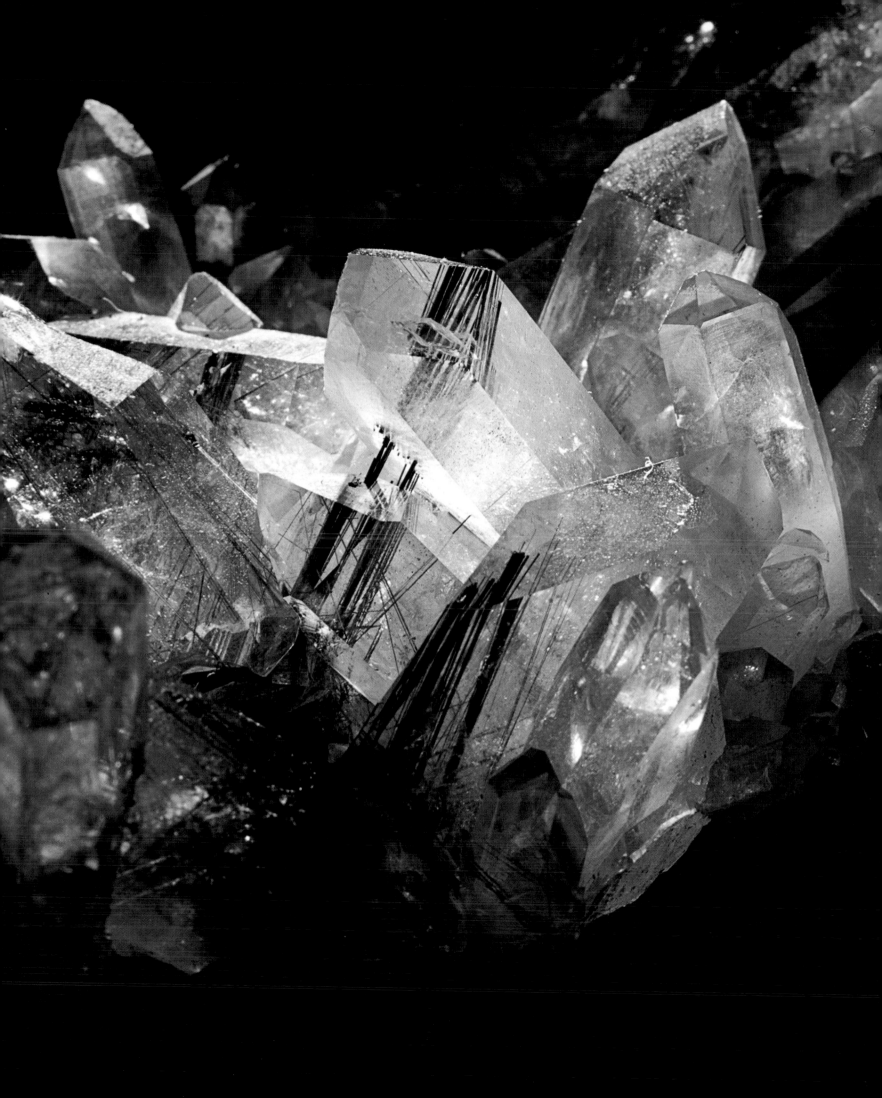

tor's passion, countless lowlanders wander into the Alps at weekends and during vacations. Proudly they carry their finds back home in their rucksacks. In consequence, the treasures of the Swiss mountains now occupy a place of honour not only in all natural history museums of the world but also in many tasteful living-rooms. Irresponsible behaviour by over-zealous amateurs has unfortunately compelled many municipalities to subject mineral collecting to regulations. Either it is entirely reserved to the natives, or collectors from elsewhere have to pay a licence fee before they go crystal-hunting. During the winter half of the year mineral exchanges are held in major localities. Mountain people who go in for professional crystal collecting offer their summer's yield for sale and hobby collectors exchange their treasures amongst each other there.

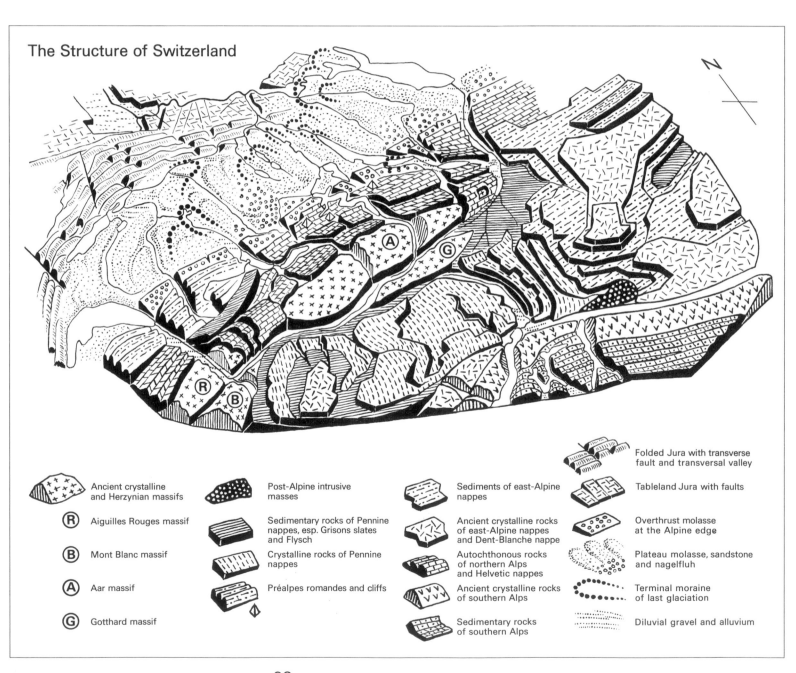

The Structure of Switzerland

Ancient crystalline and Herzynian massifs

® Aiguilles Rouges massif

® Mont Blanc massif

Ⓐ Aar massif

Ⓖ Gotthard massif

Post-Alpine intrusive masses

Sedimentary rocks of Pennine nappes, esp. Grisons slates and Flysch

Crystalline rocks of Pennine nappes

Préalpes romandes and cliffs

Sediments of east-Alpine nappes

Ancient crystalline rocks of east-Alpine nappes and Dent-Blanche nappe

Autochthonous rocks of northern Alps and Helvetic nappes

Ancient crystalline rocks of southern Alps

Sedimentary rocks of southern Alps

Folded Jura with transverse fault and transversal valley

Tableland Jura with faults

Overthrust molasse at the Alpine edge

Plateau molasse, sandstone and nagelfluh

Terminal moraine of last glaciation

Diluvial gravel and alluvium

92

"There is no purer Alpine pleasure that we can wish anyone than the view from the Stockhorn at sunset." The author of this line knew what he was talking about—the Bernese Oberland clergyman and naturalist Ludwig Hürner. On a late afternoon in 1882 he was standing on the 2,190 m (7,188 ft) viewing point of the outer Alpine chain above Thoune (Thun), looking down on the sea of mist below which was blanketing the *Plateau*.

"From the east to the south in a wide arc the wreath of the High Alps, their snowfields glowing in the evening light, embraces the calm sea above which we are enthroned high on an airy summit. Dark, their ridges steeped in violet ink, stand the drawn-out Jura mountains almost as though they were rising afresh before our eyes from the primeval sea. Now the violet hues are paling. On the wreath of the High Alps the glowing colours of life have changed to a spectral faint bluish white. The bright red of the evening sky is increasingly compressed by the approaching shadows of night."

Anyone wishing to admire the sunset from the Stockhorn today can save themselves the trouble of the climb: a cableway goes all the way to the summit. Other peaks along the northern edge of the Alps, famous for their panorama, have also been opened up to tourism— the Rochers de Naye (2,042 m = 6,702 ft) above Montreux, the Moléson (2,002 m = 6,571 ft) in the Gruyère area, Mount Pilatus (2,121 m = 6,961 ft) near Lucerne, and finally the highest of them all, the Säntis (2,502 m = 8,212 ft) in eastern Switzerland. Peaks with fine views, however, attract not only tourists but also rain clouds; in consequence the people of Lucerne, with wry humour, call their region the "rain gutter of the Confederation".

For a clear view of the articulation of the Alps we will choose a cloudless day. On wings of fancy we will rise to an altitude of 30,000 m (100,000 ft). Directly below us lies the Gotthard, the heart of Switzerland. On the left edge of our frame is Lake Geneva, to the far right are the mountains of the Grisons.

Between the *Plateau* and the high mountains some ranges of bright limestone are gleaming in the sunlight—the Northern Limestone Alps. Over a width of 30 to 50 km (about 20 to 30 miles) this belt runs across the whole of Switzerland from the south-west to the north-east. All the above-named viewing peaks belong to it, in addition to countless other well-known and unknown mountains. By the side of the impressively sheer walls of limestone the slates and sandstones with interposed layers of marl go almost unnoticed. These latter rock series are known as *Flysch* (the word is related to German *fliessen* = flow), and because of their low degree of hardness, are less conspicuous in the terrain. *Flysch* areas are usually covered with forest or grazing land. The bands of marl between the sandstones, if saturated with water, can turn into soapy lubricated slipping layers and cause entire rock packages to slide down.

The rocks of the central massifs are made of other stuff. Almost

93

61–63 *Creative ice: glacier table (Unteraar Glacier, canton of Berne, drawing by Caspar Wolf, 1785, 61); glacier mill (Lucerne Glacier Garden, 62); glacier lake (Märjelen Lake of the Great Aletsch Glacier, Upper Valais, 63).*

haughtily the hard granites gaze down on the common *Flysch* at their feet. And well they may—after all, with an age of approximately 300 million years they belong to the seniors in the gallery of Alpine rocks.

Alongside the extensive Aar massif—this reaches from the Lötschen Valley into the area east of Disentis—and the adjoining lesser Gotthard massif in the south the spurs of two French massifs extend into Switzerland: in the Lower Valais granites occur of the Mont Blanc massif and of the Aiguilles Rouges massif immediately to the north-west of it. The term massif is used by scientists to describe rock bodies rooted in the depths—in contrast to mountains which are overthrust nappes.

These Alpine overthrust nappes include the Northern Limestone Alps and the *Flysch* formations just as they do the extensive gneiss and slate regions of the southern Valais, the northern Ticino and the

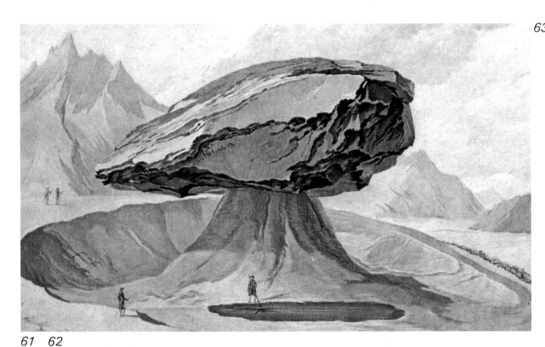

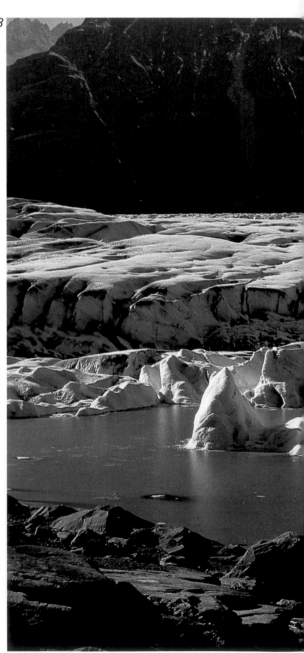

63

61 62

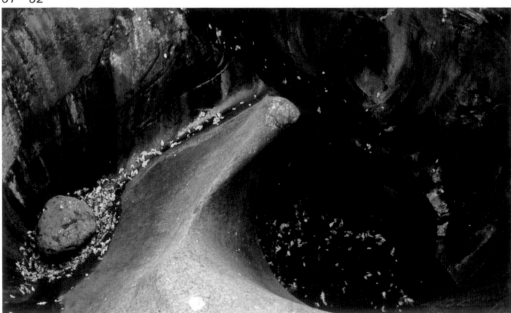

Grisons. That granites occur elsewhere than in massifs is proved by the green Albula and Julier granites which, together with enveloping sediments make up the nappes of the eastern Alps.

Which leaves the southern Ticino. Between Locarno and Lugano grey gneisses and mica schist of the crystalline basal mountains predominate. South of Lugano limestones occur, locally with underlying red porphyries of an old volcanic system. All volcanic activity in the Ticino has been quiescent for at least 240 million years. The holiday-maker in that sunlit corner of Switzerland had better not expect the natural spectacle of volcanic eruptions.

Glaciers are the problem children of the cartographer. The 1,828 ice streams of the Swiss Alps are in continuous movement—some advancing, others retreating. To represent them accurately on a topographical map one would have to print a new edition each year.

Glaciers Now— Glaciers in the Past

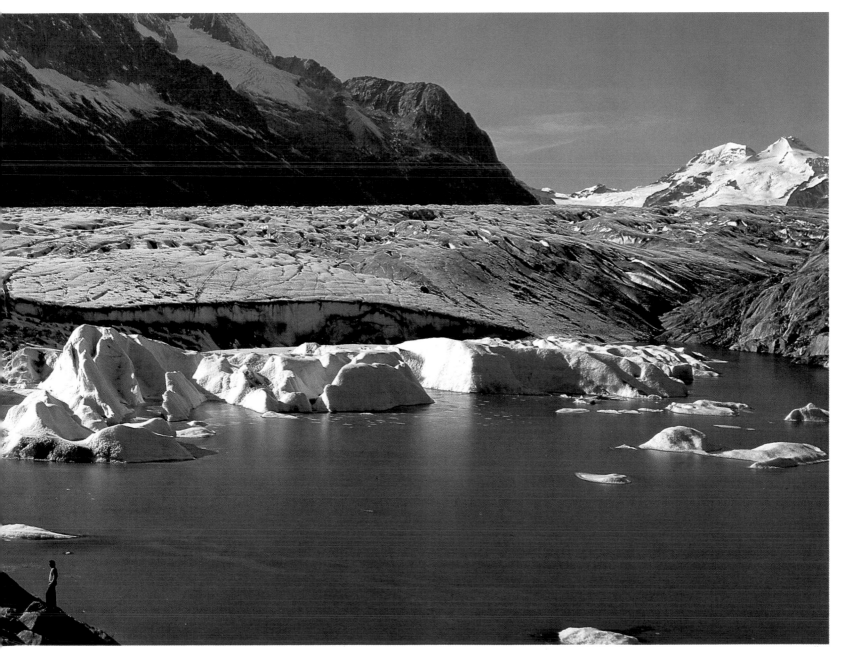

In the basins of the high mountains the snow collects. The white crystals are transformed into *névé* and finally into ice which, under the effects of gravity, starts to creep downhill. At a rate of up to half a metre (20 inches) per day the glacier moves towards that point where supply and melt-off are in equilibrium. There, at the glacier cave, an Alpine stream or at least a rivulet originates.

More than 3 per cent of the total area of Switzerland is covered by ice. The biggest glaciated areas are in the cantons of Valais (767 km² = 296 square miles), Berne (232 km² = 90 square miles) and Grisons (201 km² = 78 square miles). The Uri, Glarus and Ticino Alps account for smaller proportions. The total volume of all glaciers exceeds 60 billion cubic metres and if one were to spread them evenly over the whole of Switzerland the country would be buried under 1.5 m (nearly 5 ft) of ice.

Since the middle of the last century a general diminution of glaciers has been observed. In the relatively short period between 1900 and the present day nearly 500 km² (193 square miles), one quarter of the formerly glaciated area, has become clear of ice. Very recently it would seem that the retreat of glaciers has—for as yet unknown reasons—slowed down. Indeed, we know of over 50 glaciers which are once more advancing.

The loss of substance was less in areas of heavy glaciation. The Aletsch glacier in the Upper Valais, for instance, with a length of 23 km (14 miles) and an area of 110 km² (42 square miles)—by far the biggest glacier in Switzerland—has lost only 10 per cent of its area over the past 80 years (as against an average of 26 per cent).

The loss is regretted particularly by tourists. In the past century the Rhone glacier was a spectacular ice river, reaching down to the valley floor at Gletsch. Today it has lost a lot of ground. Its tongue—almost pitifully—hangs down on the slope between the Grimsel and Furka Passes. Its present size: 9 km (5½ miles) in length, 20 km² (7.7 square miles) in area.

In spite of their heavy losses the glaciers of Switzerland are still impressive sights. Thus the second largest, the Gorner glacier near Zermatt, with a length of 14 km (8½ miles) and an area of 60 km² (23 square miles) is far more important than the biggest French glacier, the Mer de Glace with 39 km² (15 square miles). Austria's most extensive glacier just about covers 19 km² (7.3 square miles). Glaciers play an important part in shaping the landscape. Frozen-in boulders carried along by the glaciers scour the rock base, and, together with the ice, over prolonged periods eventually grind and carve out wide valley troughs. Into these valleys with their characteristic U-shaped cross-sections and steep flanks the side valleys enter by pronounced steps. The angular rock forms of high Alpine regions are transformed by flowing ice into gently undulating rounded hump landscapes. On its back, too, a glacier carries with it,

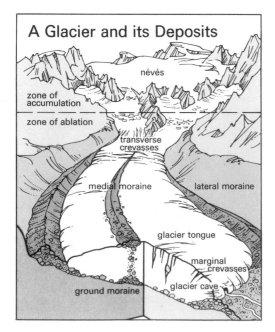

A Glacier and its Deposits

névés

zone of accumulation

zone of ablation

transverse crevasses

medial moraine

lateral moraine

glacier tongue

marginal crevasses

ground moraine

glacier cave

both laterally and occasionally centrally, long-spread-out accumulations of mountain detritus, the moraines. After the melting of the ice these form moraine ridges which mark the limits to which the ice had advanced. Ancient moraines are found not only in the Alpine region but also in the *Plateau* and in the Jura. From them protrude individual boulders of Alpine rock, the erratic blocks. These testify to the fact that glaciers used to be far more extensive in the past than they are today. During the glacial periods they had repeatedly thrust down from the mountains, and during warmer intermediate periods they had then melted back, leaving the transported rock material behind.

The Ice Age theory which has become fundamental to geology was born in Switzerland, in the early 19th century. The first to understand the causal connections was not a scientist but an inhabitant of the Lower Valais with an acute sense of observation. The Ice Age scholar Fritz Mühlberg made the following report to the Swiss Natural Science Society in Fribourg in 1907:

"If no glaciers existed at present, enabling us to discover the laws of their origin and their effect from our own experience, then erratic blocks, moraines, glacial polish and the rounded hump shapes of the Alps and their foothills would no doubt have remained an insoluble mystery; for no human imagination would have been capable of reconstructing vast glaciations theoretically. In fact it was a chamois hunter in the Bagnes Valley by name of Perraudin who, on the basis of his observations of present-day glaciers and the occurrence of erratic blocks and moraines and glacial polish far beyond and away from those glaciers, first voiced the supposition that the glaciers must have been more massive and more extensive in the past."

Jean-Pierre Perraudin communicated his ideas to the renowned scientist Johann von Charpentier in 1815. Von Charpentier decided to take a look himself, accompanied by the Engineer of the canton of Valais, Ignaz Venetz, and agreed with the chamois hunter. Von Charpentier thereupon wrote a book and succeeded in convincing his initially sceptical expert colleagues. Soon Switzerland had a number of important Ice Age researchers, among whom Louis Agassiz (1807–1873) was the most eminent.

Even before the publication of the Ice Age theory the erratic blocks in the *Plateau,* also known as findlings, had given rise to speculation. The German geologist Leopold von Buch believed that a sudden flood must have carried these often house-sized stones down from the Alps into the plains. His Swiss colleague Hans Conrad Escher von der Linth (1767–1823) who dried out the swamp in the lowlands of the Linth river, on the other hand visualized a mud lake which once filled the whole of the Valais. The liquid mass, he suggested, had eventually burst through the marginal range of the Alps and in that breakthrough transported the erratic blocks with it.

▽ *Picture of an Arctic landscape: At the zenith of the Würm glaciation, 15,000 to 20,000 years ago, a large part of Switzerland was covered with ice.*

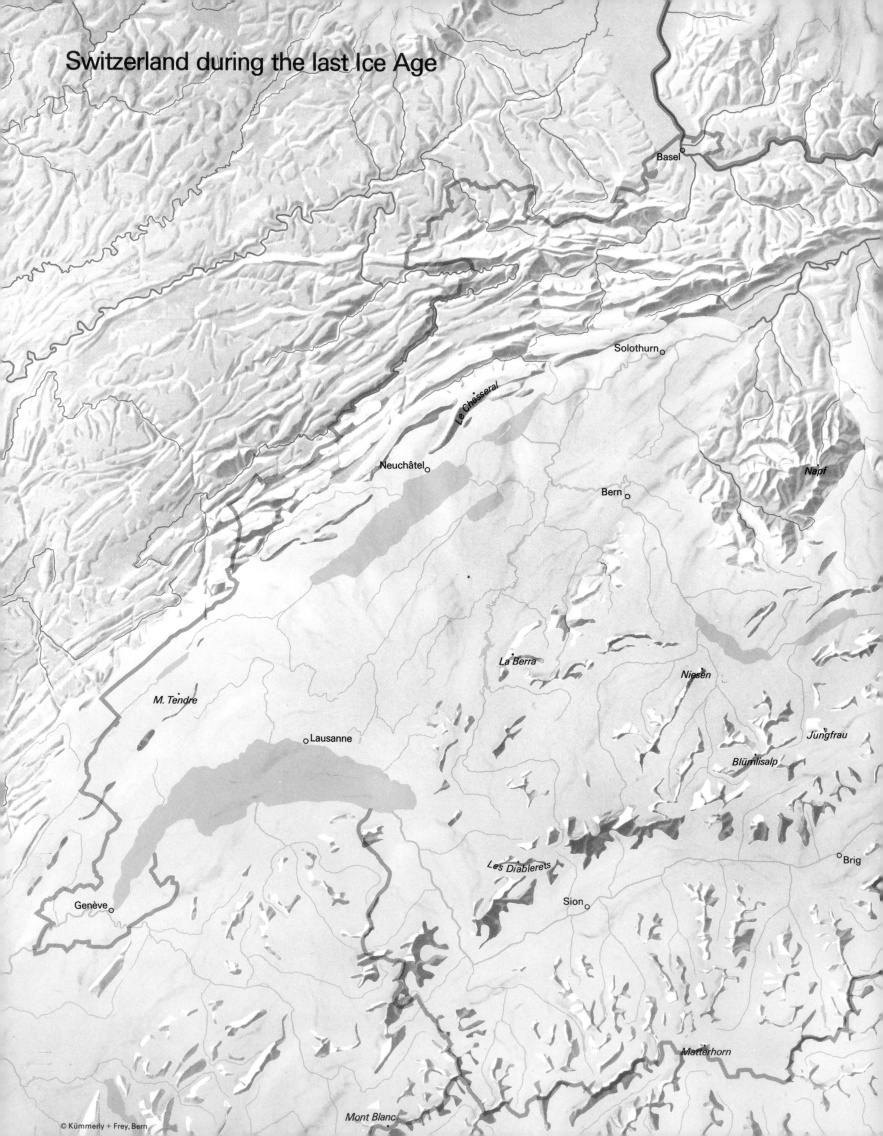

Switzerland during the last Ice Age

Basel

Solothurn

Le Chasseral

Neuchâtel

Napf

Bern

La Berra

Niesen

M. Tendre

Jungfrau

Blümlisalp

Lausanne

Brig

Les Diablerets

Sion

Genève

Matterhorn

Mont Blanc

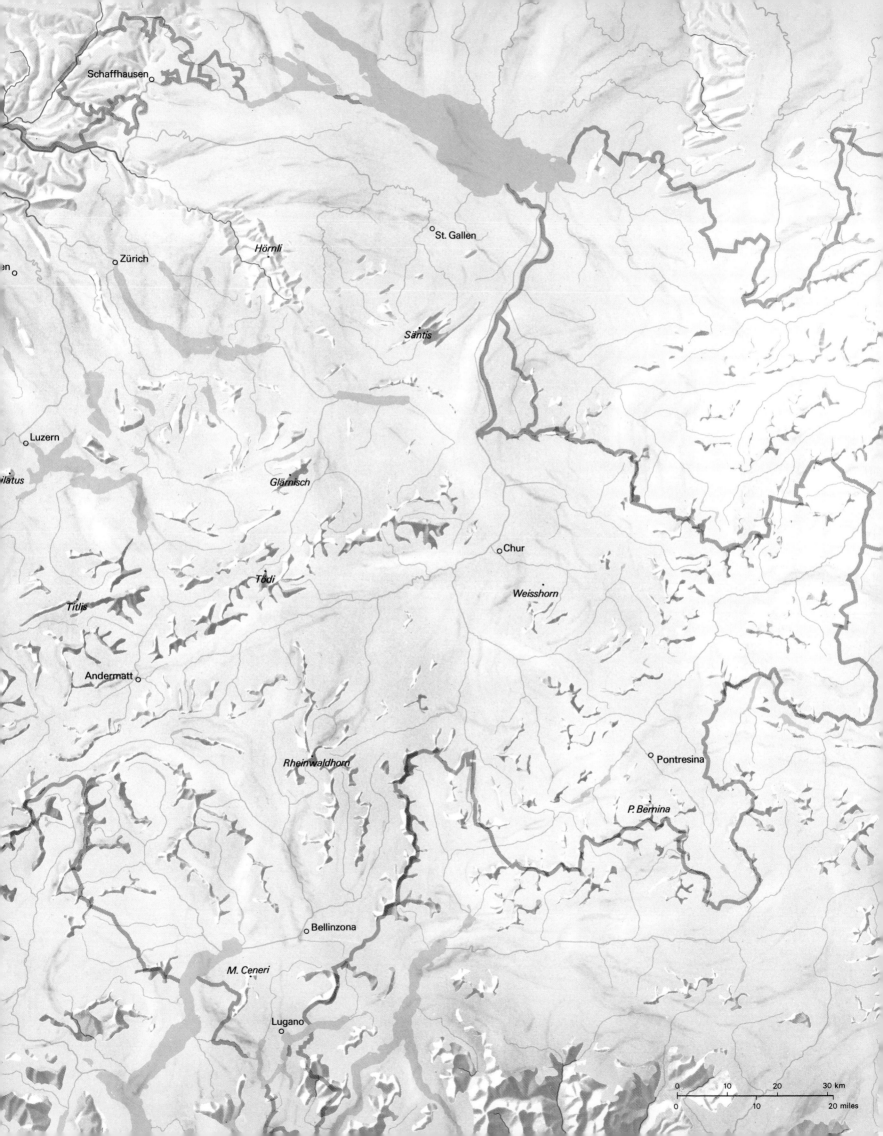

Schaffhausen

Zürich

Hörnli

St. Gallen

Säntis

Luzern

Glärnisch

Pilatus

Chur

Tödi

Weisshorn

Titlis

Andermatt

Pontresina

Rheinwaldhorn

P. Bernina

Bellinzona

M. Ceneri

Lugano

0 10 20 30 km

0 10 20 miles

The Forest Cantons

"The Gotthard ist a tranquil rock around which blow violent winds of great turbulence and thunder The people of the land are strong, of stout heart and fond of arms; Uri men are eager to get at the enemy."

Albrecht von Bonstetten, Dean of Einsiedeln (circa 1442–1504) in his "Description of Switzerland" (1479) draws a very striking picture of the cradle of the Confederation and also of the inhabitants of that inhospitable region.

It is scarcely a coincidence that the alliance of states from which present-day Switzerland has developed took its origin amidst the forbidding mountains of the original cantons. The Gotthard Pass is inseparably linked with the beginnings of the Confederation. Until the 12th or 13th century the impassable Schöllenen Gorge cut off the Gotthard Pass from the canton of Uri. Only when the "footbridge through the spume" was opened did Uri develop from a remote corner in the mountains, from a blind alley, into a transit region, into one of Europe's political and economic key areas. That precious gate through the Alps has ever since been an exceedingly valuable trump card in the hands of the Swiss.

What makes the Gotthard so important, what distinguishes it from all other Alpine passes linking Central Europe to the Mediterranean area? Many a traveller over the pass may have asked himself that question; we find an answer to it in Johann Wolfgang Goethe's "Letters from Switzerland". Three times the poet stood at the summit of the pass, looking down into the land of his yearning. "Although the Gotthard is not the highest mountain of Switzerland, it yet holds the rank of a royal range above all others because the greatest mountain chains converge upon it and lean against it. The mountains of Schwyz and Unterwalden, chained to those of Uri, rise up from the North, from the East rise the mountains of the Grisons country, from the South those of the Italian counties, and from the West the Furka, that double range that encloses the Valais, presses close to it. Not far from the house here are two small lakes, one of which sends the Ticino on its way through gorges and valleys into Italy, while the other similarly sends the Reuss into the lake of Lucerne. Not far from here the Rhine has its origin and flows towards the East, and if one also adds the Rhone, which originates at one foot of the Furka, flowing through the Valais to the West, one finds oneself at a crossroads whence mountains and rivers run towards all four points of the compass."

The great advantage of the Gotthard Pass lies in the fact that one single pass—or nowadays one single rail or road tunnel—is enough to cross the Alps; anywhere else two or three mountain ranges have to be traversed. At the same time the Gotthard area also provides a valuable west-east link, considering that the Furka Pass leads from Goms in the Valais and the Oberalp Pass from the Anterior Rhine Valley in the Grisons into the Urseren Valley. It is this superb traffic

situation that lends the Urseren Valley its special importance. This almost treeless high valley—Andermatt has an altitude of 1,440 m (4,730 ft)—had been almost totally isolated from the rest of Uri by the Schöllenen Gorge; it had been settled by people from the Valais and developed in a somewhat independent manner. Although the dialect differs from that of the rest of Uri, it is much closer to it than it is to the Valais dialect; it also contains a few elements of Italian. Politically the Urseren Valley has won for itself a predominant position—it holds one of the two seats of the canton in the States Council. In consequence, the 2,000 inhabitants of the valley return one man to the Lesser Chamber in Berne, whereas a deputy from Zurich represents more than half a million inhabitants.

The canton of Uri has lived by traffic for centuries. The people could afford to neglect crop farming in their steep and inhospitable valley, if only thanks to their foodstuff supplies from the South. In consequence, rice pudding and risotto have become important items in the Uri diet. Nowadays there is not a single plough left in the entire canton; stockbreeding has replaced crop farming.

However, Uri is not only open to the South. In addition to the above-mentioned passes into the Valais and the Grisons, the Klausen Pass provides an important road link eastward to the canton of Glarus and the Susten Pass connects the Reuss Valley with the Bernese Oberland in the west. All of these—in addition to the Gotthard motorway—represent a big task for a small canton. Even though road construction is extensively financed by the Confederation, the burden on the canton is still very heavy.

Lake Lucerne is the centre of the Swiss heartland. It, too, was of major importance to transit traffic, since ship services between Lucerne and Flüelen facilitated access to the Gotthard. But once the Gotthard railway was opened passenger and freight transport was switched to the land. Lake Lucerne owes its involved, idiosyncratic shape to its association with different geological and tectonic zones: the molasse land with nagelfluh and sandstones, the Limestone Alps and the interposed Flysch basins.

The canton of Schwyz has given its name to the Confederation as a whole. According to legend Schwyz was founded by one Suit, a Swedish immigrant. In the ancient Confederation Schwyz was regarded as the driving force of the whole country. In the train of Schwyz's policy of expansion the canton was enlarged at its northern edge beyond the catchment area of Lake Lucerne. This has resulted, in our own day, in a partition of the canton. The ancient core land is oriented towards the township of Schwyz and Lake Lucerne, while Ausser-Schwyz (Outer Schwyz) north of the watershed—largely part of the *Plateau*—is aligned towards Zurich. Only armed intervention by the Confederation in 1832 reversed the secession of the "Canton Schwyz of the outlying lands". True, occasional separatist voices can be heard even now but the peculiar district consti-

64 The alliance of the Confederates, sealed on the Rütli by the shore of Lake Lucerne in 1291, as reflected in contemporary art: «Fingers raised in oath» (iron sculpture by Werner Witschi, 1964) by the Flüelen landing-stage, canton of Uri.

64

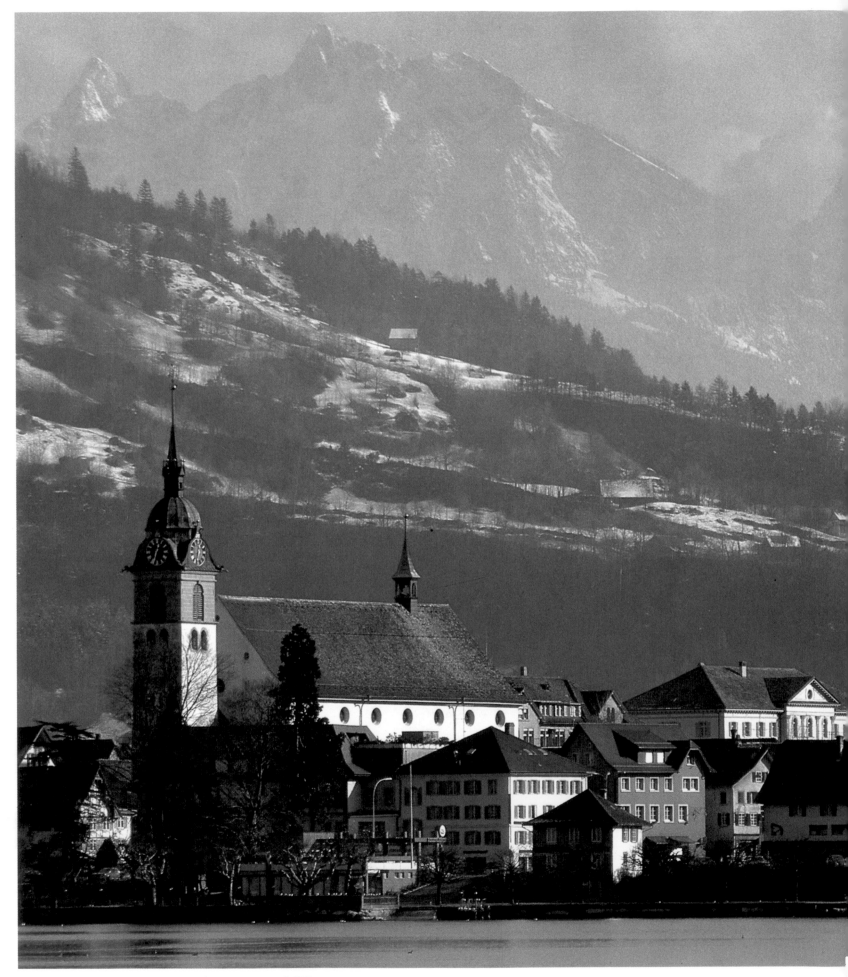

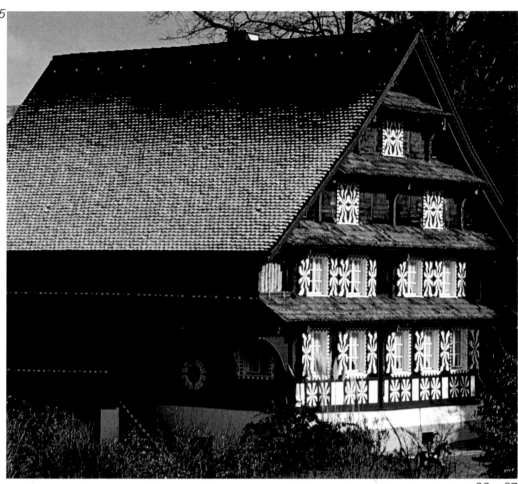

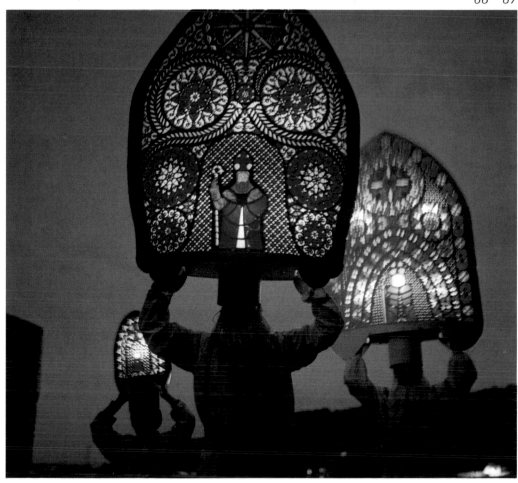

tution of Schwyz seems to make sufficient allowance for the realities of the situation.

Unterwalden is the third original canton of the Confederation. But this canton never existed. Obwalden and Nidwalden in fact are half-cantons but nevertheless two separate political units. The alliance of 1291 was concluded only by Nidwalden; Obwalden followed suit a few years subsequently. The names of the half-cantons refer to the forest at the western foot of the Stanser Horn. Obwalden consists of the valley of the Sarner Aa, Nidwalden comprises that of the Engelberger Aa; "Unterwalden" means "between the forests".

The landscape of both half-cantons is gentler than that, for instance, of Uri but still clearly enclosed within itself. Although the Brünig Pass leading out of Obwalden is much lower and more readily negotiable than the Gotthard, it did little to mitigate the remoteness of the valley. Thus the half-cantons, in contrast to Uri and Schwyz, were somewhat by-passed by affairs. A change is now being brought about by the motorway which links Lucerne direct with the Gotthard by way of the Seelisberg Tunnel. In consequence, Nidwalden, hitherto a cul-de-sac, is becoming a transit area, and the two half-cantons will, for the first time in their history, have a direct road link with their neighbour Uri.

Obwalden and Nidwalden are two rather dissimilar little countries and their inhabitants are doing everything to emphasize those differences. The Nidwalders claim descent from the hero warrior Winkelried and to have inherited his boldness and enterprise. The Obwalders, on the other hand, prefer to see the recluse Nikolaus von der Flüe as a model, with his even, controlled and conciliatory temperament. Nidwalden, moreover, is nowadays largely industrialized and farmers only account for 7 to 8 per cent of its population. This half-canton, thanks to its relatively good communications—narrow-gauge railway, road and motorway—is increasingly becoming part of the catchment area of Lucerne. Obwalden, on the other hand, is one of the poorest regions of Switzerland and farmers still account for 20 per cent of its population. On the other hand, protection of the environment has become a major slogan there recently, and with its three lakes the valley certainly is a suitable recreation area. Engelberg is a well-known winter and summer holiday centre and provides considerable revenue for the half-canton. Admittedly the village is situated in the valley of the Engelberger Aa, which is part of Nidwalden. The municipality is an enclave, and the Engelbergers have to cross the whole of Nidwalden in order to reach their administrative centre of Sarnen.

Uri, Schwyz and Unterwalden constitute the Forest Cantons and together with the extra-Alpine towns of Lucerne and Zoug (Zug), they form Central Switzerland. Does the region deserve this designation? Demographically, economically and politically the centre of gravity of Switzerland today is in the Berne—Basle—Zurich region.

104

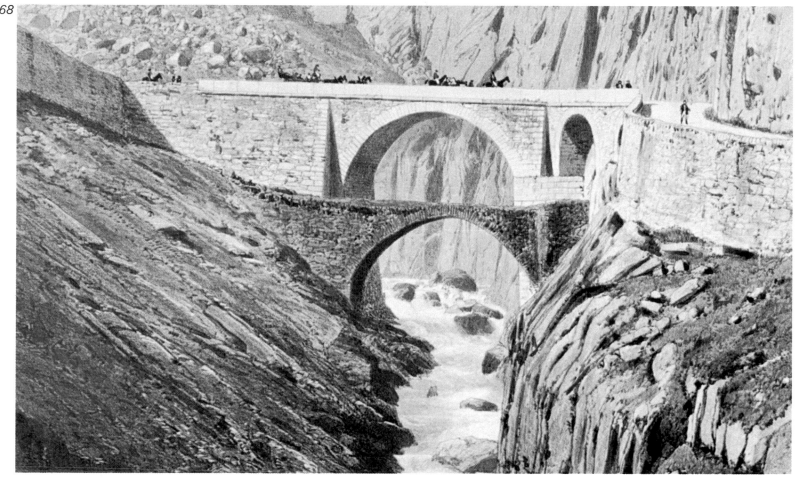

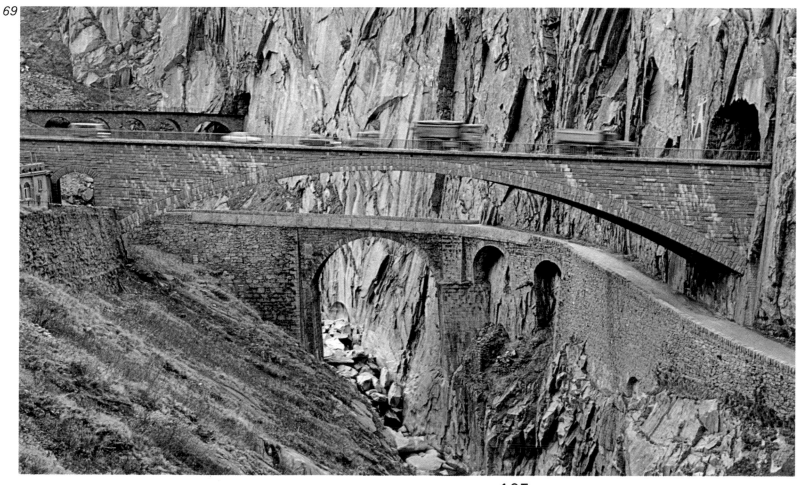

Central Switzerland has felt this shift of emphasis painfully. The term "Innerschweiz", Inner Switzerland, possibly reflects more accurately the enclosed nature of the mountain and hill cantons at the geographical centre of the country.

The Gotthard route, as the economic artery of Inner Switzerland has likewise undergone a major upheaval. To begin with, the Canton Uri nowadays is only a transit area. Higher travelling speeds and an increased autonomy of the vehicles prevent contacts between the tourists and the landscape they pass through, and of course its inhabitants. In the old days several nightfalls had to be made on the journey, and the railway timetables of the past century still envisaged meal stops. Nowadays the entire continent is traversed in a through-coach on the railway, and the Gotthard motorway enables the motorist to cross the whole of Switzerland virtually without stopping.

"Original Switzerland" has thus been degraded to the position of a transit region; in economic terms it is largely a developing area. The cradle of the Confederation is being out-paced by modern developments. Lake Lucerne used to be a welcome traffic lane; nowadays it is a major tourist attraction. Only if Inner Switzerland can continue to offer beautiful and unspoilt recreational scenery will it continue to remain a major attraction for foreign tourists in the future.

The Bernese Oberland

After the Valais and the Grisons the Bernese Oberland accounts for the major part of the Alps. Yet the canton of Berne is no Alpine canton; its centre of gravity is in the *Plateau*. Coexistence between highlanders and lowlanders may not be entirely without its problems but it is peaceful. A common history and a common religion hold the two disparate parts of the country together.

The Bernese Oberland comprises the catchment area of the Aare as far as Thun: the Hasli Valley, the Lütschinen Valleys, the Kander and Engstligen Valleys, the Simmen Valley. To these is added the Saanenland which is separated from the rest of the Bernese Oberland by the Saanenmöser, a pass of 1,269 m (4,165 ft) altitude. Each valley has its specific cultural characteristics which stem from a largely isolated development. Architecture, dialect, legends, folklore and poetry differ from valley to valley; certain upland dialects are more closely related to the German spoken in the Valais than to that spoken in Berne. The Oberland is extensive, and this facilitates the emergence of local cultures. After all, the road distance from Gadmen on the Susten Pass to Gsteig near Gstaad is the sames as that from Berne to Zurich.

The Oberland lives by mountain agriculture and tourism. Many farmers supplement their income by working in tourism during the winter. In contrast to the Valais no major industry has succeeded in establishing itself in the valleys. Small enterprises and crafts, on the other hand, are distributed through most of the valleys. The only in-

106

road of large-scale technology has been into the Hasli Valley, where a whole system of reservoirs and power stations exploit the water power of the young Aare.

The majestic Bernese Alps are the heart of the Oberland; the impressive triad of Eiger, Mönch and Jungfrau have long been regarded as the ideal of beautiful peaks. Their peculiar geological nature—the sheer faces consist of high-mountain limestone, protected at the summit against erosion by crystalline slate—have resulted in the formation of that characteristic face of rock and ice that can be seen from afar.

Not until 1811 was the long list of first ascents in the Bernese Oberland inaugurated by the conquest of the Jungfrau. This was followed in 1812 by the Finsteraarhorn, in 1854 by the Wetterhorn and all the other summits. Since the second half of the 19th century much of the tribute belongs to the English who proved themselves enthusiastic and competent mountaineers. It was at about that time that natives entered the services of tourists and alpinists in the capacity of mountain guides. The names of some guide families have achieved fame; in the Jungfrau area they are the von Allmen, Almer, Bohren, Brawand, Gertsch, Kaufmann, Rubi and Steuri families.

The Bernese Oberland has, ever since the start of tourism, been one of the best developed mountain regions of the world. This is due principally to the local mountain population who put their homes, their supplies, their transport facilities and last, but not least, their local knowledge to the service of tourism. Whereas initially this tourism consisted of explorers, naturalists and men in search of adventure, these were later followed by holiday-makers and visitors in search of recreation and rest. Since 1888 one Grindelwald hotel has been open also in the winter. Its guests amused themselves tobogganing, skating and curling. That was the start of the winter season that has become so important today. In 1891 an Englishman in Grindelwald made the first attempts at walking on skis, and in 1900 Sir Arnold Lunn, also an Englishman, was the first to climb the Kleine Scheidegg on skis. After 1905 Norwegians gave skiing instruction at Grindelwald. About the same time the first winter ascents were made, including, in 1894, the Wetterhorn and the Jungfrau by Coolidge and Almer.

The railway has accelerated the development of tourism. The Lütschinen Valleys were opened up by mountain railways. Rack railways rose to even greater altitudes, such as the Wengernalp railway, opened in 1893. Construction of the Jungfrau railway, an enterprise demanding great courage, was started in 1896; after an eventful history it was finally put into service in 1912. It runs up to the Jungfraujoch, at 3,454 m (11,366 ft) the highes railway station in Europe. The Berne-Lötschberg-Simplon railway (BLS), culminating in the 14,605 m (9 miles 138 yards) long Lötschberg Tunnel, was opened for through traffic in 1913. It is now being double-tracked

107

to ensure that it fulfils its task as a vital continental Alpine transversal communication also in the future.

In certain tourist centres winter eventually became the main season. Sir Arnold Lunn, whom we have just mentioned, made downhill skiing an internationally recognized sport. For his services to skiing and to Anglo-Swiss relations he was given a knighthood.

As the mountain farming villages gradually developed into tourist centres so Interlaken grew into a fashionable tourist metropolis. In his "Rambles in the Alps" the author and journalist Josef Viktor Widmann (1842–1911) reported: "In Interlaken you would suddenly find yourself in the middle of a Paris boulevard. Incredible multitudes in the most elegant big city fashions would sweep along the gravelled footpaths of the Höhenweg any evening, and a babel of all languages would strike the astonished ear. One had the impression that Interlaken was having a very good season."

The plentiful provision of excellent tourist facilities, of meticulously kept cultural landscapes, together with a self-assured native population, probably was a major factor in making the Bernese Oberland a favourite tourist venue. The life of the Oberlanders is reflected in living literature both in dialect and in standard German. To savour the latter, here is an excerpt from the biographical story "Tschuri" (1956) by the Brienz author Albert Streich (1897–1960):

"The path was stony and rough as soon as it left the last houses of the village behind and reached up into open country. An old grey wall, loosely built of crumbling stones between which the grass was growing, accompanied it for a while on the mountain side. Leaning against this wall there was an occasional ancient weathered barn, its shingled roof covered with moss and weighed down with black stones. Often a crooked-stemmed spreading juniper tree extended its shade-giving foliage beyond the grey shingles.

"The first thing that conveyed to me an impressive surmise of the character of the mountain was the size and massiveness of the bare rocks which, as I climbed, came ever more closely in sight. These rocks gradually rose before my eyes to immeasurable and yet strangely clear height, transforming the indifference with which I had so far regarded them from the valley into speechless intense awe. I was similarly impressed by the massive ridge leaping out towards the west and the great sheer slopes with their abrupt drop down to the depths. I could not look down for long or I would have felt giddy. Nor did I feel like speaking; the world which was opening before me, the oppressively large and heavy shapes—heavy in spite of their wealth of detail—weighed on my chest. Only the view down to the lake and its airy reflections, to the bright meadows, and leafy clumps of the fruit trees on its shores, to the colourful mosaic of the roofs of the village, of my home, provided some measure of relief."

110

The Valaisian Rhone Valley, the central axis of the Western Swiss Alps, narrows between Sierre and Leuk—a splendid example of a frontier shaped by landscape. The effects of two major natural phenomena here divide the valley and hence the entire canton. In prehistoric times a landslip had deposited mountain detritus on the valley floor. Limestones and slates had slid down from the Petit Mont Bonvin and blocked the Rhone Valley. Now gentle hills and ridges of that landslip material extend from the town of Siders all the way to the Pfyn Forest. That strange forest with its gnarled pines, juniper, buckthorn and other shrubs also covers part of the huge cone which the Illbach torrent has washed up from the southern slope. The eastern half of the detrital fan bisected by the lower Ill trench must be less at risk of being flooded seeing that, over the course of many generations, it has been sufficiently cleared of surface stones to support meadows and orchards.

It is strange how phenomena of this kind can impress their mark on a landscape. The landslide and the detrital fan together have produced a step gradient in the Rhone Valley of about 70 m (330 ft) which enables the Pfyn Forest to act as a climatic divide. Here is the boundary of the big vineyards and plantations of warmth-lowing stone fruit which are so typical of the Lower Valais.

But that is not all: man himself here encountered a frontier ever since the Migration—upstream is the Allemanic cultural sphere, downstream the Burgundian. The Upper Valais is German-speaking, the Lower Valais is French-speaking. The towns of Leuk and Siders were conceived as frontier fortifications and many a battle has been fought in the Pfyn Forest in the course of history. Finally this valley step also has some economic importance, and the Valaisians have more recently been utilizing this gradient. The water of the Rotten—this is the Upper Valaisians' name for the Rhone—is trapped at Susten and channelled to the factories of Chippis through a canal and penstock. It is this very industry that today threatens the unique vegetation of the Pfyn Forest, as the noisome substances of the waste gases seriously attack the plants. Motorists, picnicking or pitching their tents in this former hideout of highwaymen and assassins may unwittingly cause forest fires.

The Rhone Valley is a peculiar landscape: a huge longitudinal trench in the mountains, with a wide valley floor, hemmed by high mountains. To this situation amidst the Alps it owes its special climate. It is the driest region of Switzerland, with less than 600 mm of precipitation on an annual average—scarcely more than large parts of central Spain or the Atlas Mountains in North Africa. The clouds passing over the Valais discharge at the high summit but spare the valley floor. The precipitation intercepted by the surrounding peaks nevertheless benefits the Rhone Valley, and this precious moisture has since days immemorial been channelled to meadows and fields by complicated systems of canals and water conduits. The often

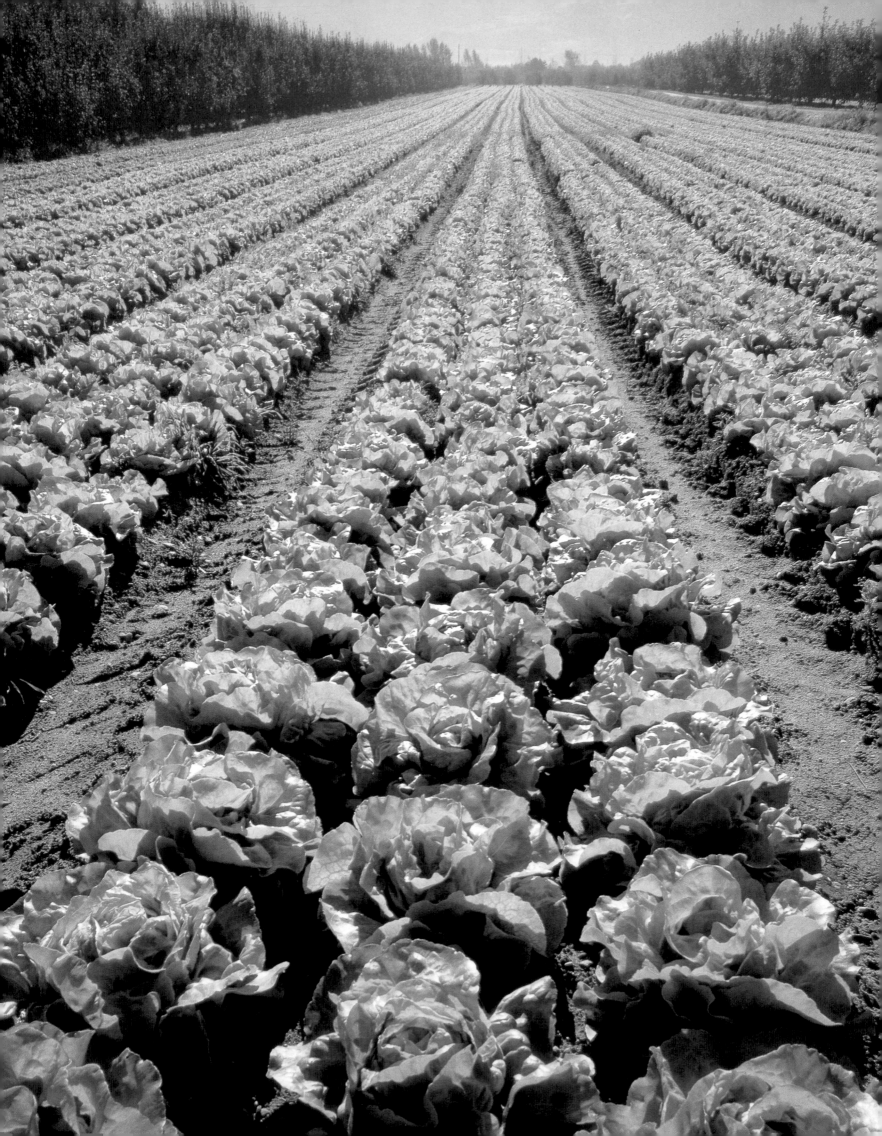

daring construction and expensive maintenance of these conduits, frequently clinging to rock faces—known in the Lower Valais as *bisses*—was a major task for the mountain population. The author Jakob Christoph Heer (1859–1925) used this setting as a background for his impressive novel "On Holy Waters". Thanks to such irrigation this sunshine-rich and relatively hot dry island in the Rhone Valley grows agricultural products which are scarcely successfully cultivable elsewhere in Switzerland.

Numerous side-valleys open into the Rhone Valley along its entire length. They open up a different world—that of the high mountains, with numerous peaks above 4,000 m (13,100 ft). These valleys once knew a flourishing intensive mountain agriculture, with crops being grown to well above 1,500 m (4,900 ft). The different climatic zones and vegetation belts were utilized within a complicated migration pattern, and municipalities, as indeed individual farmsteads, owned plots of land and buildings at various levels of altitude. The terrace villages situated at about 1,000 m (3,280 ft) through the course of the year managed the *mayens* or *Maiensässe* (at about 1,500 m = 4,900 ft) and Alpine pastures (2,000 to 2,600 m = 6,500 to 8,500 ft, and more), as well as vineyard in the Rhone Valley (400 to 600 m = 1,300 to 2,000 ft). Such migrations virtually no longer exist. The mountain pastures are frequently grazed by herds from the lowlands, and tourism has long taken possession of many villages. Numerous high valleys have been turned into lakes by dams and now supply valuable electric power to industry in the Rhone Valley and throughout Switzerland.

The Fribourg and Vaud Alps are the western continuation of the Bernese Alps. High above lake Geneva tower several summits whose names reveal a lot about their fierce shapes: Tour (Tower), Tête (Head), Dent (Tooth), Pointe (Point). Steep mountainsides lead from the cultivated level of the Rhone Valley and lake Geneva across mountain forests and Alpine grazings to the high rock faces and glaciers. On the valley floor and on the sunlit slopes vineyard adjoins vineyard. Little wonder that at Vevey a traditional vintners' festival has been held every 25 years since 1797. This township on Lake Geneva, hard by the boundary between Alps and *Plateau,* is the meeting place not only of vintners from French-speaking Switzerland but from all over Europe; they are joined, moreover, by delegations from viticultural areas all over the world. Some 3,000 actors, singers, musicians and dancers perform their impressive and delightful festival, dedicated to the vintners and to the origin of wine, in the town's picturesque market place.

The massive mountains and the magnificent landscape of the Western Swiss Alps have provided many a poet with an impressive background to his work. For many of them this plot of earth was the home of their choice. Thus Carl Zuckmayer (1896–1977) lived at Saas Fee, while Rainer Maria Rilke (1875–1926) settled in an an-

73–75 *Intensive crop farming in the Rhone Valley: good soil and favourable climate ensure maximum yields—amidst the Alps. Grapes ripen on the sunlit slopes, fruit and vegetables thrive in the plain.*

74

75

113

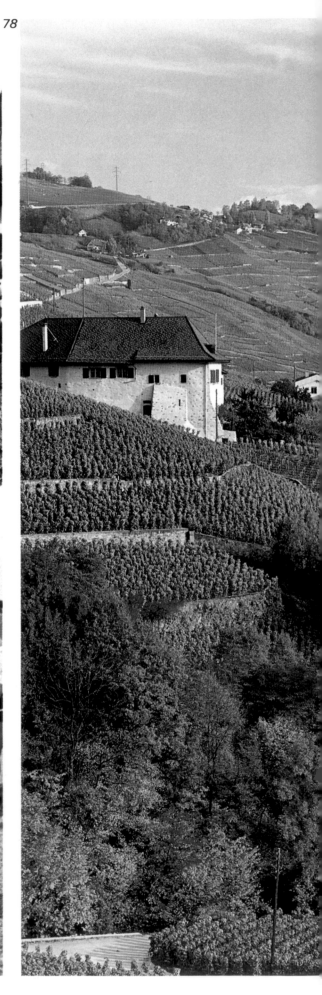

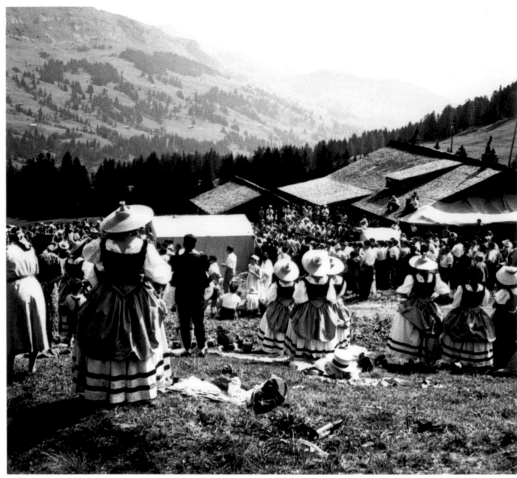

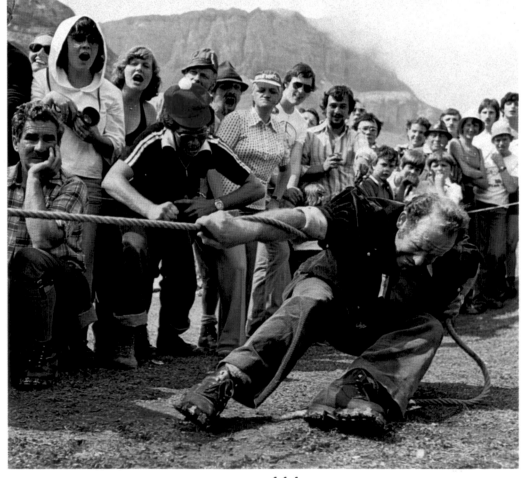

cient tower near Siders. But a large number of native writers also came from these mountain landscapes. Maurice Chappaz (born 1916) dedicated the following poem to his homeland, the Valais, which he rarely ever leaves in his creative work (from "Verdures de la nuit", 1945).

Valais, land of the Bible
Which in its shady lap
Carries the Rhone
Like a verdant twig
Ark, filled with black honey
Of murmuring rocks, of nostalgic rustling of forests
Rosy with sunshine
Springs, nut-trees, cool mountains, groves
Hills of the plain like quails
Sandy slopes
Adorned white where the anemone stands dark
The land discolours as the oat-blossom
As the hedge of mulberry trees
The immense delicate vineyards
The rosy-hued peaks
The dark spruce-hemmed lakes of my native land
Were to my soul
Its meat
The wine it craved for
As a vagabond I travelled the straight road
Where a flight of butterflies fled
Like a purple cloud
The landscape fragrant with fruit trees and spruce groves
Tastes of crushed marguerites
The earth under the shrubs smells of tanning stuff
The words of the people no longer echo in the villages
I crossed the river
Over the iron bridges paler than forget-me-nots
The grey sky curves away
Into the refuge of the quiet mountains
As perfect
As the dome of a grape...
I should like to lie down
In the strawberry-lit shade
And like a peasant kiss the earth...

Even though the Eastern Swiss Alps—the Glarus and Thur Alps, the Adula and Silvretta groups—do not reach the majestic altitudes of the summits of the Valais or Bernese Alps, they are certainly no less impressive or characteristic. From the deep valley cauldron of Glarus, in particular, the surrounding giant mountains seem oppressive to the viewer, even though they fall a little short of 3,000 m (9,850 ft). Hans Trümpy has drawn attention to his Glarus mountains, to the towering masses of rock that are his homeland (in Forum Alpinum: "Poor Soil—Beautiful Homeland", 1964):

"There they stand—the fortresses of the Tödi, the Bifertenstock, the Hausstock, the organ-pipes of the Zwölfihörner, the Tschingelhörner, the towers of the Glärnisch, the Ortstock, the Bösfaulen, the Mürtschen, and we speak to them and expect an answer. And they answer us—their magnificent silence speaks across all time. But do we interpret it correctly? Does man ever pray correctly? Does not even the Apostle Paul ask to be taught correct prayer? Therefore, do we ever achieve a correct relation to our mountain world that so lovingly embraces Glarus and all the valleys of Switzerland, as though they were God's arms? Mountains and freedom belong together, so that we do not know which came first, the mountains or freedom. And whenever, at the foot of the magnificent pyramid of the Vorderglärnisch, we take part in our People's Assembly it is as though the mountains were attending with us and protecting us"

79

In its mountainous character the valley of the Linth resembles that of the young Reuss. Yet nature has favoured it even less than other Alpine valleys, and the habitable and cultivable land is exceedingly limited. In contrast to the canton of Uri, the canton of Glarus has no pass of national let alone international importance. Yet it seems that, even in Roman days, the inhabitants were anxious to emphasize their remoteness by the "Letzi", a wall barring the valley exit.

This inhospitable and seemingly so aloof valley nevertheless reveals an economic dynamism of astonishing scale. Here as elsewhere land became scarce and since the Middle Ages the only source of livelihood, apart from the meagre mountain agriculture, was to become a mercenary in foreign service. Much earlier than in other valleys, cottage industries moved into the canton of Glarus. They reached their peak in the mid-19th century, but without producing those side-effects usually associated with that trend—decline of mountain agriculture and social and political tensions.

80

It was mainly the textile industry with its various branches that advanced vigorously into Glarus. Firms specialized in printed textiles intended for the Asian market. In social matters, too, Glarus was a pioneer. For the first time in the whole of Europe the 12-hour day was enshrined in law, and night work and child labour were banned. In 1864 the 72-hour week was introduced, and in 1918—before even the urban cantons—a cantonal old-age, disability and loss-of-breadwinner insurance scheme. In mountain cantons such as Gla-

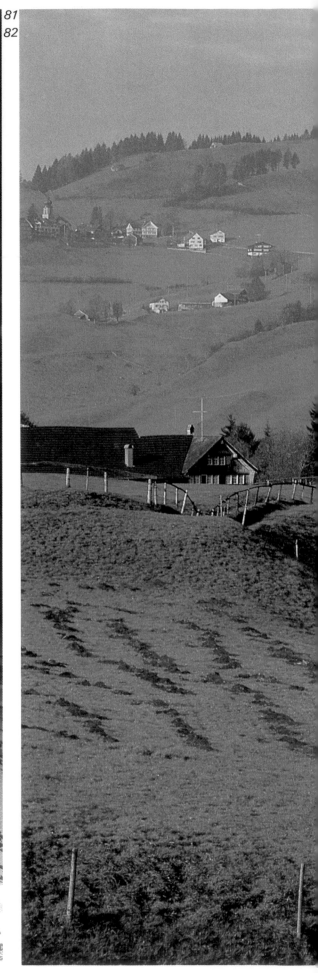

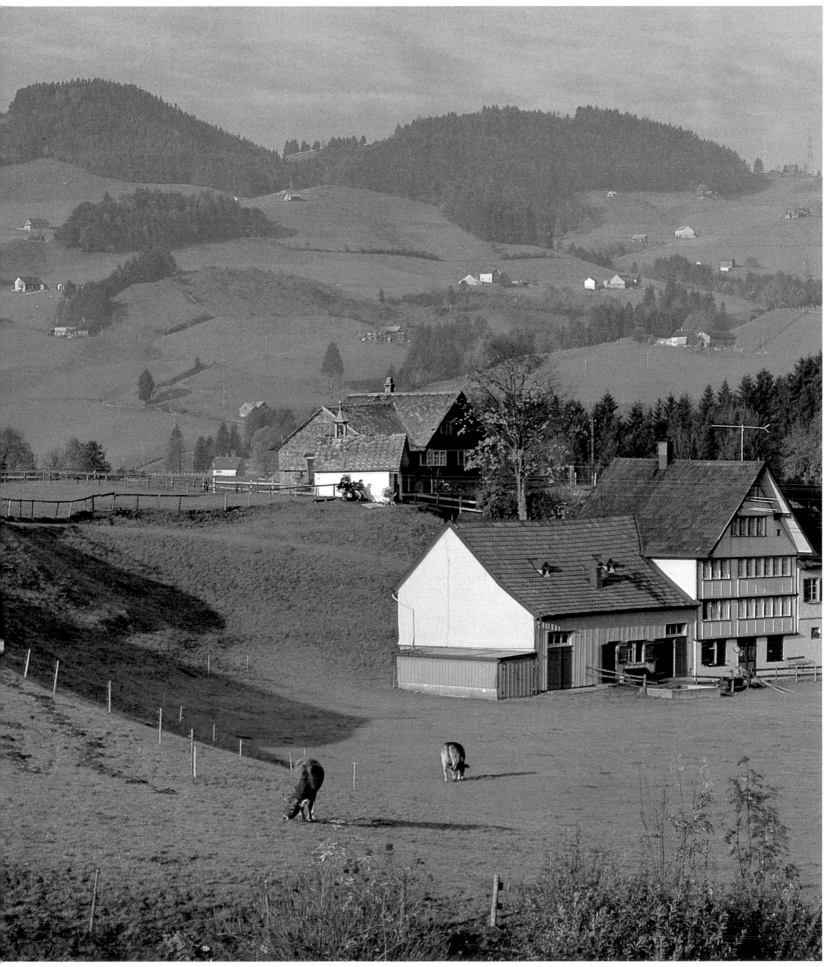

rus, Appenzell, Obwalden and Nidwalden the land community is still alive as a primal democratic tradition and as an ancient political and social organization. It has nearly everywhere survived unscathed the introduction of the vote for women, frequently regarded as an obstacle. The example of Glarus shows that there is no contradiction whatever in modern or even avant-guarde decisions being taken by this traditional moot.

Towards the northeast the height of the mountains diminishes even further but not the peculiarity of their shapes. The Säntis with its 2,504 m (8,218 ft) is probably one of the most typical peaks in the entire Alps, if only because of its isolated position. It stands in the foremost wave of the surf zone of the vast Alpine folds. At its feet lie the chains of the Appenzell mountains, formed of molasse.

The (in the most literal sense of the word) eminent situation of the Säntis has, for a long time, made it exert a powerful attraction on naturalists. Thus it was here that classical studies in the fields of geology, botany and other natural sciences came into being. The isolated peak, needless to say, was particularly suitable for weather observation and atmospheric research. In 1887 the Säntis Observatory was set up to enable the weather warden to make his observations and measurements all the year round—prior to the construction of the cableway in months-long isolation during the winter. In 1970 he

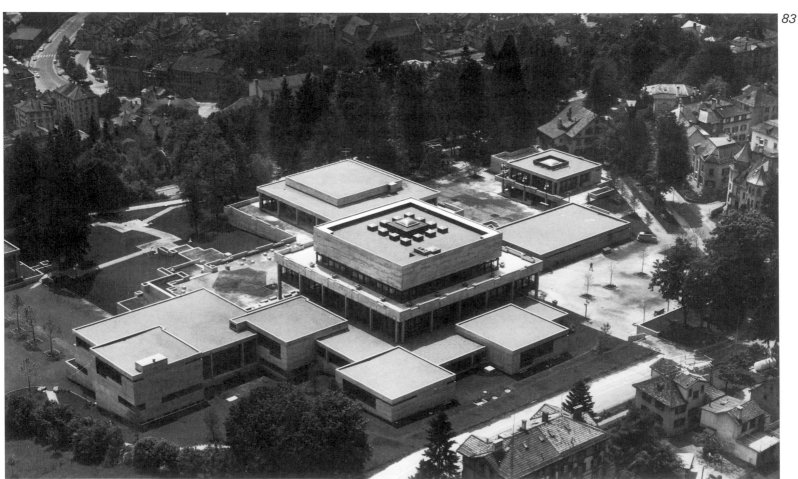

83

was eventually replaced by an automatic station. There, in a modern rock fortress, a 13-floor communications centre towers high over eastern Switzerland—a symbol of the arrival of highly specialized technology in the mountain landscape.

Appenzell owes its fame not only to its exceedingly attractive mountain and hill scenery but also to its vivacious and humourous people. In popular belief their peculiarities are explained by strange legends. As elsewhere, such different make-up is being linked with historical events—unthinkingly, but such prejudices then drag on through the centuries. The people of Appenzell, especially those of Innerrhoden, are said to be descended from the Huns which once raided the priory of St. Gall. The widely alleged short stature of the Appenzell people is similarly linked with that story.

The Appenzell landscape is marked by isolated individual farmsteads; villages are rare. To the livestock breeder it is an advantage to live on his own land, in immediate proximity to his meadows and grazings. But this is also in line with the libertarian spirit, the independence and the democratic outlook of the people. The tradition of the Appenzell peasants includes their richly painted implements and furniture. The favourite motif, stylized and represented in strong colour, is the driving-up of the cattle to the mountain pastures. One wonders whether these paintings used to be seen as a way of averting misfortune?

84

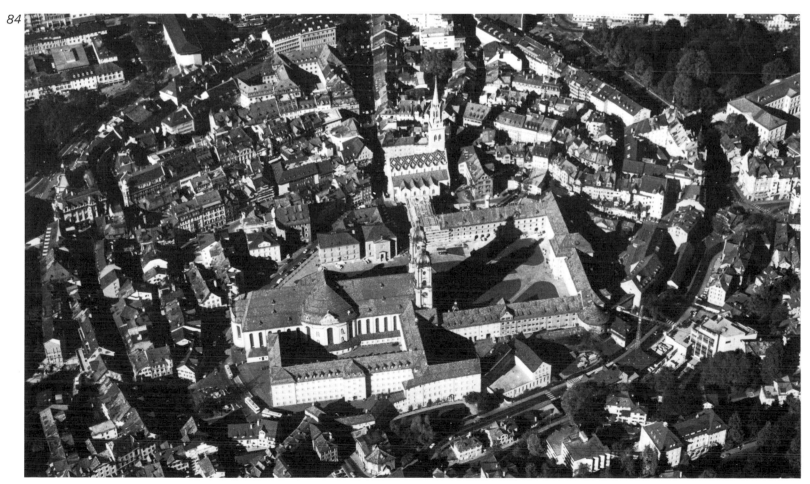

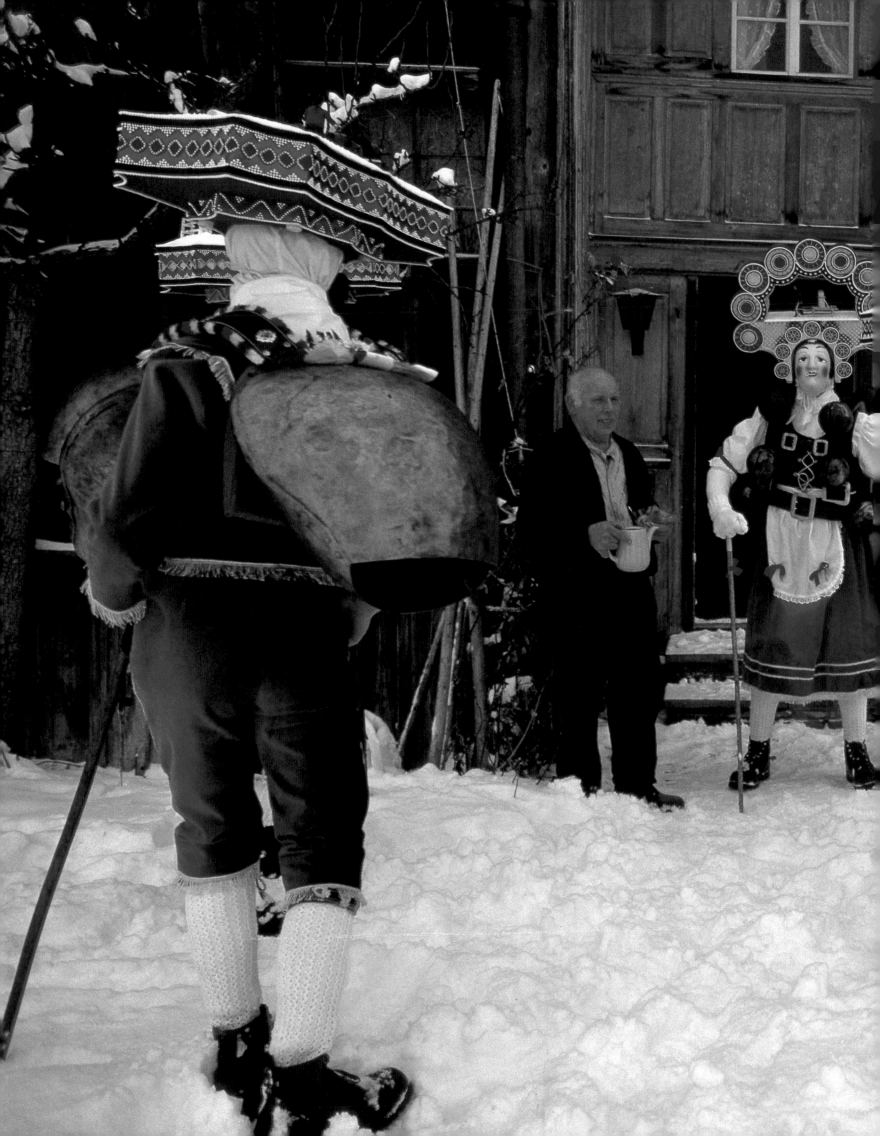

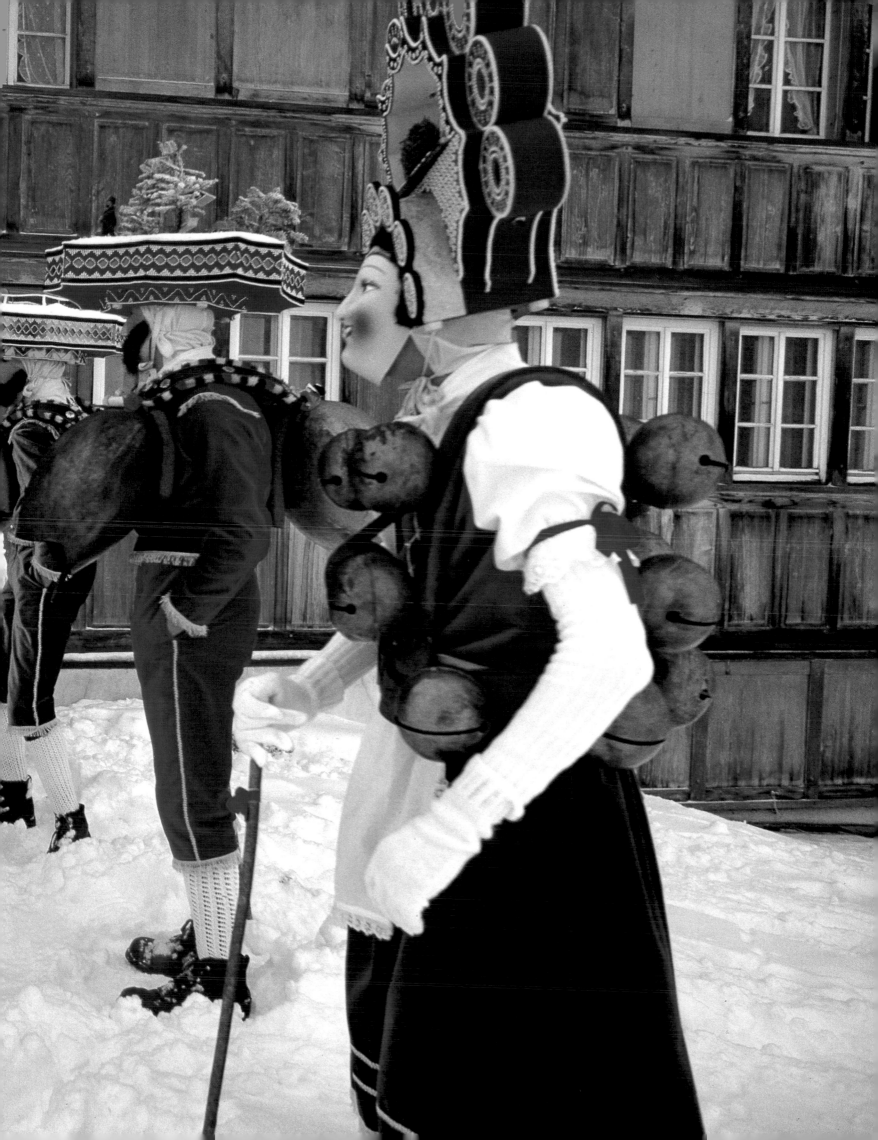

85 ◁ *Living tradition: New Year's Eve masks at Urnäsch (canton of Appenzell Ausserrhoden), their origins lost in the mists of antiquity, move from door to door as bringers of good luck.*

The Rhine Valley of St. Gall makes a striking contrast to the eastern Swiss mountain landscape. The wide valley floor, extending into the Principality of Liechtenstein and into Austrian Vorarlberg, carries the Rhine, by now a mighty river which has countless times brought misfortune to the land. This is attested by the poem "Rheinnot" ("Distress caused by the Rhine" 1898) by Johannes Brassel (1848–1916). In translation, with no attempt being made to reproduce the metre and rhyme of the original, it reads:

The night lies heavy over the valley,
All is damp and frosty.
Not a single star shines down
On the furious black waves of the roaring Rhine

They growl and roll on gravelly ground;
They grow more menacing from hour to hour.
On the trembling dam, in the black of night,
My father is on water watch.

The approaching danger is heralded from the tower
By urgent bells; they peal the alarm,
They ring in sorrow, up and down the valley,
Consigning the summer's blessing to a watery grave.

Busy with shovels in the light of torches,
Men and women in silent rows,
They pile up turf and earth.
But the waves mock: "The young stream is free!"

With angry tongue they lick the dam;
Behold, the rising crest of the wave
Crashes over the top! The sandy barrier yields,
A cry of agony is heard over the waters.

They come, they come, so high, so strong,
In wild anger they flatter the crops
While the peal of the bells dies down
The surging flood bursts into the houses.

And above the waters, like will-of-the-wisps,
The men's lanterns glow palely.
From flooded byres they try
To save the roaring animals from the waves.

Only after the comprehensive regulation of the course of the Rhine—the lifework of numerous generations of the 19th and 20th century—was the flood danger finally banished. In a sense the motorway may be seen as the latest addition to these engineering works since it has been largely built on the high-water dam widened by gravel transported by the river.

124

The borders of the mountainous canton of Grisons are a miniature replica of the frontiers of Switzerland: angular, indented and complicated. The cantonal territory belongs to three separate river systems: the Rhine (which empties into the North Sea), the Inn (with the Danube, emptying into the Black Sea) and the Ticino (with the Po, emptying into the Mediterranean). Cultural relationships are even more complex, and this is reflected in the linguistic multiplicity. True enough, Switzerland has several bilingual cantons—but the Grisons is trilingual. Two-thirds of the people speak German, one-tenth speak Italian and more than one quarter speak Rhaeto-Romance.

But Rhaeto-Romance, strictly speaking, is not one language but a group of languages. The dialects spoken in the Grisons are those of the Upper Engadine, the Lower Engadine, as well as Surmiran, Sursilvan and Sutsilvan. They differ so much from one another that schoolchildren in the canton have to be supplied with teaching aids in seven languages—counting German and Italian.

The Rhaeto-Romance language developed from Latin. At present it is spoken by about 48,000 inhabitants of the Grisons and by 12,000 Rhaeto-Romance speakers in the rest of Switzerland. In Italy it is spoken by 10,000 inhabitants of the Dolomites as well as by half a million Italians in the Friuli region—though Rhaeto-Romance speakers from the Grisons are scarcely able to communicate in their

Rhaeto-Romance Valleys

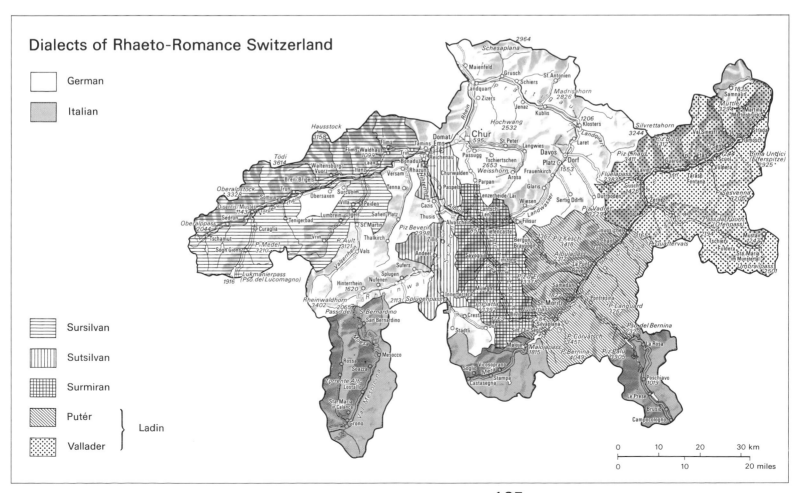

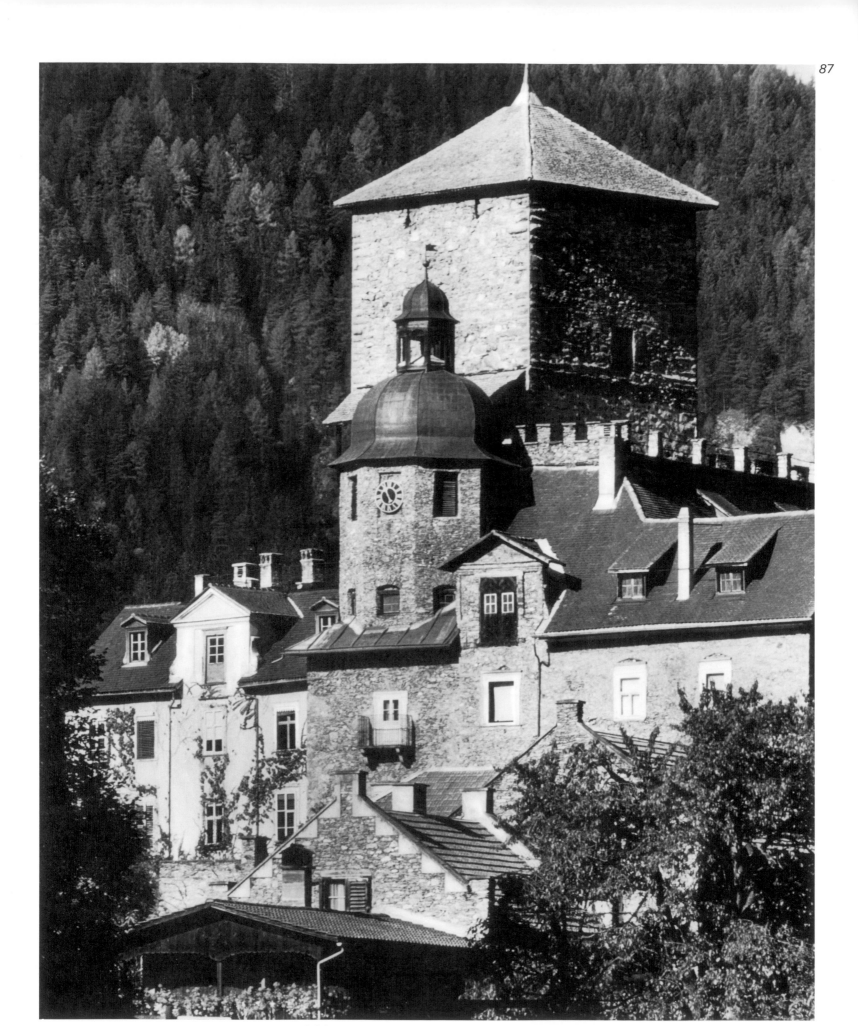

mother tongue with those from the Friuli region. The Rhaeto-Romance linguistic area has been steadily diminishing for a thousand years. In the 8th century the language was still spoken on Lake Constance, about 1000 it was still spoken in Glarus, and in the 16th century in the Schanfigg region. Valaisian immigrants displaced the Rhaeto-Romance dialects in the Anterior and Posterior Rhine Valleys, in the Prättigau and in the Upper Landwasser and Plessur Valleys. These Upper Valaisian immigrants in the Middle Ages established settlements at considerable altitudes and brought with them their customs and usages, their typical wooden domestic architecture and also their languages.

In recent years Rhaeto-Romance has also disappeared from along the main railway line from Chur to St. Moritz, as well as from the tourist areas of the Upper Engadine. The principal surviving areas are parts of the west and the south of the canton. Industrialization and tourist traffic, and above all the mass media, have to be held responsible for the decline of Rhaeto-Romance. Four hours of broadcasting per week and one television programme every three weeks constitute a rather modest offering to Romance speakers. Surselvan became the literary language of Rhaeto-Romance central Grisons, while Ladin became that of the Engadine. However, there are no Rhaeto-Romance daily papers—only a few periodicals of purely regional circulation.

The Rhaeto-Romance dialects are, moreover, threatened by linguistic dilution. Virtually all Rhaeto-Romance speakers are bilingual: their mother tongue is the language of their hearts, German is that of their livelihood. Although numerous German technical terms have entered the Rhaeto-Romance dialects as loan words, German nevertheless remains the everyday language at work and in technology and science. Young Rhaeto-Romance speakers who inevitably see their professional future in the lowlands, or maybe altogether outside their canton, must prepare themselves for their emigration linguistically. How will a language spoken by a mere 60,000 people survive in future within the framework of a nation of six million? What future is there for a minority that is divided into several groups and oriented towards a German-speaking cantonal capital, Coire (Chur)? Rhaeto-Romance was recognized as the fourth national language in 1938—though, for practical, administrative and financial reasons, not as an official language. Alongside the Confederation and the canton it is chiefly the Lia Rumantscha/Ligia Romantscha which is the umbrella organization concerned with the promotion of Rhaeto-Romance language and culture. The principal measures for the preservation of the Rhaeto-Romance language are the assimilation of speakers of other languages in the Rhaeto-Romance areas, the propagation of fundamental literature as well as children's juvenile and music literature, the creation of Rhaeto-Romance nurseries and cultivation of the language at all levels of the educational sys-

129

86 ◁ Justice within wooden walls: the District Court in session at Samaden (Engadine).

87 The numerous castles in the Grisons testify to a turbulent past: Ortenstein Castle in the Domleschg Valley.

88–91 Homes built with love: the stone-clad wooden houses in the Engadine are richly decorated externally and internally.

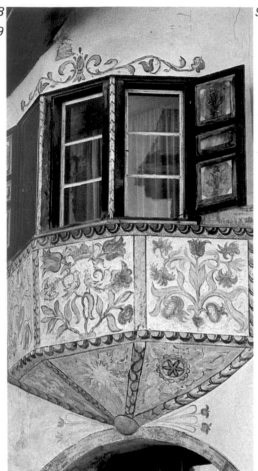

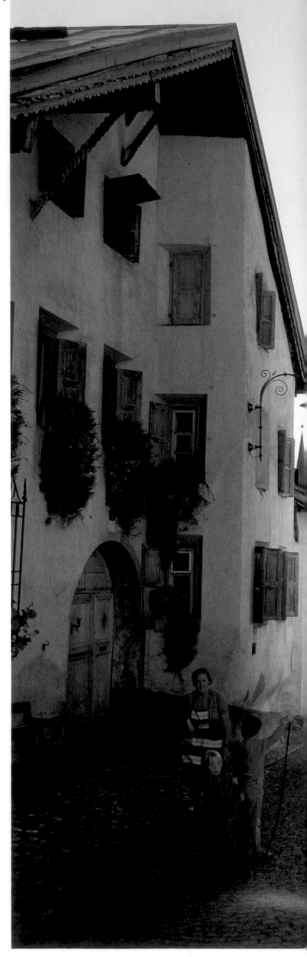

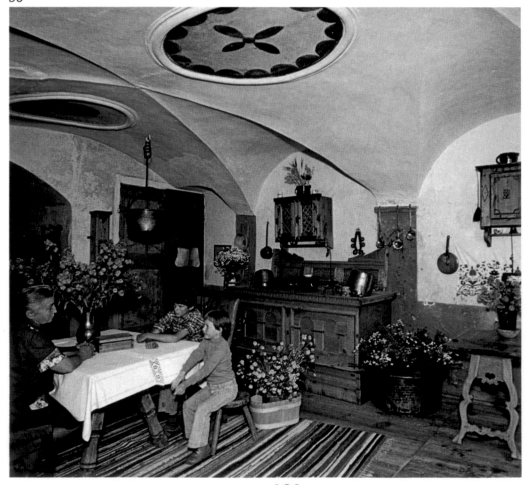

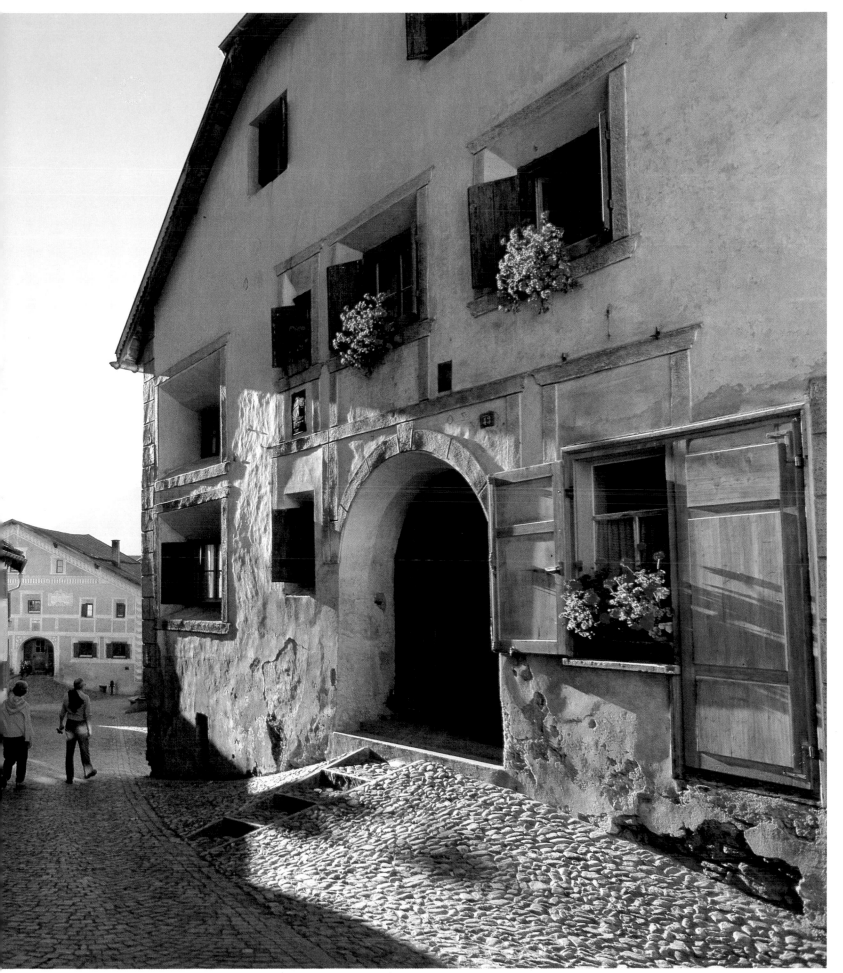

tem. "Amur e dolur van gugent insembel"—love and pain belong to one another; this Engadine proverb evidently also applies to the preservation of a threatened mother tongue.

"Parc Naziunal" reads the Rhaeto-Romance—but surely internationally comprehensible—inscription on the big notice-boards at the entrance to the Swiss National Park in the Lower Engadine. Zernez, the municipality owning the largest tracks of forests in Switzerland, in 1909 leased the Val Cluozza to the Nature Conservation Association. The National Park was continually enlarged and at present embraces 168.7 km² (65.1 square miles)—the size of the canton of Appenzell Innerrhoden. The unique fauna and flora of this virtually untouched corner of Switzerland is being protected in perpetuity against all human interference.

Italian-Speaking Switzerland

"Whenever I think of people living in the mountains, say at an altitude between 600 and 1,200 m, I am invariably seized by pity and admiration. The mountain dweller is familiar with all occupations: he is a vintner, a farmer, a bricklayer, a joiner and a cheese-maker; up on the alm he may lift his cheese from the steaming cauldron; he may stir polenta in a copper pan; he may be helping the midwife; he may be repairing the water-pipes or the electric wiring, and he does not yield much to the butcher when, shortly before Christmas, the day of domestic slaughtering approaches. A self-reliant, inventive man with gifts in many directions—that is the mountain peasant. Yet he is no amateur; he is at one with the harvester's scythe as he is with the woodman's axe. He knows how to handle a spanner, a hammer, a plane, and an oxyacetylene welding torch. If it were not for his laborious everyday life, for that loneliness, I would almost envy him; for his life is full of variety; he encompasses the whole circle of human existence; he is independent, self-sufficient, adaptive....

"Daily contact with misfortune lends that life its bitter flavour; yet the same struggle for existence also unites people and makes them helpers in time of need. They are no more peaceable than anyone else—ancient quarrels and family feuds weigh them down—but in disaster they feel that they are alone and extend their hands to one another: the vines may have been flattened, the roof may be in danger, the cow may not be able to calve.... Today I need you, tomorrow you may need me."

That is how the Ticino writer, art historian and critic Piero Bianconi (born 1899) views the destiny of the mountain folk in the harsh mountain world of his homeland (in Forum Alpinum, 1964). Life in the valleys of southern Switzerland is still poor, despite the sunny climate, despite the great beauty of nature, despite the southern glory of flowers. The linguistic boundary is largely drawn by the main continental watershed: the area draining towards the Adriatic is Italian speaking. The Canton of Ticino and the Grisons valleys of

132

Mesocco, Bregaglia and Poschiavo belong to the catchment area of two important tributaries of the Po—the Ticino and the Adda. A quarter-million Swiss of Italian mother tongue inhabit one-tenth of the country's area. The Ticinese and the Italian speakers of the Grisons form a geographic and cultural minority of 4 per cent that is quite perceptibly isolated from the rest of Switzerland. That is why the Italian-speaking part of the country is more strongly outward-oriented than any other.

"Friedrich Schiller gave us Swiss the motto: 'Be one united nation of brothers.' We Ticinese feel more like cousins of our fellow-Swiss of other mother tongues—but good cousins!" This statement indicates that the southern Swiss feel themselves to be dual citizens: politically they are clearly Swiss, but culturally they are much more Italian.

Historically Mesocco, Bregaglia and Poschiavo are a product of Grisons mountain pass policy, while the Ticino is the result of such a policy by Switzerland as a whole. The Forest Cantons and the Three Leagues (of Grisons) secured for themselves the southern flanks of such important Alpine crossings as the Gotthard, Lucomagno, San Bernardino, Maloja and Bernina.

What links the Ticino to Switzerland? What made the Ticinese repeatedly declare their allegiance to a state with a German-speaking

92 A bold construction in natural stone: the twin-arched bridge of Lavertezzo in the Verzasca Valley harmoniously blends with the Ticino landscape.

92

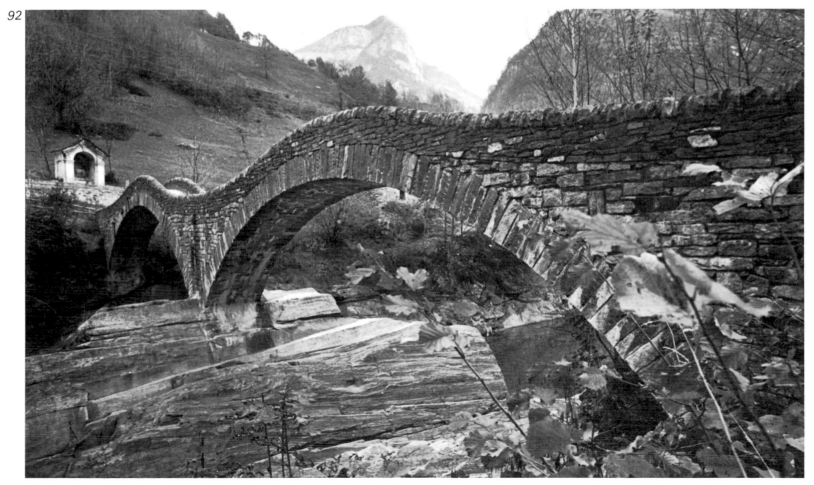

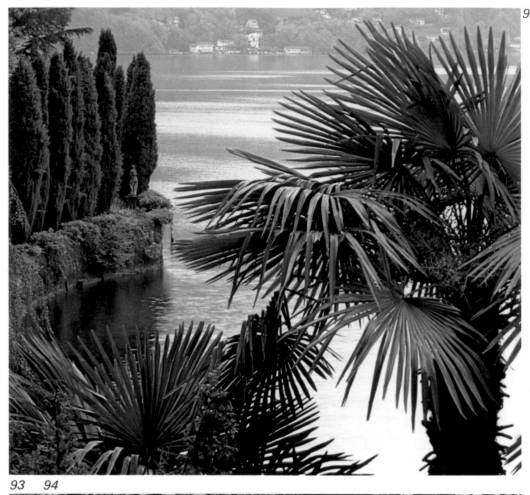

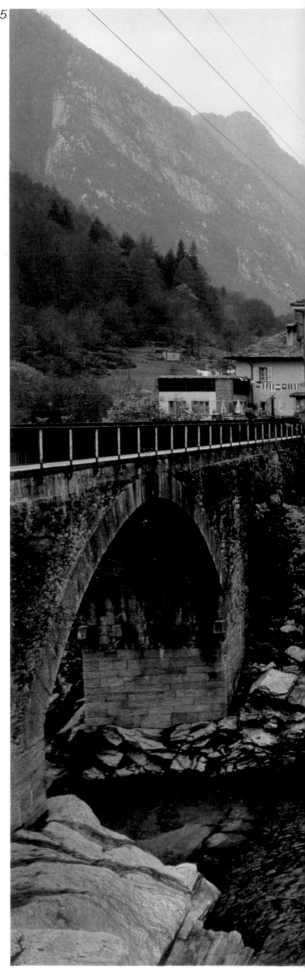

93 94

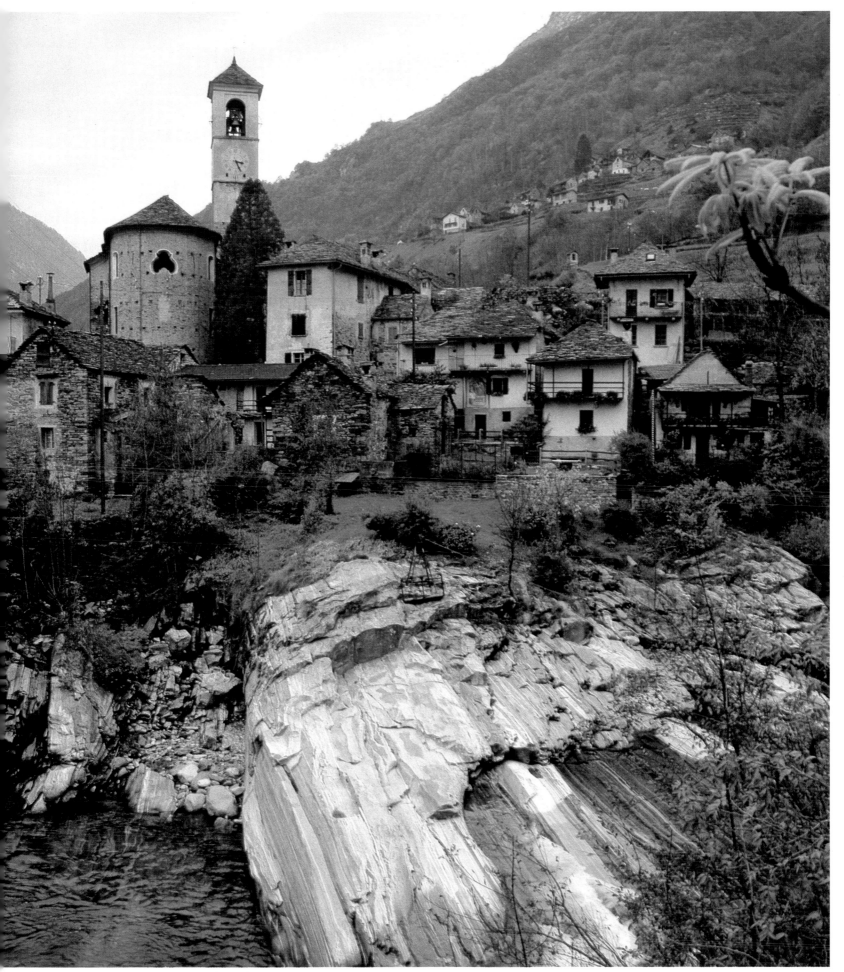

▷
▷▷

93–95 *Southern Swiss mosaic: palm trees on Lake Lugano (93); drystone wall and roof construction of Ticino gneiss slabs (94); the village of Lavertezzo in the Verzasca Valley (95).*

96–100 *Alpine scenery: view from the Hoher Kasten to Säntis (2,502 m = 8,212 ft, 96); Dents du Midi in winter (on the right-hand edge Haute Cime, 3,257 m = 10,689 ft) seen from the Val de Morgin, Lower Valais (97). The glacier-covered north face of Piz Palü (3,905 m = 12,816 ft) in the Grisons (98). Upper Engadine lakes against the background of the Bergell mountains (99). Mountain lake on the Susten Pass (2,304 m = 7,562 ft), in the background the Hasli Valley under a cloud bank (Bernese Oberland, 100).*

majority? What advantages do the inhabitants of the southern Swiss valleys see in not being part of their great neighbour that speaks their own language?

Undoubtedly, to a mountain people the Confederation could offer far more independence than a unified Italian state. Besides, no advanced centralism can flourish in a federal state. And finally, Switzerland has always imposed a very modest tax burden on the Ticino. That is why the political slogan of the Ticinese has always been "Liberi e Svizzeri", free and Swiss.

For the Ticinese their contacts with Italy are not only in the sphere of ideas but also quite realistic. No other canton has had to suffer so much as the Ticino from the emigration of its citizens. The exceedingly poor natural basis alone is not enough to explain this urge to emigrate. Artists, architects and artisans move south during the warm part of the year and in the winter return to their homes with their savings. Certain valleys and regions specialized in particular trades. The Onsernone Valley used to be famous for its chimney-sweeps, while the Centovalli sent grooms and coachmen into the world, the Val Colla coppersmiths, Brissago plasterers, the Sottoceneri bricklayers and stonemasons. Many Ticinese emigrants, however, also moved into non-Italian-speaking areas and in foreign lands found a new field of activity. Many of them have become assimilated in German-speaking Switzerland, finding a new home there, while others sought their fortunes in northern Europe, America or Australia, only returning to their native valleys to enjoy a peaceful old age there. The substantial palazzi, the retirement homes of such returning emigrants, stand out among the modest stone houses of numerous mountain villages.

Following the development of international transport, cheap farm products flooded the native market and thus ruined mountain agriculture. The result was a massive drift from the land and many mountain villages became derelict. Today southern Switzerland has the largest proportion of uncultivated land, since more than 40 per cent of formerly cultivated land is no longer worked.

Admittedly, tourism at the same time developed into an important sector of the economy, concentrating on the vicinity of the lakes. Here one may see the outcrops of this dynamic and frequently arrogant sector of the economy. Massive palatial hotels are flanked by luxurious villas and faceless blocks providing accommodation for holiday-makers. Real estate speculation has forced up land prices to metropolitan levels—not always to the advantage of the rural neighbourhood or its population.

The massive emigration of Ticinese was followed by an opposite trend. Italians sought work in the Ticino, and in 1910 that Italian population reached an unparalleled peak of 30 per cent. Not all the Italians employed in the Ticino actually live there; there are some 30,000 cross-frontier commuters.

136

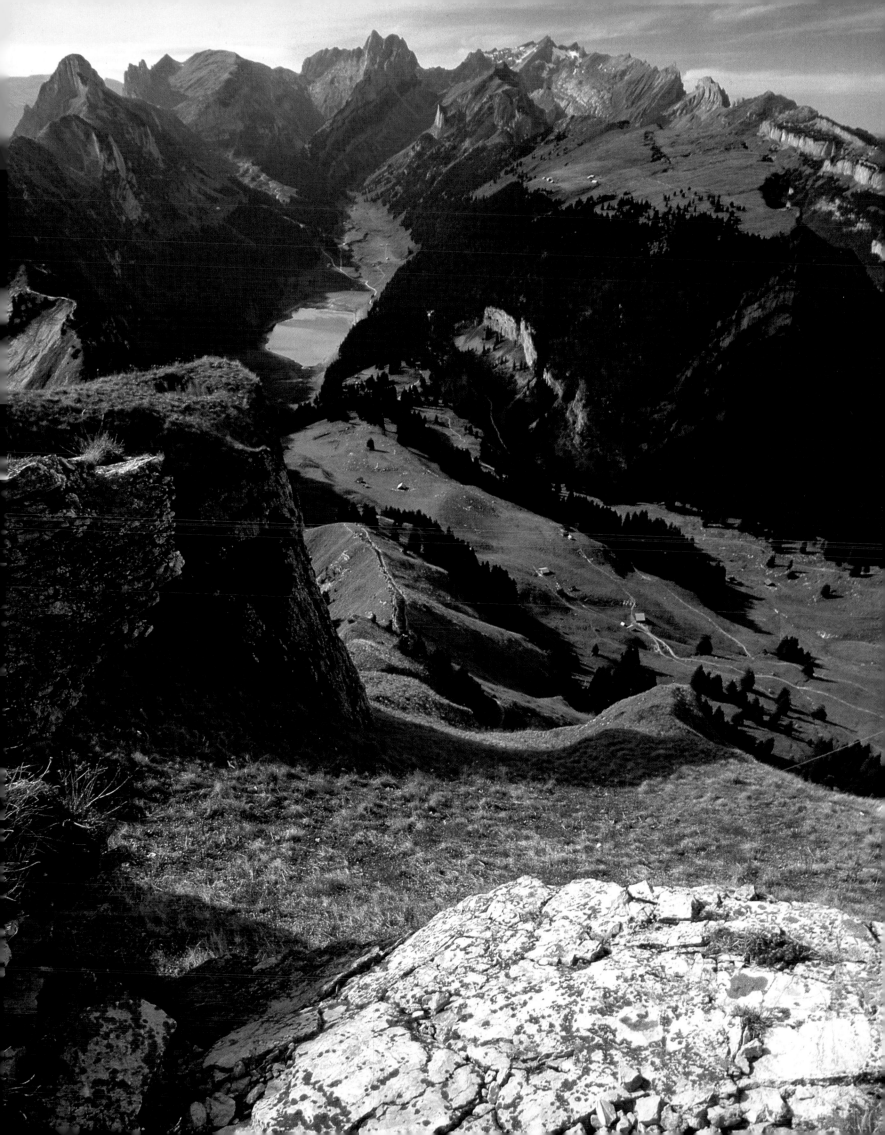

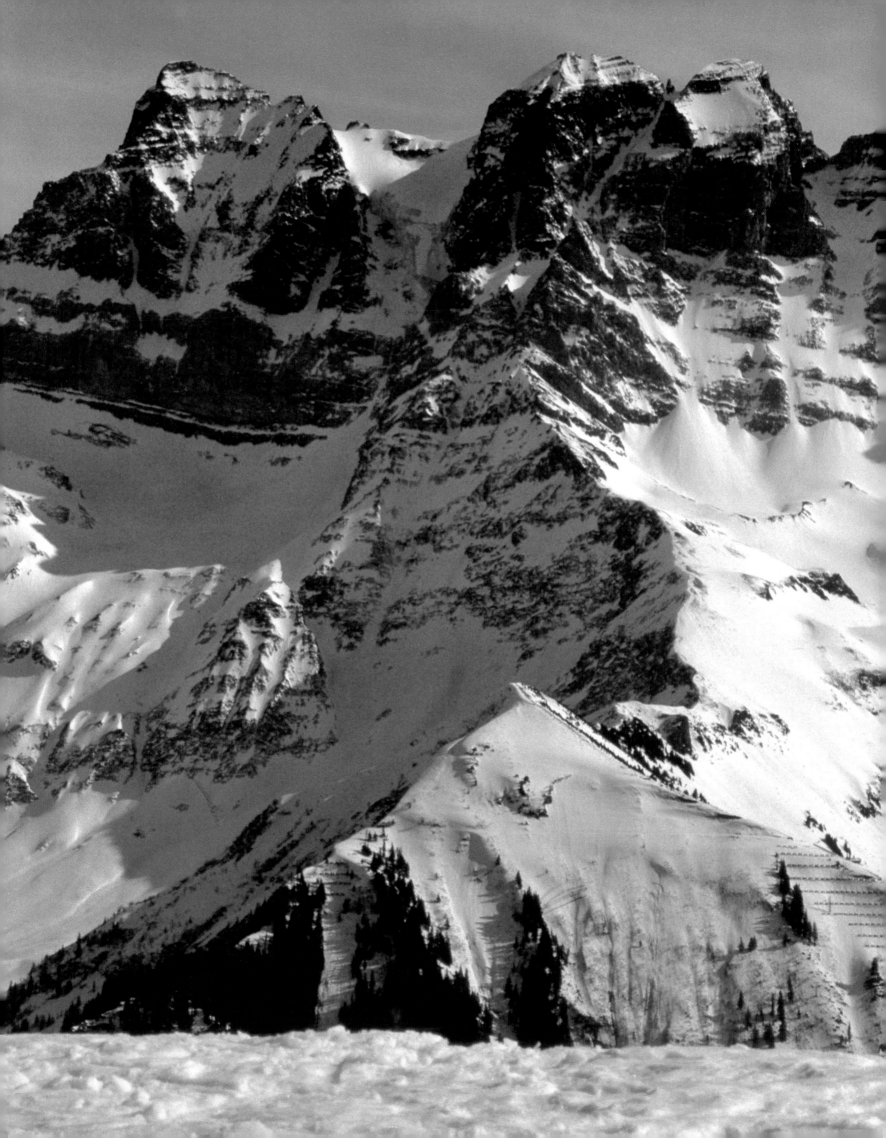

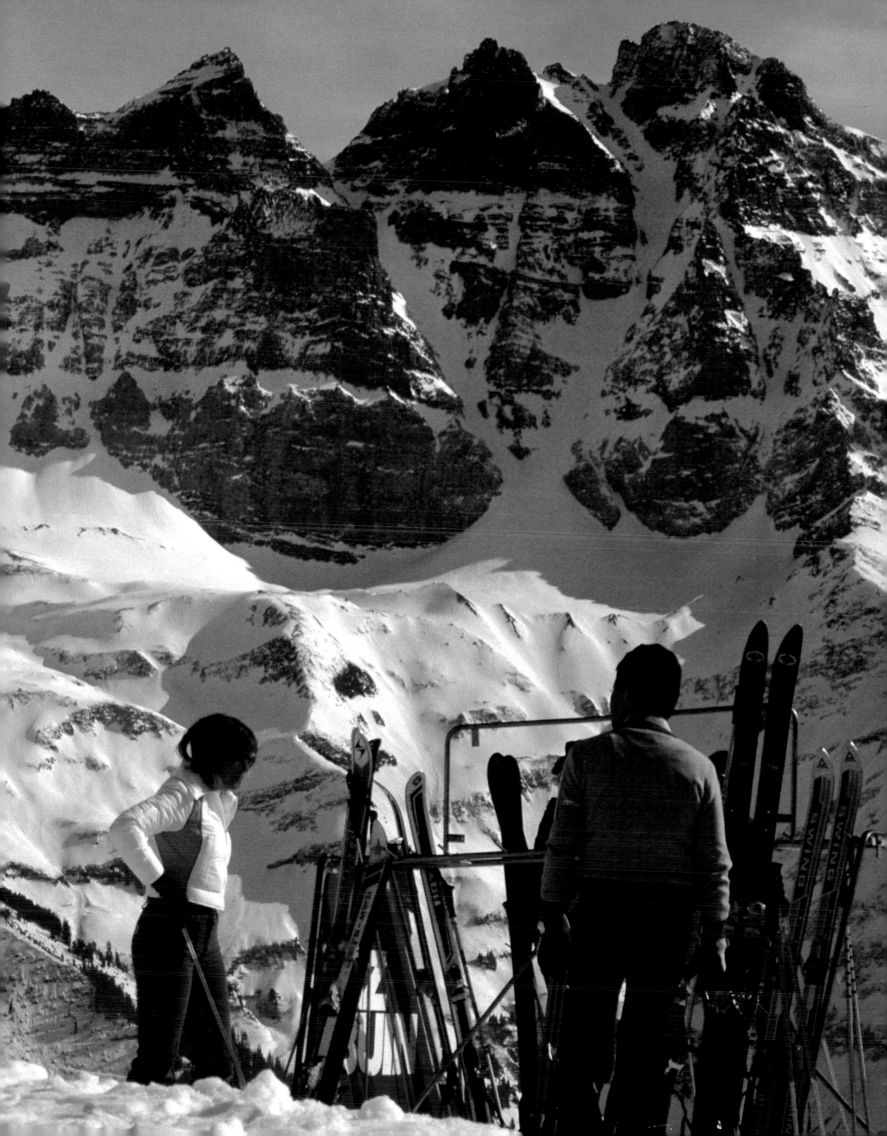

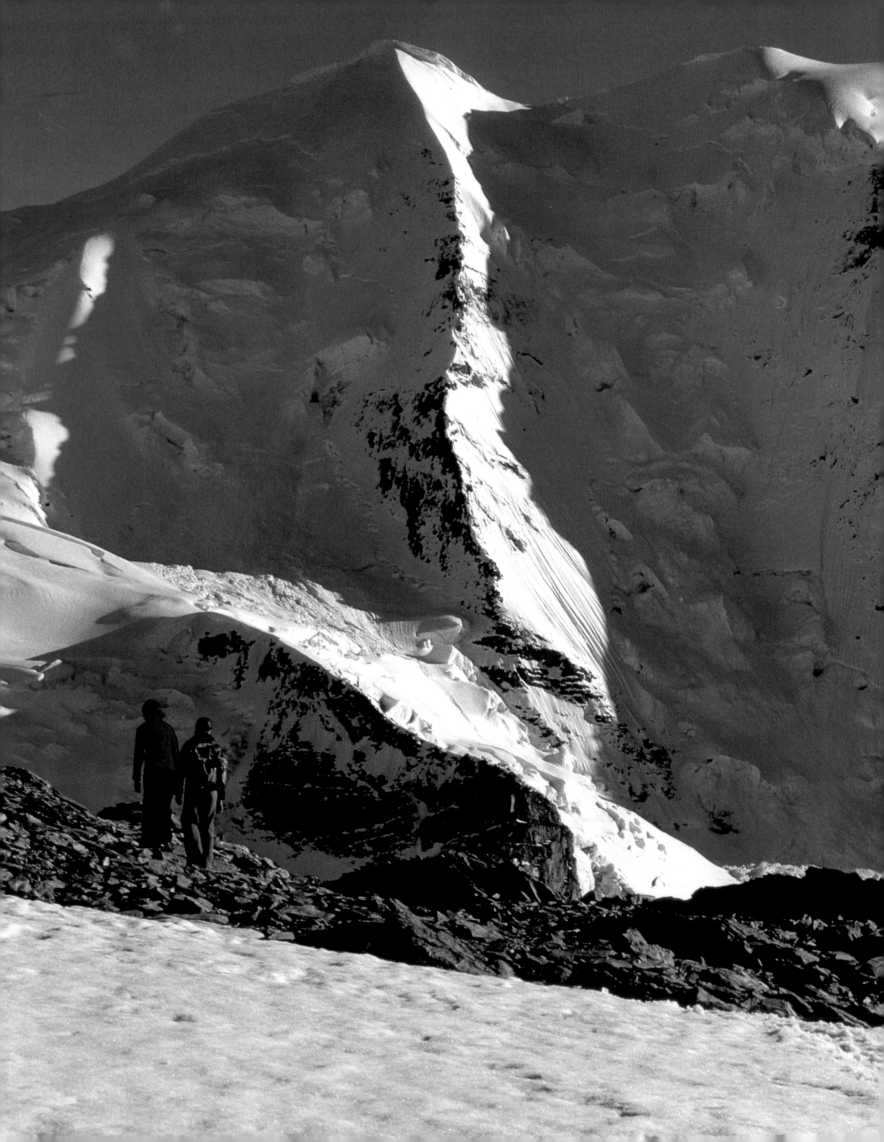

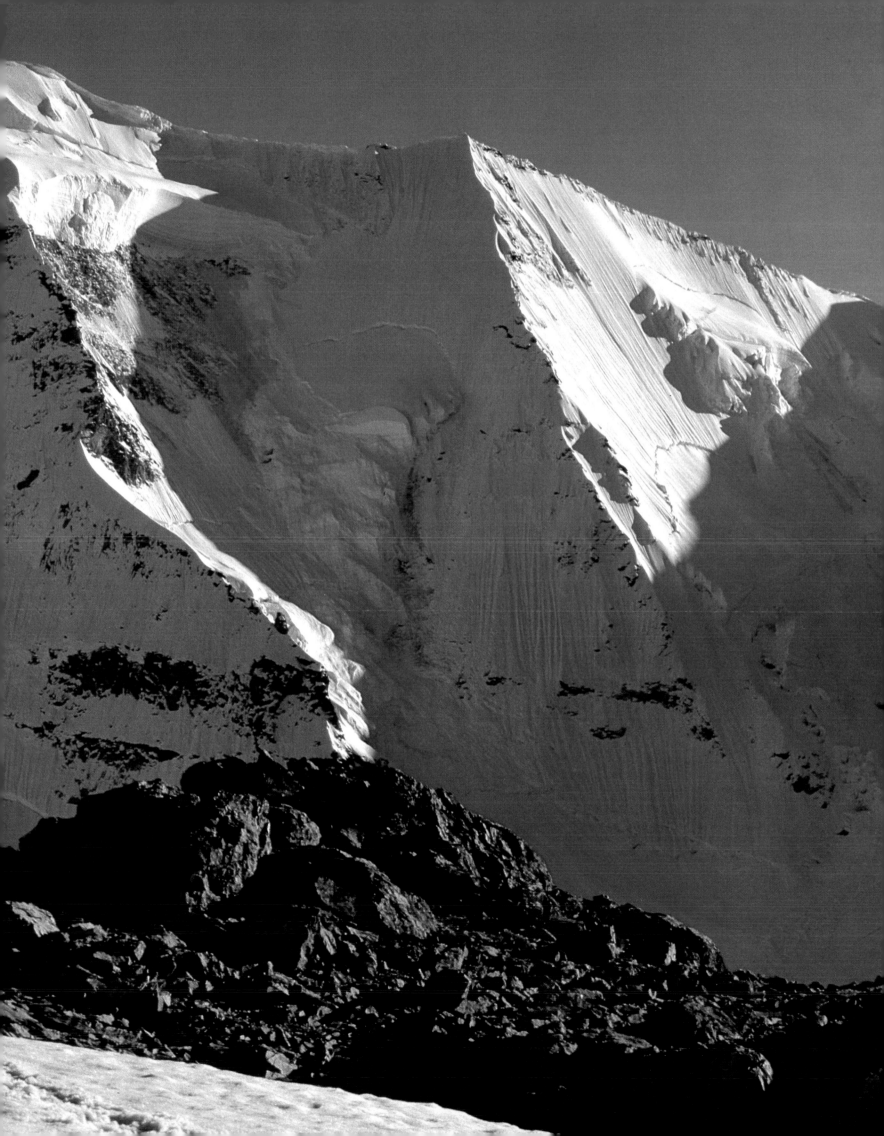

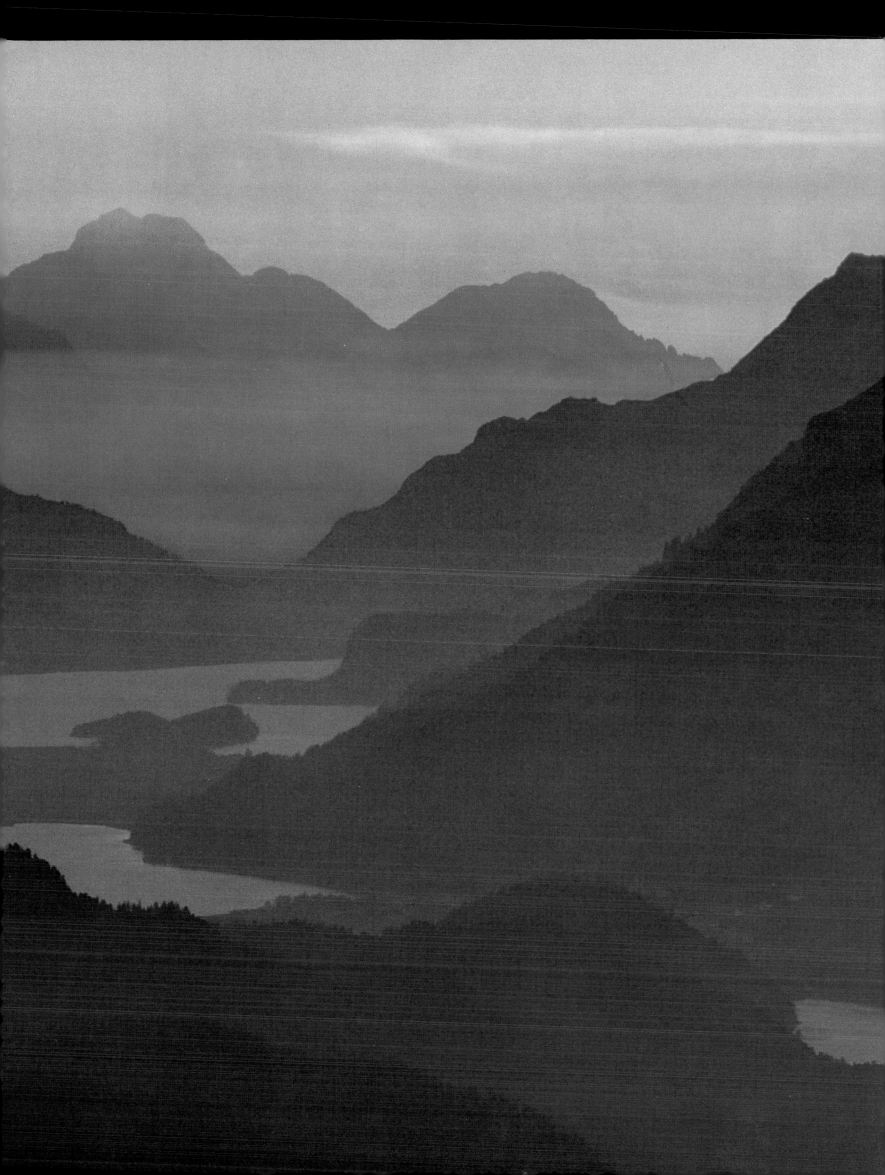

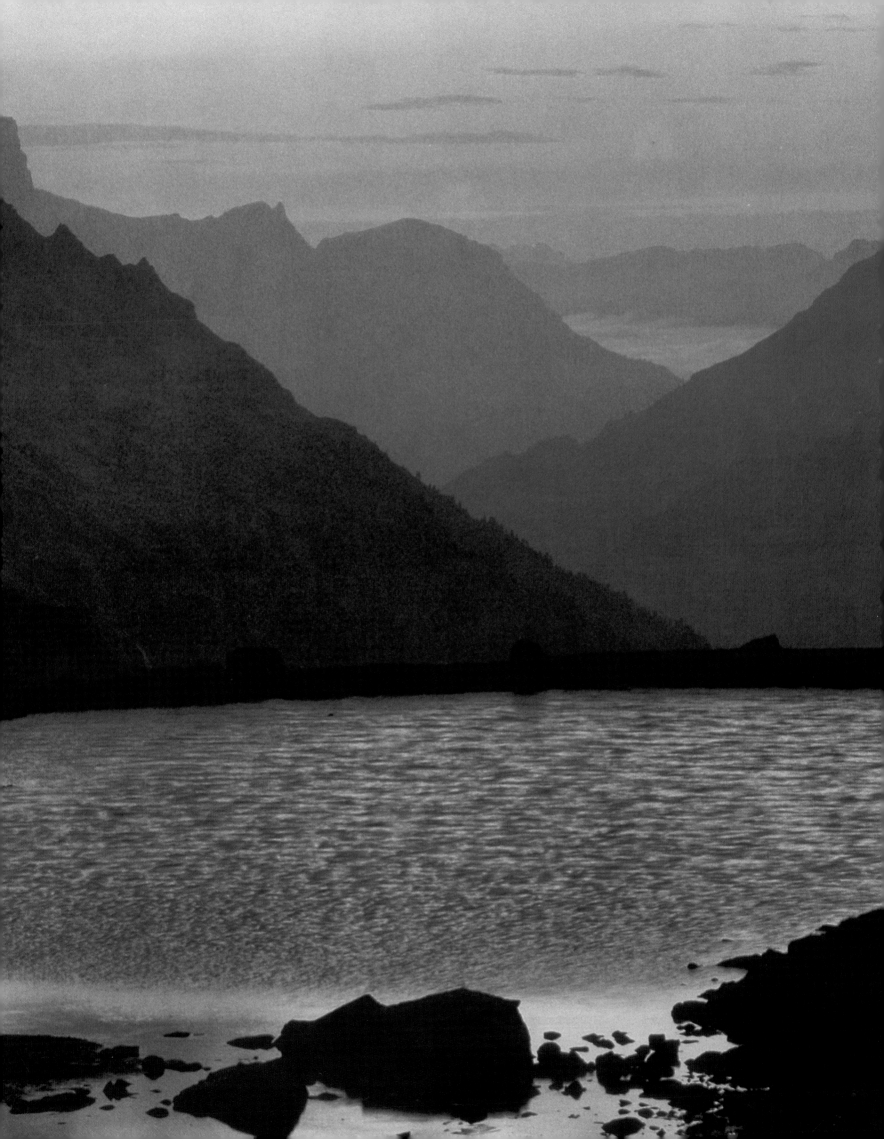

The Ticino moreover has become the dream land for many a wealthy person from the north. Retired people from German-speaking Switzerland and from Germany settle there, anxious to spend the rest of their lives in pleasant surroundings. Many artists have found a home and a place to work in this sunny corner of Switzerland—actors, painters, sculptors and writers. But not all the immigrants are able to assimilate to their new home. German speakers among them account for over 10 per cent of the population and occasionally represent a serious cultural problem. Orselina and Agra, for example, have a non-Italian-speaking majority. In Mergoscia the 1st of August (National Day) speech is made in German, at Ronco the municipal council conducts its discussions in German. But outside these threatened areas the Italian language easily holds its ground.

A novel group of immigrants has been bringing new life to the valleys of southern Switzerland. Communes and individuals are moving into regions threatened by dereliction, taking possession of abandoned farmsteads, dead hamlets and the fallow land belonging to them. These are fugitives from civilization who have said good-bye to the all-too-comfortable life of the industrialized society and who, imbued with idealism, are trying to lead a more natural, independent and self-sufficient life. Their experimental livelihoods are based on horticulture, sheep, goats and small animal breeding. These initially rather inexperienced farmers often integrate well with native communities.

A well-known instance is the interior decorator Katrin Rüegg who firmly turned her back on the big city in order to become a "country woman and author". In her third book "With Cordial Greetings from the Ticino" (1977) she outlines her life as follows:

"A no longer young woman who has to make hay on her own in a mountainous areas such as the Acquaverde Valley is not to be envied. When I stand in front of a large meadow (there is one that is so steep I have to mow it on my knees with a sickle) I certainly long for active assistance. And I long for it again when the hay has been raked together and bundled up in hay-cloths—as carrying it home is another sweaty chapter. Take, for instance, Marino's meadows by the church. There at least I don't have the problem of mowing because Marino enjoys doing it and I simply do the other jobs, like spreading the hay, tedding it, raking it together and carrying it home. The church is on the far side of the valley from my house. So I walk across in the morning to do the spreading, at midday to do the tedding, and towards evening to do the rest....
"And then there are evenings when I go to bed before it has got dark....
"But I must emphatically ask you not to pity me. After all, that's what I wanted."

145

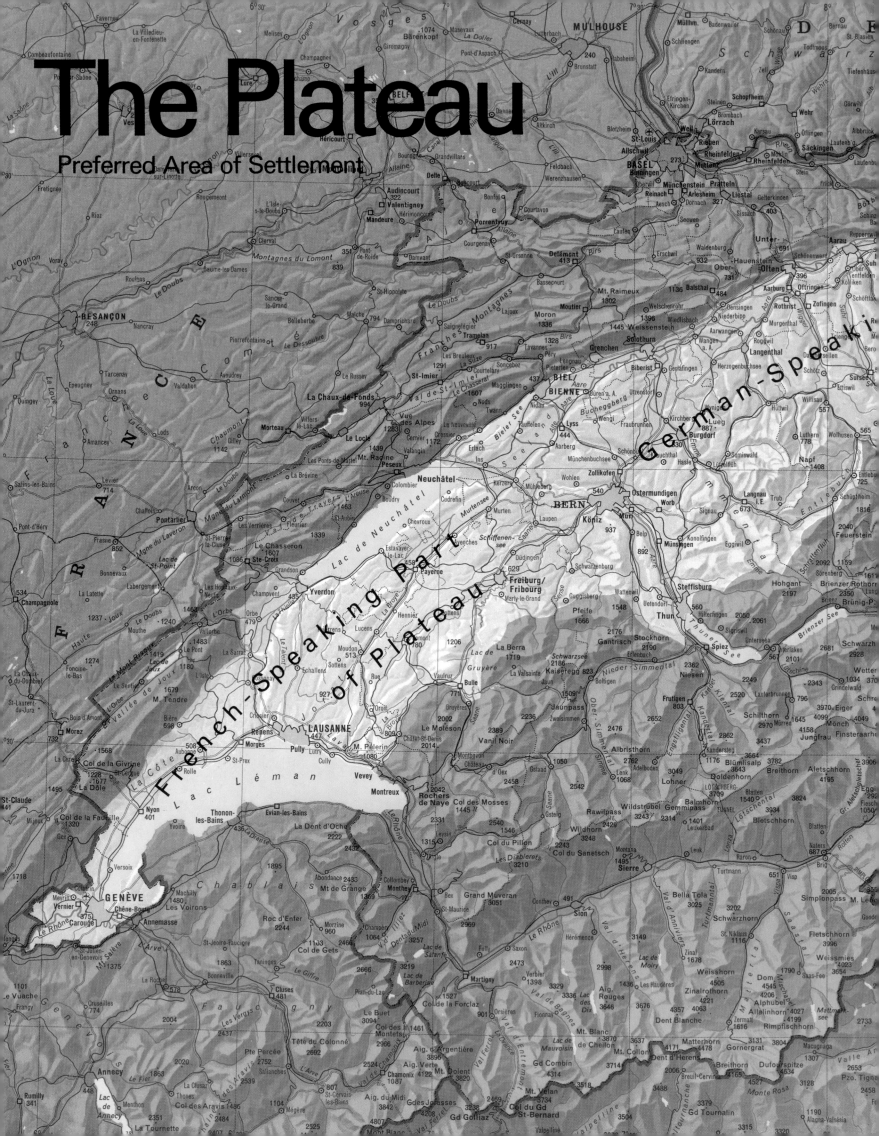

The Plateau
Preferred Area of Settlement

German-Speaking

French-speaking part of Plateau

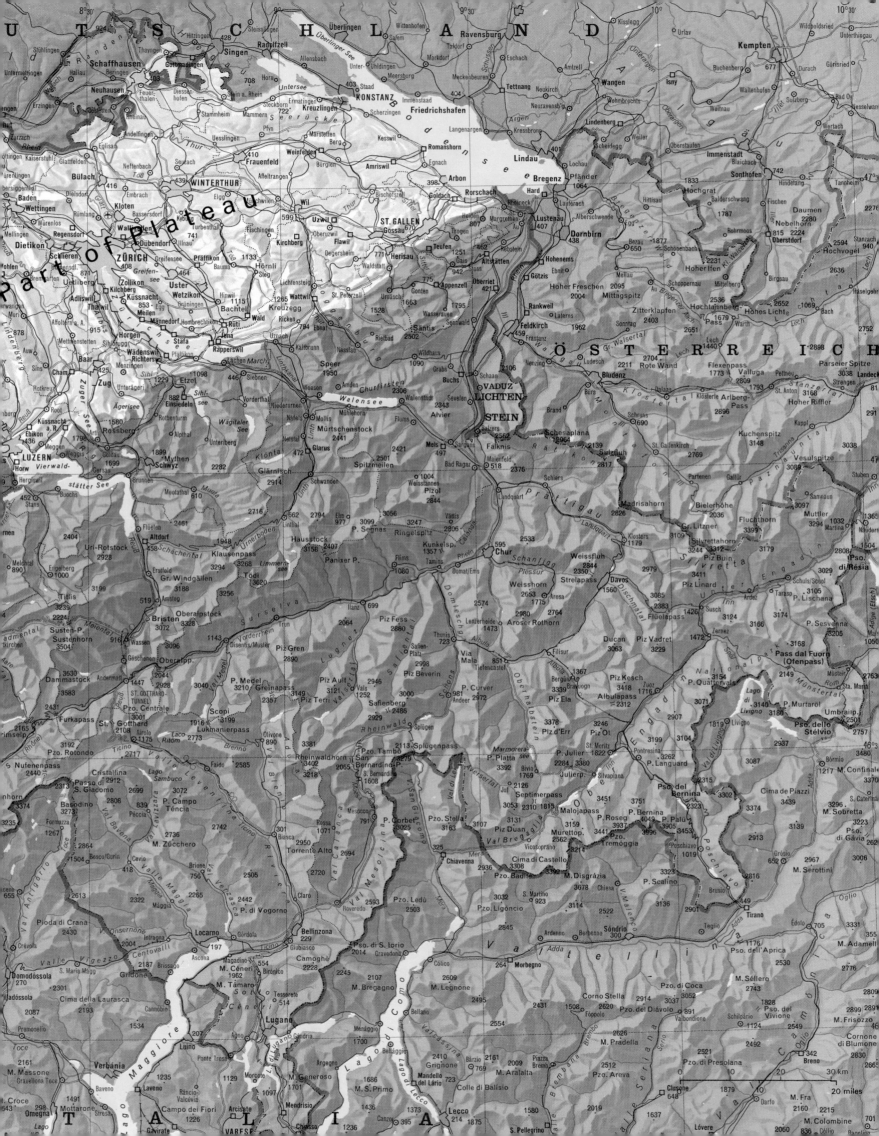

Molasse Country

Western Swiss farmers have enriched science by an important concept. "Molasse" is the name that the Vaud people give to the soft sandstone that makes up the hills of the *Plateau* between Payerne, Yverdon and Lausanne. The term has been adopted and extended by the geologists. It designates rocks deposited in an elongated trough at the foot of a mountain range. Molasse formations exist in Greenland and in the Argentine, along the Himalayas, in Italy, in France and in many other parts of the world. The classic molasse land, however, is the Swiss *Plateau*. Beyond lake Constance it continues eastwards in the Swabian-Bavarian Plateau and in the Vienna Basin.

The Molasse rocks are detrital rocks. In the Swiss *Plateau* they consist of sediments produced by the erosion of the young Alps. For 30 million years the rivers washed down gravel, sand and mud into the depressions at the northern foot of the mountains. The Molasse period began approximately 35 million years ago and came to an end about five million years ago. These then are stones of the Tertiary System which make up the landscape foundation of the densely populated areas between the Alps and the Jura. Here and there only a thin skin of glacial and post-glacial deposits covers the Molasse relief.

The Molasse may be described as a triad of nagelfluh, sandstone and marl. Limestone, widespread in the Alps and the Jura, also occurs. Nagelfluh consists of bonded roundstone. The term originated in the Bernese Emmental and plastically describes the appearance of a rockface *(Fluh)* from which stones are protruding like the round heads of horse-shoe nails. The roundstones are held together by a bonding agent of sand and limestone. Nagelfluh may be likened to a pudding with a lot of nuts and raisins in it. In French usage nagelfluh is represented by the word *poudingue*.

Nagelfluh rocks are widespread especially in the vicinity of the Alpine edge. As a general rule, the shorter the transportation, the larger the detrital stones. Locally they reach a diameter of over 1 m (over 3 ft). Where nagelfluh is found over a considerable area a watercourse must have deposited its detrital load over a long period. Such centres of accretion by primordial Alpine rivers are, from west to east: the Mont-Pélerin detrital fan north of lake Geneva, the lake Thoune (Thun) nagelfluh, the Napf detrital fan in the Emmental, the nagelfluh masses of Rigi and Rossberg in central Switzerland, the extensive Hörnli delta in eastern Switzerland, and finally the detrital fan of lake Constance, although this lies a little across the frontier on Austrian territory near Bregenz.

These nagelfluh bodies have not all been washed up at the same time. In obedience to the mountain movements in the Alpine area the rivers switched from one direction to another, gaining in strength—and hence in transportation performance—or, after prolonged periods of high activity, shrinking to unimportant rivulets.

The detrital material of the nagelfluh reflects the nature of the rock of the supplying region. There are frequent occurrences of coloured detrital stones whose origin can no longer be established. They are evidently fragments of mountain sections which have either been totally degraded or have been overlaid, at a later phase of the Alpine upfolding, by northward sliding nappes. These homeless detrital stones include well-rounded red and green granites, the pride of any rock garden.

Prolonged river transportation eventually grinds even the hardest stones down to sand. That is why, at a certain distance from the Alps, very little nagelfluh is found—at most isolated banks with small roundstones. In the centre and in the north of the Molasse country sandstones predominate. These have for centuries been a highly prized building material. Many a town, before the dawn of the concrete age, adorned itself with façades of natural Molasse stone in characteristic attractive hues, from bluish grey to a warm greenish yellow.

Interposed between sandstone banks there are—most frequently at the foot of the Jura—layers of grey, dun, blue or dark red marls. Marl consists of a mixture of clay and finest limestone. It was formed from muddy deposits of the Molasse rivers and, in consequence, is rather soft, weathers readily and produces fertile soils. Because marly rocks are usually covered with vegetation they are not very conspicuous in the landscape.

The history of the Swiss Molasse country is naturally closely associated with that of the Alps. Erosional detritus from the mountains accumulated, during the Tertiary System, in depressions which temporarily were shallow marine basins, freshwater lakes or river banks. The area of western and northern Switzerland now occupied by the Jura mountains was then part of that flat country. The most ancient formation of the Molasse period is the lower marine Molasse—bluish

101▷ *Above the* Plateau *: Between the southern foot of the Jura (left) and the wooded Bucheggberg hill the Aar river meanders towards Soleure (Solothurn, in the background). At the bottom left edge of the picture is Grenchen, a town of watchmakers.*

▽ *The* Plateau *is a depository of Alpine detritus: throughout 30 million years the proto-rivers washed gravel, sand and mud into the northern foreland of the mountains. Nagelfluh, sandstone and marl originated from those deposits.*

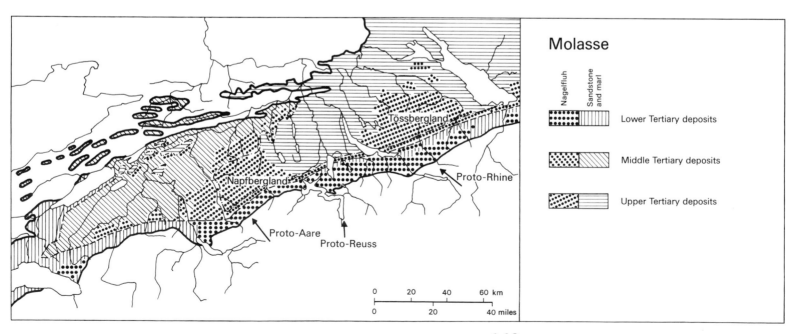

Molasse

Nagelfluh Sandstone and marl

Lower Tertiary deposits

Middle Tertiary deposits

Upper Tertiary deposits

Tössbergland

Proto-Rhine

Napfbergland

Proto-Aare

Proto-Reuss

0 20 40 60 km

0 20 40 miles

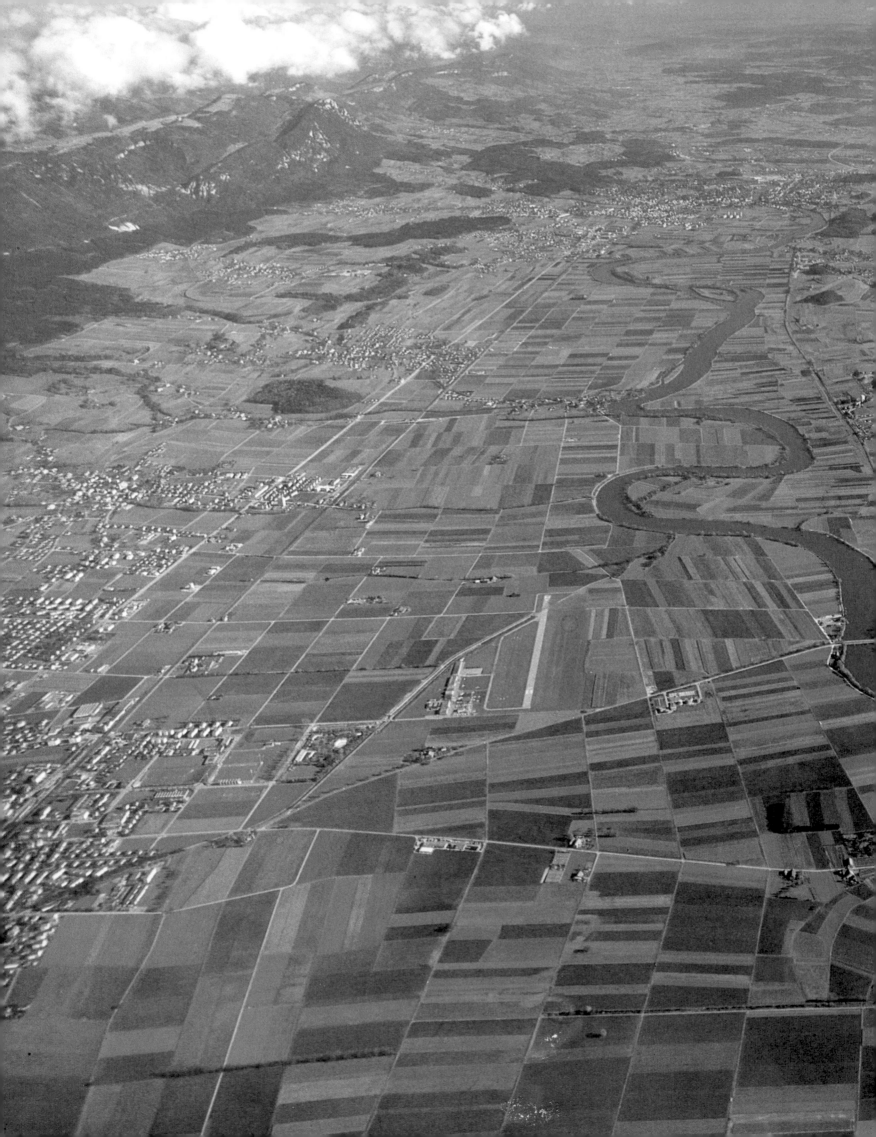

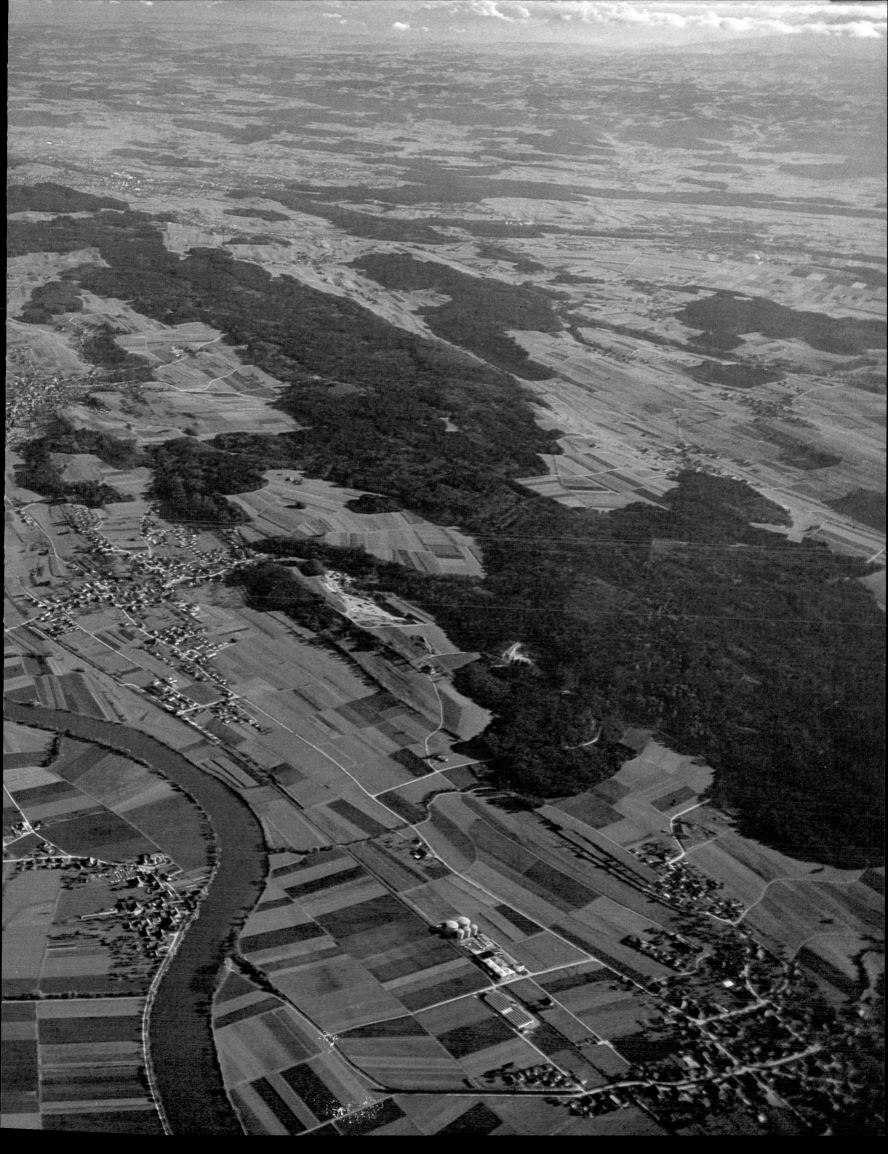

grey schistose marl and thin-slabbed sandstone containing marine molluscs and remains of fossilized fish. This rock series only occurs in a narrow zone on the edge of the Alps. It is not an outstanding feature in the appearance of the landscape but it could acquire economic importance as a possible oil-bearing formation.

An uplift of the Alpine body and its northern foreland led to the disappearance of the first Molasse sea. Powerful rivers became active and started to shape mountains and valleys. The proto-Aare, the proto-Emme, the proto-Reuss and the proto-Rhine built up the big nagelfluh deltas of the lower freshwater Molasse. In the northern part of the basin micaceous sandstones and coloured marl were deposited; in the bogs dead plants became transformed to coal under the pressure of overlying rock layers. The imprints of evergreen plants prove that there must have been a warm sub-tropical climate. The mean annual temperature is estimated at 20 °C (68 °F).

A lowering of the Molasse trough about 20 million years ago marked a return to marine predominance. Salt water coming from the west flooded into the *Plateau*. While nagelfluh continued to be accumulated on the Alpine edge, the sandstones of the upper marine Molasse were deposited in the central part of the basin. These are locally rich in fossilized mussels and snails.

About 10 million years later the sea again retreated and the period of the upper freshwater Molasse began. Now the material was no longer exclusively washed up from the south, i. e. from the Alps, but the massifs of the Black Forest and the Vosges in the north also supplied detritus to the now definitely land-locked Molasse basin. A wide river trench from the south German area brought micaceous sands into eastern Switzerland from the northeast. There and in neighbouring Hegau region volcanoes were active for some time. Wind and water transported the ejected ash over vast areas.

The Molasse period was concluded by a vigorous lifting of the whole of the *Plateau*. Thus sandstones, at one time deposited in the sea, are now found at altitudes above 1,000 m (3,300 ft). The rock strata on the Alpine edge were involved in the final phase of the orogeny, i. e. they were in part overslid by the marginal chain and forced northwards. This distributed zone of sub-Alpine Molasse, a succession of rock packets slid on top of each other, stands out clearly from the *Plateau* Molasse, where only flat folds testify to deforming forces.

The most important landscape boundary in Switzerland is the edge of the Alps. In connection with national planning geographers are now trying to determine that line with scientific exactitude. This is not an easy task because a great many factors are involved. According to weighting divergent results are found. In his dissertation "Comparative Geographical Investigations on the Swiss Pre-Alpine Edge" (Federal Institute of Technology Zurich, 1968) Rudolf Butz

102

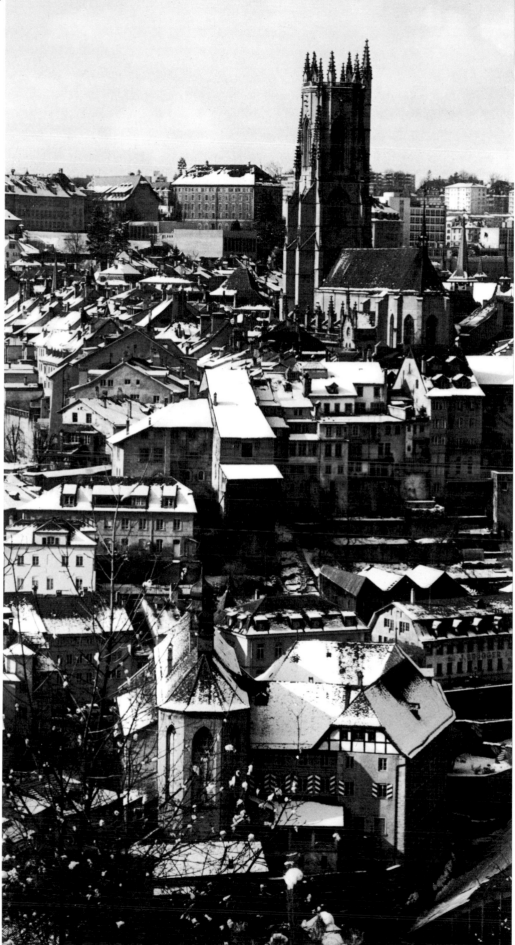

102–104 Fribourg (founded by the Dukes of Zähringen in 1157) on the linguistic boundary between German and French-speaking Switzerland. The passage of time has left its mark on the sandstone façades. The city with its outlying districts numbers 54,000 inhabitants; its historical town centre lies in a bend of the Saane river.

103

104

arrives at the conclusion: "An analysis of selected landscape elements, taken together, shows that the most suitable for drawing a boundary between *Plateau* and pre-Alps are relief, climate, forest cover and settlement. The remaining elements—vegetation without forest cover, population, type of houses, agriculture, industry and tourism—on the other hand, though of course important for the characterization of the individual landscape, are only in certain instances suitable for drawing the boundary."

Nearly one and a half centuries before him the Berne Professor Bernhard Studer (1794–1887), one of the founders of Swiss geology, had reflected on the boundary between *Plateau* and Alps. In 1825 he wrote in the introduction to his monograph on molasse: "The low lines of mountains which flatten in ever gentler waves into the hillscape, display rounded, soft forms; only rarely is the fine verdure interrupted by bare rock.... The mountain chain behind that green foreground bears a totally different character. Sheer bands of rock, lined by numerous and deep rifts, rising towards sharp points or bearing strange teeth and humps, follow the uniform direction of the high mountains rather like the ruins of gigantic walls which once enclosed the inner world of the Alps."

Traces of the Ice Ages

Had there been no Ice Ages the Swiss *Plateau* would have been the poorer in several respects. The glaciers advancing from the Alps did not only leave erratic blocks behind as a souvenir of their visit to the lowlands. The ice carried with it also large quantities of exceedingly finely ground rock detritus—a rock meal rich in mineral substances and the best possible natural fertilizer. Hostile to life though the Ice Ages themselves may have been, they created fertile soils and hence the prerequisites of prosperous agriculture.

Another gift of the Ice Ages is enjoyed mainly by industrialized society. Glaciers and glacier rivers operate like huge gravel plants: they transport, break down and grade the rock material. Millions and millions of tons of the best pebbles and sand are found in the vast gravel fields of the *Plateau,* deposited by running water in the forefield of the glaciers. Such gravels are the foundation of the Swiss building industry. Gravels, moreover, are high-yielding carriers of ground water. Ground water, of constant temperature and naturally filtered, is nowadays indispensable for supplies to the population, to commerce and industry. Thus, surprising as it may sound, the most important glaciers to Switzerland are the ones which have long since melted away. Let us therefore turn our gaze to the glacial past.

We know neither the causes nor the number nor indeed the duration of the Ice Ages. But one thing is certain: there were several advances by the glaciers, and they affected Europe, Asia and North America. The Arctic ice reached south as far as northern Germany, and the Alpine glaciers, at the time of their greatest extension, covered almost the entire territory of Switzerland.

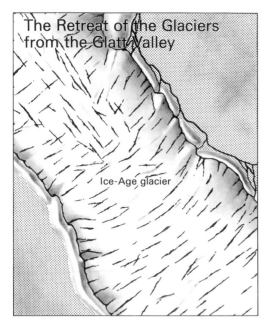

Ice-Age glacier

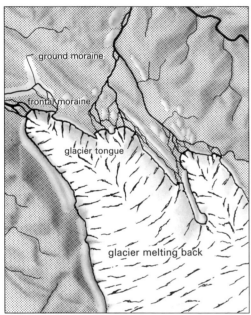

ground moraine

frontal moraine

glacier tongue

glacier melting back

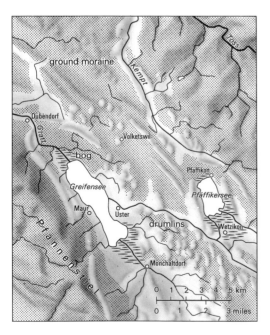

ground moraine

Dübendorf

Volketswil

bog

Pfaffikon

Greifensee

Pfäffikersee

Maur

Üster

drumlins

Wetzikon

Mönchaltdorf

On the northern side of the Alps the traces of four glaciations can be identified. The two older ones, the Günz Ice Age and the Mindel Ice Age, are assigned to the period between 600,000 and 400,000 years ago. They left behind, above all, well bonded high-altitude gravel terraces. After a fairly prolonged warm period the penultimate and, at the same time, greatest Ice Age, the Riss Ice Age, began. At its zenith the tips of all the great glaciers which once covered northern Switzerland met on the territory of what is today the canton of Aargovia. The Rhone glacier, for instance, which flooded the *Plateau* from the west, at that time extended as far as the Koblenz (Aargovia) area, where the Aar now runs into the Rhine.

The most recent or Würm Ice Age began about 90,000 years ago and ended 10,000 years ago. Since then we have been living in the post-glacial period and we do not know whether this is not perhaps merely another inter-glacial period. It is quite possible that, following a fundamental deterioration of the climate, the Alpine glaciers may return, burying everything that man has achieved by hard work. If that were to happen no technology could help us—only flight. At the time of the maximal advance of the Würm ice, approximately 20,000 years ago, the surface of the Rhone glacier was at about 1,300 m (4,267 ft) above the Lausanne area, at 1,000 m (3,280 ft) over Geneva, and at 900 m (2,954 ft) over Berne, where the Aar glacier had merged with the Rhone glacier. Other big Swiss cities, if they had then existed, would likewise have been buried under a thick layer of ice. Over Lucerne the Reuss glacier would have had a depth of 550 m (1,805 ft) and over Zurich the Linth glacier would have been 300 m (985 ft) thick. The range of the Albis with Zurich's panorama point, the Uetliberg—then still without name—was a long and narrow island in a sea of ice. The tongue of the Rhine glacier ended somewhere in the neighbourhood of Schaffhausen.

The map in this book showing the territory of Switzerland during the last Ice Age, presents a totally unfamiliar landscape. Terminal moraine walls are indicating the points which the vast ice slab had once reached. During their retreat the glaciers halted several times. These halts, too, gave rise to the deposition of moraine ridges. Ranges of hills along the flanks of major valleys consist of the deposited rock material of lateral moraines.

No sooner had the glaciers disappeared than the abandoned rocky desert began to turn green. Large blocks of Alpine rock, the erratic blocks, towered as landmarks amidst the as yet sparse vegetation. Many of them were subsequently destroyed when man began to embark on crop farming. That was done for two reasons—to make room and because they represented a supply of sought-after building material.

About the middle of the last century it was clear that the last erratic block would soon be blown up. That was why the Geneva scholar Alphonse Favre addressed an appeal to the public to preserve for

posterity those witnesses to the Ice Ages. The Swiss Natural Science Society thereupon purchased several of the threatened blocks and had them declared unassailable "in perpetuity". That was the birth of nature conservation in Switzerland.

The preservation of erratic blocks was followed, soon also with state support, by the protection of botanical features: at first individual trees distinguished by their growth or age, later whole species of plants threatened with extinction. At present the endeavours of nature conservation are aimed at preserving entire landscapes and biotopes. As for the erratic blocks, hundreds of them have meanwhile been taken under state care as protected natural monuments. The upsurge of building activity during the past few years has led to the discovery of many more blocks buried among glacial detritus. They now stand alongside motorways or before school buildings, telling their story—the story of the earth. On the Zurichberg in Zurich there is an instructional nature trail lined by 88 erratic blocks discovered in foundation pits or gravel pits throughout the territory of the canton.

These foreign bodies cannot deny their Alpine origins. There are serpentines and smaragdite gabbros from the Saas Valley in the Valais, transported by the Rhone glacier into the canton of Berne. Rocks of granite from the Mont Blanc massif are found in the canton of Aargovia. The Aar glacier carried Grindelwald marble and Niesen breccia into the *Plateau,* the Reuss glacier brought down rocks from the Gotthard, and the Linth glacier dark red verrucano from Glarus. From the Grisons mountains an entire palette of variously coloured blocks—the green Albula granites being generously represented—was transported down the valleys. The southward flowing ice streams carried rock from the forbidding High Alps into the Plain of Lombardy. Such guide rocks enable the experts to determine the path and extent of Ice Age glaciers. That the journey was not always smooth is proved by frequent scarring of the rock surfaces; this can be observed with especial clarity on the dark Alpine limestones.

Man and beast also left their traces. Finds of bones show that close to the glaciers there lived the woolly-haired rhinoceros, the mammoth (both extinct), the reindeer and the musk ox. Marmots dug their burrows into the loose moraines; ibex and chamois inhabited the coarse detritus. Grassland provided grazing for giant deer, bison and wild horse. The quarry of Ice Age man also included the bear. The Wildkirchli Cave on Mount Säntis alone contained the bones of over 1,000 animals. As the ice retreated the plants of the cold steppe moved back into the high mountains. In a few locations, however, in the Jura and in the *Plateau,* they succeeded in holding their ground against the emerging forest.

◁ *Where a river of ice once flowed are now fields, meadows and villages: the Glatt Valley with its landscape features is a continuous reminder of the Ice-Age Rhine Glacier.*

106 ▷ *The secret capital of Switzerland: Zurich is the country's financial and business centre. With its outlying districts it has 720,000 inhabitants, which makes it the country's biggest city.*

Man and Work

Viewed on an European scale, natural conditions seem rather unfavourable to Switzerland's economy. Two-thirds of the country is mountainous—the upper part of the *Plateau,* the Jura and the Alps.

These landscapes suffer the disadvantages of steep ground and a harsh climate.

For a long time Switzerland has been unable to feed all its inhabitants. That is probably one reason why industry established itself at a relatively early date. On the important question of raw materials, which poses itself in this context, the cultural geographer Professor Georges Grosjean made the following observation: "There is a deeply ingrained idea that Switzerland is 'a country poor in raw materials'. This may have been more or less accurate between 1870 and 1910, when iron ore was in fact the principal raw material of industry generally. Ever since this idea has haunted our schools,

▽ *Preferred area of settlement:*
the dotted map reflects the population
concentration in the Plateau *between*
Lakes Geneva and Constance.

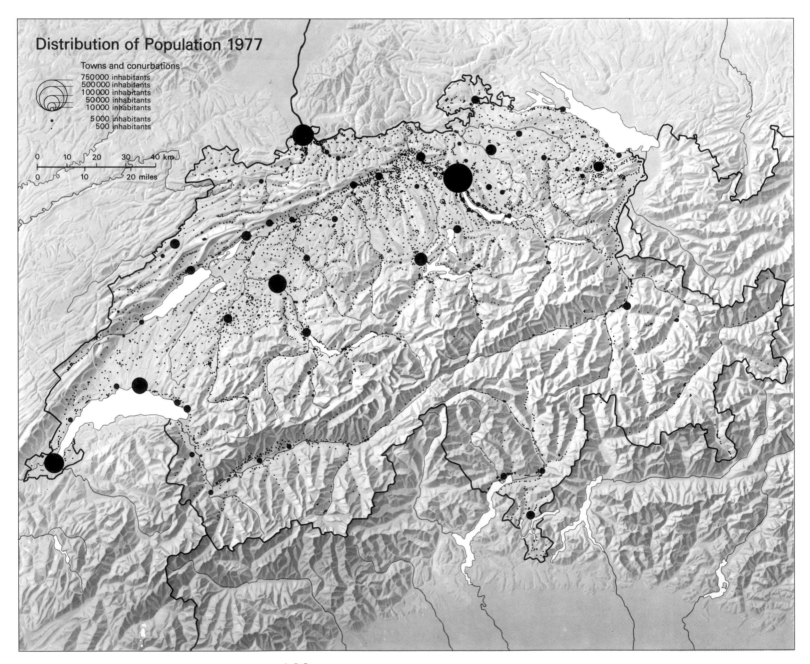

Distribution of Population 1977

Towns and conurbations
750000 inhabitants
500000 inhabitants
100000 inhabitants
50000 inhabitants
10000 inhabitants
5000 inhabitants
500 inhabitants

0 10 20 30 40 km
0 10 20 miles

given rise to amazement at Switzerland's economic miracle, and occasionally still blocks the view of realistic feasibilities."

In point of fact the chapter on "Mineral Wealth" shows that raw materials do occur in Switzerland. In the late Middle Ages 40 to 50 iron ore deposits were being exploited and Johann Jakob Scheuchzer was able, in 1907, in his "Natural History of Switzerland", to praise the country's wealth of iron ore. The building of the railways during the second half of the past century led to the collapse of Swiss iron ore mining. Imported iron became cheaper and the native ironworks processed mainly foreign raw materials. Nowadays enormous quantities of scrap accumulate in Switzerland—a most welcome raw material for the steel industry which is no longer dependent on imported ore. "Switzerland, like any other industrial country, has become its own iron ore mine", Professor Grosjean observes. He continues: "In that respect alone the slogan of the 'coun-

107 Showpiece of an active and prosperous city: the treelined Bahnhofstrasse in Zurich links the main traffic centre with the lakeshore. The upper part of this boulevard is reserved to pedestrians and public transport.

107

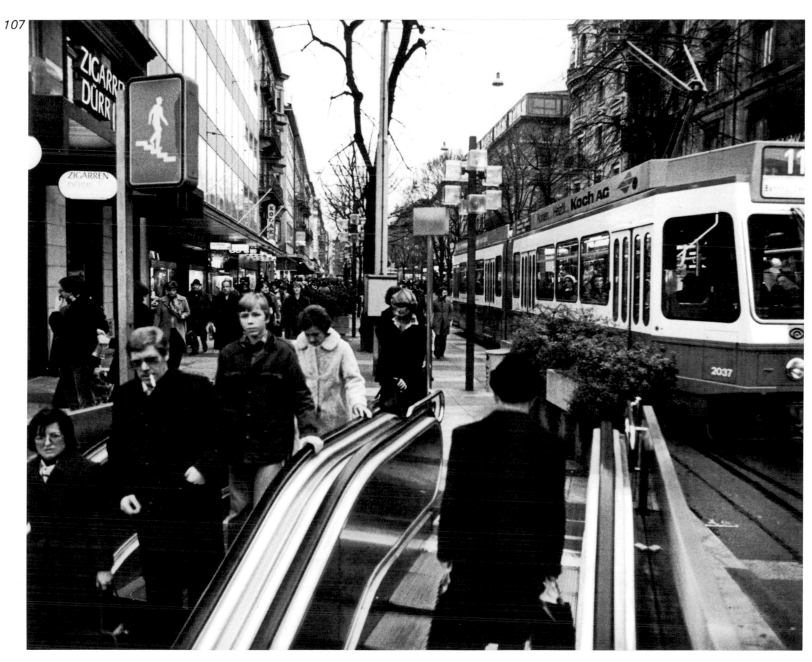

161

try poor in raw materials' no longer applies.... Switzerland's wealth is in its stone. Anyone who has watched shipload after shipload arriving in the Netherlands or in northern Germany of stones for dyke construction, of cement and gravel for concreting, for roads and bridges, will understand that a lot of stones, pebbles, sand, clay and loam also represent riches and industrial raw materials.''

Switzerland is poor in fossil fuel, which is why water power as an energy source is of considerable importance. Mills, sawmills, grinding and crushing plant, tanneries, dyeworks and other enterprises were set up in the vicinity of small watercourses. The textile industry, important since the 18th century, was dependent on a mechanical source of energy; hence cotton spinning shops and mechanical weaving mills sprang up along watercourses, which led to a considerable geographical scattering of the plants. The engineering industry arose from the intention to equip the textile industry with domestic machinery. Topographically, however, it divorced itself from water power as anyhow coal had to be used for it. Hence communications began to play an increasingly important part, and engineering works were set up in the vicinity of railway stations.

Many sectors of industry owe their location to the labour market. Agriculture has failed for a number of centuries to provide enough jobs for the Swiss population. Cottage industries, of great importance until the early 19th century, established themselves in the agriculturally disadvantaged areas—in the higher regions of the Jura, the higher regions of the *Plateau* and in certain Alpine valleys—and provided an economic compensation. The cotton industry was the first to attain a leading position, followed by the linen industry, embroidery, the printed cotton industry and the silk industry.

With the trend towards modernization some of these industries moved into the cities. Labour market conditions, however, were the real reason for the high degree of decentralization of Swiss industry, observable to this day, and thus ultimately for the relatively slight extent of rural depopulation.

Natural conditions—climate, soils, inclination of the land—together with marketing conditions provide the basis of the distribution of production areas. The lower regions of the *Plateau* are marked by intensive crop farming—unit yields are at the top even of international comparative tables—whereas on the upper levels of the *Plateau,* in the Jura and in the Alps, dairy farming predominates. Especially favoured regions allow fruit growing and viticulture. Vineyards can be found on numerous lake shores and sunny hillsides, fruit and vegetables are grown in favourable positions as well as in the catchment areas of the big cities.

Agricultural products are also processed industrially and then extensively exported. The list is headed by milk and cheese. Cheesemaking, still largely on a craft scale and decentralized, originated in the Alpine area and moved into the lowlands in the last century.

162

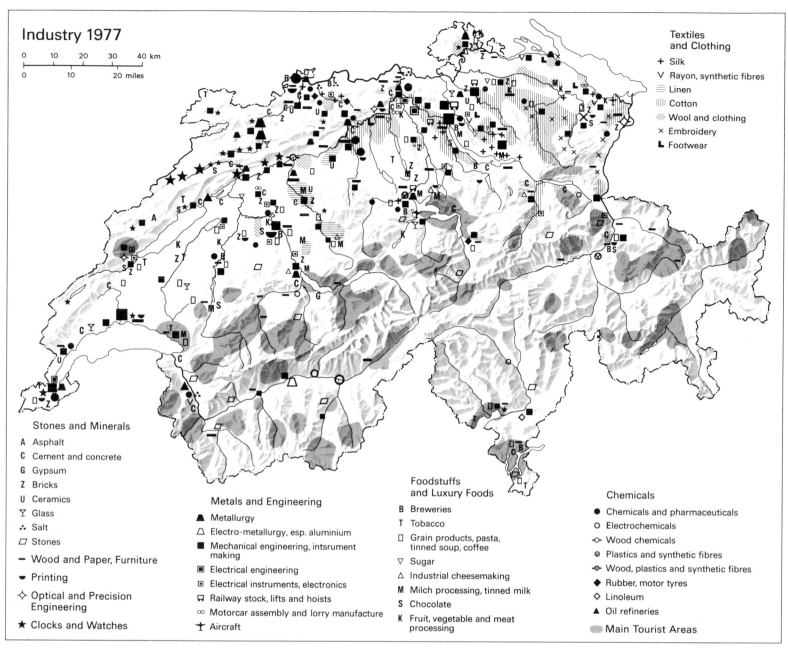

Industry 1977

Scale:
0 10 20 30 40 km
0 10 20 miles

Textiles and Clothing

+ Silk
V Rayon, synthetic fibres
≡ Linen
|||| Cotton
▨ Wool and clothing
× Embroidery
L Footwear

Stones and Minerals

A Asphalt
C Cement and concrete
G Gypsum
Z Bricks
U Ceramics
Y Glass
∴ Salt
▱ Stones

— Wood and Paper, Furniture
▼ Printing
◇ Optical and Precision Engineering
★ Clocks and Watches

Metals and Engineering

▲ Metallurgy
△ Electro-metallurgy, esp. aluminium
■ Mechanical engineering, instrument making
▣ Electrical engineering
⊡ Electrical instruments, electronics
▭ Railway stock, lifts and hoists
∞ Motorcar assembly and lorry manufacture
✝ Aircraft

Foodstuffs and Luxury Foods

B Breweries
T Tobacco
▯ Grain products, pasta, tinned soup, coffee
▽ Sugar
△ Industrial cheesemaking
M Milch processing, tinned milk
S Chocolate
K Fruit, vegetable and meat processing

Chemicals

● Chemicals and pharmaceuticals
○ Electrochemicals
⊶ Wood chemicals
⊘ Plastics and synthetic fibres
⊕ Wood, plastics and synthetic fibres
◆ Rubber, motor tyres
◇ Linoleum
▲ Oil refineries

▨ Main Tourist Areas

108

108 Technology unites mankind: production shop of the Breitenbach cableworks in the Laufon (Laufen) Valley, Jura.

109 Basle is the centre of the chemical and pharmaceutical industries: new substances are produced and tested in this research laboratory.

110 Ships' engines for the world's oceans: land-locked Switzerland exports high-quality engineering products. Engineering works at Winterthur.

Condensed milk used to be an important export to the former tropical colonies. Nowadays it has been displaced by powdered milk. The chocolate industry also depends on milk. Agriculture, in consequence, supplied numerous raw materials to industry.

Switzerland now is indisputably an industrial country. Nevertheless, agriculture has managed to survive, and not only as a sector of the economy but also as a political factor, with farmers proportionally over-represented in many assemblies and bodies.

As a land-locked Alpine country Switzerland has always aimed at the highest possible degree of self-sufficiency. True, the natural conditions are not especially favourable. Climatic problems, a shortage of fertile soil, steep terrain, but also a shortage of land generally, not only made production difficult but also make competitiveness largely impossible on an international scale. Without state subsidies agriculture would certainly not be viable; however, its survival is

111

111 *Cherries for domestic consumption: at picking time in the early summer the whole family is up on the ladders. Cherry trees in the Basle region.*

166

in the national interests and should be the concern of every Swiss. In agriculture, modernization and rationalization will, it is hoped, make production more profitable. But that can only be achieved by thorough training, scientific research and, above all, by the consolidation of small holdings. Partition as a result of inheritance has, over the centuries, led to the fragmentation of agricultural land and, in consequence, to rather uneconomic methods of work. Mechanization provided a substitute for the often expensive human labour but further increased the farmers' debts. Renovation of the exceedingly attractive, architecturally and ethnologically most valuable—though operationally outdated—farm buildings is a further problem. In some instances, usually in connection with the consolidation of holdings, the question of moving out into the fields arises: farmers decide to set up an entirely new up-to-date farm on their land, outside the narrow confines of the village.

112 Cheese for export: a substantial portion of all dairy products produced in Switzerland is exported. Emmental cheese cellar in the Emme Valley.

112

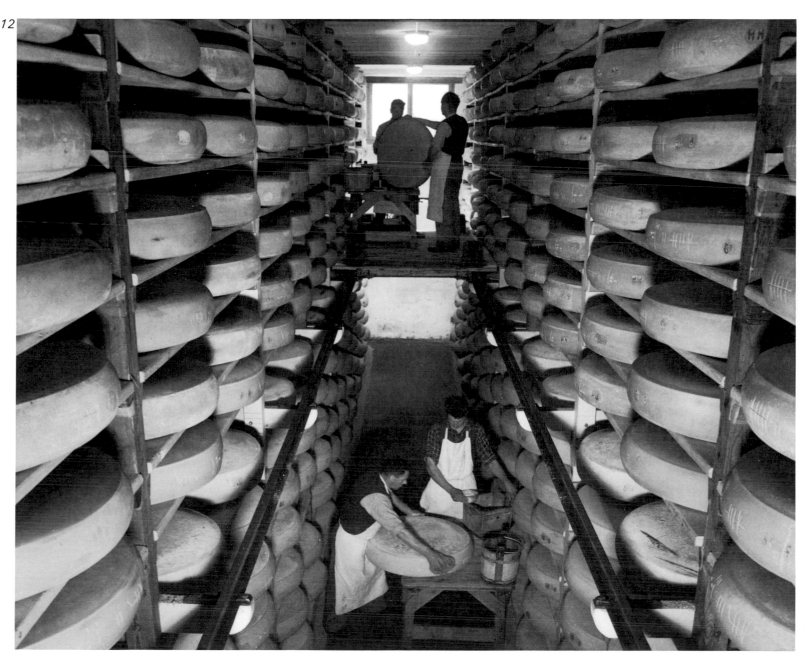

The drift from the country to the towns is not wholly disadvantageous to agriculture as a whole. The remaining farmers are able to enlarge their economic acreage. Thus the yields of Swiss agriculture have been steadily increasing despite a reduction of the overall agricultural area, the number of persons employed and the number of farms. The indebtedness of agriculture constitutes an economic and financial problem of national importance. It is, moreover, a social problem: the peasantry often lags considerably behind the rest of the population in the enjoyment of material and economic advances. The political authorities are faced with the delicate task of finding the right balance between a market economy and a state-directed economy.

Attractive Low Country

The Swiss clearly have a preference for the *Plateau*. Here, on 30 per cent of the country's area, two-thirds of the population lives. Whereas the average population density in the mountainous cantons is only a few dozen per square kilometre (31 in the canton of Uri, 23 in the canton of Grisons), the figure for the *Plateau* is many hundreds (647 in the canton of Zurich, 1,190 in the canton of Geneva). Nine out of every ten Swiss live below 700 m (3,000 ft).

Switzerland as an alpine country concentrates its population in the lowlands. The favourable climate, the relatively fertile soil, good communications, as well as the plentiful supply of jobs in industry, crafts and services have all combined to make the *Plateau* particularly attractive. Here are 24 of the country's 31 conurbations, including four of the five big cities: Zurich, Geneva, Berne and Lausanne. Like a magnet the *Plateau* continues to attract more people. The trend towards population concentration is getting increasingly marked. The drift from the mountains and from rural areas has been filling up the towns ever since the last century, and now even the conurbations are overflowing and progressively swamping their surroundings. With long greedy tentacles the towns eat into the landscape.

The urbanization of Switzerland has its origin in the changed economic system to which the lifestyle of many inhabitants had adapted. Whereas during the past century half the population was still engaged in agriculture, its share at present has dropped to 6 per cent. Industry and the rapidly developing service sector—both of them economic sectors concentrated in the towns—account for an ever-increasing proportion.

Yet ultimately the *Plateau* owes its origin and its landscape to the Alps—as has been shown in the chapters "Molasse Country" and "Traces of the Ice Ages". Degradation products of the Alps and the Ice Age glaciers produced a plateau of 350 to approximately 1,200 m (1,150 to 4,000 ft) altitude; this is by no means a plain but an exceedingly varied undulating hillscape. The lower *Plateau* includes a few lesser plains, whereas the upper *Plateau* culminates in

Agriculture

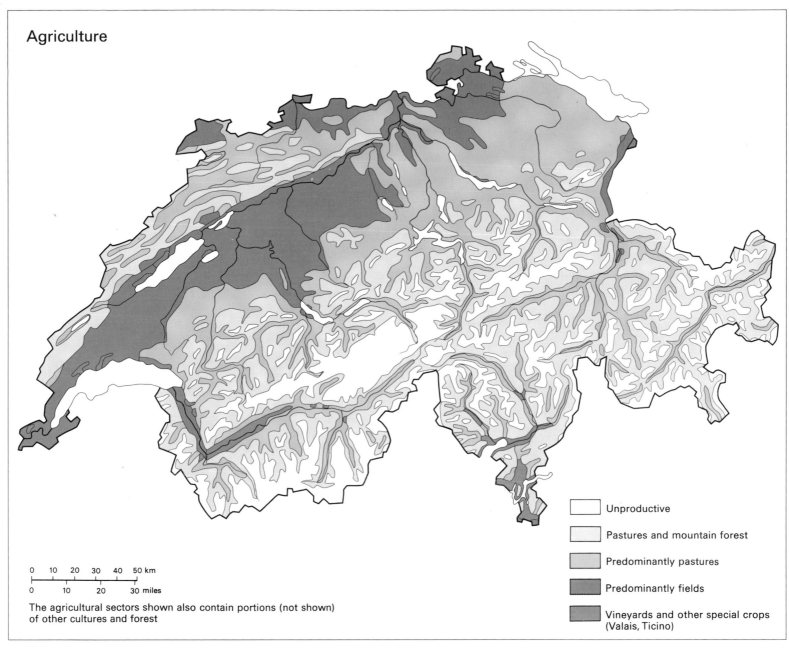

0 10 20 30 40 50 km

0 10 20 30 miles

The agricultural sectors shown also contain portions (not shown)
of other cultures and forest

Unproductive

Pastures and mountain forest

Predominantly pastures

Predominantly fields

Vineyards and other special crops
(Valais, Ticino)

113

varied and steep hilly regions. Fields, pasture and forest alternate, interspersed with villages and towns huddling in valleys and hollows. Now and again a formerly fortified township towers above the surrounding landscape.

There is also a lot of running water. Violent torrents rage after summer thunderstorms and carve their beds deep into the molasse. Rivers lazily move down wide valley floors as glistening ribbons. In such an intensively utilized and just as intensively inhabited landscape these have, of course, long been straightened out and regulated. Occasionally old patches of riverside woodlands betray the location of the big loops which together with the inundations induced man to interfere with nature's work.

Numerous lakes adorn the *Plateau*. They come in all sizes, from the smallest puddle to sheets the size of an entire canton. Mostly they owe their origin to Ice Age glaciers which created the landscape prerequisites: terminal moraines blocking the valleys or even more important ground moraines sealing the cavities behind them. In this way whole series of lakes came into being on the northern and southern edges of the Alps. The two largest of them, Lake Constance and Lake Geneva, form the eastern and western boundaries of the Swiss *Plateau*.

This charming cultured landscape is where most Swiss live. And because it has to accommodate so many people—and they represent an industrialized, highly developed society—it is important that this environment should be protected against uncontrolled or excessive utilization, against unchecked building-over and unlimited exploitation.

French-Speaking Part of Plateau

Two-thirds of the Romands—the French-speaking Swiss total over one million—live in the *Plateau*. The region consists of two landscapes: the wide basin of Lake Geneva and the undulating western Swiss plateau, separated from the former by the ridge of the Jorat and its spurs.

At the outlet of this biggest of Swiss lakes lies the city of Geneva. For the Confederation this important trans-shipment centre has always been very much on its margin, but Geneva's international relations represent a valuable supplement to the whole country. The city is crossed by two totally dissimilar rivers. The Rhone leaves the lake as a majestic river, while the Arve, originating in the Mont Blanc massif, sometimes behaves as a much-feared torrent and always betrays by its turbidity its mountain catchment area.

Geneva is an important cultural centre of Western Switzerland. The reformer Jean Calvin (1509–1564) lived and worked here. Here also numerous refugees from religious persecution found a new home, including many Huguenots from France. Their influence gave rise to new industries—watch-making, costume jewellery and precision mechanics. Today Geneva is the most cosmopolitan city in

Switzerland. This is due largely to the many international organizations which have their headquarters in the city, and also to the daily cross-frontier commuting by Frenchmen working in Switzerland, and to the importance of international rail, road and air communications.

But it is just this multiplicity of functions that divides the inhabitants of the metropolis. The inhabitants are divided into one third each of old-established Genevans, other Swiss and foreigners. For German-speaking Swiss and for foreigners Geneva is often only a temporary place of residence and not a permanent home. For new arrivals it is often difficult to make contact with the old-established families, so that the real charm of this ancient city on the Rhone remains hidden from many a non-Genevan.

That was also the impression of the Genevan author Paul Chaponnière (1883–1956) when he said of his city ("Genève", 1930):

"In effect there are two worlds living alongside each other: the ancient city, strangely reserved and independent, and the new Geneva, the international meeting point. The two complement and understand one another superbly—but each of them strictly preserves its own character. Geneva, the city of foreigners, possesses the world's most beautiful embankment, with a row of white houses mirrored in the bright clear lake, with the gigantic building of the League of Nations above a sunlit lakeshore.

But the hearts of the old Genevans beat more warmly for the other city. This, true enough, does not display such a splendid face. Its narrow little streets wind between crowded rows of houses, neglected by the sun. The high roofs, inclined towards all sides, are given a round brown hue by curved or flat tiles. Even the serious walls still preserve the magic of the past."

The author also turns towards the Geneva landscape, to the small but attractive surroundings of the throbbing big city.

"And yet, what a large number of places there are in the landscape outside, places which have preserved their rustic charm as we knew it in our childhood. The banks of the Rhone have a wildness about them, even though mitigated by grandeur and beauty; those of the Arve are simpler, those of other watercourses are more homely, with secret footpaths, one moment through bushes and the next through clearings, and under vast oaks, whose stems tower into the sky, whose shadows caress the lawns, whose foliage rustles in the wind."

Geneva is an urban canton. Of its inhabitants 95 per cent are town dwellers, in contrast to the neighbouring canton of Vaud which has largely preserved its rural character. Its capital, Lausanne—the second biggest town on Lake Geneva—has not become a metropolis in the same way as Geneva. Only about one half of the Vaud population live in urban communities; the biggest canton of French-speaking Switzerland bears a clear rustic imprint.

No other writer has caught the courteous, slow and relaxed charac-

114 Cheerful celebrations after hard work: the vintners' festival at Vevey, held every 25 years—the last in 1977—brings together vineyard owners and numerous visitors from near and far.

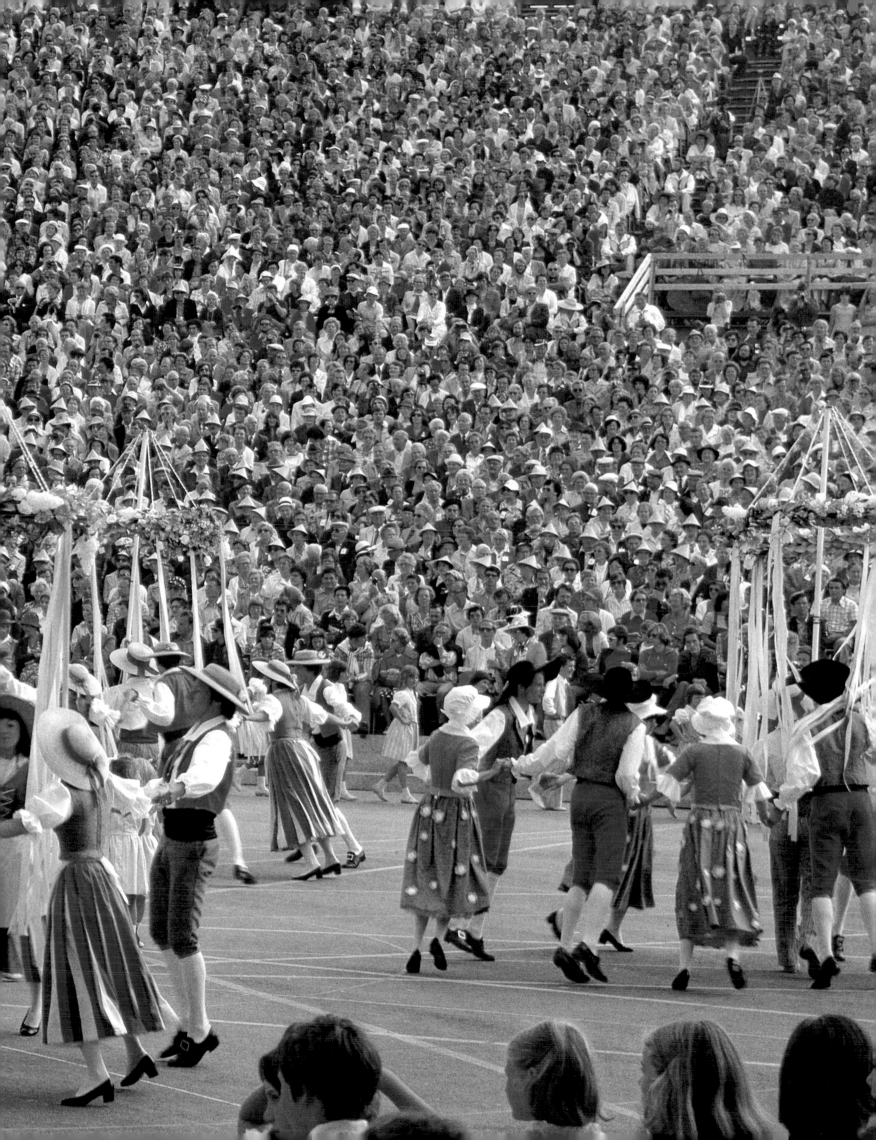

▽ *The place names reflect the linguistic boundary; cultural division runs right through the* Plateau.

The German-French linguistic boundary

ter of the proud Vaud people better than Charles-Ferdinand Ramuz (1878–1947), who devoted his writings to all the landscapes and the people along the course of the Rhone, from its source to the banks of Lake Geneva.l vineyard regions of Vaud. The entire slope of the Lake Geneva basin is terraced, intersected by narrow vineyard tracks and with occasional small vintners' villages—a cultural landscape of impressive intensity. Pride and respect were the attitudes which Ramuz put in the mouth of a vintner he described in "La Fête des vignerons" ("The Vintners' Festival", 1929): "Bovard is in his vineyard and raises his eyes to the lakeshore. 'This comes from us, this is for us, this is ours.'

And further on:

'Everything here bowed obediently while the vines were planted here. The good Lord Himself wished this land to become a land of vines; he turned the mountain to the position it is in, saying to Himself: "I will now create a fine hillside, just as it should be, with the right angle to the sun, with the necessary inclination, and below it I will place a sheet of water so that two suns shall burn upon it, so that the sun which otherwise shines from above shall come also from below" And I say that the Lord arranged all these things, and then said to us: "And now it's up to you". And then? Then he called us. As soldiers, as sergeants, as captains, all under His supreme command.'

Thus speaks Bovard in his vineyard; he is talking to himself alone, with words that come from deep inside him, and he is astonished; but more words keep coming.

'Us, humans.'

And so many words force their way up that he barely keeps pace with them.

'The good Lord started it; then we came and completed it He created the hillside, and we made it usable, we made sure it would last, it would endure.'

'Would one recognize it at all,' he continues, 'under its stone garment? Elsewhere man is content to sow, to plant, to turn the sod; and we have to pack the earth into boxes, just look at it if it isn't the truth; into boxes, that's what I said, pack it all in boxes, and these boxes we then have to pile up one on top of the other.' He accompanies his words with his hands which he raises higher and higher, in jerks, because of the many levels which rise, steplike, one above another."

The canton of Vaud is undoubtedly one of Switzerland's most fertile agricultural areas. It includes the plateau beyond the Jorat—the Gros du Vaud—with its good moraine soils and moderate precipitation. This part of the *Plateau* became the real granary of the country. To the east the canton of Fribourg is a continuation of Vaud, with similar landscapes. Fribourg is a bilingual canton, with two-thirds of the population speaking French.

174

The ancient city of Fribourg stands directly on the linguistic boundary. In it the cantonal ratio between German and French is reflected. Fribourg is the most westerly of the cities founded by the medieval princely family of Zähringen, of a system of towns which included, among others, Berne, Burgdorf, Thoune (Thun) and Freiburg-im-Breisgau (in Germany) as planned foundations. In appearance, too, these towns resemble one another, both in topographical layout and in town planning concept. The romantic old quarter of Fribourg, with its narrow twisting streets, its old oriel windows and its Gothic cathedral, is an impressive sight to this day. A Fribourg patrician, the writer and historian Gonzague de Reynold (1880–1970), in "Swiss Cities and Landscapes" (1914), describes his native town as follows: "Fribourg has the varied charm of a city whose German and Alpine substratum—forests of oak, walnut, beech and fir, molasse with horizontal layers, sheer cliffs along the Saane—is frequently overlaid by Latin forms. The Frenchman encounters Old France at every street corner: it lurks in the delicate cornices of the small patrician residences, it is present in the life and customs of a society that is, at the same time, pious and worldly. The German feels back at home on the banks of the Rhine or the Neckar whenever he crosses the squares of the Lower Town or climbs its steps, that Lower Town whose pointed gables, whose walls with projecting beams, whose pointed arches and whose steps are so closely related to Strasbourg, to Goslar, or to Schlettstadt. Even the Italian may at times think he catches the intonations of his native land when, on market day, he hears the peasants in the taverns speak the Gruyère dialect. The sculpture of the fountains suggests towns in Lombardy. The patrician class of Fribourg is reminiscent of that of Genoa, which has been an important influence."

German-Speaking Part of Plateau

Linguistic boundaries in Switzerland are usually defined by landscape divides, often by natural watersheds. In the *Plateau*, there are no clear natural boundaries which might divide German from French speakers, even though the Saane River may serve as the frontier for some of its course. The boundary in the *Plateau*, therefore, is more variable. Thus Murten was Germanized as a consequence of the Burgundian wars, while a French-speaking group settled in Bienne (Biel) in the course of industrialization and in consequence made this town bilingual.

The Swiss *Plateau* divides into two types of landscape. The lower part, in the north, comprises the only plains in the country, at altitudes varying from 350 to 500 m (980 to 1,640 ft) alongside some undulating and gently hilly terrain which only exceptionally exceeds 800 m (2,550 ft). The lower *Plateau* owes its forms to soft and readily eroded sandstones and marls. In the higher southern part, on the other hand, steep hills predominate, with peaks occasionally exceeding 1,500 m (4,900 ft). Several of these mountain areas, con-

175

sisting predominantly of nagelfluh, were spared by Ice Age glaciation and therefore lack those traces of the glaciations described in a separate chapter. Typical landscapes of the Upper *Plateau* are the Fürstenland area of the Canton of St. Gallen, lower Toggenburg, the Tössbergland, the Zurich Oberland, the Höfe district of Schwyz, the Emmental and the Schwarzenburgerland.

Even the harsh landscapes of the upper *Plateau* have inspired certain writers. The most important of these is Albert Bitzius (1797–1854) from the Bernese Emme Valley, who has gone down in world literature under his pseudonym of Jeremias Gotthelf. This clergyman from Lützelflüh portrayed the culture of the Emme Valley, exposing the social and economic shortcomings of his day, protraying the hardships of the peasants and of their farmhands and maidservants, and writing about the human side of being a schoolmaster. The hard life among those steep hills has moulded a particular type

115

of person, silent, tough and proud. The main source of livelihood is stockbreeding, the principal manufactures are dairy products.

In his novel "Cheese-making at Vehfreude" Gotthelf outlines the history of the cheese-makers who made the name "Emmental" famous throughout the world: "In the old days cheese was only made on the mountain pastures throughout the summer, while the cattle were grazing; true enough, when the cowhand descended to the valley in the autumn, feeding his 60 or 80 cows on the holding of one or several big farmers, he probably made a few small cheeses for domestic use or for a landlord who wanted to sweeten some sour customer of his by a rather special cheese. In every part of the country some particular kind of cheese was made on the high grazings, in the way practised since great-great-grandfather's day—and everyone believed such cheese was determined by the soil and by the herbs growing on it."

115/116 Popular entertainments: each part of the country has its own musical and sporting traditions. Sunday open-air concert (115) and Hornussen, *a team game (116). A vulcanite disc (*Hornuss*) is hit into the pitch with a driver; the opposing team tries to intercept the missile with wooden boards.*

116

117/118 Each Emmental farmstead is a world of its own: the farmers heat their homes with wood from their own forest (117). The vegetable garden is the realm of the farmer's wife (118).

About 1820 cheese-making was introduced in the Bernese low land. Gotthelf continues: "As is usual in the Berne area, where people have never been keen on innovations, the whole business was at first viewed with a great deal of mistrust and there was little imitation. Sniffing contemptuously, people would give the locally made cheeses a wide berth and act as though their smell was scarcely bearable. Shopkeepers would admit that the things looked like cheese but were not really cheese and could not properly be sold unless the reputation and credit of Emmental cheese was to be jeopardized for all eternity; these cheeses, they suggested, were just about good enough for Buechiberger people whose throats had been hardened by seven-year-old butter milk, or for Zurich people who had survived their wine and managed to live to an age of twenty."

The difference between the upper and the lower *Plateau* is clearly

117

reflected in the types of settlement since man has always adjusted to natural conditions. In the steep, humid and climatically harsh hills of the upper *Plateau* forestry and stock-breeding predominate. Difficult communications and the relatively great demand for land compel the farmers to live amidst their farmland; in consequence, isolated farmsteads are the rule. In the relatively dry lower *Plateau* with its fertile moraine soils, on the other hand, crop farming predominates. With intensive cultivation these farmers need less soil and have therefore been able to settle in villages or even towns.

The settlements of the lower *Plateau* in the Middle Ages, were often planned and built on top of Roman ruins. Until the 18th century these towns developed slowly and steadily, always surrounded and protected by a (simultaneously growing) town wall. This urban order was shaken when, as a result of the introduction of modern weapons, the medieval fortifications became superfluous. In the

118

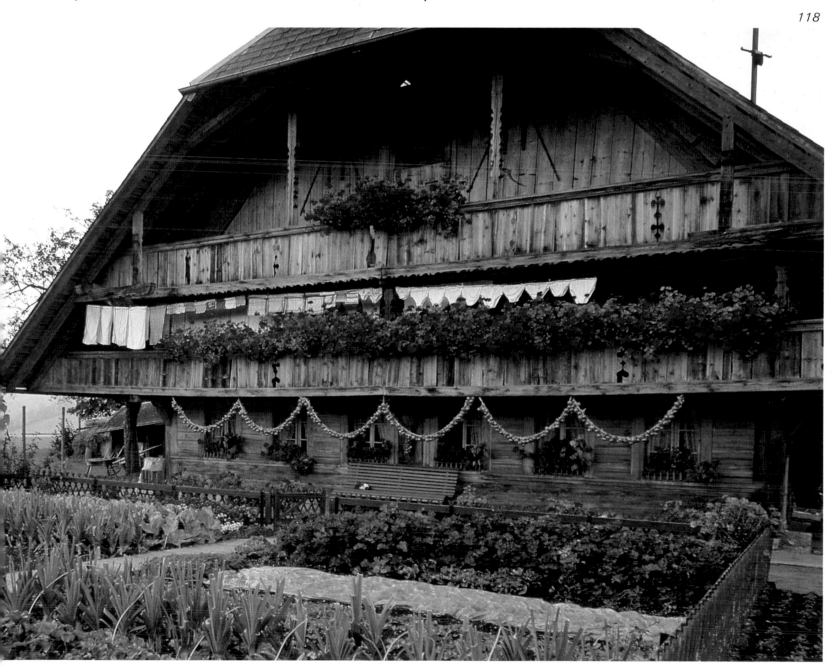

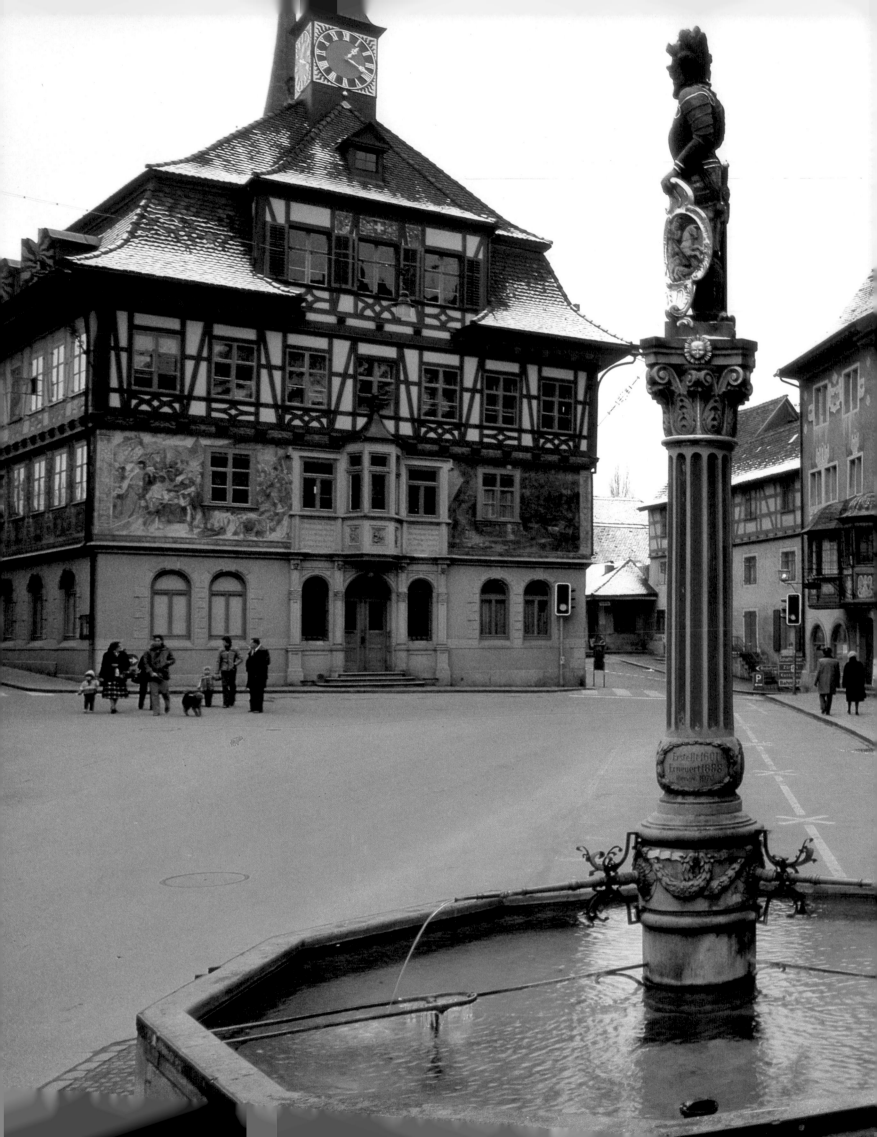

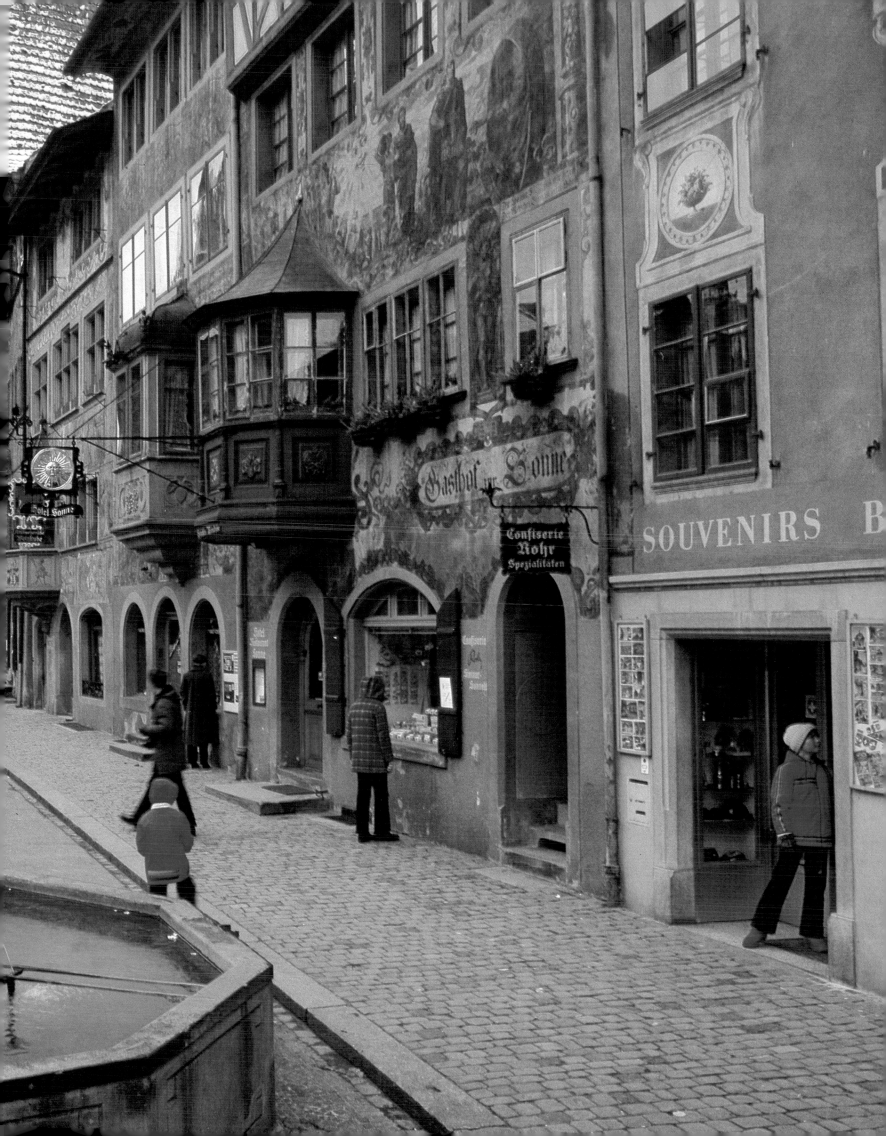

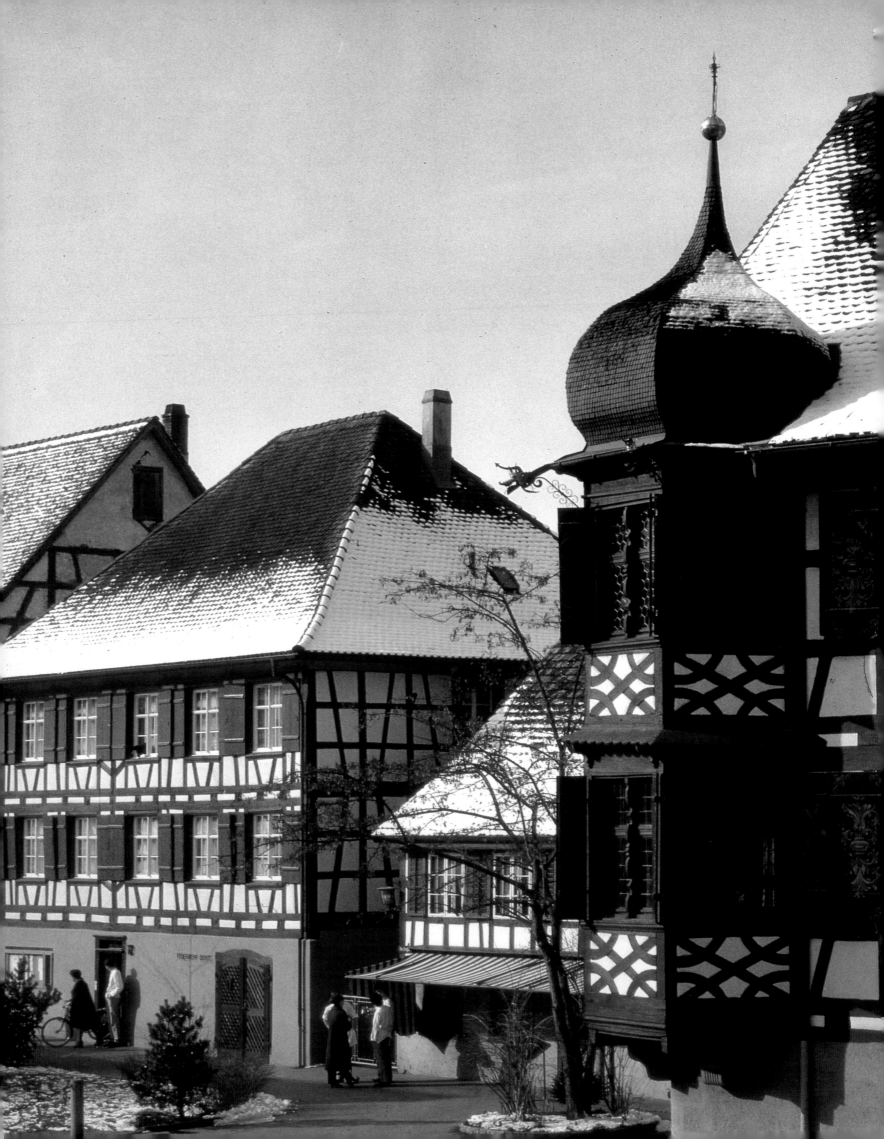

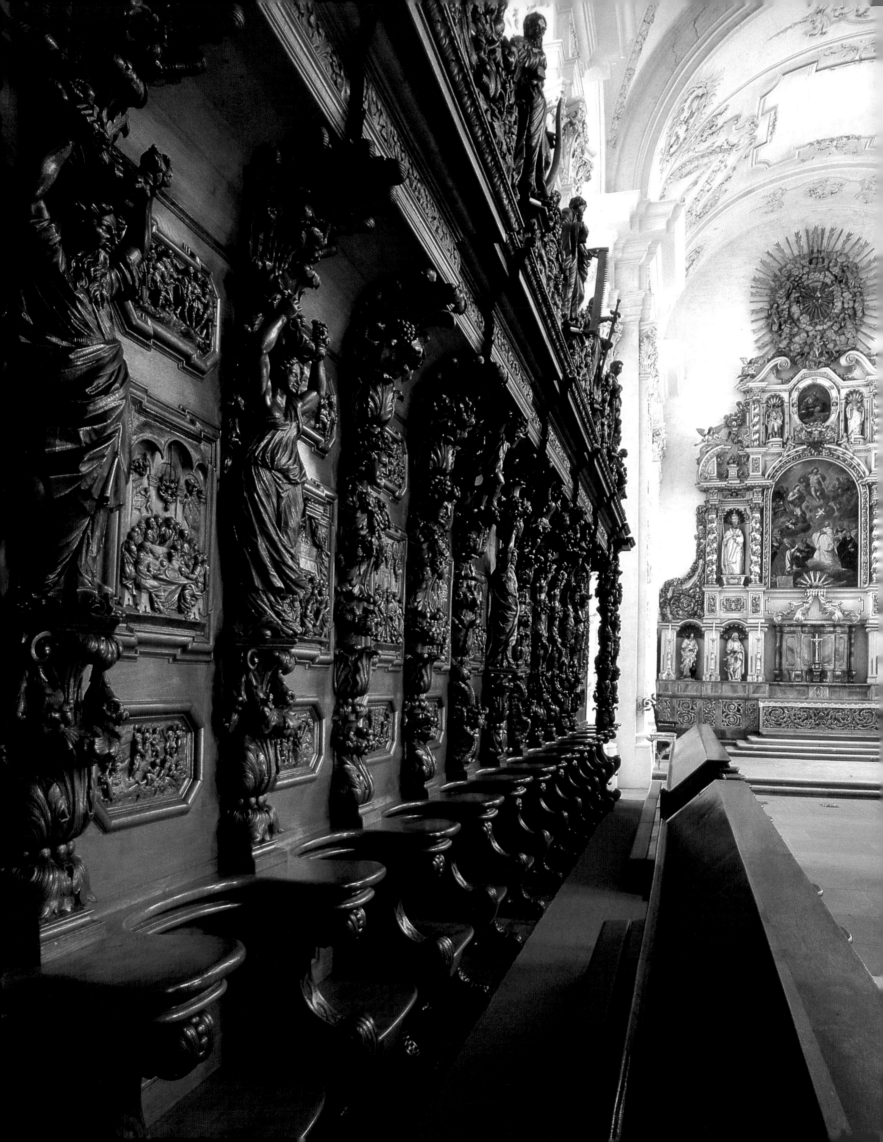

second half of the 19th century the railways began to arrive, and their stations occupied those very patches of ground on the edge of the towns that had become vacant by the demolition of the town walls. Since then the cities have developed explosively under the stimulus of industrialization—and not to their advantage. Now, in the 20th century, the problem of inner-city traffic has become acute, alongside such problems as air pollution, social difficulties, loss of individuality and alienation from nature. World-wide trends have not stopped at Switzerland's big cities—but a large number of small towns have been spared and now represent most delightful gems in the cultural landscape.

Zurich, the biggest conurbation, is sometimes derisively called "the Chicago of the pre-Alps". From a rather different period comes the poem which Conrad Ferdinand Meyer (1825–1898)—a contemporary of Gottfried Keller (1819–1890)—dedicated to his city, a city which still plays a leading part as a cultural centre of German-speaking Europe.

As a child with rosy cheeks
I still walked through the gates of Zurich;
It burst out of its walls and grew and built,
Rejuvenating itself while I grew grey.

It broke the rigid circle of its ramparts
And spread out full of life and vigour,
And on ever more tempestuous wing
It set up pinnacles on the surrounding hills.

Yet from a richer frame and structure
The same beloved features still emerge—
Cosily, in the dream of poetry, they slumber on,
The buildings pulled down to make new space.

The Limmat has been spanned by new bridges,
But no longer its blue waters overspill,
And with blissful pure brows
The same snowfields still glisten up high.

Human time is a brief moment,
Cities have a longer destiny,
They have their genius that lives on with them
And hovers over them in growing circles.

119 The magnificent façades of the houses reflect middleclass affluence: Stein-on-Rhine (canton of Schaffhouse/Schaffhausen) has successfully preserved its small-town character.

120 Wooden beams are the principal structural element in this attractive house: the fishing village of Gottlieben on Lake Untersee, Thurgovia.

121 Superb wood carvings proclaim the glory of God: choir stalls in the Abbey Church of St. Urban in the canton of Lucerne. This former Cistercian Abbey is regarded as one of the finest baroque buildings in Switzerland.

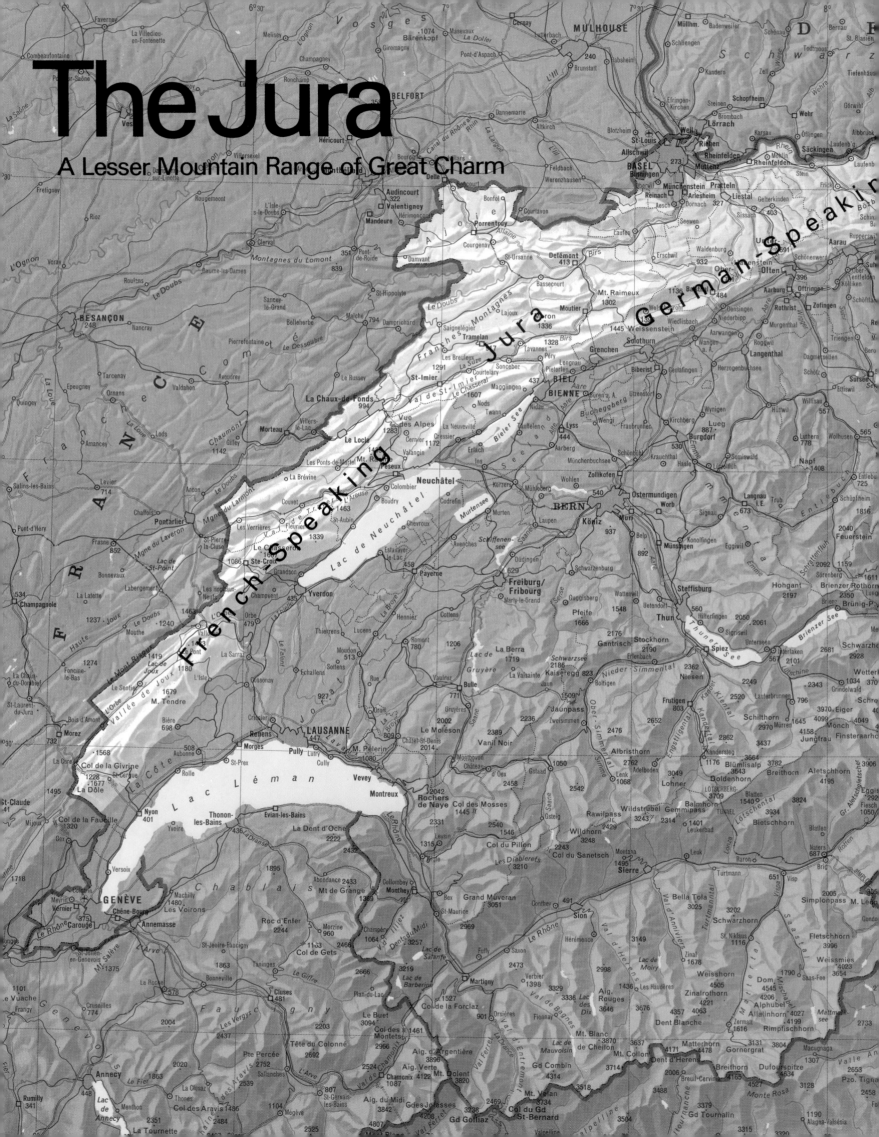

The Jura
A Lesser Mountain Range of Great Charm

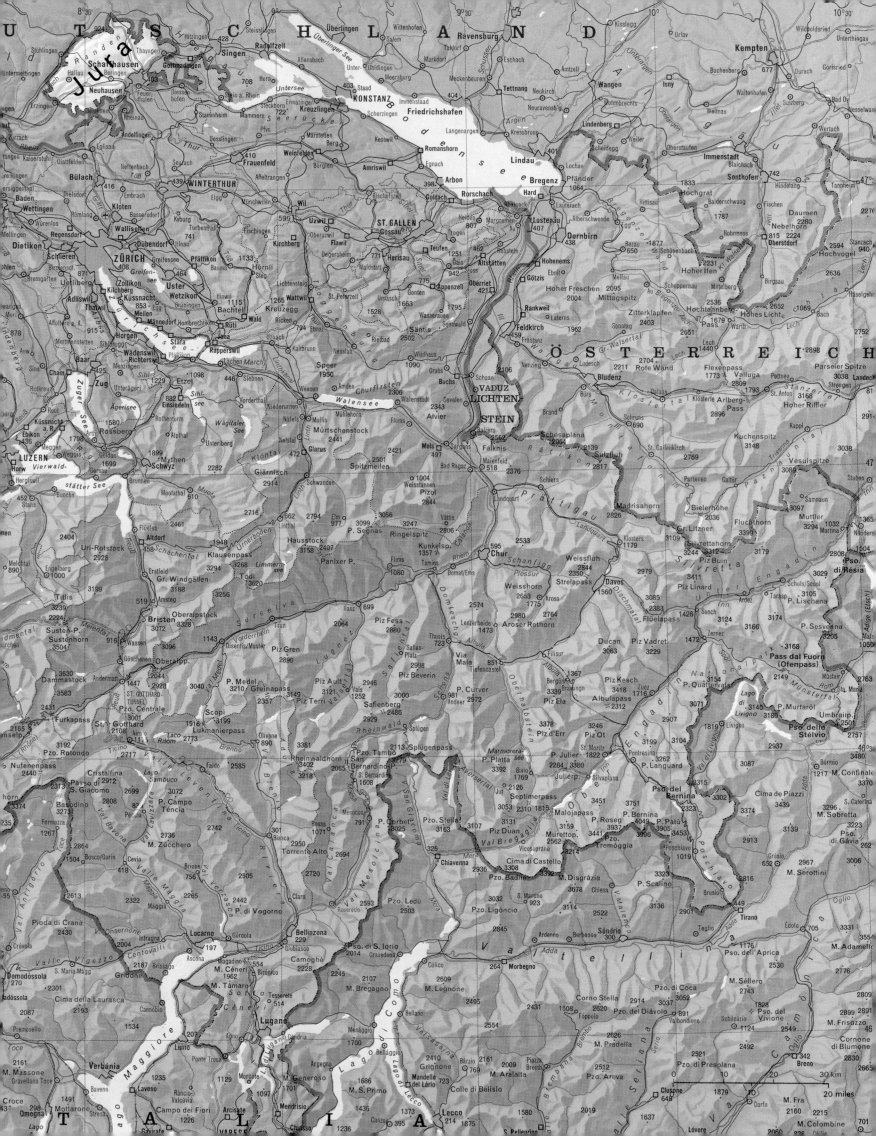

Features of the Jura Landscape

Nearly all the rocks throughout Switzerland are closely related to the Alps. They either belong to those mountains themselves or else their material has originated there (Molasse, glacial deposits, river-transported material). The Jura, too, is a child of the Alps. Its birth pangs were thrusts from the south and south-west, effective during one of the final phases of the Alpine folding five million years ago.

Admittedly, the Jura lacks the impressive grandeur of the high mountains—but that is just why it is more easily seen as a whole, more accessible, and seemingly more ordered; the laws underlying the structure of its landscape are less complex and are directly accessible even to the layman.

This state of affairs was explained by Professor Albert Heim at the annual meeting of the Swiss Naturalists in Geneva in 1915 when he said:

"The Alps and the Jura are only ruins now. But there is a considerable difference: degradation in the Jura has peeled off the layers, one after another, so that the internal structure is still clearly visible in the external shape, whereas in the Alps the external forms have often massively overcome and blurred the internal structures. True, the Jura is far less deeply based. It is not a massive branch of the Alps but only a small particularly attractive and harmonious twiglet, a small harmonious note in tune with the powerfully thundering chord of the Alps."

A glance at the map shows that Switzerland shares the Jura—as indeed it does the Alps—with its neighbours. Oblivious of political frontiers the wooded mountain ranges of the French Jura stretch into the canton of Vaud, and in the extreme north the tableland of the Randen at Schaffhouse (Schaffhausen) is continued in the Swabian and Franconian Jura.

The Swiss share of the mountain range may be divided into three parts—the Folded Jura (or Range Jura), the Plateau Jura, and the Tableland Jura. The Folded Jura reaches its greatest width in western Switzerland, where it also achieves the most impressive elevations. La Dôle, Mont Tendre and Chasseron in the canton of Vaud, and Chasseral on the border between the cantons of Neuenburg and Berne all exceed 1,600 m (5,250 ft).

East of the line from Soleure (Solothurn) to Basle the picture changes. To the north the Tableland Jura now predominates and folds are increasingly confined to the region bordering on the *Plateau*. Eventually the Folded Jura dies away in the ridge of the Lägern which extends into the vicinity of Zurich.

The best picture of the structure of the Folded Jura is provided in the transversal valleys known as *cluses*. These valleys, intersect the ridges at a right angle, in the form of ravines, and expose them right down to the core of the folds. The origin of these transversal valleys is not yet clearly understood. One theory assumes that the folding of the Jura proceeded so slowly that, by continous erosion, the earlier

river network succeeded in counteracting the uplift. Nowadays a railway line and a road squeeze through these valleys in addition to the watercourses, and in doing so avoid considerable vertical differences in north-south traffic.

Apart from these transversal valleys the Folded Jura also has two types of longitudinal valleys: the wide valley floors of the synclines, where settlements adjoin one another, and the smaller, combes—notches produced by weathering along the ridges or the flanks of the anticlines.

The Plateau Jura is part of the Folded Jura which has been largely levelled down by the forces of erosion. The folds have been degraded, and the plateau is now only sub-divided by ribs of hard rock strata. The horse paradise of the Franches-Montagnes with its forests and pastures is the most beautiful—and in Switzerland the only—example of this particularly attractive type of landscape.

The Tableland Jura is a block-faulted area whose flat high plateaus are bounded by steep flanks which lead abruptly down to narrow valleys. It comprises the canton of Basle-Land, the northern part of the canton of Aargovia as well as the eminence of the Randen in the canton of Schaffhouse (Schaffhausen). The Ajoie—the trapezoid tip near Porrentruy projecting into France—is commonly assigned to the Tableland Jura even though slight folds occur there.

In the past the Folded Jura was too readily seen as a cluster of normal anticlines and the Tableland Jura as a plateau with but slight irregularities; however, geological research since the turn of the century has identified overthrusts and faults as typical phenomena. Faults are lines of fracture along which rock parcels have been displaced—raised or lowered—relative to each other. The biggest overthrusts, amounting to up to 5 km (3 miles), are found in that strip of the mountains where the Folded Jura came to lie on top of the Tableland Jura.

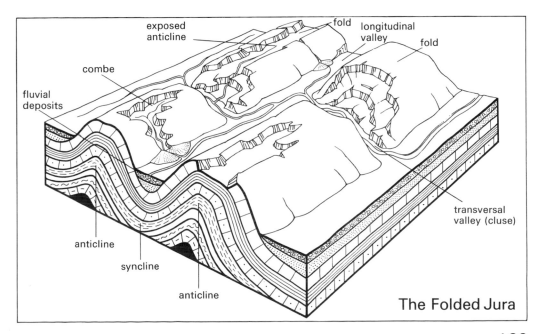

The Folded Jura

189

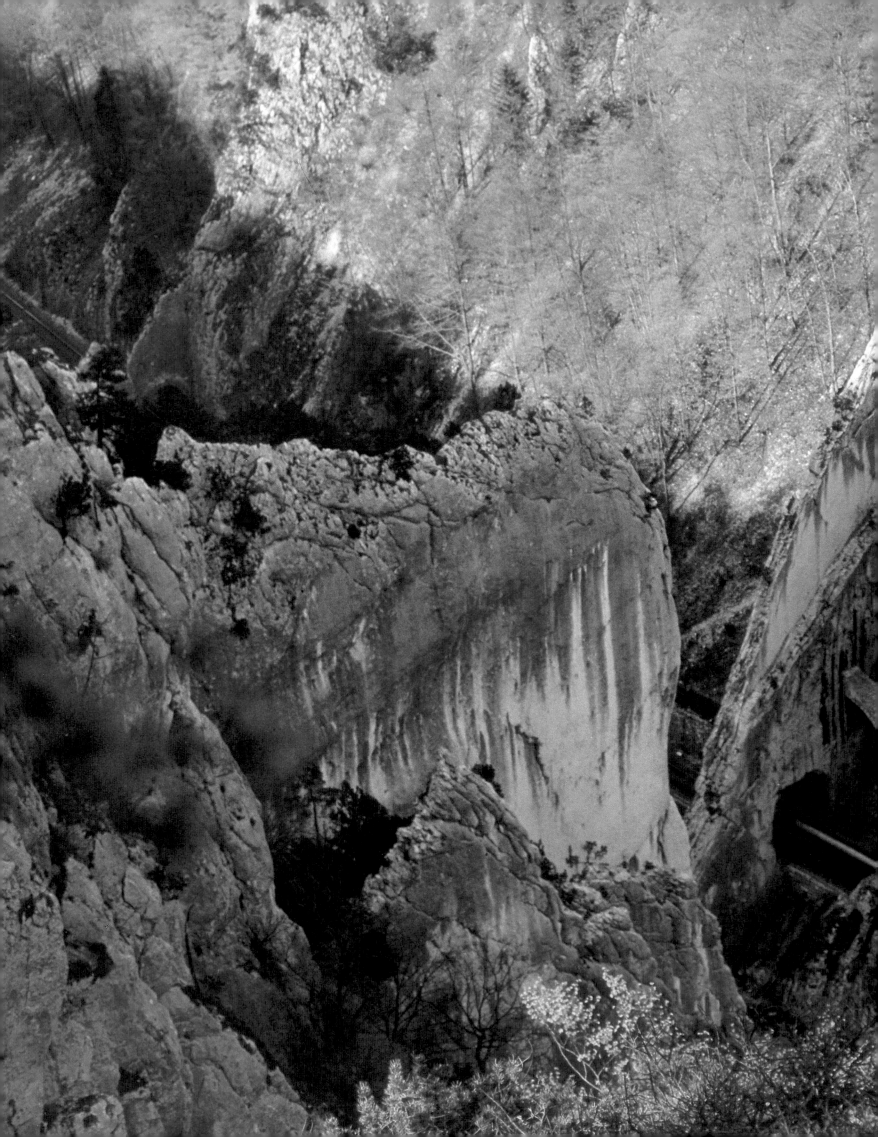

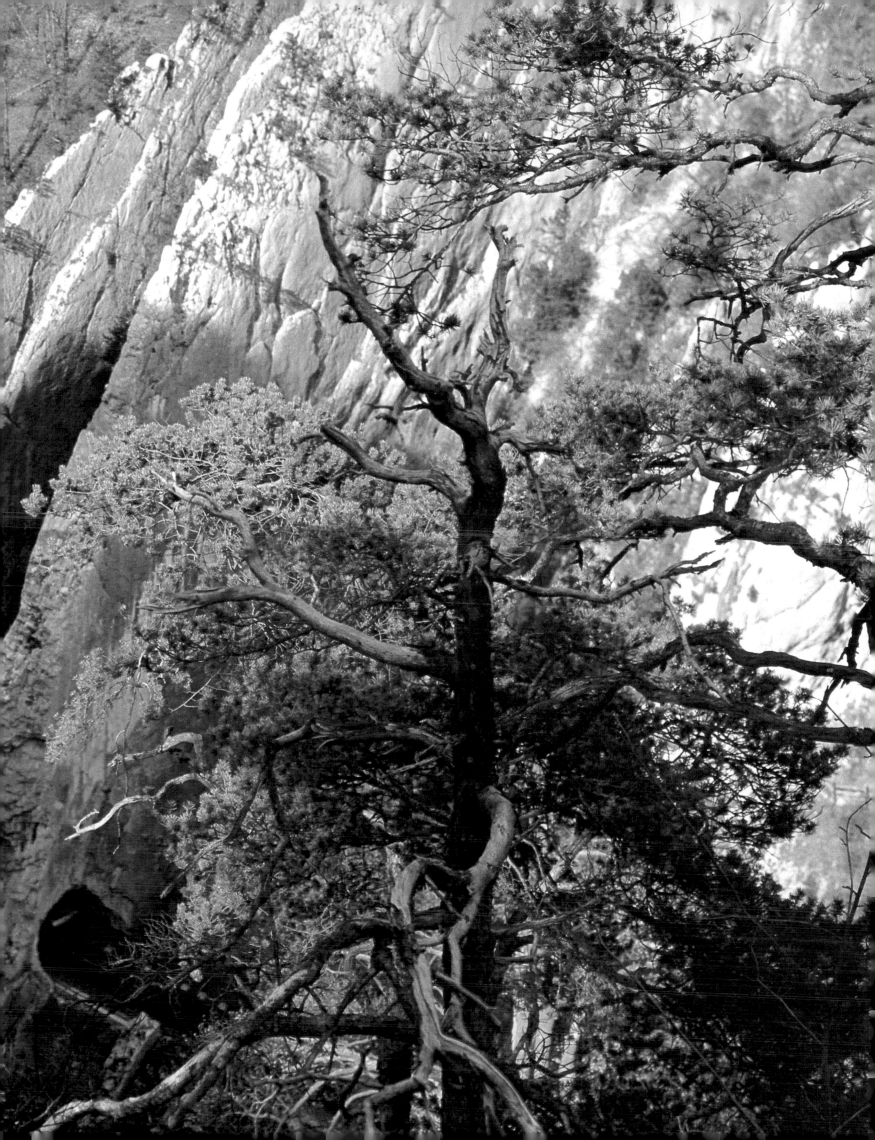

122◁	*Dramatically romantic mountain scene: in gorge-like transversal valleys the rivers carve their way through the Jura ridges. Rail and road follow the path carved out by the water, as here in the Moutier ravine.*

123	*Subterranean water courses: in karst areas the rainwater washes out cavities in the limestone and, after a long criss-cross journey, emerges on the surface as an abounding source.*

In the Basle area the 200 km (124 miles) long and 40 km (25 miles) wide trench of the Upper Rhine Valley ends on Swiss territory. This is a wide rift between the massifs of the Vosges to the west and the Black Forest to the east. The sinking of the Upper Rhine Valley began 40 million years ago, and is still continuing. Proof of such recent movements is the disastrous earthquake of 1356 which shook the northern Jura and reduced the city of Basle to rubble.

In the Laufenburg area (canton of Aargovia) the Black Forest reaches across the Rhine which here forms the frontier. There, banded reddish and grey gneisses are found. The Jura overlying these basal mountains, on the other hand, consists of a series of sedimentary rocks, reaching a thickness of up to 1,000 m (3,300 ft) in places.

At the bottom of the cross-section lies variegated sandstone. This belongs to the Triassic System, the oldest period of the Mesozoic, and is responsible, as a building material, for the warm reddish hue of the old quarter of Basle. Above the variegated sandstone follow the limestones and dolomites of the coquina, the sequence being interrupted by layers of salt and anhydrite (anhydrous gypsum). These soft strata provided the sliding plane on which the Folded Jura was sheered off its base. The uppermost element of the Triassic System, known as Keuper, contains variegated marls, banks of dolomite, crumbly sandstones and gypsum.

The Jurassic deposits, a succession of limestones and marls, are the dominant rocks throughout these mountains. Reading from the bottom up the Jurassic period is sub-divided into Lias (also known as Black Jurassic, after the predominant colour of the rock), Dogger (Brown Jurassic) and Malm (White Jurassic). All three sub-divisions are rich in marine fossils. During the Malm period, 150 million years ago, a tropical coral reef rose in the area of what is today St. Ursanne. Light-coloured Malm limestones, in which remains of

123

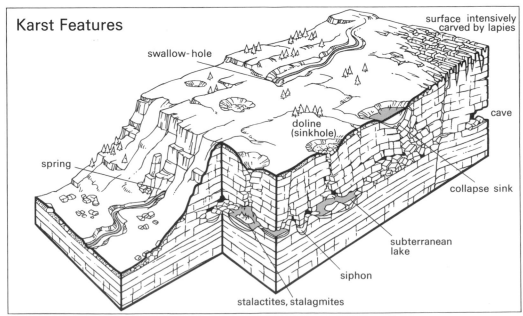

Karst Features

surface intensively carved by lapies
swallow-hole
cave
doline (sinkhole)
spring
collapse sink
subterranean lake
siphon
stalactites, stalagmites

192

giant turtles have been found, are the favourite natural building material in the city of Soleure (Solothurn).

Whereas Triassic rocks are widespread chiefly in the Tableland Jura, and Jurassic sediments mainly in the Folded Jura east of Bienne (Biel), Cretaceous strata, dating back to the most recent period of the Mesozoic, occur in the ranges of western Switzerland. Just as the people of Basle and Soleure (Solothurn), those of Neuchâtel were also able to help themselves to building materials virtually on their doorsteps: prior to the existence of concrete they used the yellow Cretaceous limestones on which their city stands.

At the time when western Switzerland was covered by the Cretaceous sea there was already dry land in the central and eastern Jura. There, rainwater and atmospheric carbon dioxide dissolved large quantities of the limestone which formed the surface over extensive areas, and thus created an eerie karst landscape with sharp ridges and deep clefts, with chimneys, caverns and sinkholes (funnels formed by chemical erosion). The insoluble residue collected in chimneys and pockets: this was a brown clay-like soil, called Bolus, granules of iron oxide (bean ore), quartz sands and nodules of flint.

Large areas of the Jura still exhibit karst features. Precipitation percolates down the ravined limestones and collects in underground streams which unexpectedly issue again from caves—often at great distances from where the surface streams disappeared into the ground. The inhabitants of karst landscapes cope with their permanent water shortage by collecting the rainwater off their roofs and channelling it into cisterns. Tourists and speleologists are normally unaware of such hardships; they enjoy the subterranean caverns with their bizarre stalactites and stalagmites.

The Ice Ages have left far fewer traces in the Jura than in the *Plateau*. During the Riss Ice Age large parts of the Jura mountains were covered by the Rhone Glacier whose ice surface, at its peak,

▽ *External features reveal the internal structure: the block-faulted landscape of the Tableland Jura is subdivided by faults. Geological cross-section of the area north of Eptingen in the Canton of Basel-Land.*

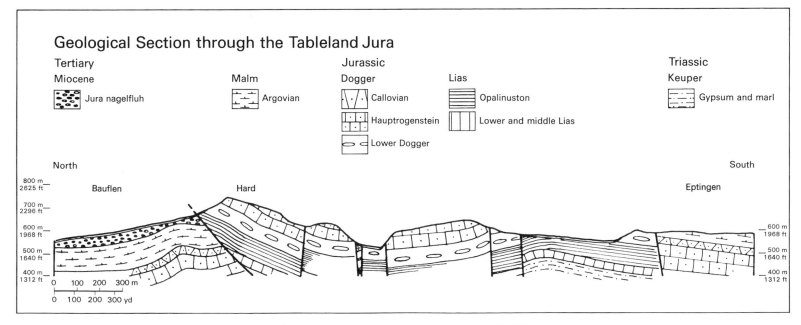

Geological Section through the Tableland Jura

Tertiary
Miocene
- Jura nagelfluh

Jurassic
Malm
- Argovian

Dogger
- Callovian
- Hauptrogenstein
- Lower Dogger

Lias
- Opalinuston
- Lower and middle Lias

Triassic
Keuper
- Gypsum and marl

North — Bauflen — Hard

South — Eptingen

800 m / 2625 ft
700 m / 2296 ft
600 m / 1968 ft
500 m / 1640 ft
400 m / 1312 ft

600 m / 1968 ft
500 m / 1640 ft
400 m / 1312 ft

0 100 200 300 m
0 100 200 300 yd

124 *Long winter months: this stone house in the Jura, with its thick walls, small windows and shallow-pitched roof protects its occupants against the cold and the wind.*

reached 1,450 m (4,760 ft). Not until the Würm Ice Age did small Jura glaciers proper come into being because the Alpine ice then rose to lesser altitudes and hence also advanced less far. Along the higher ranges of the western Folded Jura independent hanging glaciers with local moraines came into being.

A pronounced trough on the slope of Mont Soleil above St. Imier (canton of Berne), enclosed by a horseshoe-shaped ridge, was long regarded as a glacier trough. Recent investigations, however, have identified it as a large meteorite crater. An iron missile from space, weighing many hundreds of thousands of tons, must have struck the earth at that point, largely evaporating through the heat produced on impact. On a geological timescale, this natural catastrophe occurred quite "recently"—less than 125,000 years ago. It is unlikely that there were any casualties since the valleys of the Jura presumably were not yet inhabited at that date.

124

The geological structure of the Jura is largely responsible for the condition of its soils and hence for vegetation. Three factors above all determine the present plant cover: altitude, steepness of the ground and basal rock material. When the first people moved into the Jura the whole mountain-range—apart from bogs, rock falls and the very highest ridges above the treeline—were covered with dense forest. For their clearings the settlers, displaying assured judgment, chose the most fertile soils. In the Folded Jura these are in the longitudinal valleys (loamy glacier deposits over fine Molasse sandstone) and on the shoulders of the ridges, where there are outcrops of soft marls. On the steep dry flanks of the mountains, where the hard limestone is covered by only a thin layer of humus, the forest was left standing. Thus it is possible, for instance on a map, to trace the course of the mountain ranges merely by the distribution of forest and cleared land.

125 *Snow as a traffic obstacle: as the highest town in the Jura, La Chaux-de-Fonds (canton of Neuchâtel, 1,000 m = 3,300 ft; 40,000 inhabitants) has special climatic problems.*

125

Communications and Economy

With its ranges of hills grouped one behind the other the Jura cuts off the Swiss *Plateau* from the adjacent areas of France and Germany; it almost seems as though it objected to European north-south communications. Railway and road, in consequence, squeeze along winding routes from valley to valley, from one gap in the mountains to another, laboriously picking their way through an accumulation of traffic obstacles. Even the transversal valleys are anything but easily passable: they are a succession of bridges, tunnels and other engineering works. Where passes over the mountains once had to be used, modern means of transport use routes, shortened by tunnels—such as the railway on the Mont d'Or, on the Vue des Alpes, on the Grenchenberg, on the Weissenstein, on the Hauenstein, and on the Bözberg, and the motorway on the Bölchen. The attractive mountain landscapes of the Tableland and Folded Jura and the strange wide plateau of the Franches-Montagnes offer rest and relaxation. Tourism plays quite a significant part here, even though there are no centres with an international reputation. On fine weekends thousands of walkers and sportsmen from the neighbouring *Plateau* and from the big cities of Geneva and Basle make for the forests and meadows of the Jura. Natural features such as caves or rapids, and cultural monuments such as churches and monasteries, attract numerous visitors. Because day tourists contribute relatively little to the economic prosperity of the regions concerned, an effort is being made to encourage holiday tourism.

Agriculture is severely restricted by the harsh climate and put at a disadvantage by the water-permeable limestone base. More or less flat land, such as would be suitable for agriculture, is generally only found in this mountainous area on the floors of the sheltered valleys and on wind-lashed high ground. These in fact are the areas which, in the course of agricultural development, were cleared and now, in addition to meadows and pastures, also support crops. The steeper

126

mountain flanks, on the other hand, have remained densely wooded which has led to the name of Jura which means "wooded mountains". On the high plateaus of the Franches-Montagnes finally, forest grazings predominate. Among the sparse forest stands—exclusively spruce—horses and cattle graze freely; this is a unique and magnificent park landscape.

The Jura is a highly industrialized mountainous region. Industry as an economic sector here plays a substantially greater role than in most Alpine areas. Indeed the meagre gifts of nature forced the Jura inhabitants to seek economic alternatives. Watchmaking was a way of bridging the long winters. At first this was purely a cottage industry but later manufacture was switched to factories. A characteristic feature is the extent of the division of labour; in this industry, which is still largely decentralized, most factories only produce certain parts. From Geneva the watch industry spread in an easterly direction across the Jura regions of the cantons of Vaud, Neuchâtel, Berne, Soleure (Solothurn) and Basle, as well as to the southern piedmont of the Jura.

The high degree of this industry's dependence on exports has made it vulnerable to recessions. Production has partially switched to other precision-engineering industries. Nowadays not only mechanical but also electronic watches are being manufactured. It is, of course, true that the watch industry in the Jura had been based on quality work; nowadays watches have become mass-produced articles that can be manufactured more cheaply abroad. However at present nearly all sectors of industry are represented in the Jura.

French-Speaking Jura

The Jura is predominantly a French mountain range. This is true in the sense that the major part of the mountains—in particular its southern and north-western outspurs—is situated in France. The southern Folded Jura, the Tableland Jura and the Franches-Montagnes as a small part of the Plateau Jura together constitute the Swiss Jura. At one time in history the German language, coming from the east, penetrated into this French-settled mountain system.

Four cantons share in the French-speaking Jura. Whereas the Vaud Jura and the Bernese Jura are both parts of large political units covering several macro-landscapes, the Canton of Neuchâtel is a Jurassic canton. This is true also of the new canton of Jura which has been hived off the canton of Berne. Whereas the Vaud Jura is an organic part of its canton, the Bernese Jura differs from the rest of the canton in linguistic, cultural and religious respects.

In 1815 the canton of Berne was given the prince-bishopbric of Basel and the territory of the Bernese Jura by the Congress of Vienna, in compensation for its lost possessions of Vaud and Aargovia. The northern Catholic districts of Porrentruy, Franches-Montagnes and Delémont constitute the new canton, while the three southern, Protestant, districts of Moutier, Courtelary and Neuveville remain with Berne. The foundation of the canton is an important political

197

127–129 *Internationally famous quality products: the watch industry in the Jura, once predominantly a cottage industry, has had to adapt to the market. Manufacture of electronic chronometers.*

and constitutional event in the history of the Confederation. The new canton is given a progressive constitution which might well point the way to future revisions of the constitution in Switzerland. One would scarcely expect to find a settlement of big-city character on the heights of the Jura, at altitudes which normally support Alpine grazings and mountain forests—but a tragic event was to trigger off an astonishing development. One night in the spring of 1794 the prosperous village of La Chaux-de-Fonds was completely burnt down. By the morning 62 houses as well as the presbytery and the church were in ashes. One hundred and seventy-five families had lost not only their homes but also all their belongings. In this hopeless situation it was decided to rebuild the little watch-makers' township from scratch. The former untidy cluster of fire-risk houses gave way to a carefully planned town pattern. Wide streets, intersecting at right angles, created an almost American impression

127

128

129

which may not be particularly beautiful but reflects a certain vitality. The regular chequerboard pattern enabled the town to extend regardless of obstacles—which is precisely what happened in spite of the harsh climate. Alongside watch factories La Chaux-de-Fonds also has other industrial enterprises. Simultaneously a cultural centre has developed there.

The canton of Neuchâtel identifies entirely with the Jura, even though it is divided into two disparate parts. "Le vignoble", the vineyard, comprises the piedmont of the Jura along the shores of the lake, while "Les montagnes", the mountains, cover the upper part of the canton. The higher levels of the French-speaking Jura are characterized by major industrial centres which, astonishingly, have developed into fairly large townships in spite of their unfavourable position with regard to communications: Ste. Croix, Le Locle, La Chaux-de-Fonds, St. Imier, Tramelan. These are primarily watchmakers' towns and appreciable concentrations of industry. In size La Chaux-de-Fonds exceeds not only all other towns in the Jura but also some of those in the *Plateau* such as Fribourg and Thoune (Thun). All these townships are situated in a unique landscape whose beauty has suffered little over the course of the centuries. The first to extol the Jura scenery was the poet and nature-lover Jean-Jacques Rousseau (1712–1778) who describes the scene in his last posthumous work "Solitary Perambulations" (1783):

"I was on my own and moved deeper into the twists of the mountains; from tree to tree, from rock to rock, I eventually came to such a remote spot than which I had never seen a wilder aspect before. Tall firs and other trees, some of which had fallen from old age and were intertwined with one another, enclosed that spot; through a few gaps there was a view of steep cliffs and immense depths, such as I scarcely dared view lying on my stomach. The eagle-owl and the night-owl were calling from clefts in the rock, a few strange small birds by their presence somewhat moderated the terrible wilderness of this wasteland...."

Yet the solitary wanderer's ear also caught a familiar ringing noise from a short distance. "Filled with wonderment and curiosity I rose to my feet, pushed through some bushes towards the place whence the noise came, and in a hollow caught sight... of a hose manufactory. I cannot express the confused and conflicting commotion that I experienced in my heart on making that discovery.... Who indeed could have suspected to find a factory in a rocky cavern? Only Switzerland offers such a mixture of wild nature and human industry. The whole of Switzerland, in a manner of speaking, is but a city whose long and wide streets are lined with forests and intersected by mountains, and wherein the scattered houses hang together only by English gardens."

German-Speaking Jura

The eastern Folded Jura is shared by the cantons of Soleure (Solothurn) and Aargovia, while the Lägern, as its easternmost spur, reaches into the canton of Zurich, and in the north a small corner extends into the Laufon (Laufen) Valley. The Tableland Jura covers the northernmost fragmented part of Soleure (Solothurn), the canton of Basle-Land and the Frick Valley in the canton of Aargovia. The Randen range in the Canton of Schaffhouse (Schaffhausen) may be seen as the easternmost spur of the Tableland Jura—as a transition from the Jura to the Swabian Alb.

The Jura and its piedmont are the most important landscapes of the canton of Soleure (Solothurn). As elsewhere, the most southerly range of the Jura is also its highest, and the light-coloured rockfaces of the exposed anticline and of the combe of the Weissenstein are visible from a great distance. This mountain has become famous for the magnificent panaroma it offers of the *Plateau* and the Alps—exemplified in the panoramas in the chapter "Representation of the Alps". It is not therefore surprising that numerous convalescent homes as well as holiday and ski chalets are found there. The Weissenstein Sanatorium was established in 1828 as a treatment centre in conjunction with an Alpine pasture chalet. Above the cowhouses rooms were installed for patients with chest complaints, and air from the cow-houses was ducted to these rooms through openings in the floor. The sanatorium, moreover, offered its visitors milk, dairy products and herb cures. Its operation was replaced in the 20th century by an intensive flow of visitors which opened up new opportunities for a livelihood in the mountains.

The Soleure (Solothurn) writer Josef Reinhart (1875–1957) described the ambassadorial city at the foot of the Jura as follows:

"We could call this Aar city by yet another name, should we wish to do so—the Jura city. It huddles close to the blue mountain, almost as if seeking protection against a threatening thunderstorm, against cold wintry winds. The Soleure citizen without his mountain? Unthinkable! It is not only that the mountain and the forests at its feet fuel his big tiled stoves, that they once provided coal for the blacksmith's hearth and for the pressing iron, not only that the white, yellow and dove-grey Jura stone supplied the building blocks for the churches, bastions and burghers' houses. No, the Jura is the Sunday venue of the past and the present. Proudly the Solothurners stand up there, above the fields or in front of the ancient Weissenstein sanatorium, looking down on their beloved township, over the rich villages with the factory smokestacks, and across the rich farmland, until their eyes shine with the pure splendour of the snowy peaks."

The landscapes of the canton of Basle-Land bear the imprint of the Tableland Jura: Broad, box-like valleys alternating with wide plateaus. The sheer slopes between—covering vertical differences of up to 300 m (1,000 ft)—are wooded. The valley floors and the tableland

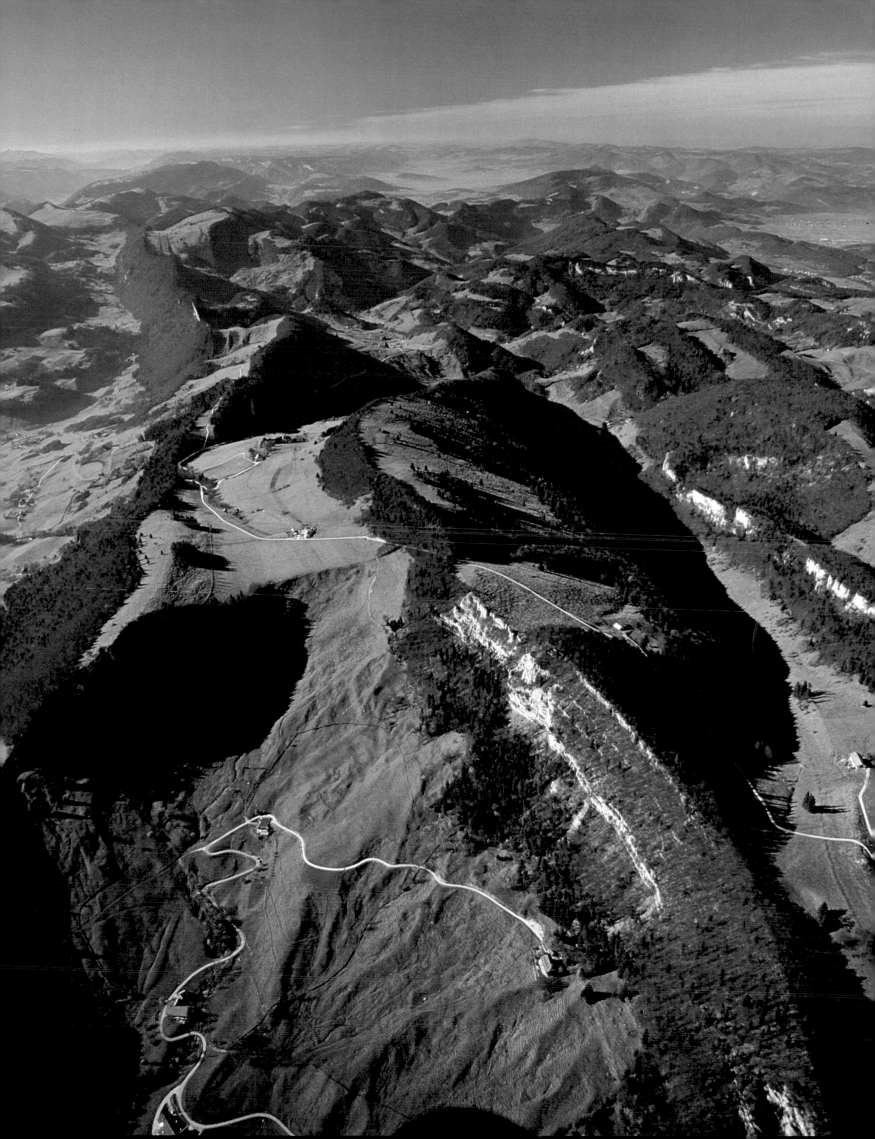

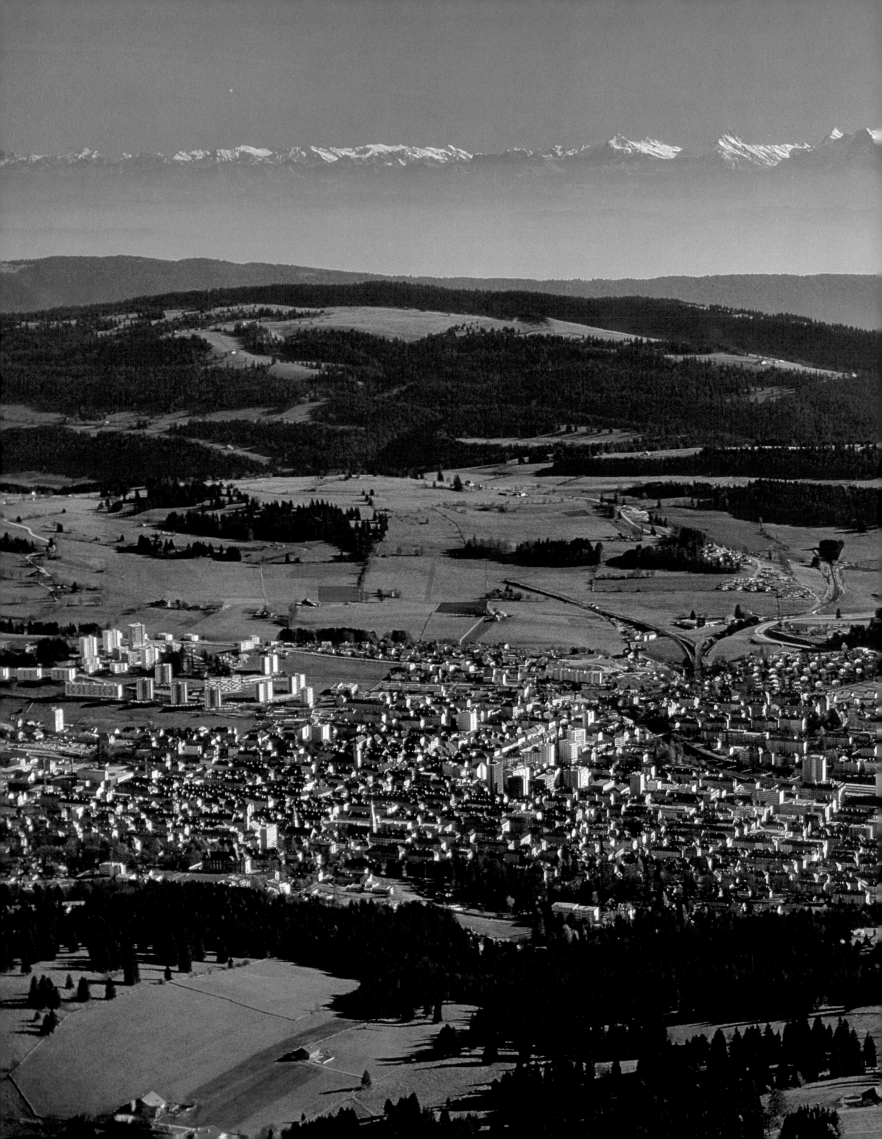

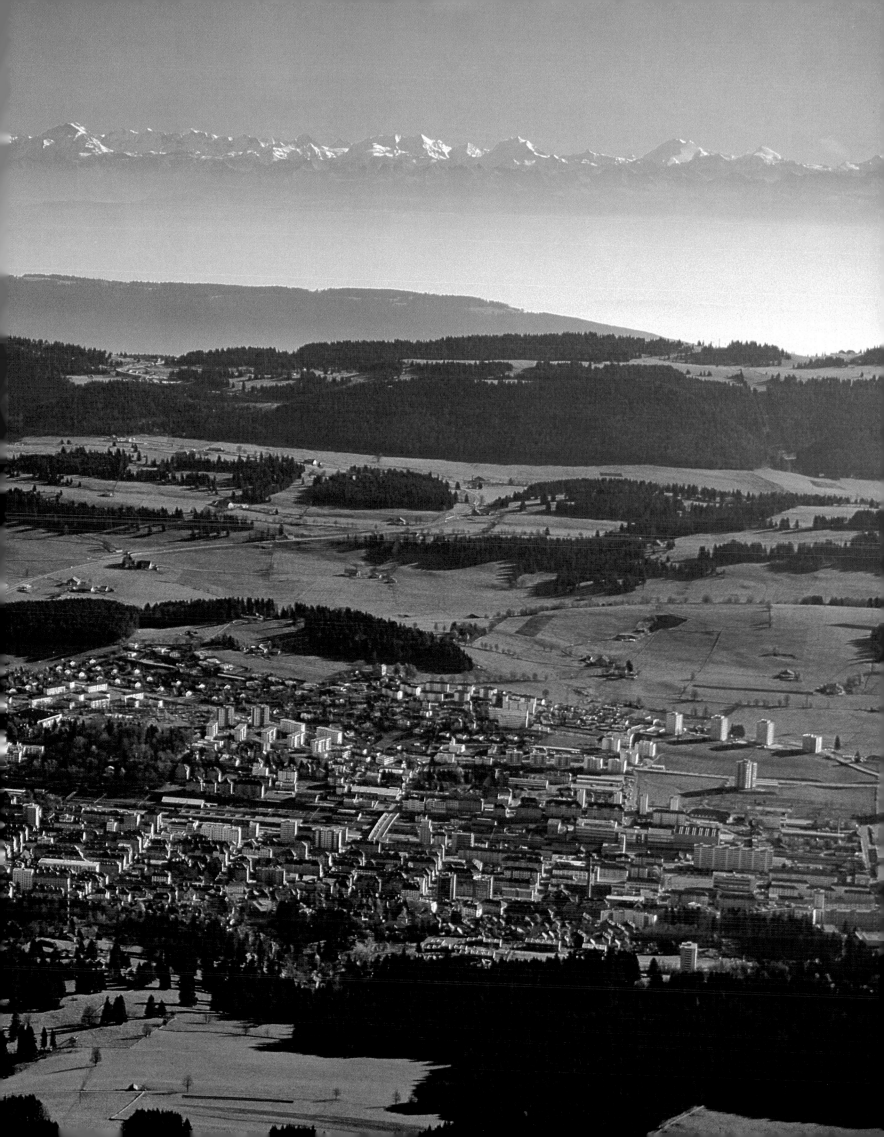

surfaces have been cleared; they are most suited to intensive crop growing and fruit farming. It is no accident that this is the home of the famous Basle cherries. An area once characterized by agriculture and cottage industries has developed into a highly industrialized canton. In the 18th and 19th centuries silk ribbon weaving flourished here, the manufacture of haberdashery. Three times a week the silk used to be delivered to the villages, the finished ribbons collected at the same time, and the workers' wages paid.

While the southern ranges and valleys are orientated towards the towns of the Jura piedmont, such as Soleure (Solothurn), Olten, Aarau and Baden, Basle is the centre for the entire northern part. The city of Basle no longer belongs to the Jura but to the Upper Rhine lowland, that wide valley that has slid down between Vosges and Black Forest. Basle, the only big city at the northern tip of the Jura, is at the same time Switzerland's northerly gateway—an important communications centre and, more particularly, the upper terminal of the Rhine river transport.

Basle owes its importance, especially its economic position, to this superb position. The chemical industry, for instance, relies on good communications, dependent as it largely is on coal and oil. As an important business and industrial centre Basle has an ample supply of jobs; as a university and research centre it develops a lively cultural activity. It is no accident, therefore, that the planning region of Basle—the catchment area of the conurbation—embraces not only the cantons of Basle-City and Basle-Land but also parts of the cantons of Berne, Soleure (Solothurn) and Aargovia. The "Regio Basiliensis", however, also extends into the French Upper Alsace and into the German southern Black Forest, since planning of this enormous catchment area demands international co-ordination.

Many a famous native of Basle has carried the city's reputation out into the wide world. Nostalgically they all look back on their ancient picturesque city in the Rhine bend, no matter where they may find themselves. The historian and diplomat Carl J. Burckhardt (1891– 1974) in his "Discourses and Notes" (1952) said:

"I regret that I have so little opportunity to refresh the image of Basle that I carry within me. My mental picture of the city snuggling admist hills, valleys and lowland, is ever-present to me, clearly and plastically, and I can, in my mind's eye, step out in the late morning from the cloisters of the Minster and stand in front of the barbarian Modern School, that presumptuous temple of education, and quickly doff my hat because some dignitary is passing by, or I can, in my mind, stand in the small park by the Lohnhof and St. Leonard's Church, and see the spires of the Minster glow red in a strange golden and blue light and at the same time hear the shouts of the little boys running out of the military school on the Heuberg, flinging challenging words at one another in the unmistakable local idiom."

130–134 A variety of Jura landscapes: the steep slopes are wooded, both valleys and high ground support fields, meadows and grazing land. View to the west across the Soleure Jura (130). Cherry trees in blossom in the Basle area (131). In a dip of the folded Jura lies the modern industrial town of La Chaux-de-Fonds (132). Winter magically transforms the mountain forest (133). The basin of La Brévine in the Neuchâtel Jura, where temperatures of −40°C (−22°F) are nothing unusual, is known as «Switzerland's Siberia» (134).

209

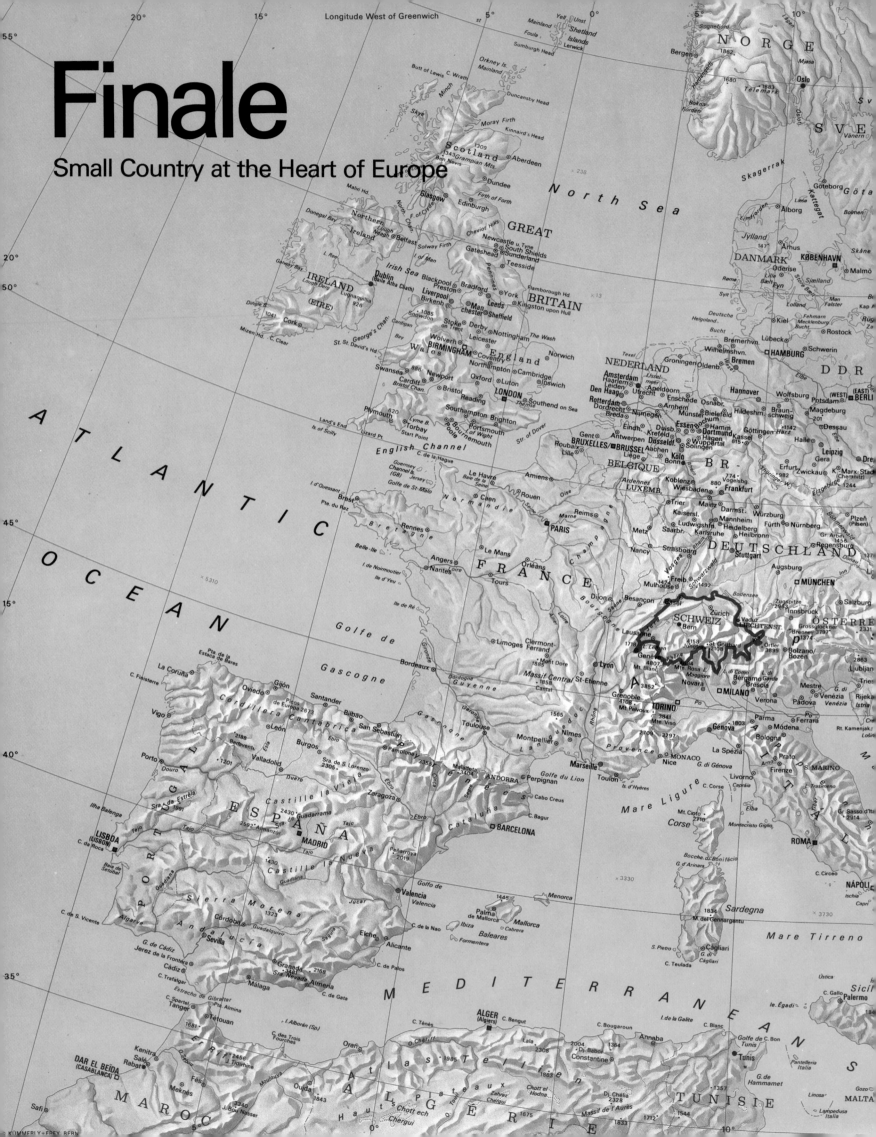

Finale

Small Country at the Heart of Europe

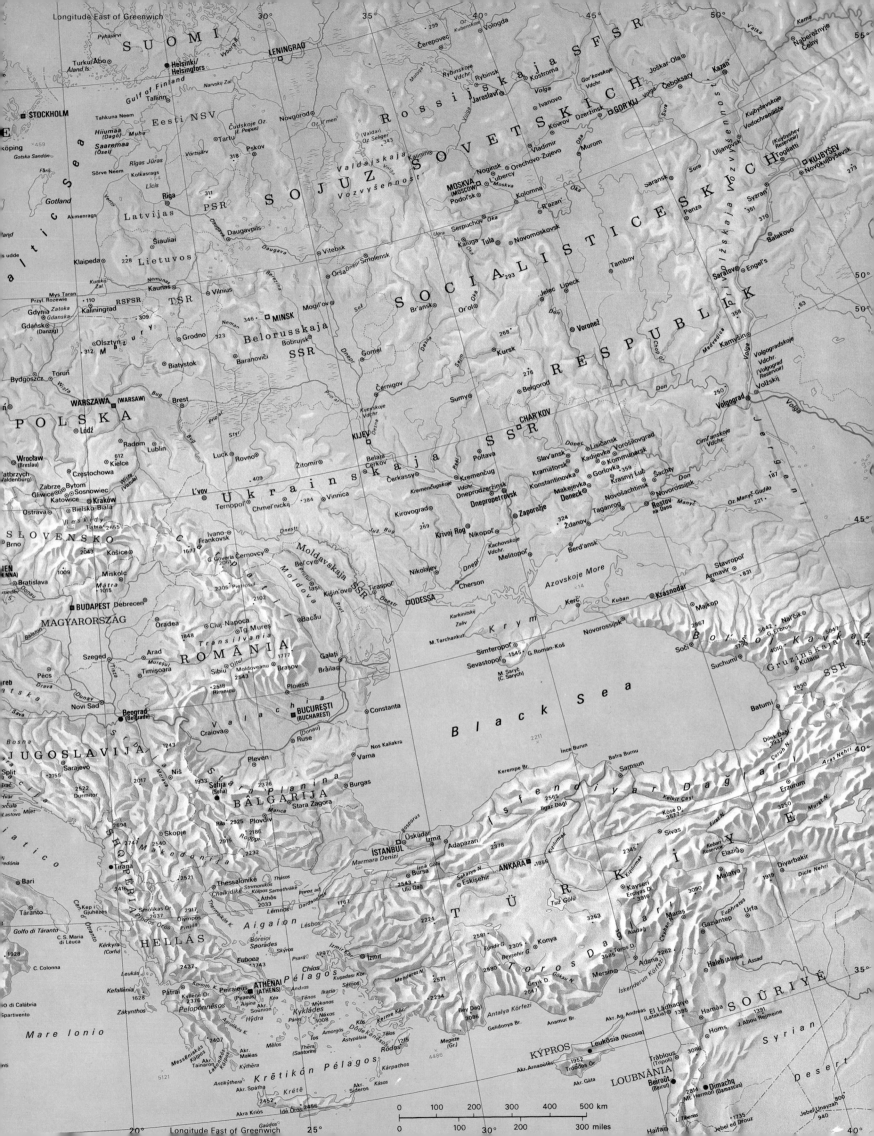

Key Position in a Continent

Switzerland lies at the centre of Europe. This continent is bisected by a huge mountain system. The Alps themselves cover an area of about 180,000 km² (69,500 sqare miles); of this total Switzerland possesses nearly one-seventh. But far more important than its share of the area is its position on the north-south communication axis, between Germany and Italy, between northern Europe and the Mediterranean zone.

Although nature has not lavished on Switzerland either mineral wealth or a climate or terrain suitable for agriculture, its position yet represents a very important asset. The Swiss have always ensured for themselves a substantial part of the transit traffic through the Alps. With their glacis policy the Confederates pursued the objective of controlling not only access inside the country but also the "outer ramps" of the passes.

Switzerland's warlike conflicts with its neighbours have often been over just these Alpine crossings, representing as they did a vital basis of the existence of its mountain people. Thus the Confederation succeeded in utilizing its position among the Alps and in Europe both politically and economically. The importance of Switzerland's role has been outlined by the geographer and author Emil Egli in his geographical work "Switzerland" (4th edition 1970). He says:

"Instances to the contrary cannot essentially weaken the assertion that, as a whole, our national frontier is a monument to a wise border policy. Above all it may be pointed out that Switzerland's frontier, by embracing the central Alpine passes, has been elevated to a line of European interest, a defensive line guarding coveted and vulnerable natural and political assets. These natural roads are, up to a point, a European cultural heritage. Their guardian can only be a servant of European peace if he is a neutral guardian.... In Swiss hands an Alpine pass is held in trust. And Switzerland's armed neutrality is, for the general staffs of the European countries and also for the totality of Europe, a calculable factor, one that must and can be taken into account."

That situation is exposed, as history has repeatedly demonstrated. What Switzerland has to defend, however, is not only its key position in the Alpine mountains but also the living space of a small country with all its—however modest—economic foundations. An offensive military force (throughout 200 years it was the strongest in Europe) has become, since the 16th century, a defensive army. In between there was a phase when the military prowess of the Swiss was also an export article. The mercenary service which existed from the 16th until the 19th century, had a double purpose. On the one hand it relieved the population pressure in the country-which was unable to feed all its inhabitants—and on the other it ensured that welcome financial assets flowed back into Switzerland.

National defence today is concerned with the protection of Switzerland and its values in the present world, including in particular inde-

pendence and neutrality. The latter originated from the weakness of the Old Confederation, due to its structure as a federation of states; not until the 19th century did it become a principle of the new Federal State.

"Armed neutrality is the means of preserving one's freedom in foreign policy. Without an independent foreign policy there can be no true freedom at home. The citizens of a satellite state cannot shape their lives the way they want. That, after all, was why the perpetual alliance of 1291 was founded. The battles for freedom of the Old Confederation were rarely, at first, concerned with conquests but instead with repulsing those enemies who were threatening the country's independence."

This was written by Adolf Guggenbühl (born 1896), a lawyer and journalist, whose life's work was dedicated to the preservation of the Swiss way of life, in his book "The Swiss are Different" (1967). This then is the justification for the existence of the Army.

Switzerland's readiness to defend itself is also illustrated by the fact, nowadays unique in the world, that a serviceman keeps his uniform, his equipment, his weapon with pocket ammunition, at his home.

Critical comment on the Swiss Army rarely concerns the justification of the armed forces as such but more often its structure. Even an army designed to defend a democracy must, so it appears, be undemocratic in its whole character. The Soleure (Solothurn) author Peter Bichsel (born 1935) has this to say in "The Swiss Man's Switzerland" (1969):

"We think of ourselves as sober. I should like a sober Switzerland. If our Army were a sober affair I might reconcile myself to it more readily. But the Swiss does not learn to handle his weapon for an emergency but for its own sake. We do not primarily regard our Army as a necessity, let alone as a necessary evil, but we love it.

135 ▷ *The gateway to the great world: it is through Basle and its various means of communication (railways, highways, motorways, river navigation, air communications) that a large part of the international passenger and goods traffic passes. In the foreground the Bruderholz forest, in the background the plain of the Upper Rhine, shared by France (on the left, with the airport of Basle-Mulhouse) and Germany (on the right, with spurs of the Dinkelberg).*

▽ *Mountain pass policy of the Old Confederation: campaigns of conquest secured the southern approaches to the principal Alpine crossings.*

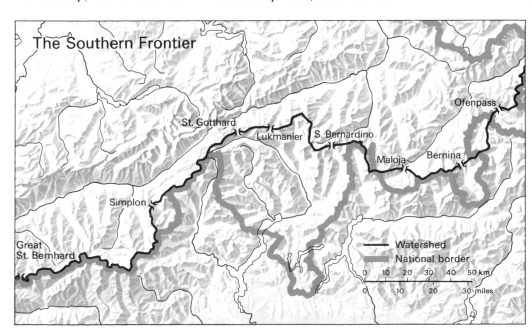

The Southern Frontier

Ofenpass
St. Gotthard
Lukmanier S. Bernardino
Maloja Bernina
Simplon
Great St. Bernhard

—— Watershed
━━ National border
0 10 20 30 40 50 km
0 10 20 30 miles

It is not sober, it is drunk with enthusiasm. We are convinced that it is an educationally valuable institution and that it discharges far more purposes in times of peace than merely preparation for an emergency.

At the recruits' school a Swiss youngster becomes an adult. It does everyone good, they say. All through his life one can spot a man who has not been through it, they say. The recruits' school thus becomes a seventeen-weeks ritual of manliness and maturity."

A Small Country in Search of its Destiny

If a cultural group is not backed by a "great nation" there is bound to be a perpetual search for a national sense of purpose and direction. If, moreover, a nation is linguistically and culturally fragmented, additional problems arise. And to many people this geographical mini-scale suggests the danger of sliding into provincial mediocrity. But not every outspoken critic of his native country questions

Switzerland's justification to exist in terms of principle. Mostly such criticism merely reflects the debate about such concepts as "homeland", "native land" and "nation". The author Kurt Guggenheim (born 1896) devotes his "Homeland or Domicile?" (1961) to the writer's inner struggle with these problems: "Asked what identifies the Swiss writer among German-writing writers, I would answer: 'The fact that a Swiss writer at some point in his life, faces the issue of Switzerland.' This confrontation seems inevitable. Sooner or later the Swiss writer will become aware of the special, particular situation of his native country with which his own special particular situation is linked. In doing so the Swiss authors of our century carry on an old-established tradition."

That is why there is an infinite number of critical publications about Switzerland, its inhabitants, its institutions, its authorities, its system of government, its national defence. They all testify to the efforts of a

136/137 *A country ready to defend itself: deep inside the mountains are the control points of the «Florida» surveillance system (136); mountain troops have to face the rigours of snow and ice (137).*

137

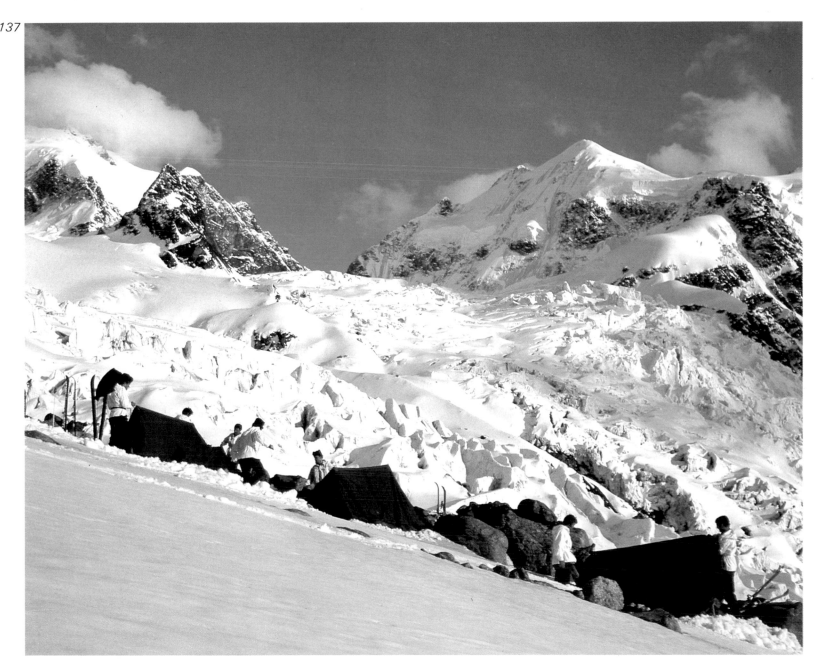

Here the waters divide: on Piz Longhin in the Grisons originate the waters flowing into Rhine, Danube and Po.

small country not only to formulate its justification to exist, but also to find its own national identity. The spectrum of titles reflects the multiplicity of ideas, emotions and intentions of the authors: "Attention, Switzerland!" (Max Frisch and Luzius Burckhardt, 1955), "Malaise in a Small Country" (Karl Schmid, 2nd edition 1963), "Helvetic Malaise" (Max Imboden, 1964), "Switzerland as an Antithesis" (Herbert Lüthy, 1969), "Switzerland above all Suspicion" (Jean Ziegler, 1976). But from abroad, too, there has been comment on the phenomenon of Switzerland: from America, for instance, comes Walter Sorell's "Europe's Small Giant" (1976), from France André Siegfried's "Switzerland, a Realization of Democracy" (1949), from the German Democratic Republic Jean Villain's "Switzerland, Paradise after the Fall" (1969).

"It would seem that the small country demands from its creative citizens a big Yes, a Yes to difficulties which are imposed also on the small country itself.... There is serious talk about a malaise in this small country.... The country is small. But its breathing space is the whole world. The frontiers are open. The world can radiate into the country, its own achievements can radiate outwards. There are great areas whose frontiers are closed. What then is great—and what small?" (Emil Egli in "And Yet—Switzerland's Hope", 1977).

The Natural Framework

An Alpine country in Europe is something like an island. Although the continent is by no means particularly flat, the Alps nevertheless are the only genuine high mountain range in Europe, dividing such disparate zones as northern and central Europe on the one hand and the Mediterranean zone on the other.

The climatically determined differences have their effects on numerous aspects—on vegetation, on the fauna, on people, on language, culture and history, on economic conditions—all these differ from one side of the Alps to the other.

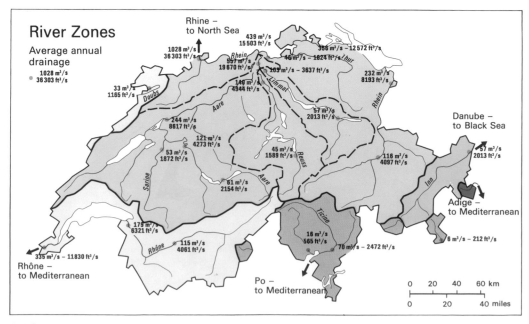

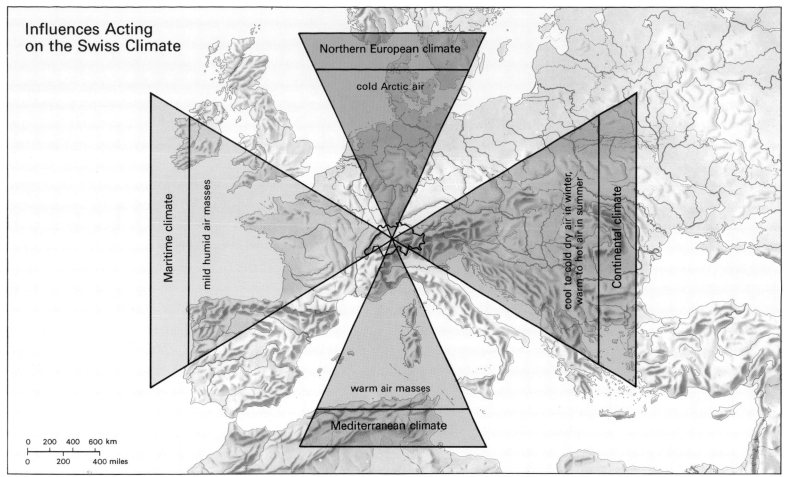

Influences Acting on the Swiss Climate

Northern European climate

cold Arctic air

Maritime climate

mild humid air masses

cool to cold dry air in winter, warm to hot air in summer

Continental climate

warm air masses

Mediterranean climate

| 0 | 200 | 400 | 600 km |

| 0 | 200 | 400 miles |

138

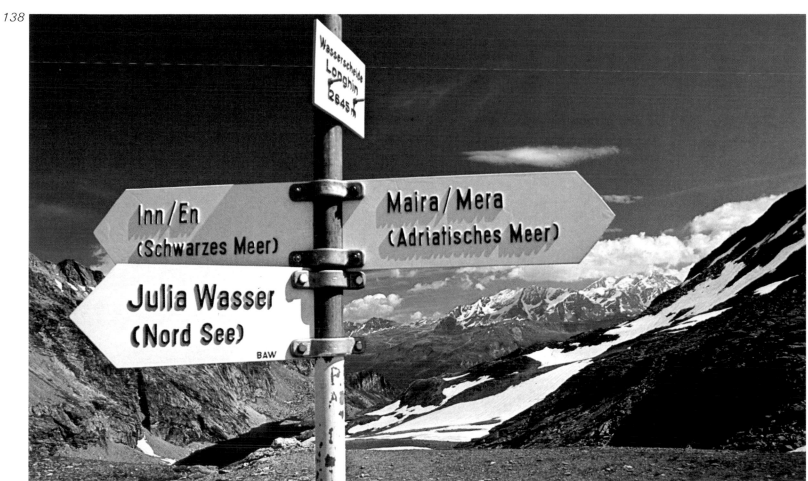

Wasserscheide
Longhin
2645 m

Inn/En
(Schwarzes Meer)

Maira/Mera
(Adriatisches Meer)

Julia Wasser
(Nord See)

BAW

139 ◁ *Every patch of fertile land is utilized: to reduce its dependence on foreign countries Switzerland, as a mountainous country, depends on intensive agriculture.*

▽ *The resident population of Switerland according to the 1970 census: a striking feature is the (then still) high proportion of aliens and the recent decline of the birth rate typical of industrialized nations.*

Switzerland's share of the Alps covers the centre of the mountain system and also comprises some of its highest elevations. The higher the mountains are, the more precipitation they collect. The precipitation descending on the Swiss Alps runs off in all directions of the compass: in the Rhine towards the North Sea, in the Rhone towards the Mediterranean, in the Ticino, as a tributary of the Po, into the Adriatic, and in the Inn, as a tributary of the Danube, into the Black Sea. In contrast to the Western and Eastern Alps the Swiss Alps are drained also towards the north. The Rhine is the only central European river originating in the Alpine region. The Rhine provides the Alpine country of Switzerland with a natural access from the north.

If one crosses the Swiss frontier anywhere in the Jura the same landscape continues into France. And yet the traveller will notice considerable differences. On the Swiss side of the frontier he left behind him intensively cultivated fields, luscious meadows and carefully fenced grazing land; on the French side he is struck by the absence of fields. Here the meadows are neglected and fallow predominates. What are the causes of these differences which may be observed also at other frontiers? They can hardly lie in the natural conditions since the French Jura is no higher than the Swiss, the country beyond the frontier is scarcely more inclined or less fertile. But whereas the Jura, measured by Swiss yardsticks, offers entirely favourable conditions for agriculture, the adjoining territory, from a French view-point, is only second-rate because that nation has at its disposal large acreages of far more suitable agricultural land. This fact illustrates Switzerland's handicap due to harsh environmental conditions.

Switzerland's agricultural production is relatively modest; it covers only something like 60 per cent of the resident population's food requirements. Supplies of foodstuffs, in consequence, depend on

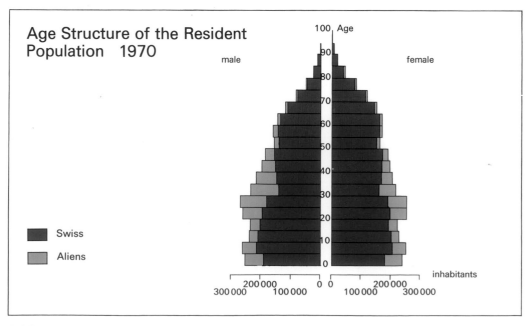

imports; but imports are possible only if other products are exported. The exportation of industrial manufactures as well as the earnings of the tourist industry—the money spent in Switzerland by foreign tourists—earn the country the foreign currency it needs for buying agricultural products abroad.

In this sense Switzerland is truly an island in Europe. Although—or possibly just because—it cannot entirely feed its population from its own soil it developed, over the centuries, into a considerable economic power. That is why the journalist Lorenz Stucki (born 1922) speaks of a "secret empire". In his book, under that title (1968), he unrolls the exciting and many-sided history of Switzerland's economic development:

"This contrast reflects an astonishing and in its way unique success story which is by no means accidental: its very handicaps in the natural prerequisites have forced this little country without access to the sea and without political-military power to make a huge economic effort, without which it would have had no hope of capturing a place in the sun. These economic efforts were directed towards upgrading cheaply imported raw materials into products of greater and greatest value, by the work of their hands and brains, and exporting them again with a profit. That required—both in foreign trade and in domestic industry, which can only achieve success in close symbiosis—the emergence of pioneering personalities who, shrewdly and persistently, by hard work and readiness to take risks, discovered and seized every opportunity to adjust themselves to a changing world and who, tough in their dealings, overcame countless difficulties and crises."

Switzerland is a small country. In area—disregarding miniature states such as Liechtenstein or San Marino—it occupies the third place from the bottom in Europe, and in terms of population the fifth last. At the same time, present-day Switzerland occupies, in Europe and in the world, a more important position than would be due to it on statistical grounds. It is an economic power to be reckoned with, it has a political weight that cannot be discounted, as an important financial centre it supplies the headlines—the "Gnomes of Zurich" are forever haunting the world press.

Fortunately its financial strength is not the only means by which Switzerland makes itself noticed in the international scene. Its spiritual force and its humanitarian objectives are other spheres which do not end at the national frontier. Culturally Switzerland is closely tied to its neighbours, in view of the fact that its various cultural spheres are downright dependent on a fructifying exchange with neighbours speaking the same language.

Economically the Confederation would probably never be able to exist on its own. It is unlikely ever to be able to supply all its own needs; it is not therefore viable in isolation. Its modest natural

Switzerland and Europe

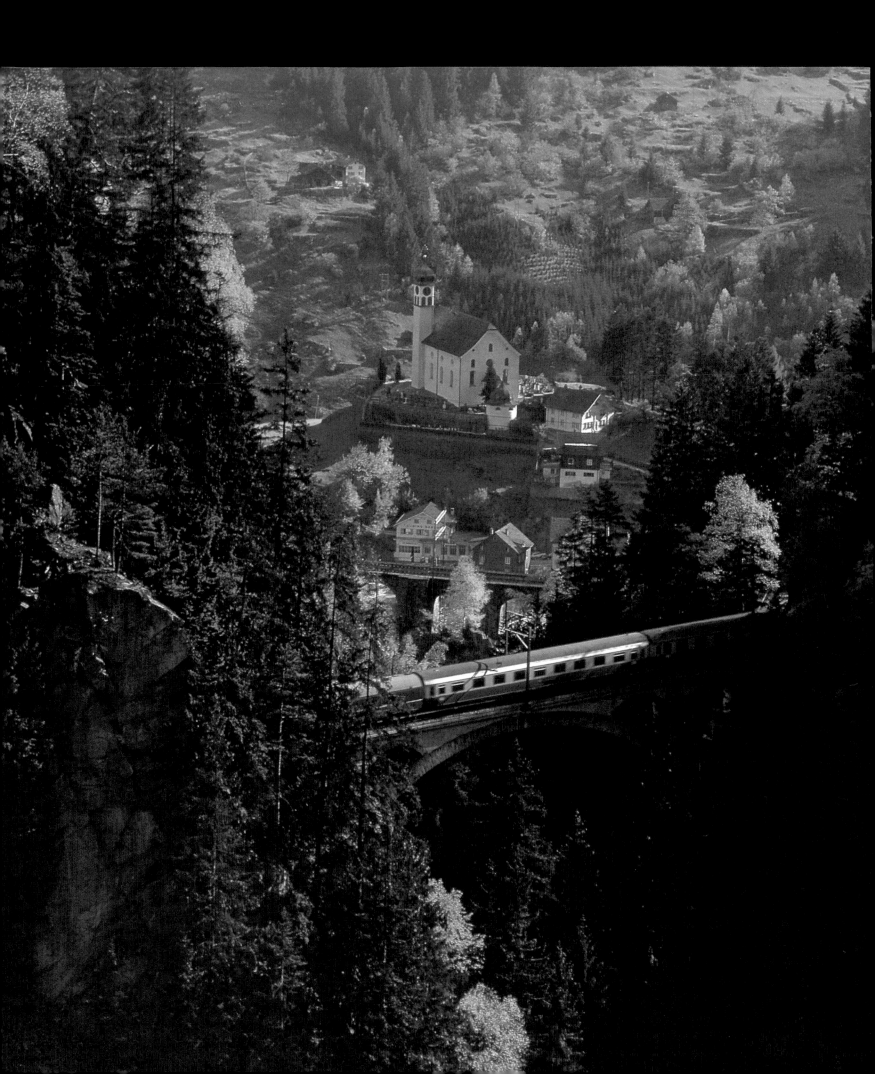

wealth has always compelled Switzerland to import raw materials and foodstuffs—at the same time it also needs foreign markets for its industrial and agricultural products. Its fate is therefore tied up with that of Europe and the world by a complex system of economic links. Ever since the Swiss defeat in the Battle of Marignano in 1515 the country's foreign policy has been characterized by neutrality. This attitude—combined with other considerations—naturally makes it more difficult for the country to join a Europe in process of unification. Although Switzerland participates in all economic unions it hesitates the moment the issue of political unification emerges. However, neutrality is a voluntary attitude; Switzerland could abandon it at any time. The Neuchâtel author Denis de Rougemont (born 1906)—his spheres are literature, ethics and politics—is deeply involved in the future of Europe. In his book "Switzerland—the Model for Europe" (1965) he actually proposes the "Swiss Confederation as a model for European federation":

"The reason is that Switzerland has a secret. It took me a long time, a lot of research, travelling and astonished homecomings to arrive at this realization. Will it be able one day to express itself by words or by deeds, if not indeed by the scream that one expects from it? It is here that the heart of Europe beats. It is here that Europe would have to make its avowal, take its treaty oath and constitute itself. Switzerland would then lay the foundations of its destiny within itself, true to its innermost nature, from its beginnings to its highest goals. That dream might become reality tomorrow, and it must become reality—but can it ever become reality if we remain silent? In spite of everything that holds us back, but at the same time thrusts us forward and places upon us an obligation, I shall believe with Victor Hugo: 'Switzerland will have the last word in history.'
But it will have to utter it!"

After all, nature has predestined Switzerland to be a transit country

▽◁ Arterial railroads linking the nations: the international trains passing Switzerland, the Gotthard route being the most important alpine traffic transversal.

▽ Traffic flow in the Middle Ages: Switzerland was a favoured transit country even then.

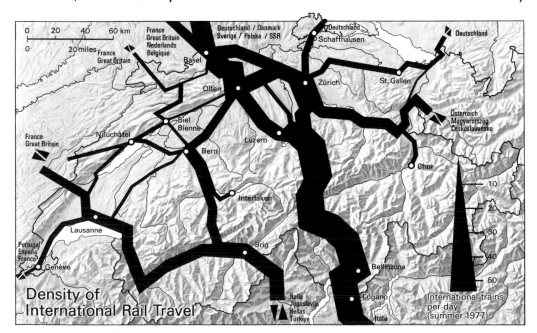

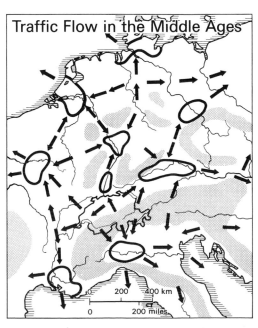

Traffic Flow in the Middle Ages

225

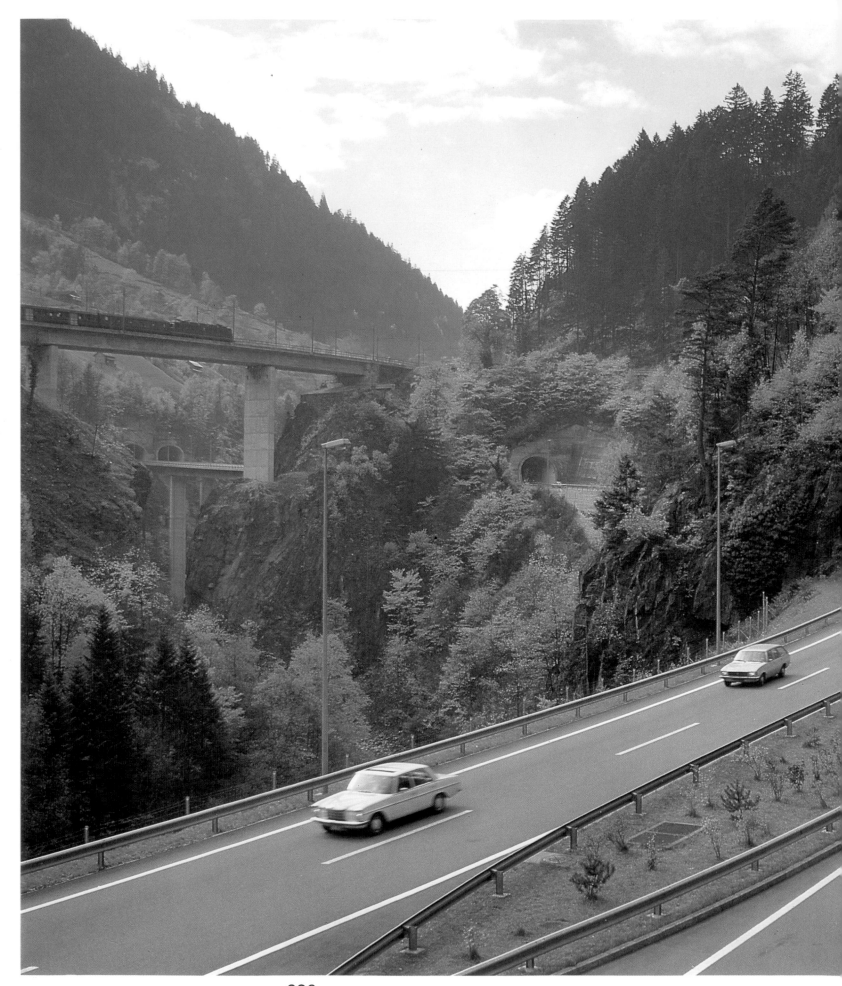

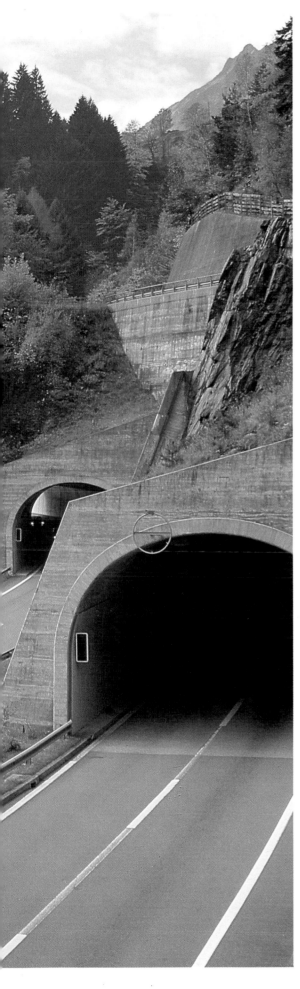

◁141 142

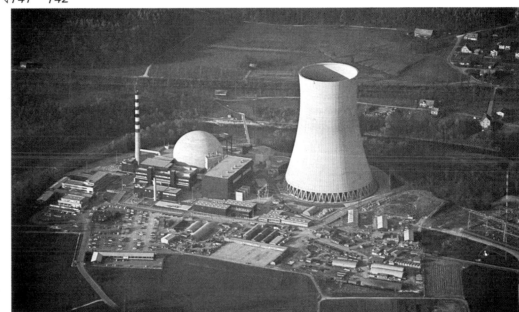

143 144

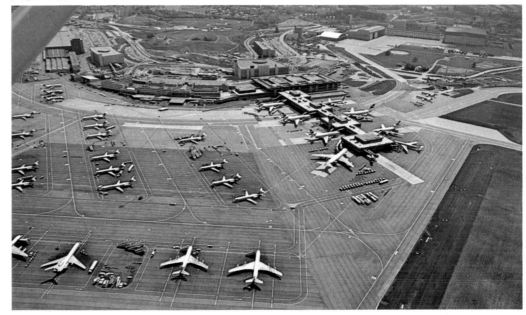

227

*141–144 Grand-scale technology in a
small country : the Gotthard motorway and
the Gotthard railway at Gurtnellen in the
Reuss Valley (Uri, 141). High-voltage
transmission lines on the Albula Pass in the
Grisons (142). The nuclear power station
of Gösgen in the Canton of Soleure
(143). Zurich international airport at Kloten
(144).*

*145 Historical events are commem-
orated by annual celebrations : the inhabit-
ants of Geneva commemorate the* Escalade
*of 1602, the « climbing of the city walls »,
when the Savoyards vainly attempted to
capture the city.*

Past and Future

between zones of great economic weight. It was discharging that function long before modern means of communications such as railways, the motorcar and aviation existed. Even in pre-Roman days axes of communications were emerging to link the centres in southern France, northern Italy, the Danube Plain, the Upper Rhine, the Rhine-Main triangle and Champagne with each other. Today the lines of communications are still the same, only the means and the scope have changed. Switzerland must now see to it that its traffic facilities are adequate to meet the demands, in order to ensure that this country continues to fulfil its task as the hub of Europe. At the same time this sector must be integrated into the overall economy without destroying the landscape substance as a foundation.

Switzerland has traversed a long road—what then still lies ahead? The origin of the Confederation was a complex pattern of interactions. The founding elements of Original Switzerland were gradually joined by others, step by step, and so the alliance grew in concentric circles. The Confederation was enlarged by conquests, purchases, acceptance of patronage and, above all, by the conclusion of new alliances. From that patchwork the modern Federal State eventually emerged in the 19th century. The Constitution of 1848 was the foundation for the new start; it was completely renewed in 1874, and another general revision may be expected before the end of the 20th century.

Yet what changes have the lives of the citizens undergone since the foundation of the Confederation! The modern age has presented the Swiss with many new achievements: technical progress has made their lives easier, their radius of action has greatly extended. Economic success has largely eliminated poverty and material hardships; prosperity has brought security and comfort.

But, in a world so greatly changed, what happens to living space? It is finite—compared with the growing number of inhabitants and also with the increasing share that every individual now claims of the living space available. The Swiss—over six million people—are increasingly living in detached houses; industry and trade clamour for more land, additional public parks are being created, and the area required for transport has to be continually enlarged.

In all this a disturbing aspect is the diminution of cultivated land, the loss of agriculturally valuable area. Thus, in the course of 25 years (1942–1967) Switzerland lost one-twelfth of that area. If the area concerned is marginal land in the mountainous regions then this is less disturbing than when fertile flat fields in the lowlands are built over. Whenever cities grow in size, whenever new residential districts spring up, whenever new factories or shopping centres are set up, whenever the communications network is extended—all this is almost invariably at the expense of the best agricultural land.

It is, therefore, probably indispensable for the state to involve itself

228

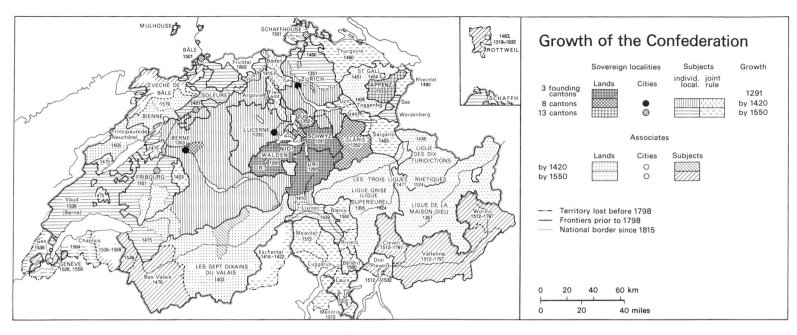

Growth of the Confederation

Sovereign localities

Lands | Cities
3 founding cantons
8 cantons
13 cantons

Subjects
individ. local. | joint rule

Growth
1291
by 1420
by 1550

Associates

Lands | Cities | Subjects
by 1420
by 1550

–·–· Territory lost before 1798
—— Frontiers prior to 1798
········ National border since 1815

0 20 40 60 km
0 20 40 miles

145

229

in the protection of the living space and in safeguarding a dignified existence for the individual. The state must also see to it that the foundations of such a life and the country's landscapes can be handed down in good condition to future generations. These are the essential tasks of regional planning which, however, in Switzerland does not comprise economic direction by the state or the general nationalization of economic life. It is restricted to "protecting the natural foundations of life such as soil, air, water, forest and landscape" and to "preserving or creating habitable, harmoniously shaped settlements". It is perhaps rooted in the traditions of Switzerland that such regional planning should strive to achieve "an appropriate decentralization of settlement" and to reduce "upsetting imbalances between rural and urban, economically weak and economically strong areas" (draft of the Federal Law on regional planning, published in "Raumplanung Schweiz" 2/1977).

146

Regional planning and the protection of the environment have become important public concerns at a time when the negative aspects of industrialization and affluence are making themselves painfully felt. An "Environment Club" rallies the country's most important organizations which direct their efforts towards the struggle for the preservation of an environment worth living in. This is not just a matter of air, water, soil, plants and animals but also of the living space created by man.

"Building itself—both in general, and increasingly, the longer we continue—has become an aspect of destroying the environment. Of course, everybody talks about the destruction of the environment—but they believe that this concerns only the aspects of water, atmosphere and refuse removal; no one mentions destruction through building." This was written by Rolf Keller in his challenging book

146/147 *Ecclesiastical and secular tradition: the Corpus Christi procession in the Lötschen Valley (Valais) is attended also by* Herrgottsgrenadiere *in their historical uniforms from the days of mercenary service.*

147

148/149 All Europe meets in Switzer-
land: modern winter sports would be
inconceivable without ski lifts or chair lifts
(148). A sunday in the Bernese Oberland.
The Kleine Scheidegg with the north face
of the Eiger (149).

148

"Building as Destruction of the Environment—Alarming Pictures of
an Un-Architecture of our Day" (1973).

The energy problem is one that is posed to all industrialized coun-
tries. For Switzerland it is especially pressing because native energy
sources are very scarce; they are practically confined to water pow-
er, whose yield can meet only 12 per cent of the total energy con-
sumption. Energy plays an enormous part in the life of modern man.
It not only provides him with greater comforts but, above all, in-
creases his productivity, in other words it multiplies human labour.
Only the employment of energy has made it possible to improve the
social position of the industrial worker.

Wood and peat, once upon a time, were important native fuels; in
the last century, however, they were outstripped by coal. Since the
beginning of the 20th century electricity has been advancing from
success to success. Development of hydro-electric power stations
was concluded in Switzerland in the early seventies. Altogether 430
major hydro-electric power stations have been in operation since
1972 and this very largely exhausts all potential sources. In retro-
spect, while, on the one hand, tribute has to be paid to the gigantic
achievement of building these power stations inside and outside the
Alpine area the drawbacks, on the other hand should not be over-
looked. The High Alps in particular have become a landscape of
advanced technology. Over long distances mountain rivers now
carry but a fraction of their water, riverside meadows have dried up,
waterfalls have gone dry, ground water has failed, valley floors have
turned into steppe. Economically the mountain valleys concerned
benefit from power station construction; they collect fees, jobs have
been created, and an infrastructure financed by the electricity com-
panies—roads, water and power supplies and many other things—
has been made available to natives and tourists.

If no further hydro-electric power stations can be built then any in-
crease in power consumption in Switzerland must mean an increase
in the share of liquid fuels. But this already amounts to three-quar-
ters and the question of alternatives has become pressing. A number
of nuclear power stations are already in operation. No other topical
issue causes so much upheaval and so inflames attitudes as that of
nuclear power stations. In principle new methods will probably not
be realizable until the end of the century and it is possible that so-
called medium technology—solar energy, heat pumps, biogas, etc.—
together with a restriction on consumption may solve the power
bottleneck.

Environmental protection in all its aspects is primarily concerned
with the preservation of the landscape as the real raw material, as
the basis of an important sector of the economy, as the substance of
recreational activities and tourist traffic. Tourism during the second
half of the 20th century is characterized by mechanization and mass
patterns. Yet the hectic and one-sided way of life of the highly de-

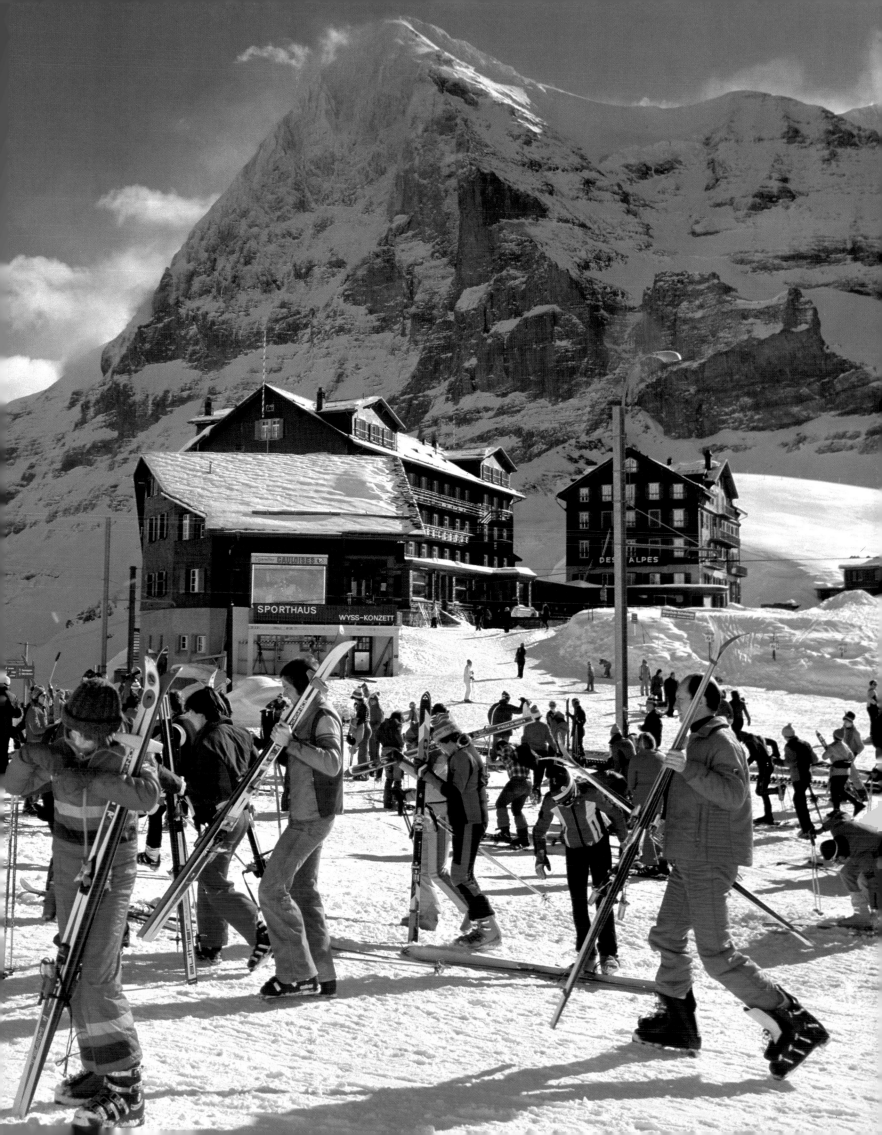

Restaurant zum Löwen

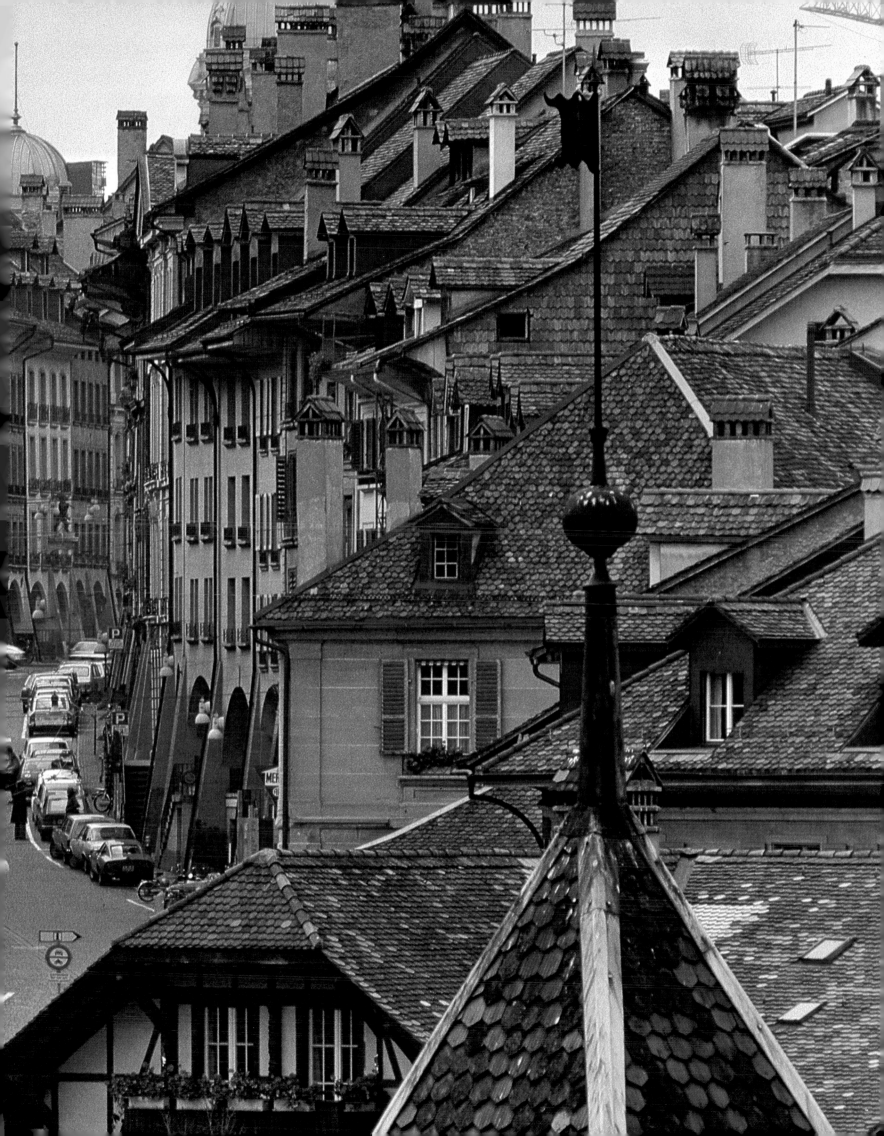

veloped industrialized nations demands peace and recuperation, balance and natural surroundings, unspoiled and romantic landscapes. Often, however, the visitor in search of relaxation expects at least a minimum of the comforts that have become part of his everyday life.

There is a danger that tourism may find itself caught in a disastrous vicious circle. The more unnatural everyday life in the city becomes, the greater will be the demand for compensating relaxation in an attractive landscape. The more people become aware of that need the greater will be the rush to the recuperation areas, the more massive will be the infrastructure of tourism, the more numerous the hotels and holiday apartments, the more important the communication facilities, and the greater the pollution of the environment—in short: the more alarming will be the civilizational problems from which the tourist is trying to escape. Professor Jost Krippendorf, a tourist traffic expert, discussed this trend in a distrubing report entitled "The Landscape Devourers. Tourism and Recuperation Landscape—Curse or Blessing?" (1975). After sketching the above trend he put forward 23 "theses for a desirable future", outlining ways in which landscapes might be opened up and preserved for the urgent functions of tourism.

"We must understand modern tourism as a mass shuttle between town and country, as a temporary 'flight from the city to the country'. Obviously the future satisfaction of this mass demand for recuperational and vacational opportunities comes up against a rigid boundary: the size of the open country is finite. The stream of tourist refugees from the cities pours into the open country. The flood keeps growing but the landscape cannot grow; it no longer absorbs the tourist masses, it becomes flooded and is destroyed. That is the central problem of present-day tourist policy. How can the object of tourist demand be saved from inundation and destruction while, at the same time, the growing demand is met?"

Recreation and tourism live by the landscape; it is their substance. Switzerland's cultivable landscapes are therefore a national raw material that has to be husbanded in the most economical way possible. This applies both to recreational areas in the vicinity of the towns and to the classical tourist regions of the Alps; it applies as much to newly opened tourist centres in the mountains as it does to scarcely discovered recreational landscapes in all parts of the country.

All the landscapes of Switzerland can and must discharge recreational functions. While the *Plateau* and the Jura are recreational areas mainly for their neighbourhood, the Alps are visited by an international clientèle. Many mountain holiday centres have enjoyed an international reputation for many centuries. Thus Leslie Stephen (1832–1904), an English professor of theology from Cambridge, in his well-known book "Playgrounds of Europe" (1871), described

150–153 *The future is rooted in the past: the market is the traditional form of buying and selling merchandise. The township of Laufon (Laufen) in the Jura (150). A well preserved townscape in Berne, the Federal capital. Gerechtigkeitsgasse with the tower of the Nydegg Church (151). Where eagles used to soar hang-gliders now practise their sport. The Parpaner Rothorn, not far from Coire (Chur) (152). Autumnal idyll in the Upper Engadine (153).*

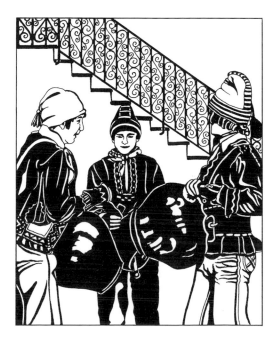

241

the Alps as an area of recreation and a meeting place for an entire continent.

The small Alpine country of Switzerland has long adopted a political neutrality which facilitates its humanitarian engagement on an international scale. The relations of industrialized countries with the countries of the Third World invariably pose serious problems. A relatively rich country such as Switzerland, which lives largely by the processing of cheap raw materials—many of which come from developing countries—into expensive industrial products must not stand aloof from endeavours to bridge the gap between poor and rich nations. Solidarity not isolation—that must be the slogan if small countries and great powers, industrialized nations and development areas, countries devoid of raw materials and countries rich in raw materials want to continue to survive on this "spaceship earth". But even a peaceful country, in which such institutions as the Red Cross were founded, has to face domestic argument time and again on such issues as understanding for the hardships of distant nations. Here as elsewhere there is a need for effective information work to ensure that a contribution, however modest, is made to urgent worldwide development efforts. In particular, it should be demonstrated in a convincing manner that the need is not only for aid but, more importantly, that the unilateral economic dependence between developing and industrialized countries can be transformed into a form of partnership.

Switzerland, certainly, is not only a tourist paradise just as it is not only an industrial nation. It is a viable state at the centre of a densely populated continent, economically dependent on its own resources, politically a unique and complex organism. It is endowed with a wealth of raw materials which cannot be produced in mines.

What part has a small mountainous country to play in a world that is, in some respects, highly developed but often marked by cruel contrasts? What are the chances for a small, culturally and linguistically divided nation to hold its own in a world dominated by great powers? How, finally, can a small tradition-conscious country survive in a fast-living internationalized community of world citizens?

The answers to these questions on the future of Switzerland may be found in the relationship which its inhabitants are continuously developing with their living space. The landscapes are the foundation of all economic activity, they not only mould the character and mentality of their inhabitants but also their opportunities for spiritual and material development. What is going to happen to the mountains, hills and valleys at the heart of Europe will ultimately be determined by the Swiss—as inhabitants of an Alpine country.

Nature and Buildings

Rural buildings testify to their occupants' relationship with the surrounding landscape. Nature supplies the building materials and with its environmental conditions determines the outward framework, while culture and tradition give the buildings their shape and character. Switzerland, at the crossroads of European civilizations, is characterized by an impressive multiplicity of original architectural types.

In German-speaking Switzerland timber is the predominant building material. On the northern flank of the Alps straight coniferous logs can be used; there the rule is log-cabin construction with the beams jointed at the corners. Wherever the available timber is crooked hardwood the construction is by means of upright posts as load-bearing elements. If horizontal timbers are used for in-fill the result is a post-and-beam structure. The ancient high-stud or post roofs—with a vertical post supporting the roof-tree—reflect a simple tent construction. In the relatively dry *Plateau* the steep roofs were covered with straw. Originating in the Emmental, the *Ründi,* a curved wooden canopy projecting over the gable area, spread far beyond the Berne region and has become a characteristic of massive rustic architecture. A *Plateau* farmstead included, in addition to the main building—the *Dreisässenhaus* with living accommodation, threshing floor and byre/stabling—a number of outbuildings.

The store is used for the storage of foodstuffs, implements and treasured possessions; the *Stöckli* is a small residential building for the parents living in retirement. The north-eastern Swiss *Plateau* is characterized by half-timbering. The bright in-fill areas contrast strikingly with the often ornate beam construction. This method of building developed in the cities from the Gothic to the Renaissance period and was later transferred to rural buildings.

In the French-speaking Jura stone buildings have replaced the earlier timber houses. Small windows and flat-pitched roofs testify to the occupants' adaptation to the harsh climate. Log-cabin construction, on the other hand, is found in the Fribourg and Vaud Alps. In the Valais the type is invariably mixed; in the central part of the canton the kitchen part is stone-built, as in the Upper Valais, whereas the living-room part is in log-cabin construction: this type is known as the Gotthard house. In the tower-type multi-family houses of the Valaisian mountain villages there is an ancient tradition of floor-by-floor ownership, with property relations being governed by custom and usage. The Lake Geneva area is characterized by the tiled roofs of the vintners' houses, betraying a Roman legacy. Cellars and wine-press rooms discharge economic functions. The vintners' villages acquire an urban character through the patrician-looking terraced houses.

The Alpine areas of Italian-speaking Switzerland lie in the gneiss zones. This rock, because of its fissibility, is suitable also as a covering material. The façades consist of undressed stone walls, with only the window openings being plastered. In the upper Ticino valleys, such as in the upper Mesocco Valley, the Gotthard house with its timbered living-room part occurs, whereas in the Bregaglia and the Poschiavo Valleys stone-clad log-cabin structures—known as Engadine houses—are widespread. In the limestone zone of the Sottoceneri the Lombard type of homestead is covered by Mediterranean tiles—living quarters and farm buildings are grouped around an enclosed courtyard.

The predominant style in Rhaeto-Romance Switzerland is the Alpine log-cabin construction. Surselva and Oberhalbstein are characterized mainly by the Gotthard house, whereas in the Engadine the log-cabin structures have been covered with a stone skin ever since the 17th century, as this offers protection against fire and cold. Behind the large round-arched portals lies an entrance yard. Oriel windows and external wall decoration—scratched ornaments and sgraffitto—lend the Engadine house an elegant appearance.

243

Villages and Towns

Stockbreeders tend to live on isolated farms while crop farmers prefer a village. Agricultural circumstances thus shape the pattern of rural settlements. But the towns did not arise accidentally either: most of them were founded either in antiquity or in the Middle Ages at a location specially selected for the purpose. Often they were situated at a landscape boundary as transshipment centres or markets.

 The Jura, the Upper *Plateau* and the Alps of German-speaking Switzerland are characterized by scattered settlements; in the Lower *Plateau* cluster-type or longitudinal villages are the rule. In the valleys and lowlands we find the towns whose origins often date back to Roman times. With the exception of a few Church foundations, such as Basle, Lucerne, St. Gall and Coire (Chur), they are predominantly secular planned settlements of the Middle Ages. These include the town system founded by the Zähringen dynasty, embracing Morat (Murten), Fribourg, Berne, Thoune (Thun), Burgdorf and Rheinfelden as original foundations and Soleure (Solothurn) and Zurich as enlarged cities. Numerous other families were also active as town founders, as for instance the Counts of Froburg (Aarburg, Olten, Liestal) and the House of Habsburg-Austria (Brugg, Baden, Bülach, Sempach). Since the 19th century many a village has, as a result of industrialization, developed into an urban settlement.

 The higher-lying areas of French-speaking Switzerland are less marked by scattered settlements than those of German Switzerland. In the valleys of the Jura and the Valais, as indeed throughout the *Plateau*, villages predominate. Utilization of the different levels of altitude resulted, especially in the Lower Valais, in a highly complex annual pattern of migration of the mountain population between the vineyards of the Rhone Valley, the fields and meadows of the lateral valleys and the Alpine pastures above the tree-line. The shores of lakes Geneva and Neuchâtel are characterized by picturesque wine villages. Among the towns the majority are ecclesiastical foundations: Geneva, Lausanne and Sion are bishops' sees. The Bishops of Lausanne founded towns on the *Plateau,* those of Sion founded towns in the Rhone Valley. Among secular town founders the House of Savoy (Rolle, Morges, Yverdon), the Counts of Geneva (Moudon), Neuchâtel (Boudry, Valangin) and Gruyère were particularly active. Here, too, modern developments have blurred the clear distinction between towns and villages.

 In Italian-speaking Switzerland individual farmsteads in permanently settled areas are virtually unknown. The houses invariably crowd together into hamlets and villages, with narrow little streets winding through these picturesque settlements, huddling as a rule around the church and bell tower. In the mountainous areas a migration between valley farm and Alpine grazing used to be the rule, but here, more than elsewhere, depopulation has now become painfully noticeable. Italian-speaking Switzerland comprises three towns, all of them in the Ticino. Bellinzona has, since time immemorial, owed its position to the traffic routes converging there. The Dukes of Milan built the fortifications which later fell into Confederation hands. Locarno had been settled long before Roman times; Lombard families ruled the city and extended it. Lugano, finally, is the biggest Italian-speaking conurbation in Switzerland. Even though this city was an object of tense rivalry between the Dukes of Milan and the Bishops of Como, it primarily developed as a Confederation city.

 The Rhaeto-Romance population lives in solid-looking villages which used to be organized in a quite specific manner, considering that the spatial pattern determined the organizational and social structure of the village community. Whenever houses change ownership, the rights and duties—e.g. in connection with cooperative well ownership or use of grazing—devolve to the new owner. Village bye-laws and specialization of village functions are typical of the Rhaeto-Romance population of Switzerland. In this they differ from the Valaisians who penetrated into originally purely Rhaeto-Romance areas and nowadays inhabit the upper levels in scattered settlements as pure livestock breeders.

Feasts and Custom

The number of ancient traditional festivities in Switzerland is very large. They go back to all periods of history and pre-history: they may be of pagan or Christian origin, they may have an economic or social background, or accompany a sporting or political occasion—throughout the year they all reflect a vigorous national life.

Carnival is observed throughout German-speaking Switzerland with the exception of the Cantons of Berne and Aargovia. The most famous carnival without doubt is that of Basle, with its traditional, "Morgestraich", "Cliques" and "Guggemusiken". In the spring, many areas have a Blessing of the Crops: in Beromünster this takes the form of a procession on horseback, while the Lötschen Valley (Valais) has a Blessing Sunday. Commemorative ceremonies are held at all important battlefields, such as Morgarten (Schwyz), Näfels (Glarus), Sempach (Lucerne). Popular assemblies are the occasion for festivities in Appenzell, Glarus, Stans and Sarnen. Markets invariably attract a numerous public, for instance the "Zibelemärit" in Berne. Marksmen's festivities, such as the "Ausschiesset" in Thun, the "Amts- und Wyberschiessen" at Entlebuch, the boys' rifle event at Zurich and the "Rütlischiessen" are annual events. There are also many customs in winter, such as the "St. Nicholas Chase" at Küssnacht on Mount Rigi and in Arth (Schwyz), a similar

New Year's Eve event at Urnäsch (Appenzell Ausserrhoden), Wald and Stäfa (Zurich), and many more. And finally the cold season has to be driven out again and again: "Roitschäggätta" in the Lötschen Valley (Valais), the Zurich "Sechseläuten".

In French-speaking Switzerland many customs are associated with religious festivals. At Romont (Fribourg) Good Friday is observed by a procession of black-veiled keening women ("pleureuses") carrying the instruments of torture from the Passion of our Lord through the streets. On St. Sebastian's Day in the Valaisian mountain village of Finhaut a blessed raisin loaf is distributed to the faithful participating in the procession. Summer festivities are often observed on the Alpine pastures, such as the "Mi-été" at Tavayannaz (Vaud). In the cantons of Fribourg and Vaud the "Bénichon" is associated with the driving of the animals down from their high grazings; this is a cheerful popular festival with processions in costume, markets and dancing. The "Fête de l'Escalade" in Geneva commemorates the failure of the Savoyard attempt to capture the city. At Saignelégier (Jura) the "Marché-Concours"—a horse market with a bareback riding competition—is a genuine popular holiday. More patriotic occasions are the "Fête de la République" in Neuenburg and the 1st of June in Geneva (commemoration of its accession to the Confederation). Colourful vintners' festivals are held on Lake Neuchâtel, on Lake Geneva and in the Rhone Valley.

In the Ticino the month of May is welcomed with the "Maggiolata", the singing of children round festively decorated maypoles. In all major localities there is a traditional risotto feast given for the population in connection with the carnival. On 24th June, St. John's Day, the shepherds observe their feast. Parish fairs and traditional Patron Saints' Days are part of the ancient customs of the Ticino and of the Italian-speaking part of the Grisons. Particularly impressive processions take place at Mendrisio on Maunday Thursday and on Good Friday. The Lugano vintners' festival has become famous for its magnificent flower parade.

Everyday life and work in the Rhaeto-Romance Grisons is still strongly interwoven with custom and folklore, and this is reflected in particular on religious and secular holidays. In the Engadine, in the Oberhalbstein and Lenzerheide areas the winter demons are driven out with a ringing of handbells and cracking of whips: "Chalanda Marz". At Schuls the "Homstrom", a straw puppet, is burnt for the same purpose. Rhaeto-Romance Switzerland also has religious feasts: dignified processions at Disentis and elsewhere mark the Feast of St. Placidus. The "Schlitteda Engiadinaisa" is a cheerful sleigh-ride by young unmarried people.

Music and Theatre

Music is part of any nation's cultural expression. Popular and symphonic music, chamber music, jazz, light music, chansons and hits are the principal categories practised also throughout Switzerland. Against the pressures of cinema, radio and television the live theatre has remained alive—both for the spoken and sung word, i.e. for plays, operas, operettas, musicals and ballets. Alongside the professional theatre of the major centres dramatic activities are undergoing a new upsurge on countless small stages up and down the country.

 The traditional song of German-speaking Switzerland is chiefly characterized by yodelling. Among traditional instruments the zither, the concertina and the *alphorn* are typically Swiss instruments alongside the more universal violin, cello, double bass and clarinet. Cowbells, handbells and coins in milk-churns are also occasionally used in folk music. In eastern Switzerland and in the Upper Valais various forms of the dulcimer have developed. Symphonic music and chamber music are performed mainly in the big cities. Thus Basle, Berne, Bienne, Lucerne, Zurich, St. Gall and Winterthur have permanent large orchestras. During the summer famous music festival weeks are held in towns and at tourist centres, such as Lucerne, Interlaken, Meiringen, Zurich and Gstaad. Certain localities also have jazz festivals on their calendar of events: the Zurich Jazz Festival, the Vitznau Whitsun Jazz Days and the International Old Time Jazz Meeting at Bienne. The Lenzburg, the Gurten above Berne and the City of Basle provide the settings for International Folk Festivals. Numerous localities have theatrical stages. Alongside the big theatres of Zurich, Basle, Berne and St. Gall, fringe events take place in a great many localities. Numerous small theatres and basement theatres perform not only plays but also cabarets, pantomimes, marionette plays and chansons. There are finally the well-known Tell performances at Interlaken (open-air theatre) and at Altdorf during the summer.

 French-speaking Switzerland has a great wealth of popular music. Here the traditional folk orchestra frequently includes trumpets and trombones. The climax of traditional musical life is the vintners' festival of Vevey, held once every 25 years. A peculiar feature in many places are the carillons. These sets of tuned bells are played by one or several bell-ringers. Geneva and Lausanne are the centres of serious music. Geneva organizes an international music competition each year, while music festivals are held at Montreux, Lausanne, Neuchâtel and Sion. Montreux also has a Jazz Festival and Nyon a Folk Festival. As for theatrical life, Lausanne and Geneva hold the lead with their great theatres, but other places, such as La Chaux-de-Fonds, Mézières, Carouge, Morges and others also have a noteworthy theatrical life. And finally there are quite a number of large and small theatres all over the country.

 Italian-speaking Switzerland has a rich tradition of folk music, and this is cultivated in countless associations and by village bands. The typical brass bands *(bandella)* are joined, as accompanying instruments, not only by violins, double basses, accordions and mouth-organs but also by mandolins and guitars. Lugano has a large symphony orchestra. At Ascona, Locarno and Lugano musical festivals are held in spring or summer. At Ascona, Lugano and Verscio there is also a flourishing theatrical life on the stages of permanent theatres.

 Rhaeto-Romance popular tradition also has many peculiar features in the field of music, which is cultivated with special love. After all, the Rhaeto-Romance speakers are more conscious of their language and culture than other national groups. Native wind and dance music as well as choral singing are widely practised. The Rhaeto-Romance valleys have given rise to some strange popular instruments: helical and chain rattles, hinged boards, handbells, primitive lutes and harps, beak and transversal flutes, and animal horns. Concert weeks are held at the tourist centres of the Engadine every year.

Education and Museums

Education is, as a matter of principle, the concern of the cantons, and each canton in consequence has developed its own educational system. Compulsory schooling is for eight or nine years, and this may be followed by vocational training or by a higher secondary school. Trade schools, higher technical colleges and universities open the doors to the more demanding occupations. Adult education, libraries and museums provide opportunities for further education and cultural activities.

 In the German-speaking cantons the school year as a rule starts in spring. In Berne, Basle, Zurich and Fribourg there are universities, in Lucerne there is a Theological College, at St. Gall there is a Business College and in Zurich the Federal Institute of Technology. Brugg (Aargau) and Augst (Basle-Country) have important collections of Roman finds, while the Swiss National Museum in Zurich provides a survey of Swiss culture and history. The Federal Records Archives at Schwyz houses important documents of the Old Confederation. Numerous natural history museums provide information on the nature of the country (especially in Zurich, Berne, Basle, Coire and Frauenfeld). The Glacier Garden at Lucerne in particular illustrates the effects of the glaciations, while the Alpine Museum in Berne is devoted to the high mountains and to alpinism. At the open-air museum at Ballenberg (near Brienzwiler/Bernese Oberland) typical houses from various parts of the country are displayed. Outstanding ethnographic collections (especially in Basle) convey to the Swiss the traditional art of distant countries. The Transport Museum in Lucerne is Switzerland's most visited museum.

 In the western Swiss cantons the school year begins in the autumn. The universities of Geneva, Lausanne, Neuchâtel and Fribourg (the last named being bilingual) as well as the Federal Institute of Technology in Lausanne enrol a strikingly large number of foreign students. At Avenches (Vaud) there is a museum with finds from the Roman city of Aventicum. Several castles recall the Middle Ages; many of them have been turned into museums of old-time life (Gruyères, Chillon, Grandson and many others). The Historical Museum at Vevey also houses collections illustrating the history of viticulture. The Watch Museums in Geneva and La Chaux-de-Fonds are devoted to this important economic sector of western Switzerland, while Ste. Croix (Vaud) has an exhibition of musical boxes. There are important ethnographic museums especially in Geneva and Neuchâtel. Geneva also has an Automobile Museum, but veteran motorcars may also be seen at the Castle of Grandson (Vaud). The Castle of Colombier (Neuchâtel) houses a rich military collection. The Jurassic Museum of Delémont presents the history of the Jura.

 In the Ticino and the Italian part of the Grisons the school year begins in the autumn. In the Ticino there are grammar schools and teacher training colleges, but in order to get a university education students from Italian-speaking Switzerland have to go either north of the Alps or to neighbouring Italy. Alongside important historical museums in Bellinzona and Lugano there are a number of noteworthy regional and local historical collections in the Ticino valleys, and in the Mesocco, Bregaglia and Poschiavo Valleys. In Bellinzona there is a Ticinese Costumes Museum. A curiosity, finally, is the Customs Museum at Gandria, dedicated to customs control and smuggling.

 If the Rhaeto-Romance language is to survive it must be cultivated in the kindergarten and in the schools. But this is precisely where the problems arise: all teaching aids have to be made available in the five different dialects. Higher education in the Rhaeto-Romance language is not, unfortunately, possible. Valuable Rhaeto-Romance cultural records are kept in the Disentis and Müstair Abbey collections and in the Rhaetian Museum in Chur. Tarasp Castle is a museum of bygone life, while the Engadine Museum at St. Moritz contains an important collection of cultural history and ethnological exhibits. Museums of local and regional importance exist at Schuls, Trun, Valchava and Waltensburg.

247

Bibliography

Principal sources and works quoted

Aerni, Klaus, 1975: Gemmi — Lötschen — Grimsel. Beiträge zur bernischen Passgeschichte. Jahrbuch der Geographischen Gesellschaft von Bern, Band 51/1973–1974
Allemann, Fritz René, 1977: 25mal die Schweiz. Panorama einer Konföderation. Piper München + Zürich (3rd edition)
Bachmann, Fritz, 1975: Naturparadies Schweiz. Das Beste aus Reader's Digest, Zürich
Bächinger, Konrad; *Kaiser*, Ernst, 1968–1974: Arbeitshefte für den Unterricht in Schweizer Geografie (11 volumes, different editions). Arp St. Gallen
Bär, Oskar, 1973: Geographie der Schweiz. Lehrmittelverlang des Kantons Zürich
Bartholet, Hansueli, 1964: Geologie des Tafel- und Faltenjuras zwischen Eptingen und Oltingen (BL). Tätigkeitsbericht der Naturforschenden Gesellschaft Baselland, Band 23
Bichsel, Peter, 1969: Des Schweizers Schweiz. Arche, Zürich
Blumer, Walter, 1957: Bibliographie der Gesamtkarten der Schweiz. Von Anfang bis 1802. Bibliographia Helvetica, Faszikel 2. Schweizerische Landesbibliothek, Bern
Brassel, Johannes, 1898: Neue Gedichte. Fehr'sche Buchhandlung, St. Gallen
Bundesgesetz über die Raumplanung 1977: Entwurf in Raumplanung Schweiz 2/1977, Bern
Burckhardt, Carl J., 1952: Reden und Aufzeichnungen. Manesse, Zürich
Butz, Rudolf, 1968: Vergleichende geographische Untersuchungen am schweizerischen Voralpenrand. Dissertation Eidgenössische Technische Hochschule, Zürich
Chappaz, Maurice, 1945: Verdures de la nuit. Mermod, Lausanne
Charponnière, Paul, 1930: Genève. Arthaud, Grenoble
Egli, Emil, 1962: Erlebte Landschaft. Die Heimat im Denken und Dasein der Schweizer. Eine landeskundliche Anthologie. Artemis, Zürich und Stuttgart
Egli, Emil, 1970: Die Schweiz. Eine Landeskunde. Haupt, Bern (4th edition)
Egli, Emil, 1977: Dennoch — die Hoffnung Schweiz. Gute Schriften, Zürich
Flüeler, Niklaus et alii (editor), 1975: Die Schweiz — vom Bau der Alpen bis zur Frage nach der Zukunft. Ex Libris, Zürich
Folienausschuss des Schweizerischen Lehrervereins (SLV), 1978: Transparentfolienserie JURA, Kümmerly + Frey, Bern
Forum alpinum, 1965: Karger Boden — Schöne Heimat. Zürich
Generaldirektion der Schweizerischen Bundesbahnen 1977: Amtliches Kursbuch, Ausgabe Sommer
Glauert, Günter 1975: Die Alpen, eine Einführung in die Landeskunde. Geocolleg. Hirt, Kiel
Goethe, Johann Wolfgang, 1837: Briefe aus der Schweiz (1792). Literatur-Comptoir, Herisau
Gotthelf, Jeremias, 1850: Die Käserei in der Vehfreude. Eine Geschichte aus der Schweiz. Springer, Berlin
Grosjean, Georges, 1970: K + F Atlas. Naturbild und Wirtschaft der Erde. Kümmerly + Frey, Bern
Grosjean, Georges, 1972: Historische Karte der Schweiz. Kümmerly + Frey, Bern
Grosjean, Georges, 1973: Kanton Bern, Historische Planungsgrundlagen. Planungsatlas 3. Lieferung. Kantonales Planungsamt, Bern
Grosjean, Georges; *Cavelti*, Madlena, 1971: 500 Jahre Schweizer Landkarten. Orell Füssli, Zürich
Gschwend, Max, 1971: Schweizer Bauernhäuser. Material, Konstruktion und Einteilung. Schweizer Heimatbücher 144/145/146/147. Haupt, Bern
Guggenbühl, Adolf, 1967: Die Schweizer sind anders. Spiegel, Zürich
Guggenheim, Kurt, 1961: Heimat oder Domizil? Die Stellung der deutschschweizerischen Schriftsteller in der Gegenwart. Artemis, Zürich
Gurtner, Othmar (editor), 1960: Sprechende Landschaft. Eine erdgeschichtliche Heimatkunde in zwei Bänden. Frei, Zürich

Gutersohn, Heinrich, 1958–1969: Geographie der Schweiz. Band 1: Jura. Band 2: Alpen. Band 3: Mittelland. Kümmerly + Frey, Bern
Häberli, Rudolf, 1975: Verlust an landwirtschaftlicher Kulturfläche in den Jahren 1942–1967. Raumplanung Schweiz 2/1975, Bern
Heer, Oswald, 1879: Die Urwelt der Schweiz. Schulthess, Zürich
Heierli, Hans, 1974: Geologische Wanderungen in der Schweiz. Ott, Thun
Heim, Albert, 1932: Bergsturz und Menschenleben. Vierteljahrschrift der Naturforschenden Gesellschaft Zürich, Band 77
Hesse, Hermann, 1904: Peter Camenzind. Fischer, Berlin
Imhof, Eduard, 1976 (17th edition): Schweizerischer Mittelschulatlas. Konferenz der Kantonalen Erziehungsdirektoren, Zürich
Imhof, Eduard (editor), 1965–1978: Atlas der Schweiz. Eidgenössische Landestopographie, Wabern
Ineichen, Fritz et alii, 1977: Ferienbuch der Schweiz. Schweizerische Reisekasse reka, Bern
Keller, Rolf, 1973: Bauen als Umweltzerstörung. Alarmbilder einer Un-Architektur der Gegenwart. Artemis, Zürich
Konzelmann, Max, 1929: Jakob Bosshart, eine Biographie. Rotapfel, Erlenbach-Zürich
Kraske, Paul (editor), 1975: Freizeit in der Schweiz. Kümmerly + Frey, Bern
Krippendorf, Jost, 1975: Die Landschaftsfresser. Tourismus und Erholungslandschaft — Verderben oder Segen? Hallwag, Bern
Kündig, Ernst; *De Quervain*, Francis, 1953: Fundstellen mineralischer Rohstoffe in der Schweiz. Schweizerische Geotechnische Kommission, Bern
Le Corbusier, 1946: Manière de penser l'urbanisme. L'architecture d'aujourd'hui. Boulogne/Seine
Lombard, Augustin; *Nabholz*, Walter; *Trümpy*, Rudolf, 1967: Geologischer Führer der Schweiz. Wepf, Basel
Loosli, Carl Albert, 1921–1924: Ferdinand Hodler. Leben, Werk und Nachlass. Rascher, Zürich
Meyer, Conrad Ferdinand, 1882: Gedichte, Leipzig
Nething, Hans Peter, 1976: Der Gotthard. Ott, Thun
Oppenheim, Roy, 1974: Die Entdeckung der Alpen. Huber, Frauenfeld
Osterwalder, Christin, 1977: Die ersten Schweizer. Scherz, Bern
Pichard, Alain, 1975: Vingt Suisses à découvrir. Portrait des cantons alémaniques, des Grisons et du Tessin. 24 heures, Lausanne
Rambert, Eugène, 1866: Les Alpes suisses. Deuxième partie. Delafontaine et Rouge, Lausanne
Ramuz, Charles-Ferdinand, 1929: La fête des vignerons. Paris
Reinhart, Josef, 1951: Gesammelte Werke. Sauerländer, Aarau
Reynold, Gonzague de, 1914: Cités et pays suisses. Payot, Lausanne
Roesli, F.; *Wick*, P., 1977 (3rd edition): Gletschergarten Luzern. Stiftung Amrein-Troller, Luzern
Rougemont, Denis de, 1965: La Suisse ou l'histoire d'un peuple heureux. Hachette, Paris
Rousseau, Jean-Jacques, 1783: Les rêveries d'un promeneur solitaire. London
Rüegg, Kathrin, 1977: Mit herzlichen Tessiner Grüssen. Müller, Rüschlikon
Schweizerischer Bundesrat (editor), 1975: CH — Ein Lesebuch — Choix de textes — Raccolta di testi — Collecziun da texts. Schweizerische Bundeskanzlei, Bern
Schwendimann, Max A., 1972: Gegenwartsdichtung der Westschweiz. Benteli, Bern
Siedentop, Irmfried, 1977: Die geographische Verbreitung der Schweizen. Geographica Helvetica 1/1977
Stein, Max, 1949: Morphologie des Glattales. Dissertation phil. II, Universität Zürich
Streich, Albert, 1956: Tschuri. Gute Schriften, Basel
Stucki, Lorenz, 1968: Das heimliche Imperium. Scherz, Bern
Studer, Bernhard, 1825: Beyträge zu einer Monographie der Molasse. Bern
Suter, Hans; *Hantke*, René, 1962: Geologie des Kantons Zürich. Leemann, Zürich
Wälti, Hans, 1929–1964: Die Schweiz in Lebensbildern. Ein Lesebuch zur Heimatkunde für Schweizer Schulen (11 volumes). Sauerländer Aarau

Weilenmann, Hermann, 1925: Die vielsprachige Schweiz. Eine Lösung des Nationalitätenproblems. Rhein, Basel
Weiss, Richard, 1959: Häuser und Landschaften der Schweiz. Rentsch, Erlenbach-Zürich
Weisz, Leo (editor), 1942: Landtafeln des Johann Stumpf 1538–1547. Kümmerly + Frey, Bern
Widmann, Josef Viktor, 1882: Spaziergänge in den Alpen. Wanderstudien und Plaudereien. Huber, Frauenfeld.

Map Bases

Principal data for the preparation of the thematic maps and diagrams; for detailed information see Bibliography

Bachmann 1975: page 331
Bär 1973: different graphs
Bartholet 1964: plate IV, cross-section 17
Blumer 1957: page 113
Folienausschuss des Schweizerischen Lehrervereins 1978: 2 diagrams
Generaldirektion der Schweizerischen Bundesbahnen 1977: different pages
Grosjean 1970: pages 70/71, 72, 75
Grosjean 1973: page 25
Grosjean + Cavelti 1971: plates 16 and 23
Gurtner 1960: 2nd volume, page 38
Imhof 1965–1978: different tables
Roesli + Wick 1977: page 22
Stein 1949: maps
Weisz 1942: table IX

Contributors

Photographers

Walter Imber, Laufen (with Canon F-1 and Canon-lenses from 20 to 600 mm) all with the exception of
Comet Photo, Zürich No. 49, 84, 106, 149
Eidgenössisches Institut für Schnee- und Lawinenforschung, Weissfluhjoch-Davos No. 38, 39
Eidgenössisches Militärdepartement, Bern No. 136
Gletschergarten, Luzern No. 19, 20
Anne-Marie Grobet, Russin GE No. 77, 114, 145
Hofer + Burger, Zürich No. 9
Dr. François Jeanneret, Orvin No. 23, 24, 26, 27, 30, 55, 62, 94, 117, 123, 126
Herbert Maeder, Rehetobel No. 137
Hans Peter Nething, Zofingen No. 68
Wim Porton, Scuol No. 40
Fernand Rausser, Bolligen No. 56–60, 67, 112, 144
Galerie Scheidegger, Zürich No. 42
Firma Sandoz, Basel No. 109
Firma Sulzer, Winterthur No. 110
Verkehrsverein St. Gallen No. 79, 80, 83
Verkehrsverein Villars No. 76
Franz Villiger, Gstaad No. 78
Dr. Heinz J. Zumbühl, Stuckishaus No. 36, 61, 63
Willi P. Burkhardt, Buochs panorama

Specialist consultant

Prof. Dr. Georges Grosjean, Kirchlindach

Draft of maps and diagrams

Kümmerly + Frey, Bern, with the exception of:
Eidgenössisches Statistisches Amt, Bern page 222
Prof. Dr. Georges Grosjean, Kirchlindach pages 97, 163, 223
Dr. François Jeanneret, Orvin pages 28, 39, 76, 156, 160, 219, 225

Thematic drawings

Rolf Schöpflin, Boll-Sinneringen